THE
MADONNA
OF THE
FUTURE

ARTHUR C. DANTO

THE
MADONNA
OF THE
FUTURE

ESSAYS IN A PLURALISTIC
ART WORLD

mfink33 @ aol.com

UNIVERSITY OF CALIFORNIA PRESS

Berkeley · Los Angeles · London

University of California Press
Berkeley and Los Angeles, California

University of California Press, Ltd.
London, England

First Paperback Printing 2001

Published by arrangement with
Farrar, Straus and Giroux

Library of Congress Cataloging-in-Publication Data

Danto, Arthur Coleman, 1924–
 The Madonna of the future : essays in a pluralistic art world / Arthur C. Danto.
 p. cm.
 Originally published: New York : Farrar, Straus and Giroux, 2000.
 ISBN 0-520-23002-7 (alk. paper)
 1. Art, Modern—20th century. 2. Art. I. Title.

 N6490.D2385 2001
 709'.04—dc21 2001027452

Most of these essays were first published in *The Nation*, and the author is grateful for the magazine's permission to have them published here. "Andy Warhol and the Politics of Prints," written for the catalog raisonné of the artist's work, edited by Frayda Feldman, is published here with the permission of Feldman Fine Arts, Inc.

For
Art Winslow, Literary Editor, *The Nation*

and for
Ralph Raimi, Saul Wineman, Donald Shapiro, and Doris Vidaver,
friends of my youth

CONTENTS

■ ■ ■

PREFACE

■ ■ ■

*W*HEN, FIFTEEN YEARS AGO ALMOST TO THE DAY, I BEGAN MY
tenure as art critic for *The Nation*, my editor asked only that my reviews ap-
pear while it was still possible for the shows discussed to be viewed. This was
not in general an onerous restriction, as I was otherwise entirely free to write
as I wished on whatever I wished, often at the length I thought necessary.
But it turned out to be an important one. Reviews appear in art magazines
long after the shows are matters of history, so whatever benefits they may
bring the artist and his or her supporters, they necessarily fail in bringing
readers together with the work. Because my pieces appear in time for moti-
vated readers actually to engage with the art, a special relationship between
us—the critic, the reader, and the art—is opened up. Part of my task, as I saw
it, was to furnish readers with a piece of thought they could carry into the
galleries with them, to be modified or rejected if it failed to square with their
experience. This way they would not be mere passive observers, but in fact
be taken up into a critical conversation. They would become critics them-
selves, as it were, by participating in a discourse. Works of art, and especially
contemporary works in an art world grown increasingly pluralistic, do not
generally speak for themselves. Much of what contemporary art is about is
the concept of art itself, so its meaning must be understood with reference to
art-world discourses which are still ongoing when the work is shown. Artists
always have an ideal audience in mind—an art world for which they work.
One is a member of an art world precisely through participating in the dis-
courses that define it—and this, in effect, means learning how to think criti-

cally about the work at hand. My editor's request thus determined the form my criticism was to take, as well as the relationship it projected with those who read my pieces.

In general what I undertake to do in these reviews is to describe what the work is about—what it *means*—and how this meaning is embodied in the work. A prominent critic, whom I'll call K, has written: "The primary question for me about works of art is what they are rather than what they mean." He adds: "One of the things that is wrong with a lot of art that is highly praised is that it can only be experienced in its 'meaning' because what it is is so negligible that you're being invited to respond to its posted agenda, not what the artist has actually made for you to look at." The thought that a poem "should not mean but be" entered the dictionary of received opinions some decades ago, but the dichotomy it enjoins lacks philosophical subtlety. What it fails to recognize is that the being of a work of art *is* its meaning. Art is a mode of thought, and experiencing art consists of thought engaging with thought. It is, I suppose, possible to treat a work of art as a mere thing which happens to gratify the eyes, and K inevitably favors work of this sort. But even the most optically engaging art is a vehicle of meaning, which has to be unpacked to do more by way of criticism than simply to express one's pleasure in it. The great works of art are those which express the deepest thoughts, and treating them as mere aesthetic objects cuts one off entirely from what makes art so central to the needs of the human spirit. A friend recently told me of how he just was unable to "get" a set of paintings by Cy Twombly, which consist of lines of white cursive ovals, "written" across a black surface—something like exercises in awkward penmanship. One day he met Twombly, and their conversation gave him a reason to look closely and to think further about these works, which he ended up loving. What they are is so disproportionate to what they mean that it is not surprising that Twombly's work evokes explosions of invective when K writes about it. Discourse about art is like moral discourse. Chains of argument carry us from observations to judgments and back again. Criticism is reasoning of a kind we are familiar enough with in this sense—but we live in an atmosphere in which the paradigm of artistic response must be sudden and subrational, like a blinding flash.

The being-meaning dichotomy may have seemed a deep thought when

artworks were believed to have a closed set of material properties—made of paint or bronze, for example, and designed to hang on walls or occupy a niche. These antecedent conditions have turned out to have been entirely conventional, and in the world of contemporary art they have no application whatever. We are living in a time when anything can be a work of art, when works of art can be made of whatever material seems suitable, and where there are no perceptual criteria in virtue of which some things are works of art and some things not. Contemporary art celebrates the thought projected by the work, which may itself have very little distinction, aesthetically speaking. Marcel Duchamp's readymades were selected primarily by the criterion of having nothing aesthetic to recommend them. One of them was a simple metal comb, of the kind used to groom dogs. It had nothing to contribute to the eye's gratification—or if it did, that gratification was equally available to combs exactly like it, which happened not to be works of art. The difference between artworks and mere objects is momentous, but it cannot rest on anything that meets the eye. The distinction between meaning and being is a good place to start in working toward a critical assessment: one has to ask how the meaning is embodied in the material being of the object. What is important to stress is that the whole shape of the art world as it has evolved at century's end was generated by Duchamp's experiments. What Duchamp did was to instill philosophical reflection in the heart of artistic discourse. The thoughts with which I endeavor to equip my readers are themselves pieces of disguised philosophy. Each piece of philosophy is designed specifically for the work of art at hand. With contemporary art one is always making a new beginning, having to bring the work's philosophy into the light of day. The structure of critical thought is little different when dealing with the art of the past—but never before have artworks come in so endless a diversity and drawn so heavily on the philosophy of art. K's aesthetic was developed when the object by itself was believed to be all one needed. But that obscured the fact that the core of the object was a structure of meaning that the mind was required to grasp.

The Nation is a national publication, and most of its readers do not live in or around New York, where most of what I was to write about is shown. The fact that in principle the exhibitions can be seen when the review appears does not mean that they will be seen. That gives me my second task as art

critic. I feel an obligation to write in such a way that the essays can be read for themselves. And this means that I think of them ideally as literature. Clement Greenberg, my great predecessor as *Nation* critic, wrote in 1955: "Art criticism, I would say, is about the most ungrateful form of 'elevated' writing I know of. It may also be the most challenging—if only because so few people have done it well enough to be remembered—but I'm not sure the challenge is worth it." Whom do we remember in fact? Diderot, Hegel, Baudelaire, Ruskin, Greenberg himself. We remember them because what they wrote engages us as literature, irrespective of what they tell us about the art they address. John Ruskin's critical response to Veronese's *Solomon and the Queen of Sheba* raises that work to an entirely new level, as a celebration of the gorgeousness of the world contrasted with the religious thought that the world is a sorry site of distractions and trials. The lithographs of Constantin Guys are transformed by Baudelaire into celebrations of modern life and immediately raise the question of what makes modernity possible and different. Diderot's amazing essay on Fragonard's presentation piece for membership in the royal academy—*The High Priest Corseus Sacrifices Himself to Save Callirhoe*—survives as a piece of literature while the painting lives on only as an example of a bad start in a career made glorious by abandoning the pomp and pretense of historical painting. When Frank Stella, as critic of his own work, said, reductively, that what you see is what you see, the thought was immediately falsified by saying it. It said, in effect, that the painting was only an object. But objects in that sense say nothing at all. The degree to which my pieces actually achieve a status as literature is not for me to say, but my effort as a writer is in every instance to remove obstacles to their being such. At the very least, this means making them as clear as possible, which means that I bring to the writing on art what I learned as an analytical philosopher, inspired by such literary models as David Hume, Bertrand Russell, G. E. Moore, Ludwig Wittgenstein, and W. V. O. Quine. Only, it seems to me, if essays have a degree of literary quality is there any good reason to republish them. The first of my tasks assures that the essays serve as documents for the period in which they were written. My second task, if successfully executed, means that the pleasure the essays give should in the end be as important as whatever critical truths they transmit.

There is a third critical task that has little attraction for me, which is to

be critical of the work I write about. The freedom to choose my subjects makes it possible for me to select only those artists whose work already has quality sufficient enough that nothing needs to be said beyond explaining the way they embody their meanings. I deplore the waspishness of critics, who must take extreme pleasure in savaging work in which so much time and hope, thought and effort is invested that it ought instead to enjoin a high degree of respect. Criticism in the New York press is marked by cruelty and the exercise of a will-to-power, which gives it its bad name. I make, however, one distinction. Art is not immune to moral criticism, and when I am negative, as in the essays on Richard Avedon and Bruce Nauman, it is because their work, in my view, violates what I feel is the respect due human subjects. The openness of art no more gives artists license to degrade than the etymology of "criticism" licenses what is tantamount to a public rape.

Most of these pieces were published in *The Nation* from 1993 to the present, and so round out a decade and a century. The book begins and ends with a pair of philosophical essays which take up issues raised in this preface, and serve as examples of philosophical thinking about our unprecedented moment in the history of art—a moment in which everything is possible as art, a moment in which there are no rules, in which everything is finally open. It is against this seemingly hopeless heterogeneity that we must frame a philosophy of art which can only be valid for our time if it is valid for every time, even those with the narrowest of options allowed its artists. "Art and Meaning" is a much amplified version of an essay of the same name, originally published in *Theories of Art Today*, edited by Noel Carroll, to whom I am grateful, as for so many things, for having goaded me to set my thoughts in order on a topic central to my philosophy of art (University of Wisconsin Press, 2000). "The Work of Art and the Historical Future," which serves as the end piece, benefited greatly from the venues in which it was presented as a lecture—in Budapest, Vienna, Munich, and The Humanities Center at the University of California at Berkeley. It serves to put in place the philosophy of art history that the critical essays presuppose.

A word about the title, which will be recognized as Henry James's inspired title for one of his early stories. I discuss that story in "The Work of Art and the Historical Future." It was Paul Elie, my editor at Farrar, Straus

[xiii]

and Giroux, who suggested I use the title, since I often attempt to see the future looking back on the present as if it were past. There is another reason for using the title. Titles do not fall under copyright, and that makes it possible to appropriate any title at all to one's own purpose. But appropriation itself is very much an artistic practice of recent times—a practice which consists of taking for oneself images or phrases that others have used before. James used his title for one kind if irony, I for another. The art world of the expatriate artist in 1870 in Rome has very little in common with the art world of an artist—or critic!—in Manhattan in the year 2000. My discussion of Theobald—James's failed artist—is precisely an exercise in viewing 1870 through the lens of 2000.

I owe too much to too many to be able to thank them individually. But I cannot let pass the opportunity to thank *The Nation*, which has given me a forum I could not have hoped for as a philosopher. Without its great editor, Betsy Pochoda, I would almost certainly never have written a word of art criticism in my life. I must acknowledge my boundless gratitude to Art Winslow, who has edited my pieces over the years with tact and sensitivity, and seen to it that the writings exhibit the virtues of clarity, concision, and consequence which belong to philosophical expression as I endeavor to practice it. I am grateful to Jack Bankowsky, the imaginative and adventurous editor of *ARTFORUM*, which has become a second venue for my writing. And I am grateful to Farrar, Straus and Giroux for agreeing to publish a fourth collection, and especially for the support of Jonathan Galassi. It was a piece of luck to have Paul Elie as editor, since he has a rich and vital relationship to the art world on which these essays are based.

On the cover of each of the books I have published with Farrar, Straus and Giroux, there has been an image by Russell Connor, a wonderful and witty artist. It would have been unthinkable to allow this tradition to lapse, if Russell could be persuaded to put his talent toward illuminating the concept of the title. He surpassed my hopes, and did so in the subtlest ways. In a flash of creative insight, Russell was inspired by the fact that the "Madonna of the Past," in James's story, is Raphael's *Madonna of the Chair*—a painting composed in tondo form (giving rise to the myth that Raphael had painted it on a barrelhead!), which shares a form with a CD–ROM. So he combined the two: the image itself shows the great painting in anamorphic perspective,

projected onto a disk, uniting the present with a past in which it was unthinkable. Moreover, it was a design that exists only on the hard drive of a computer: there is no "original" (or, rather, every jacket for the book is an original). What it demonstrates is that art does not in the end lose its aura when mechanically reproduced. Nothing marks post-Modernity more sharply than that!

But I owe most to my wife, partner, and pal—the artist Barbara Westman—who almost always notices things about the art that passed me by completely. Our conversations are good examples of the kind of critical discourse I envision as ideal. But beyond that she has made my life with art and artists—herself of course included—what Rimbaud speaks of as *un festin—Où s'ouvraient tous les coeurs, où tous les vins coulaient*—"A banquet where every heart stood open and the wines all freely flowed."

ACD
New York City, October 24, 1999

ART AND MEANING

▪ ▪ ▪

*T*HROUGHOUT THE HISTORY OF PHILOSOPHICAL SPECULATION ON art, it was tacitly assumed that works of art have a strong antecedent identity, and that one could tell them apart from ordinary things as easily as one could tell one ordinary thing from another—a hawk from a handsaw, say. So obviously was the distinction between art and everything else that the Greeks evidently did not require a special word for designating artworks, which they nevertheless undertook to account for in the grandest metaphysical terms. There have, especially in Modernist times, been efforts to transform the term "art" into a normative concept, according to which "good art" is tautologous since nothing can be both art and bad. New York critics were known to say of something they disapproved of that it was not really art, when there was very little else but art that it could be. Any term can be rendered normative in this way, as when, pointing to a certain handsaw, we say "That's what I call a handsaw," meaning that the tool ranks high under the relevant norms. But it would seem queer for objects which rank low under those norms to be exiled from the domain of handsaws, and in general normativization must drop out of the concept, leaving a descriptive residue. It is with reference to this residue that works of art were tacitly held to be recognizable among and distinguishable from other things.

At the beginning of the Modernist movement, say in the mid-nineteenth century, certain problems arose at the boundaries of the concept, initially, perhaps, with photographs which were unmistakably pictures, though produced by, as the coinventor of the process, Fox Talbot, phrased it, The Pen-

cil of Nature. There was a double history until very recent times as photographers attempted to emulate paintings, and painters began to distance their work from photography by one or another of the stylistic matrices of Modernism—Cubist, Futurist, Dadaist, Constructivist, etc. Photography was still an outcast in the era of Stieglitz's journal, *Camera Work*, and perhaps its claim to art was vindicated only when the Museum of Modern Art opened the first photography gallery under Edward Steichen. When that happened, the distinction between pictures drawn by Nature's Pencil and by the hand-held pencils of painters dropped out of the concept of art. And articulating the logical structures of that concept proved to be more exacting than anyone might have believed, when it had been taken for granted that artworks constituted a relatively homogeneous class of things, the members of which could be picked out easily and immediately. It was consistent with this assumption that the borderlines expanded and dilated under pressures of various sorts: articles of furniture, for example, would have been considered works of art in the eighteenth century, when made with precious veneers and elegantly designed by master-*ébénistes*. But when Jacques-Louis David, associating these luxurious objects with the aristocracy, drew a sharp line between high art and practical art, objects of *vertu* had to emigrate, like their noble patrons, and became craft instead of art. The distinction remains in effect today, so that one dismisses as craft anything that carries an aura of utility, leaving behind the uncomfortable idea that works of art can have no function, which is a desperate way of keeping borders closed. This leaves intact the assumption that artworks are a special class of things, and that one could walk through any space whatever and pick the artworks out with a high probability of attaining a perfect score. In this respect the distinction between art and anything else was understood as in no way different from the distinction between any pair of classes—hawks and handsaws, once again. From that perspective, the question "What is art?" was never understood as "Which are the artworks?"—to which it could be assumed that we knew the answer—but rather "What are art's essential features?"

What set my book, *The Transfiguration of the Commonplace*, apart from that philosophical tradition was its recognition that the distinction between works of art and ordinary things could no longer be taken for granted. The question with which the book wrestled was, "Given two things that resemble

one another to any chosen degree, but one of them a work of art and the other an ordinary object, what accounts for this difference in status?" This would not have been a question philosophers could have asked when the difference between artworks and ordinary objects seemed for the most part obvious and uncontroversial. They would not have asked it, I think, because the issue had never arisen, except in the somewhat limited contexts of fakes and forgeries, where one depended on connoisseurship to draw distinctions. In the twentieth century, however, through certain internal transformations in the history of art, works of art began to appear that either were, or appeared to be, objects of daily life and use. Duchamp's readymades (1915–1917) were ordinary snowshovels, bottle racks, grooming combs, and, in one famous case, a urinal, and these, before Duchamp, would certainly have been considered as entirely outside the scope of art. My favorite example, of course, was Andy Warhol's *Brillo Box*, a photograph of which would be indiscernible from one taken of the commonplace containers in which the scouring pads were shipped to supermarkets. So why was one art and the other not, since they looked as much alike as anyone cared to make them? So much alike that the assumption that we could pick the artworks out was put ineradicably in doubt.

Transfiguration sought to answer this question, and it arrived at a provisional formulation of part of the definition of art. I argued, first, that works of art are always about something, and hence have a content or meaning; and secondly that to be a work of art something had to embody its meaning. This cannot be the entire story, but if I could not get these conditions to hold, I am unclear what a definition of art without them would look like. In this essay, I want to respond to certain philosophical objections meant to put my meager set of conditions in doubt.

George Dickie, founder of the Institutional Theory of Art, insists that there are counterinstances to my first claim, offering non-objective paintings as his example. It would be extremely interesting to consider which non-objective paintings Dickie could have had in mind. The Guggenheim Museum in New York was originally called The Museum of Non-Objective Painting, and it displayed work by Kandinsky, Mondrian, Malevich, and Rudolph Bauer. The term "non-objective," if not first used by Rodchenko, was certainly used by Kandinsky to designate a pure art that seeks to express

only "inner and essential feelings"—and the phrase "non-objective" is closely synonymous with the word "subjective." The paintings present a reality— albeit an inner reality, or, if an outer reality, then one which has the same spiritual identity as inner reality. And this, to take the other seemingly diffi- cult case, was Schopenhauer's view of music: it is the language of our noumenal being. Similar stories could be told about Suprematism and what Mondrian termed Neo-Plasticism. Malevich perhaps invented monochrome painting as something other than a joke, but would have been astonished to be told that his *Black Square* was not about anything. Robert Rauschenberg's all-white painting was about the shadows and the changes of light which transiently registered on its surface, and in that sense is about the real world. To be sure, I cannot account for every historical example, but I am fairly convinced that I could if presented with any historical case. So we are in the realm of the philosophical counterexample, leached of any content, viz., "What about a painting about nothing?" I would want to know if it had geo- metrical forms, nongeometrical forms, whether it was monochromatic or striped or whatever—and from this information it is a simple matter to imag- ine what the appropriate art criticism would be, and to elicit the kind of meaning the work could have. Sean Scully's paintings are composed chiefly of stripes, but they are meant to assert propositions about human life, about love, even about death. We can of course imagine someone in the spirit of philosophical counterinstantiation painting a work about nothing. But there is a problem of distinguishing between not being about anything and being about nothing, and I incline to the view that nothing is what the painting is about, as in an essay by Heidegger. So my challenge to Dickie would be: give me an example, and I will deal with it. Without some specificity, the game of counterinstances gets pretty tiresome.

The second condition was that a meaning is materially embodied in art- works, which *show* what they are about. This, if true, must put me in conflict with Hegel's formulation of what he terms "symbolic art," the meaning of which, as with a name, is external to rather than embodied in the object, though he and I would be in harmony in respect to the other two forms he distinguishes, classical and romantic art. Since his example of symbolic art is the (Egyptian) pyramid, it can certainly be questioned whether the shape, dimensions, and vectors do not embody the meaning appropriate to its

mummified tenant. But there is a more immediate objection to my second condition, namely that something can at once possess aboutness, and embody its meaning, and yet not be a work of art. It has, for instance, been pointed out that the ordinary boxes of Brillo in the stockrooms of supermarkets are about something—Brillo—and that they embody their meanings through the designs on their surfaces. Since I wanted a definition that would distinguish artworks from real things, however something looked, I cannot have succeeded, since the definition, while it fits Warhol's box, fits equally well the ordinary boxes from which I was anxious to distinguish it. This was raised as a friendly criticism by Noel Carroll, and it requires a somewhat intricate answer.

There are two senses of "content," that in which Brillo cartons physically contain scouring pads, and that in which we may speak of the content of a work of art, which may in no physical sense whatever be "in" the work. What the *content* of *Brillo Box* as a work of art might be, was a matter of interpretation, having nothing to do with opening the box to see what was there. The "Combines" of Robert Rauschenberg possess content in both senses: they physically incorporate ordinary objects—cans, funnels, brooms, Coke bottles—which then contribute to whatever larger meaning the works may convey. The way in which these ordinary objects get taken up and transfigured is, in Rauschenberg's case, partly achieved by heeding what one might call the poetry of the commonplace. The objects of the household, for example, are dense with meanings we begin to grasp when they are lost or broken or worn out. They define the structures of life as it is lived, and, if we know how to read the objects of vanished forms of life, we have access to what it meant to live those forms, and hence to the minds of those who lived them. Indeed, we can learn a great deal more about those forms of life from what Rauschenberg's pieces appropriate, than from those pieces themselves, which were exceedingly strange when they first appeared in galleries in the 1950s, for example a stuffed goat ringed with an automobile tire, which calls upon interpretative responses only tangentially connected with our antecedent ability to recognize automobile tires and stuffed goats.

It follows from these considerations that it becomes quite out of the question that one identify the content of works of art on the basis of their visual qualities, and this does not apply merely to contemporary or near con-

temporary art, but to art of the distant past, inasmuch as it is always possible to imagine objects indiscernible from given works of art but caused by factors in terms of which they cannot mean what the works which resemble them mean. Though this did not occur to writers in the period in which the definition of art seemed a less vexed question than it had become in our own century—whole books today are published on the question of art's definition!—there are aspects of the concept of art which have made it clear from the beginning that people were worried about fakes and copies, and these preoccupations can always be phrased in terms of indiscernibles, even if it is thought, as with Nelson Goodman, that differences will sooner or later emerge, and we will wonder, as we now do with the paintings of van Meegeren, how anyone could have supposed them original. It was important, for complex motives, that van Meegeren not be told apart from Vermeer since he was anxious to be regarded as as good a painter as Vermeer himself was. Perhaps the discernibility would have been obvious, were it not for the experts, such as the unfortunate specialist, Professor Bredius of the Netherlands, who knew more about Vermeer than anyone then living. He surmised that there had to have been an unrecorded Italian journey—how little after all is recorded about Vermeer's life!—and a direct encounter with Caravaggism, to which van Meegeren's first painting appeared perfectly to point. So Bredius was more capable of being fooled through his specialized knowledge than others who knew far less—but who accepted Bredius as the great expert. Of course it is a crazy painting, but what van Meegeren meant in painting it was profoundly different from what Vermeer could have meant, had he produced one indiscernible from it. In fact van Meegeren's *Christ at Emmaeus* is a vaudeville of Vermeer-like mannerisms: one of the heads is exactly like an authentic head by Vermeer, and those little dots of fused light which we see in *View of Delft* are used in ways having nothing to do with the dots in the great landscape, where, for some, they imply the use of a camera obscura. Another dimension of concern arose in connection with restoration, as with the Sistine Ceiling. Is it the same work Michelangelo painted, or has it been changed by the removal of something essential to its meaning? When the painter Morris Louis died, he left upward of six hundred paintings, with no indication of how they were to be stretched. He stained his canvas by pouring, and when the paint was dry, he rolled it up

and stored it. It was decided that Clement Greenberg, who knew the work well, should be the authority as to where the stretcher-marks should be drawn, and this unsettled the art world, in which some held that these were not Louis's but Greenberg's works. No need to settle the matter now, but it is clear that some decision had to be made, even if we have no incontestably clear idea what Louis would have done had he lived.

In any case it may be assumed that there were enough actual differences between *Brillo Box* and Brillo boxes that we can even now tell them apart, however visually alike they are. But those differences will not tell us which of them is an artwork, and in implying that they both are, the force of Carroll's objection is to explain how we are to account for their difference. This I will now seek to do.

In my original discussion, I used the two boxes to raise the question of why one was art and the other not, and hence to ask how to draw a philosophical line between art and reality. But it has since become clear to me that the "real" Brillo boxes might themselves indeed be considered art, and that what set them apart from what Warhol fabricated was the difference between fine and commercial art, comical as it might have sounded to anyone but myself to think of Warhol's boxes as fine art in 1964 when they were first made and shown. (Eleanor Ward, the owner of the gallery, felt that Warhol was pulling something over her eyes, and the Director of the National Gallery in Ontario swore that the boxes were not sculpture—a question on which he was taken to be authoritative.) I was obliged to make this concession when it became undeniable that the cartons satisfied my two conditions, which would require me to find a third condition to get rid of the problem, or just accept that the distinction between fine and commercial art was no more and no less pressing than the parallel distinction between fine art and craft. The cartons were certainly about something; and since I was using aboutness to distinguish art from reality, the cartons would make the first cut. And it seemed to me no less clear that they would make the second cut as well, that of embodiment. The upshot was that the cartons made an unsatisfactory paradigm for a real object, since they were after all embedded in a system of meanings, as I shall argue in a moment. So the problem arose of what paradigm to use for a real object, and that turns out not to be so easy. It would require finding something which did not derive some part of its iden-

tity from a network of meanings, and it is not clear that any could be found—it would be like seeking for something that was not in the mind in an effort to rebut the claims of Bishop Berkeley. To the contrary, the moment you find it, it is no longer outside the mind. It was not important for me to step off the edge into metaphysics, since the philosophical tradition used as its generating paradigm beds painted by artists and beds built by carpenters—and no one can deny the aura of meanings surrounding the bed as a site of suffering and joy. So the line between commercial art and fine art became a problem.

In my early essay "The Art World" I invoked a knowledge of the theory and the history of art to achieve this end, and while this remains true, I now think we might talk as well about different structures of art criticism connected with the two objects. Or *three* objects, if we expand our group to include the *Brillo Boxes* by the appropriationist artist Mike Bidlo, who, in an exhibition at the Bruno Bishofsburger Gallery in Zurich, installed, in the same configuration in which they were shown at the Pasadena Museum of Art in 1968, eighty-five Brillo boxes, which Bidlo had had fabricated. The show was called *Not Andy Warhol*. (The show in Pasadena could not have been titled that way!) So let us mount the exhibition I usually try to imagine when I discuss these matters—the Warhol box, the Not Warhol box, and the "real" Brillo box made famous by Warhol but also not Warhol, though not Not Warhol either. I ask you to grant me their relative indiscernibility, in that the differences between the objects do not penetrate the differences between the works, since they could as readily be imagined as belonging to the others instead of the one they belong to in fact. If you look at Warhol's box, there is a kind of dripping where the paint is stenciled on, showing a certain indifference to clean edges. But the Warhol could be clean and the Bidlo dripping. Or they could both be clean and the real Brillo box be dripping— or at least some of them, say a bad batch. There is no reason to protract this reasoning. So let us apply the structures of art criticism to the three, and imagine that they look entirely alike, and that no visual basis is to be invoked for discriminating the two examples of fine art from the one example of commercial art, or, for that matter, discriminating between the appropriation and the appropriated.

It is now well-known that one of the reasons the design of the Brillo box

is so good is that it was done by a fine artist who was obliged to practice commercial art when Abstract Expressionism faded in the early 1960s. This was Steve Harvey, about whom I would like to know a great deal more than I do. In any case, his Brillo carton is not simply a container for Brillo pads: it is a visual celebration of Brillo. (You can verify this by looking at the way Brillo is shipped today, in plain brown wrappings like pornographic literature: the difference between the container of 1964 and the container of today expresses as eloquently as anything could the difference between 1964 and today!) The box is decorated with two wavy zones of red separated by one of white, with blue and red letters. Red, white, and blue are the colors of patriotism, as the wave is a property of water and of flags. This connects cleanliness and duty, and transforms the side of the box into a flag of patriotic sanitation. It gives two connected reasons for using Brillo, which is printed in proclamatory letters B-R-I-L-L-O, the consonants in blue, the vowels—IO—in red. The word itself is dog-Latin, viz. "I shine!"—which has a double meaning, one of which is consistent with the condition of embodied meaning. The word conveys an excitement which is carried out in the various other words in which the idioms of advertising are distributed upon the surfaces of the box, the way the idioms of revolution or protest are boldly blazoned on banners and placards carried by strikers. The pads are GIANT. The product is NEW. It SHINES ALUMINUM FAST. The carton conveys excitement, even ecstasy, and is in its own way a masterpiece of visual rhetoric, intended to move minds to the act of purchase and then of application. And that wonderful band of white, like a river of purity, has an art historical origin in the Hard-Edge Abstraction of Ellsworth Kelly and Leon Polk Smith. It could not have been done before that movement, the clean edges of which give a certain palpable contemporaneity to Brillo. Harvey deserved a prize, and Warhol, who had won prize after prize as one of New York's leading commercial artists, would have been the first to appreciate its value.

That, in general, is a sketch of the art criticism for Steve Harvey's carton, and you can see how meaning and embodiment are connected. What Harvey would never have thought was that the Brillo box might be fine rather than commercial art; fine art by his criteria would have been the paintings he admired by Pollock and de Kooning and Rothko and maybe

Kline. So what Warhol did was to make something visually of a piece with his, but which *was* a work of fine art. And one will have to note that none of the art criticism appropriate to Harvey's box is at all appropriate to Warhol's. Warhol was not influenced by Hard-Edge Abstraction: he reproduced the forms of an artist who was, only because they were there, the way the logo of the Union of Orthodox Rabbis was there, certifying that that Brillo was kosher (as it was in 1964). It was essential that he reproduce the effects of whatever caused Harvey to do what he had done, without the same causes explaining why they are there, in his *Brillo Box* of 1964. So where does art criticism come in? It comes in because commercial art was in some way what Warhol's art was about. He had a view of the ordinary world as aesthetically beautiful, and admired greatly the things Harvey and his heroes would have ignored or condemned. He loved the surfaces of daily life, the nutritiousness and predictability of canned goods, the "poetics of the commonplace." After all, the Brillo box was but one of the cartons he appropriated for that first show at the Stable Gallery, all of which had their rhetoric but none of which were as successful as Steve Harvey's. By 1964 real objects had penetrated art as subjects for realistic depiction: a case in point is the sign for Mobil gasoline, the Flying Red Horse, in a characteristically haunting painting by Edward Hopper. Crossing that line shows a philosophical shift from rejection of industrial society—which would have been the attitude of William Morris and the Pre-Raphaelites—to endorsement, which was what one might expect from someone born into poverty and in love with the warmth of a kitchen in which all the new products were used. So Warhol's cartons are as philosophical as the wallpaper of William Morris, meant of course to transform rather than celebrate daily life, and, in Morris's case, to redeem its ugliness into a kind of medievalized beauty. Warhol's boxes were a reaction to Abstract Expressionism, but mainly with respect to honoring what Abstract Expressionism despised. That is part of the art criticism of *Brillo Box*, and there is a great deal more. But the two pieces of art criticism are disjoint: there is no overlap between the explanation of Harvey and the explanation of Warhol. Warhol's rhetoric has no immediate relationship to that of the Brillo boxes at all.

And this is true of Bidlo's work as well. If Warhol's *Brillo Box* can be considered the emblematic work of the 1960s, Bidlo's *Not Warhol* can be the

emblematic work of the 1980s. It was done in 1991, when Bidlo had a residency fellowship at Fullerton, where he made, as if reenacting the "Factory," over eighty of the boxes, among other appropriations from Warhol. Indiscernible as Bidlo's is from Warhol's, *his* box could not have been made in 1964. It could as an object, of course, but not as a work of art. For it presupposes Appropriationism, which arose in the 1980s as a way of dealing with a perceived end of art. Warhol's peers were Lichtenstein, Oldenburg, and Rosenquist. Bidlo's peers were Sherrie Levine, Elaine Sturtevant, and Richard Pettibone, all of whom, not incidentally, appropriated works by Marcel Duchamp. Bidlo, the art historian Robert Rosenblum has written, "has much to reveal about the rampant historicism of the twentieth century, when suddenly the wildest rebels of early- and mid-twentieth-century art have been transformed into ancestral figures of remote nostalgia from a lost age, textbook classics no longer capable of disturbing the status quo or the future, but saints of another, now distant era whom we can resurrect with every possible homage."

So Bidlo has appropriated Picasso and Léger in addition to Warhol, and is currently making urinals, since the entire generation of urinals from which Marcel Duchamp's notorious *Fountain* (1917) was drawn has disappeared from the face of the earth. He is making, so to speak, handmade readymades. It happens that his boxes look as much like Harvey's as like Warhol's, but they are about Warhol's and not about Harvey's, and they are about what Warhol made with no special further interest in why he made it. The art criticism appropriate to Bidlo—but not to Warhol—is the art criticism generated by Appropriationism: which works are appropriately appropriated and why. It raises, certainly, acute questions of quality. Are Bidlo's Not Warhols better than his Not Picassos? Are his Not Duchamps better than Levine's *After Walker Evans*, where she photographed a reproduction of Evans's sharecropper woman? We would be hard-pressed to use the art criticism appropriate to photography with Levine's achievement!

I do not want to prolong my discussion past this point. The claim is that all of these differences are invisible, that the actual box before you underdetermines which work it is—Warhol, Harvey, or Bidlo. It is important to the problem that in all relevant visual respects, the three are entirely alike. That is what I have meant in saying so often that what makes something art is not

something that meets the eye. And that makes clear as well why so much rests on meaning, which it is the task of art criticism to make explicit. The works are not, as it were, synonymous. This is not to say there are not visible marks by which to tell Warhol from Bidlo and Bidlo from Harvey. There are, and these would be enlisted in the connoisseurships so important to collecting and selling art. And are, after all, important to how we look at these things and think about them. We don't want to discover that we were thinking about the Bidlo when we thought we were thinking about the Warhol. Still, telling a Harvey from a Warhol from a Bidlo, while it is telling a work of fine art from a work of commercial art, and an original from an appropriation, is not in any further sense telling the difference between fine art and commercial art, which rests instead upon philosophy. And this is true even if you are telling the difference between a work of fine art and one not a work of fine art. The criteria may depend upon measurements, paint samples, mode of imprinting, and the like, none of which pertains to the conceptual division between these various objects. The definition of art remains a philosophical problem.

We can confirm this if we think for a moment on how the flagged properties of the connoisseur are precisely those on the basis of which fakes are constructed. The forger is in constant symbiosis with the connoisseur, attempting to outflank him by incorporating as many of the relevant properties into his fabrications as can be found. The great Morelli based connoisseurship on properties no one had paid attention to, which opened possibilities up for forging Fra Lippo Lippi in such a way that Morelli could mistake it for Filippino Lippi. Bidlo, doubtless in order to demonstrate the irrelevance of connoisseurship to distinguish his work from Warhol's, made no effort to duplicate the latter millimeter for millimeter, or by employing just the same plywood Warhol used—which by now would probably be as difficult to find as a token of the same Mott Works urinal–type to which *Fountain* belonged. But the point is that telling art from nonart, if we can identify the latter at all, is not like distinguishing two works from one another when their status as art is not in question—as with Lippo and Filippino. But this returns me to the distinction between art and reality, from which the recognition of commercial art diverted me.

I have argued that with the emergence of indiscernibles, the true philo-

sophical question was recognized this way: Given two indiscernible objects, one art and the other not, what accounts for the difference? The insufficiently considered case of commercial art did not belong to this question, though an analogous problem arose in case someone thought that commercial art must in every instance look different from fine art. My view, in any case, was that once the question arose, anything could be an artwork, and that, in consequence, the history of art, construed as the quest for self-consciousness, had reached its end. But I would like to make an observation concerning aesthetic responses to objects in the Post-Historical Period, as I have come to call the history of art since it achieved what I think of as philosophical self-awareness. What does it mean to live in a world in which anything could be a work of art? A family snapshot, a most-wanted poster, an aluminum kettle, a hawk, a handsaw? For me, it is to invent a suitable art criticism for an object, whether or not it is a work of art, though if it is not one—if, for instance, it is not about something—the criticism is void. It is to imagine what could be meant by the object if it were the vehicle of an artistic statement.

I recently visited the Museum of Modern Art in San Francisco, and went the next afternoon to lunch with the graduate students in art history at Berkeley. As I headed for the elevator, I passed a large room on the first floor that was clearly being remodeled. There were planks and saw-horses and tipped steel shelves and sheetrock, as well as some power tools here and there, and I thought: I could have seen something exactly like this in the museum! Had I done so, I might in truth have been thrilled, and would have thought of the meaning of such an installation. Not long ago I saw an installation by Haim Steinbach at the Sonnabend Gallery in SoHo in which a room was lined with mostly empty steel shelves of the kind we might see in a storeroom. On one there was a pair of running shoes. On another a television set with a grainy screen. In one corner there was a random stack of drab office chairs, beneath which there was a pile of sand. There was something melancholy about it, and my companion observed that it looked just like some political headquarters in the Negev. With this the possibility of a meaning concerning the state of Israeli culture came into view. To be sure, the headquarters themselves are eloquent on that matter, all the more so if they resemble Steinbach's work. Its disarray and barrenness express the atti-

tudes that the latter represents through exemplification. It is clear that a distinction between two modes of aboutness is what we now require, but drawing it can safely be left to the profession as a way of bringing the definition of art into line with actual practice.

Even more recently, I found myself in the ground floor gallery of the Museum of the American Indian, on Bowling Green in lower Manhattan. It was a vast high room, with columns along its side, and the scuff and scruff one associates with downtown art spaces today. On the floor were a number of wooden pallets, on which stones were neatly piled. I said to my guide that these days such spaces almost always look as if they house installations. I thought a work consisting of stones piled on flats would be pretty impressive if it were art. She said, Well, it really had been an installation, but had since been taken down. The stones were still there because no one knew what to do with them. The work had been blessed by some medicine man, so does that mean that the stones themselves were blessed? Can we discard blessed stones if we cannot afford to return them to the river from which they came?

One final example. A memorial meeting for Richard Bellamy, an adventurous dealer from the 1960s, was held at PS1, in Long Island City. The art world turned up as a clan, since Bellamy was a beloved and admired person. It was uncommonly warm for May, and chairs had been set up in the courtyard of the building. I had the foresight to find a shady place, and sat next to Karen Wilkinson, a critic. We listened to the speeches, but began to notice how people were moving their chairs this way and that—carrying them from one part of the court to another. It was almost as though these movements were choreographed, and Karen said to me that it had begun to look like a performance. She was right. It looked that way. And how appropriate to transform the memorial into a work of art! It would have been an appropriate tribute from that community to that man. Too bad it hadn't been thought of.

These cannot have been thoughts for anyone in the era before the one that made urgent *The Transfiguration of the Commonplace*. It is the mark of our period that everything can be regarded as a work of art and seen in textual terms. I count this, to vary a title I envy Suzi Gablik for inventing, the re-enchantment of the world. Contemporary art replaces beauty, everywhere threatened, with meaning.

THE
MADONNA
OF THE
FUTURE

JOHN HEARTFIELD AND MONTAGE

▪ ▪ ▪

"How to philosophize with a hammer" is the subtitle of Nietzsche's late philosophical masterpiece *The Twilight of the Idols*, but the activity it describes turns out to be wittier and less Teutonic than it sounds. Nietzsche slyly identifies the hammer with the kind used by piano tuners, and the image he conveys is that of an iconoclast who does not so much smash idols as tap them, in order to evoke the flatulent noises that reveal their inner corruption. I can imagine an autobiography for the great political artist of Weimar and the years of the Third Reich, John Heartfield,* with a chapter titled "How One Wages War With a Scissors." An apt illustration might be the clever photomontage of 1929, in which Heartfield shows himself snipping off the head of the Police Commissioner, Zörgiebel, the artist peering out at the viewer beneath a fierce scowl, which is rendered comic by the bloodless decapitation. What he has achieved is a marvelously self-referential image in which a photograph of him holding a large pair of scissors is pasted next to a photograph of the jowly bureaucrat's bald head, already partly sheared off. Zörgiebel looks almost beatific and half-asleep, as

*Born Helmut Herzfeld in 1891; anglicized his name in 1916 in counter-patriotic protest against the nationalistic anthem *"Gott strafe England"*—"May God Punish England."

if anesthetized for purposes of the operation, while the artist holds the head with his fingers, the way he would hold a piece of paper—which is what he in fact does hold.

It is a brilliant image in part because it exploits and in part because it would be impossible without the medium of the photomontage. Just imagine a painting of one man cutting off the head of another with a pair of scissors: Though of course it might be possible to paint someone cutting the head off a painting of a man, such a work would be puzzling, and in any case could not refer to its own processes, as the 1929 photomontage refers to the practice of snipping, arranging, and pasting photographic images in evocative juxtaposition. And in any case, what would be the point of such a painting, or, as the manifesto for the First International Dada exhibition of 1920 (of which Heartfield was one of the organizers) suggested, of painting *anything*, when photographs of things lie ready to hand and in great abundance? The task is no longer to represent the world but to rearrange it. So the use of photographic images in the montage of Heartfield cutting off the head of Zörgiebel, like a latter-day Judith with the head of Holofernes, was not to make an end run around painting. It had to be palpable that the artist is only cutting up a photograph, and indeed, in this work, the Commissioner's head is appropriately presented as flat, with all the flatness of the photograph. And what Heartfield is saying, in effect, is that with cut-and-rearranged photographs art is to be a means for rearranging the political order.

It is customary in traditional logic to identify the extension of a term with the class of things the term in question designates. Thus the extension of the term "dog" is the class of dogs, as the class of birds is the extension of "bird." The philosopher Nelson Goodman, for reasons too abstruse to canvass here, at one point introduced the concept of *secondary* extensions, which consist in pictures or images of things: So the secondary extension of "dog" would be paintings and photographs and effigies of dogs. Since "dog" can now mean either the primary or secondary extension of the term, it becomes ambiguous whether it designates a dog or merely a picture of one. But this accords well enough with the practice of using the same word to name the pictures of things as the things themselves: No one demands that a child who says "doggy" in pointing to a picture of a dog in an alphabet book should say "picture" instead. And it accords well with the fact that we do not need to

undergo a further piece of learning to find out what to call a picture of something, once we know what it is called. Finally, I think, it helps account for the somewhat uncanny relationship we intuitively feel holds between things and their pictures—spooky in the case of Dorian Gray, magical in the case of voodoo effigies, emotional as when we kiss the photograph of someone we love, erotic when we get aroused by pictures of what we get aroused by in life.

And secondary extensions underlie certain wry pictorial jokes, as when we propose to show someone a photograph of a man having his head cut off by another man, and what we show is not after all a shot of gore and violence but a photomontage in which a picture of a man wielding scissors is pasted next to the picture of a man whose likeness is cut where head joins body. Or when I say that someone turned a man into a monkey, when what I have in mind is a photomontage in which John Heartfield has pasted onto an ape's body the head of Adolf Hitler—and pasted a helmet such as Siegfried wore on top of Hitler's head, and has pasted the whole monstrosity on top of the spinning world, as if to say, "What goes around comes around." Because secondary extensions include the photographic images of things, and because photographs inevitably refer us to the realities they depict, juxtaposing items from the secondary extensions of two distinct terms—like "Hitler" and "monkey"—seems to elicit some deep affinity between them, which the montage (and only the montage) can make manifest. The montage becomes a pictorial metaphor with all the strength and energy metaphoric truths carry: They show that Hitler is a monkey, that the terrifying Police Commissioner Zörgiebel has no more substance than a piece of paper—a "paper policeman," like a paper tiger.

The manifesto of the 1920 Dada show lists John Heartfield as the "Monteurdada," and indeed *monteur* is what he preferred to be called, rather than "artist." (The placards for that show proclaim the death of art and derivatively the death of artists; but they hail *Maschinenkunst*—or "machine-art"—which of course photographic reproduction, being mechanical, exemplifies.) *Montieren* means "to arrange," and the art of photomontage is precisely the art of arranging photographs in such a way as to elicit the deep surprising affinities of which great metaphors are capable, and which require the kind

of genius Aristotle had in mind when he said it requires genius to make good metaphors. It is widely appreciated that the photomontage was the main artistic contribution of the Berlin Dada movement, and not surprisingly, almost every one of the members of that movement claimed to have been its inventor. Raoul Hausmann (listed on the announcement for the show as "Dadasoph") claimed to have invented it in collaboration with his companion, the great *monteuse* Hannah Höch. And Heartfield claims to have invented it in collaboration with his artistic sidekick, George Grosz. Little matter, I think, for clearly photomontage lent itself to the spirit of high jinks and iconoclasm that defined the advanced art of the Weimar era. One can see many now-famous montages displayed in the old snapshots of the Dada show, including Höch's masterpiece, "A Slice With the Kitchen Knife Through the Beer-Belly of Weimar Culture," in which an epic composition is made of cut-up photographs, showing the Dadaists as the good guys and the capitalists and politicians of Weimar as the forces of darkness. (You can get a vivid sense of Höch's art in a spirited study of her work by Maud Lavin, *Cut With a Kitchen Knife*, published by Yale.) And some of Heartfield's montages, which were in the Berlin show, may be seen in the fascinating exhibition of his work currently on view at the Museum of Modern Art in New York. But the bulk of the exhibit is of montages that were not intended to be exhibited, and whose natural locus is not the gallery wall. They were intended, rather, for the pages of periodicals of mass circulation, and especially for the left-wing *AIZ*—the *Arbeiter-Illustrierte-Zeitung*, or "Workers' Illustrated Times"—in which they appeared monthly.

The Berlin Dadaists were by nature revolutionaries, and Karl Marx's image appears on the side of good in Höch's "A Slice (etc.)." But it was Heartfield who appropriated the form and bite of the photomontage to the ends of political agitation, and he saw art, and certainly his art, more and more as an arm not merely of the Communist movement but of the campaign against Nazism—so that cutting someone up with a pair of scissors became less an allusion to the penetration of primary by secondary extensions and more a way of entering the political process directly by means of savage imagery. In the process, a pair of scissors gets to be a weapon of political change. But it becomes that just because Heartfield took the montage out of the rarefied precincts of the exhibition hall (not that the Dadaists did not get into hot wa-

ter with that show, specifically for its disrespect for the German Army, since Grosz and Heartfield displayed a pig-headed dummy in an officer's uniform, named it "Prussian Archangel" and hung it from the ceiling). He had his montages photographed and then reproduced by means of photogravure in the sepia tones of that period's popular illustrated periodicals. Heartfield was to the *AIZ* what Daumier was to *Le Charivari*, or Aubrey Beardsley to *The Yellow Book* and *The Savoy*, or what David Levine is to *The New York Review of Books*. Perhaps, indeed, the closest we have had to Heartfield's art would have been Levine's caricatures of Johnson and Nixon in the years of the war in Vietnam. The difference of course was in the kinds of risks that Heartfield and Daumier ran. In 1933 and the beginning of dictatorship in Germany, the *AIZ* and Heartfield were obliged to flee to Prague.

Seeing those montages framed and annotated along museum walls cannot but be felt as incongruous, given their vitriolic intentions. Of course the enemies have long since been vanquished, and we can now ponder Heartfield's graphic ingenuity and his aesthetic means, even if it requires a degree of specialized scholarship to understand exactly what was being targeted, and a command of German slang to get all the jokes. Despite the incapacities of most viewers (myself included), it is striking how the work survives as art when the objects of its fierce aggressions are no longer available for artistic injury. Yet it is no less striking to set Heartfield's work side by side with so much of what passes as political art today, such as so much of what turned up in the 1993 Whitney Biennial. The difference is that while contemporary political art *expresses* the political sentiments of its makers, they show no serious intention of changing political reality through that art. That is because they continue to think of the museum as the primary venue within which art is to be experienced, and hence aesthetic appreciation as the primary avenue through which the art is to have its impact. But that makes the museum audience the primary and indeed only target, since no one else is going to see it. Yet the museum audience is typically already fairly likely to subscribe to the artists' attitudes and values, and while museumgoers may not be quite as "correct" as artists would like them to be, by contrast with the surrounding population they are a fairly enlightened group, likely to experience the art as hectoring, since it is preaching to the converted. We clearly expect some-

thing more from political art than that it express the views of the artist. To be seriously interested in politics is to be seriously interested in political change, and that means as a first step taking the art out of the museum and into life.

Heartfield of course at times did a certain amount of hectoring in endeavoring to get the readers of *AIZ* to vote a certain way or to protest what was happening in Germany. So in part he was expressing his views and those of his readers. But he was also and mainly using his art to attack and discredit the extremely powerful enemies he and his readers feared and shared. Heartfield appreciated, as great artistic polemicists always have, that in order to be politically effective art has to be public, which means that the museum is just the wrong place for it. (Though of course museums too are natural targets for their policies: Projecting Robert Mapplethorpe's photographs onto the facade of the Corcoran in Washington was a marvelous and intuitive form of protest against that museum's cancellation of the show of those works in 1988.) Basically, the art has to be in the world where the changes are wanted, the way the lithographs of *Le Charivari* or the wood engravings of *Harper's Weekly* circulated in the real world, or, today, the way television images enter the general mind. The proper venues for public art are the billboard, the poster, the newspaper cartoon, the broadside, the leaflet, the videotape. And its audience cannot be restricted to the artistically literate, whose members pay their admissions fees and wear the metal badges. The images have to go past the defenses of consciousness and strike into the souls of those who vote or demonstrate or fight.

And that is what Heartfield's montages did in their basic capacity as visual metaphors. The metaphor is among the favored tropes of the rhetorician, whose charge is to move minds and change or arouse feelings by means of figures of speech, encouraging connections of the kind only rhetoric—or art—is capable of. The abrupt, at times irrational juxtapositions of the photomontage inevitably found application in advertising, which is the modern figuration of rhetoric, and whose strategies artists must master if they aspire to political effectiveness. And because in Heartfield's case the enemy saw how his viewers viewed *him*, the art had to be suppressed and the artist hounded out of the country, so that the enemy could claim the minds of Heartfield's erstwhile viewers for its own rhetoric. Luckily, the emblems of

health and military virtue favored by Hitler as the artistic embodiment of the Third Reich were no match for Heartfield's images on cheap paper, which flooded the collective mind in monthly intervals. Unluckily, Hitler had other rhetorical devices.

Heartfield exhibited in a show of caricature in Prague in 1934, which caused sufficient friction with Germany that the Czech authorities found it prudent to have the more offensive works removed. Heartfield's response was a masterful montage in *AIZ* that depicts the exhibition, in which a good many of his most biting images are shown, while, in the blank spaces left by the removed ones, the viewer sees the walls of a prison and a man with head wounds lying bleeding in the street. The caption reads, "The more pictures they remove, the more visible reality becomes," which might, just as a slogan, play a role in the polemics of censorship today. In 1938, Heartfield fled to England, as it were to be reunited with his name, but where, ironically, he was interned as an enemy alien. And when he finally sought to return to what was then East Germany, he was regarded with suspicion by the authorities and accused of having treasonous connections with the West. He was grudgingly reinstated after the death of Stalin, but his art, so far as I can tell, did not keep its edge. A great political artist requires a serious political enemy.

The present show is the first major exhibition of his work in this country, and one now can look at the marvelous caricatures of Hitler, of his henchmen, the scary image of the dove of peace spitted on a bayonet in front of the League of Nations building in Geneva, and all the sarcastic readings of the Nazis' speeches and slogans. There are among the prints a number of mockups, but it is important to recognize that these do not stand to the prints in the relationship of original to reproduction but rather that of means to end. And this merits some comment. A few years ago, I asked the artist Arakawa to design the jacket for a book of mine. And I hoped I would be able to prevail on his generosity further by requesting the "original," for I admired his work and would have been glad to have a piece of it. There really was, however, no "original." Arakawa presented the designer of the book with three or four transparent sheets on which he had drawn some arrows, or mounted a photograph. The image was only on the jacket. So one could say that the jacket was the original, since there was nothing anterior to it that it integrally

reproduced. The reproduction, if you like, was the work, and in virtue of that anyone who purchased the book got an original Arakawa thrown in. David Hockney once did something like that for a magazine, which advertised on its cover that it contained "an original work by David Hockney." And Hockney in fact exhibited the magazine page in his show at the Metropolitan Museum of Art.

All of Heartfield's *AIZ* montages were originals, in this sense. And I cannot suppress the thought that each of the proletarian purchasers of the *AIZ* got not merely a piece of propaganda for the money but an original work of art by one of Germany's best living artists. In his early, sparky days, before politics made him become serious, Heartfield started a magazine with George Grosz featuring a montage of a soccer ball with a man's legs, arms, and head. The title of the magazine was *Jedermann sein eigner Fussball*— "Every man his own soccer ball," which I am told had the kind of sense "A chicken in every pot" has. The implicit slogan for the *AIZ* montages was "Every man his own art collector." That is what it seems to me "the work of art in the age of mechanical reproduction" comes to—a way of overcoming the difference between original and reproduction. But it is nice to think, too, that these original works of art were mechanically reproduced in as many numbers as the *AIZ* printed, and that each was a mass instrument in the war against dictatorship. The show reminds us what art is capable of when it becomes a secondary extension to life itself.

—June 28, 1993

HAND-PAINTED POP

■ ■ ■

A FEW YEARS AFTER CLEMENT GREENBERG RESIGNED AS *THE NATION*'S regular art critic, he reflected, "Art criticism, I would say, is about the most ungrateful form of 'elevated' writing I know of. It may also be one of the most challenging—if only because so few people have done it well enough to be remembered." Greenberg was clearly one of the few: His thoughts, or at least what people believe his thoughts to have been, penetrate present discourse about art more by far than those of the somewhat woozy Frenchmen whose names were stammered in gallery precincts a few seasons back. And artworlders grow considerably more exercised over his alleged critical agenda than anyone anywhere does over the painting he championed. Greenberg's collected essays have been published in four volumes by the University of Chicago Press, and this past May, the Centre Pompidou in Paris devoted a two-day colloquium to Greenberg, which was attended by capacity crowds. "Greenberg's discourse represented a serious blow to the extremely mediocre practice of French art criticism," Yves-Alain Bois wrote in his remarkable text, *Painting as Model*. Rosalind Krauss, who for a time counted herself a follower of Greenberg's critical practice, recently declared that her no less remarkable text, *The Optical Unconscious*, which canonizes artists to whom Greenberg would not give the time of day, breaks every rule she learned from the master.

Perhaps the greatest tribute that could be paid Greenberg, given what his views of the scene today would be, is the high degree to which he has been demonized by that scene's spokespersons, largely in consequence of the

"formalism" with which his name is indissolubly associated. Greenberg was anathematized in an essay by Robert Storr in a volume published by the Museum of Modern Art collaterally with its "High & Low" show of 1990, which in general drew the fiercest invective from critics who might be said to embody the Greenbergian disdain of "low" art. Greenberg "deprived subsequent generations of their true intellectual heritage," Storr wrote. "Like the Great Oz, he . . . continues to impose his will through a theatrical absence." Greenberg is "woefully and consistently unreliable. By turns cavalier and hectoring in manner, and always ready to pigeonhole work he did not comprehend and movements into which he had not inquired . . ." And Greenberg's voice! "Categorical, disembodied, and censorious . . . echoes in the countless articles, catalogues, and lectures that emanate from our contemporary journals, museums, and symposia." It is the voice of the art world itself—"intellectual kitsch, a debased form of thinking"—and pretty much the voice that spoke in all those indignant denunciations, those critical animadversions, those tony snarls, growls and grumbles on the occasion of "High & Low."

The "High & Low" show was, among other things, a studied response, as its conjunctive title affirms, to Greenberg's famous essay of 1939, "Avant-Garde and Kitsch." Greenberg appropriated the term "kitsch" from German, where it generally indicates what those with bad taste regard as good taste, and extended its meaning to cover commercial and popular art in its entirety: "magazine covers, illustrations, ads, slick and pulp fiction, comics, Tin Pan Alley music, tap dancing, Hollywood movies, etc., etc." Kitsch, so identified, is the "rear guard" to the army of culture, of which the high art of Modernism was the avant-garde (it may be asked whether there was such a thing as avant-garde before Modernism). That show undertook to demonstrate the great extent to which high Modernism drew inspiration from the despised "magazine covers, illustrations, ads . . . comics . . . etc., etc." In my view it did this magnificently, but the mere presence of low art in the temple of high art was more than the critical establishment could bear.

A good bit of what "High & Low" considered high art consisted of works that, in their first appearance, seemed to flout the distinction "High & Low" respected: paintings that looked like panels from Thimble Theater, from advertising illustrations, or commonplace objects such as flags and tar-

gets, or signs and emblems from what phenomenologists call the *Lebenswelt*. "Hand-Painted Pop: American Art in Transition, 1955–1962," the wonderful exhibition that has moved from venues in Los Angeles and Chicago and is now installed at the Whitney Museum of American Art, consists almost entirely of these boundary-breaking artworks, and it is hardly surprising that the catalogue that accompanies the show consists, in significant measure, of commentaries on Greenberg and on his original disjunction between avant-garde and kitsch. This is altogether justified, it seems to me, because that disjunction defines the premise of the show. Its paradigm works deploy, as if camouflaged, certain of the characteristics Greenberg allocated to high art and especially to Modernism, but apply them to motifs whose province, until those years, had very largely been what Greenberg put down as kitsch. In practice that meant the works were hybrids, in which a lot of paint was slathered over images like Mickey Mouse or the label from a can of Del Monte peaches.

For Greenberg, of course, avant-garde painting was abstract or non-objective, or, if there were images, they were vestigial and largely irrelevant to what made painting modern, namely that its *means* were its *meaning*: "Content is to be dissolved so completely into form that the work of art or literature cannot be reduced in whole or in part to anything not itself." Kitsch, by contrast, would not be about itself, but about the kinds of things Hollywood movies would have been about—lovers, cowboys, gangbusters, crooks, tap-dancing preadolescents, "etc., etc." Here is the way Greenberg thought about the Masters of Modern Art:

> Picasso, Braque, Mondrian, Miró, Kandinsky, Brancusi, even Klee, Matisse, and Cézanne, derive their chief inspiration from the medium they work in. The excitement of their art seems to lie most of all in its pure preoccupation with the invention and arrangement of spaces, surfaces, shapes, colors, etc., to the exclusion of whatever is not necessarily implicated in these factors.

In a footnote, Greenberg credits this formulation to Hans Hofmann, to whom in fact he owed a great many of his ideas, so it is not entirely to be

held against him that it is false. Europe was a good bit farther away in those days, but Picasso had recently exhibited *Guernica*, whose excitement can hardly be segregated from its meaning and the rhetoric of its forms; and Miró had just completed what he regarded as one of his most important works, a still life with an old shoe that was intended to "depict this very dramatic and sad time." It is possible that this formulation fit Hofmann's work to a T, but the recalcitrance of contravening fact provoked no modification in Greenberg's overall aesthetic: He hardly changed a thing in his 1960 essay "Modernist Painting," in which he interpreted artists of the past to fit the scheme: Manet (whom he regarded as the first modern) "abjured underpainting and glazes, to leave the eye under no doubt as to the fact that the colors they used were made of paint that came from tubes or pots"; Cézanne referred explicitly to the rectangular shape of the canvas, for the sake of which he "sacrificed verisimilitude, or correctness"; and it was "the stressing of the ineluctable flatness of the surface that remained . . . more fundamental than anything else to the processes by which pictorial art criticized and defined itself under modernism." Painting must be, to use the Greenbergian adverb, "ineluctably" about painting, which meant about paint, the shape of canvas, and its flatness.

Now, the date of "Modernist Painting" falls squarely within the period represented in "Hand-Painted Pop," and the paintings that exemplify its title celebrate what in the show Greenberg insisted Modernist painting itself celebrates, namely paint. The paint is brushed on, in fact, in just the way the Pop artists learned about from the Abstract Expressionists, whose importance as artists Greenberg received immense credit for having been among the first to recognize. Paint—viscous, fluid, gummy, dripping, unctuous, slathery, ropy, brushy, pasty, opaque, and splattering—was as much the substance of the Abstract Expressionists' universe as gold was of the universe of the Van Eycks. An artist could use the figure (though not without charges of heresy and betrayal from the Greenbergian ranks), providing, as in the case of de Kooning's *Women*, the figures were made out of paint. Since paint as paint was the criterion of the New York art Greenberg championed, it was imperative, for any art intended to be taken seriously, that it show, talismanically, a certain high sign of heavy pigmentation—some drips, some smudges, some splashes, some puddling. But this was by way of protective

[14]

coloration, a form of allegiance paid, for the images of Pop were unmistakably the images of kitsch. It is a great irony that by the time Pop felt sufficiently confident to shed its painterly disguises, Abstract Expressionism all at once collapsed. "The fact is," Greenberg wrote in 1969, "the demise of Abstract Expressionism was an unusually lingering one. Nor did the art-historical style that displaced it come into view nearly so suddenly as the events of 1962 made it appear." Greenberg had an uncommonly keen sense for historical cadences, and the present show must be taken as, among other things, evidence for this thesis of gradualism: In hand-painted Pop we see the new shedding the skin of the old. Still, in my view, this gradualism screens the radical newness of what was new in Pop. In my view it was not just the ascent of the low. It was the end of Modernism itself, and the beginning not of a new period but of a new kind of period.

The archetypal hand-painted Pop works are those of Claes Oldenburg, Roy Lichtenstein, and, above all, Andy Warhol. The show begins with hand-painted but non-Pop work by Jasper Johns and Robert Rauschenberg, and it ends with non-hand-painted Pop work by James Rosenquist. (There are other artists in the show, but they are marginal, I think, to this history, though it is possible that Jim Dine belongs with the hand-painted but non-Pop group, as does Wayne Thiebaud, who, perhaps rightly, disclaims Pop as a label—in his case what looks like Pop might simply have been a natural evolution out of California painting culture.)

Let's look at Warhol's *Dick Tracy* of 1960. It shows the hatchet-faced detective in full profile, looking like a crude counterpart of Piero della Francesca's portrait of Federigo da Montefeltro, with the yellow fedora replacing the dapper red biretta. Tracy's suit jacket, which is black, and the green background both stop before the canvas stops, emphasizing that they are painted because the canvas is *un*painted: The effect was most famously exemplified in Gilbert Stuart's *Unfinished Portrait of George Washington* (a paleo-Pop work, given the popularity of its subject, and hand-painted in the bargain). As was de rigueur at the time, there is a drip of red paint on the bare canvas, and Tracy's hat brim shows some further drips. These are what one might call drips of certification: They situate Warhol in the painterly avant-garde. But the image is as familiar as the mug of Washington, and

comes from the vocabulary of icons that define popular culture. Warhol's genius lay in his recognition of the power of these icons. His use of hand-painting was mere superstitiousness and aesthetic conformity.

One can see Warhol breaking free from the dictatorship of painterliness in two other works from 1960, both entitled *Storm Door* (unfortunately, not in the Whitney show but reproduced in the catalogue). They are based on the same boilerplate image that belongs in advertising fliers from the local cut-rate lumberyard or in the closely printed ad pages of tabloid newspapers. The first *Storm Door* carries the mandatory drips, smears, smudges, and blurs of the Abstract Expressionist canvas. But it also contains the kind of image none of the Abstract Expressionists would have considered: a schematic storm door, advertised at $12.88. The second *Storm Door* looks as if it might be a replica of the advertisement, with all the painterly mannerisms dropped. Both paintings are monumentalized, and each is extremely handsome, but they conform to two different aesthetics. The second is hard-edged, easy to read, free of half-tones, utterly without touch. The subject, meanwhile, carries connotations of the deepest human significance: protection, shelter from the elements, domestic orderliness, economy, the security of the household. A lot for $12.88! And the same range of meanings is activated by the splendid *Icebox* of 1960 ("icebox" is what they called refrigerators in Pittsburgh). Despite the irrelevant smears of ochers and whites, which signal "art," the work is as reassuring in its meaning as an image of Christ enthroned would be. The interior of the icebox is neat but copiously stocked: a marvelous cake, some watermelon, a piece of meat, eggs, milk, lettuce, corn on the cob, condiments. Warhol's work from this period is rich in the poetics of dailiness and the assurances of warmth and plenty.

Artists have ranged in their attitude toward industry from hostile and deploring, to celebratory of the forms and rhythms of the "Machine Age," as satanic mills, as incidental features of the landscape, and as futuristic emblems. But no previous artist had celebrated the products of industry as Warhol did, construed from the perspective of consumption, of predictability through standardization and of economy. I used to wrangle with Herbert Marcuse over the contributions of Pop, which he condemned because it reinforced bourgeois values when the office of art was to criticize them. But Warhol is one of the few nonelitists in his symbolism—most artists exclude

from their imagery what they are content to make use of in their lives, if only as tubes of paint and factory-produced canvas. Warhol did the reverse of this: He gave a certain dignity to the most commonplace and utilitarian of products in his art, even if in his life he collected antiques and rubbed shoulders with celebrities. Neither of his closest peers, Lichtenstein and Oldenburg, shared his attitude toward the natural still lifes of the mass-produced. Lichtenstein's attitude was largely ironic, for all the laconicism of his treatment of such things as, say, roller skates, and often one feels he was giving serious artistic treatment to what everyone would acknowledge was kitsch, as in his large painting of frilled curtains of 1962 or his *Large Jewels* of 1963 (another work not included in the Whitney installation), a monumentalized, flatly descriptive effigy of (I guess) a rhinestone pin of the sort by means of which one could teach the meaning of kitsch. None of these subjects carries anything like the moral weight of Warhol's abundantly stocked icebox or his storm doors. Oldenburg's subjects, certainly as commonplace as Warhol's, are almost submerged beneath the paint through which they are realized: *Mu Mu* or *Green Stockings*, both of 1961 (the time of his "Store" on East 2nd Street in New York), could as easily be shaped canvases with Abstract Expressionist surfaces (the mumu has a Newmanesque red "zip" running down its middle). But Oldenburg's spirit is comic rather than ironic: There is something irresistibly funny about two pairs of panties, one pink and one blue, treated with the mock heroics of expressionist brushwork. ("You weren't 'with it' at all in those days," Greenberg later remarked, "unless you lathered your paint or roughed your surfaces.") And Dine seems aggressive toward the objects it is easy to imagine being treated with dignity, irony, and comedy by the other three: His *Green Suit* of 1959 is smeared over with paint, and the pants have been cut to ribbons in a gesture sufficiently violent in feeling that were anyone but an artist to have done it the question of psychopathology would instantly arise.

The early Johns works, as said, are hand-painted without being especially Pop, though the American flag certainly was the kind of emblem Pop assimilated to its lexicon of forms. It is an unanswered question in historical explanation whether the movement would have existed had it not been for Johns's inspired preemption of ordinary, one might even say universal, forms as matrices for his fluent and even delicious brushwork. In later years ab-

stract artists used the concentric circles of the target or the horizontal stripes of the flag to their own compositional ends, without these having much by way of reference. But there was something intoxicating in seeing these altogether familiar objects insinuated into the surface of paintings, along with numerals and letters. Johns also used familiar objects, like brooms, and recognizable ones, like effigies of facial or bodily parts, in a way that served to defamiliarize them and everything else in the works to which they were attached. He remains a mysterious artist for me, whereas Rauschenberg, who incorporates a pair of pants in one of his paintings in a spirit that makes clear how aggressive Dine's use of garments is, is not mysterious but exuberant. These early works were waiting for the term "grunge" to be invented in order to achieve their aesthetic vocabulary.

I have a serious complaint to register with the catalogue for "Hand-Painted Pop." There are too many essays with too much overlap (too many references to Greenberg, just for example), and none of them gives a satisfying account of the movement as a whole, nor helpful accounts of the individual artists, let alone the individual works. But beyond that, the book violates what must be a cardinal rule. Ordinarily, illustrations are of two kinds in catalogues: plates of works in the show, and then figures that, though not in the show, illustrate themes of the texts. Here what should be plates are treated as figures, reduced in scale, and scattered throughout the print. This gives the sense that the show is text-driven, rather than, as should be the case, the text being picture-driven. The catalogue simply does not reflect the importance of the show.

Pop Art was the first of a wide range of artistic efforts that Greenberg stigmatized as Novelty Art, by which he meant that it placed shock and fashion ahead of the great Modernist principles he had done so much to articulate. He was not interested in Novelty Art, and considered it an aberration from Modernism, which, in his view, continued to define the present period of art, even if most of what was being produced was Novelty Art and did not fit the critical canon of Modernism at all. What makes the art from 1962 to the present so difficult to deal with is that so much art criticism continues to be based on Modernist criteria but is applied to art that rejects those criteria altogether. My view, expressed here in passing, is that we are living not

merely through a new period but through a new kind of period in that there is no hope for a single set of critical principles that will do for the art of our time what Greenberg hoped to do for Modernism. It is as if different critical principles must be evolved for each sort of art being produced. If this is an age of pluralism in art, as I take it to be, it must no less be an age of pluralism in criticism. Needless to say, the propensity toward monism in art criticism appears to be inextinguishable.

—September 27, 1993

RRYMAN

■ ■ ■

I HAVE NEVER SEEN, OUTSIDE PHOTOGRAPHS OF THEM, THE LEG-
endary "White Paintings" Robert Rauschenberg did in 1951 while a student
at Black Mountain College. Rauschenberg was eighteen at the time, and
though the "White Paintings" have a distant affinity with Kasimir Malevich's
Suprematist masterpiece *White on White*, one would hesitate to describe as a
prodigy someone who (merely) covered squares of canvas with white house-
paint, laid on with a roller. And Rauschenberg (who disclaims having known
of Malevich at the time) had so wild and exuberant an artistic personality in
his youth that it would have been easy to dismiss them as some kind of high-
spirited prank, like dyeing one's hair chartreuse or wearing a nose ring. But I
am sufficiently sensitive to the aesthetics of monochrome painting that I
would withhold making an a priori critical judgment; for the all-over white
paintings of different painters, even when also in the square format, may
turn out to be crucially different from one another. The paintings of Robert
Ryman (on view at the Museum of Modern Art in New York), at least in
what one might think of as his classic phase, are all more or less white mono-
chromes, invariably in square formats of differing sizes; but they are, when
one tunes one's sensitivities to nuance, astonishingly different from one an-
other, as they are from his earlier work, and certainly from Malevich's all-
white painting (which in any case is of a square *in* a square, the two set at
different angles from each other, and has in consequence a content quite
lacking from at least the defining works of Ryman's corpus, which have al-

most no imagery as such). And I am convinced they would differ as well from Rauschenberg's early achievements.

In an interview, Chuck Close once described the painstaking preparation of the canvases on which he executes his colossal portraits:

> I'll spend three weeks gessoing and wet-sanding a canvas—ten to twelve coats—getting it all smooth and getting it perfect, and it reminds me of those apartment signs you see on the highway, "If you lived here you'd be home now." If I were Robert Ryman, I'd be done.

Rauschenberg did not set out to make an all-over white painting: Like Close, his intention was to go on to paint something on top of the white, which was to have been ground. But unlike Close (who of course was being impish), he found the white so pristine that he could not bring himself to sully it, rather in the way any of us pauses before scarring the hushed whiteness of new-fallen snow. (It must be remembered that the presence of Josef Albers at Black Mountain created an artistic atmosphere in which purity was a prized attribute.) But in fact Rauschenberg's "White Paintings" turned out to be not so much objects of aesthetic experience as occasions for it. They served as screens for trapping ephemeral phenomena, like shadows and passing headlights. They enabled one to tell what time of day it was. Rauschenberg said he was interested in seeing "how much you could pull away from an image and still have an image." What he did was put himself into collaboration with the world in producing an endlessly varied play of light and shadow. It was precisely in this that the "White Paintings" had a fateful impact on Rauschenberg's colleague at Black Mountain, the composer John Cage, who was inspired by them to compose their auditory analogue, *4'33"*, in which the performer drops his or her hands for exactly four minutes and thirty-three seconds to produce an interval of silence just that long. During the silence, the sounds of the world invade musical space to become music rather than noise, exactly as the passing shapes of the world invade the space of Rauschenberg's paintings to become art. And indeed Cage held a sort of Zen philosophy that enabled him to view this as a task for art. That view is handsomely expressed by an artist with somewhat similar objectives, Robert Ir-

win, who writes in the Epilogue of his text *Being and Circumstance* that "the wonder of it all is that what looked for all the world like a diminishing horizon—the art-object's becoming so ephemeral as to threaten to disappear altogether—has, like some marvelous philosophical riddle, turned itself inside out to reveal its opposite." Of course, a true performer is required to create silence, as is a real painter to create emptiness.

It is important to stress that it is never a relevant observation to make in front of an all-over white painting—or any painting for that matter—that "anyone could do that," even if it is true that no great skill is required to cover a surface with housepaint, using a roller (Ryman's paintings are, if sometimes but marginally, more complex than that). But it requires more than being an artist to "do that" as well. Close is a major artist, with gifts of an altogether different order from those possessed by either Ryman or Rauschenberg; and he is certainly capable of achieving a smooth white surface that, had he been Ryman, would already be a painting. But he would not stop there, unless he underwent a conversion as radical as the one he recalls having caused him to give up his version of Abstract Expressionism to do the gigantesque portrait heads that have made him famous. Nor is prior intent a requisite: Rauschenberg merely meant to paint the surfaces white, not make white paintings. *That* intention was formed, so to speak, only once the painting was done. What it requires to make a monochrome painting out of a uniformly painted surface is the kind of atmosphere of experiment and transformation that defined the artistic mentality of Black Mountain as an institution. Rauschenberg participated in that atmosphere, through which he saw in all-over white canvases possibilities and meanings of the kind he had learned to see in painting in general. And once he saw them, he decided to "let the painting be"—a perfectly Zen-like gesture. Black Mountain was a world in which such decisions were a matter of course, and though Close knows about those worlds, he does not live in them. In the Black Mountain world, it was natural to progress to the "Black Paintings," which, though also monochromes, exemplified a wholly different aesthetic: They were heavily textured and inches thick, virtually as if Rauschenberg had *paved* the canvas, or tarred it like a roof. It says a great deal about the differences between him and Ryman that it is no part of Ryman's project to have gone on to black paintings next. White came to satisfy most of his chromatic needs, as the

square format came more or less to satisfy his formal needs. That left him free to experiment with size, texture, and other properties of works, to which I shall turn below.

There is in the philosophy of Jean-Paul Sartre a fascinating if heavily criticized concept he designates "original choice." This is the basic choice each of us makes that colors all the subsequent choices our life consists in, and to which what Sartre calls "existential psychoanalysis" finally directs us. The "White Paintings" of Rauschenberg, and Ryman's white paintings, spring from distinct "original choices," though this might be invisible in the paintings themselves. Only when one sees that Rauschenberg went on to do thick black paintings and then "Combines," including the famous paint-smeared goat with a tire round its neck, can one see that he must have been getting at something quite different from Ryman, whose entire evolution has consisted in making painting that takes the all-over white square as a kind of Platonic ideal. How would one know this on the basis of just the paintings that might outwardly so resemble the ones Rauschenberg did? The meanings of works that look just alike often turn out to be available to us only when seen in the historical afterlight of what led up to them, and what the artist then went on to do. That is why, in addition to "anyone could do that," it is so pointless to say "somebody else already did that."

Beginnings are endlessly fascinating. Ryman was a jazz musician, holding down odd jobs in New York, when, out of what must have seemed an impulse, he bought paint, canvasboard, and brushes. "I was just seeing how paint worked," he told Robert Storr, who curated the MoMA show. "I was just using the paint, putting it on thinly with turpentine, and thicker to see what that was like, and trying to make something happen without any specific idea what I was painting." To me this sounds as if the original choice was thick-and-thin, and seeing what would happen when . . . Ryman was not an art student, and he never became one in any formal sense. Yet, while he lacked the supportive world of Black Mountain, he was clearly in some sort of art world, for one does not merely make a decision to think of paint *first*, without reference to what one is going to paint, or to think of the possibilities of thick-and-thin. These would have been fairly advanced ideas in the 1950s, and not something that would just come to someone. To think of art

in terms of the materials of art, for example, was exactly the directive Clement Greenberg was putting forth as the mark of the Modernist avant-garde. It tells us something that in 1953 Ryman took a job as a guard at the Museum of Modern Art, where he would have been able to see *White on White*, if he had not indeed come to know it already. The roster of guards and other lower-echelon employees at MoMA in those years would compose a Who's Who of today's major artists. For Modernists, it was the kind of school the Louvre was for the artists of Paris. The important point to stress is that Ryman, from or as the beginning, should have found himself almost exclusively concerned not so much with abstraction, as such, as with what we might call the *material abstract*—where paint on whatever it was to be applied was the entire focus of his thought. White pigment may not have been chosen for any special meaning—its purity, its potentiality for spiritual metaphor—but because it facilitated the paint-surface interactions that absorbed him in those years, and indeed have ever since. (He did at first experiment with green, and with orange.) What one might say is that from the 1950s to the present there have been variations in Ryman's paint styles, from the worked and impastoed surfaces of that era through the quietly uniform and uninflected surfaces of Minimalism, to where the paint might be applied virtually the same way it goes onto automobile bodies, with reversions and excursions and advances reflective of the ongoing evolution of painting elsewhere in the art world.

A good example of paint-surface interaction is the fourth painting in the show, done in 1958 and, like so many, called *Untitled*. It is not a white monochrome square, but it contains a squarish expanse of white paint that does not go quite to the edges of the space it occupies. It is on a surface that is the brown of paper bags, which not only shows through where the edges of the square give out before reaching the lateral and top edges of the surface, but forms a large space below the square. The painting thus has two main components, the painterly squarish form, notched by a small black rectangle at the half-point of its left edge; and then the expanse of paper-bag brown below. It struck me, for whatever it is worth, that this is the color scheme of MoMA's galleries: white walls descending to brown (wooden) floors. So it is difficult to avoid the thought that it is a visual memorial to Ryman's years as a guard in those very galleries. There is one further element, what is less a

signature than a graffito consisting of Ryman's name, painted in the same white pigment as the square, in large letters, along with the numeral "58," with no space between it and the letters. The letters and numerals are strikingly large, as if, when a guard, Ryman had wanted to write his name somewhere in the gallery. And it is impossible not to notice the double R: The whole inscription reads RRYMAN58. Of course, he is entitled to the double R, being Robert Ryman, but Marcel Duchamp's *nom de femme* was Rrose Selavy; and while I have no support that an art-historical pun was intended here, the mere fact that it is thinkable is underwritten by the spirit of playfulness in this work, and in most of its contemporaneous peers in the show. Thus the black notch, slightly crooked, the ambitious but failed square, the very large letters, suggest a certain sense of humor, a kind of formal wit, an absence of the kind of austerity that "white monochrome" might suggest of Ryman's artistic personality. The spirit of play is consistent with a dedication to material abstraction. That one has forsworn chromatic indulgence does not mean that one cannot have a good time painting, or that one is forbidden to allow pleasure to show through. One can be reductionist without being dour.

The paintings, from the late 1950s at least, form a loose set of wry caprices, in which, as with the signature and date, Ryman integrates into his compositions elements usually looked past as not belonging to the work (Van Gogh also used his signature this way). In one, "58" is painted in large careful numerals, sideways on a patch of canvas left bare by the surrounding paint. In another, "58" is loosely scrawled in huge red numerals, again spread sideways across the painting, which consists in a wobbly white rectangle brushed across tan paper but which leaves enough space for RRYMAN in tall skimpy letters of the kind associated with Saul Steinberg. A patch of black seeks to balance the red numerals that have taken over its space. These are deliciously crazy paintings.

My favorite among these early *scherzi*—and one of the rare titled paintings in the show—incorporates the title into the painting: THE PARADOXICAL ABSOLUTE is lettered, with studied ineptitude, into a black cartouche at the bottom of the painting, and to the viewer's left. It is of course an exceedingly pompous title, one scarcely in keeping with the scruffy lettering, unless indeed the paradox is sparked by that discrepancy. Given the wit of the place-

ment of dates and signature—and now the title—there is scarcely a limit one can assign to the painterly self-consciousness of this artist. He is reported in the catalogue as saying: "I was interested in the word 'absolute' and its meaning, and how things were not exactly that way"—were not, one might say, *absolutely* absolute. Ryman says, "I think I was thinking at that time about philosophy," and I was bound to ask him what philosophers he might have been reading. The British metaphysician F. H. Bradley was about the last serious thinker to write admiringly of the Absolute; most philosophers have used the term derisively, as an example of a term "devoid of meaning," as Carnap would say. Ryman told me he thought he might have been reading Heidegger, but Heidegger would have had little use for traditional philosophical vocabularies, inventing his own. My conjecture is that he may have been looking into Schopenhauer, just the sort of philosopher apt to turn up in artists' libraries. Schopenhauer was precociously dismissive of the term, and here he gives it a sneer with a nice Rymanesque image: "We cannot imagine an absolute absolute like a blank wall in front of us." *The Paradoxical Absolute* is far from a painting someone unsympathetic to monochromy might compare to a blank wall—Ryman did not begin his all-over white squares until the middle 1960s. With those, color and shape were fixed values, but that left plenty of other variables in a painting to play with, leaving room for as much caprice as one desires. It might incautiously be suggested that there is some parallel with Ad Reinhardt's all-over black squares, but Reinhardt really did believe in an absolute absolute, where values for all painterly variables were eternally fixed and there was no room for play at all. Ryman is a much freer spirit, an *open* absolutist, fiercely inventive within the domain he has left for himself, having restricted his shape and color as he has so far done.

I suppose it is consistent with the impulse to play with the marginalia of painting in our culture—with signatures, dates, mountings, titles, and the like—that the artist should have turned his attention to the relationship between the work and the surrounding wall space. Ryman has evidently decided upon a kind of counter-Rauschenbergian course, excluding everything extraneous from one's experience. In the present show, this has meant an interdiction of wall labels, believed, for whatever reason, to be distracting. Since it is a one-person exhibition, of course, we do not require labels to tell

us who executed the paintings. On the other hand, if one is eager to know the title, when there is one, or the date, or the materials (one will be surprised by Ryman's use of waxed paper!), the staff has printed a sort of newspaper with diagrams of the rooms and the numbers of the paintings, which correspond to texts that ordinarily would be on wall labels. Now, inasmuch as habituation has made the label as invisible as the signature commonly is to those not specifically interested in it, I imagine the decision to eliminate labels belongs to the same overall impulse as the decision to enlarge a signature, or make a painting out of a date—for in fact the absence of the labels is more distracting than their presence possibly could be. But even if one resolves to face the blankness of unlabeled walls stoically, one's fellow visitors will be rattling their programs and asking which particular *Untitled* they might be looking at. In a true spirit of caprice, the proper gesture would have been to play with the labels, enlarging them, printing them backward, pasting them at crooked angles. On the other hand, if the artist really believes they distract from his work, he may be here overtaken by the dangers of the absolute absolute after all!

Just over a year ago, I saw a magnificent installation of Ryman's painting in the Espace d'Art Contemporain in Paris. The Espace is a Parisian presence of the renowned Hallen für Neue Kunst in Schaffhausen, Switzerland, where the visionary figures Urs Rassmüller and Christel Sauer, his wife, have created a space for showing art of the kind Ryman's work, at its best, exemplifies. They opened the Paris space in a missionary spirit, to show the French by example how work of this kind and order ought to be seen. It was a tremendous experience. I don't remember whether or not there were wall labels, but it hardly would have mattered. In those spare gallery spaces, under natural light, the paintings were arranged in such a brilliant way that they communicated with one another: The air was alive with painting-to-painting dialogue. Sometimes a wall held only a single painting, sometimes two or three. But one experienced the exhibit as one would have one of the great philosophical conversations.

Rassmüller and Sauer might consider establishing a didactic space in New York, where those who practice installation might find an inspiration. The MoMA show is for the most part hung in a very routine way, and its premise is chiefly chronological. Since temporal succession is the principle of

its organization, the internal references from painting to painting, unless they occur sufficiently close together in time to hang in the same gallery, are left to the viewer to provide. But chronology then makes the absence of wall labels pretentious, and in a way contradictory: A Rassmüller-like installation brings out the *timeless* qualities from which the wall labels are assumed to distract. There *is* an impressive gallery with three large paintings, *Surface Veil I* (and *II* and *III*), which, because of their scale and, let us face it, the iconography of half-raised veils, imply the space of a chapel. The spiritually minded collector of Minimalist art who once owned them, Count Panza di Biumo (whose collection was in part sold to the Guggenheim to wide consternation), at one time had them installed in this way. But that would be an easy call: The gift of the installationist consists in juxtaposing paintings to bring things out that would not be seen in them separately or, for that matter, serially. So this is a flawed exhibition. But for those with an appetite for painting that is subtle, spare, evocative, spirited, witty, deep, playful, and beautiful, what the show contains is a treat. It is a treat even for those who think the art world has moved beyond painting. That it was not a treat for Morley Safer, who could barely suppress his giggles before one of Ryman's white squares in his recent savaging of contemporary art on *60 Minutes*, is but one of many signs of a sadly underdeveloped critical sense screened by a dangerously ill-justified complacency. As Safer reaches a vastly larger audience than I, this essay is offered as a contribution to his aesthetic rehabilitation.

—November 22, 1993

LUCIEN FREUD

■ ■ ■

WE SPEAK OF THE NAKED BUT NOT OF THE NUDE TRUTH, LARGELY, I
think, because we regard truth as something to be uncovered or *dis*covered.
Nakedness implies covering, and hence connotes a condition of having been
stripped bare, seen as one is without the protective rhetoric of garments, *ex-*
posed to the view of lookers who perhaps have no right to see. "Naked truth"
would be redundant in Greek, where the word for truth was *aletheia*, which
means unhidden, or revealed (from *velum*, or veil). The Greek word conveys
a picture of truth as something not manifest to the eye until made manifest,
and hence of the truth-seeker as the stripper away of (mere) appearances.
The nude truth, by contrast, would be truth self-assertive, impatient, and
disdainful of cover-ups, not caring a damn who sees it, proud of itself—and
would imply an altogether different picture from the one *aletheia* sponta-
neously paints: The truth, if nude, would stare you in the face.

The naked body implies the garments that have been taken away, and
without which its owner is ashamed—as Adam and Eve were when they in-
vented clothing upon finding themselves naked. "Who told thee that thou
wast naked?" God asked when they tried to hide their nakedness with fig
leaves. Until they acquired knowledge, they were merely nude. To be sure,
Genesis in the King James version relates: "And they were both naked, the
man and his wife, and were not ashamed." But that is because the word
"nude," according to Kenneth Clark, "was forced into our [i.e., English] vo-
cabulary by critics of the early eighteenth century to persuade the artless is-
landers that, in countries where painting and sculpture were practiced and

valued as they should be, the naked human body was the central subject of art." Nude goes with beauty as naked goes with shame. The nude has nothing, the naked everything, to hide.

Adam and Eve felt no shame before the Fall, nor did they, according to the quaint theory of the early church fathers, know sexual desire. That is, they knew sex but not sexual craving. So sex was not a mechanism for reducing drive and appetite that might cloud the higher faculties; it was as affectless as shaking hands, and hence done to comply with the imperative to be fruitful and multiply, since—again, according to patristic tradition—there was no pleasure in it. Intercourse was a rational act, Adam erected by will rather than a reflex of passion—like dropping a seed with his hands, to use the image of Saint Augustine. It is when male and female were transformed from nudity to nakedness that sex became associated with darkness, as a kind of natural concealment, whereas in Eden it took place in the open, under the friendly sun. Because human sexuality has been deeply, and perhaps inextricably, connected with clothing and with shame, the ideology of nudism sees nudity as an emblem of innocence, and the official images of nudist practice show men and women tossing balls back and forth or bathing together like children. The nude body is not "a huddled and defenseless body," to use Lord Clark's language, but "a balanced, prosperous, and confident body." *The New York Times Magazine* reproduced an image recently of Christy Turlington in her own elegant skin, posed on a bare floor beneath the slogan "I'd rather go naked than wear fur." The text underneath suggests that the image might be counterproductive: When women get a glimpse of Turlington's body, they might decide that "rather than go naked, they'll wear anything," including, probably, furs. And the suggestion is that it is not so much naked bodies we are ashamed of but the fleshly lumpiness we call our own. Of course, it is Turlington's *image* that we compare invidiously with the reality of our graceless bodies—and who knows what retouching might have been done to create an illusion of centerfold perfection? Since nudity is chiefly learned about through images, art ill prepares us to deal with the truth of nakedness.

Something like this appears to have been the case with John Ruskin, whose aesthetic appetite brought him into contact with the golden nudes of

Titian and Veronese, but whose sexual appetites were not of a kind to bring him into contact with the naked bodies of real women until, at the age of twenty-eight, he married Effie Gray and evidently found her sufficiently *un*-aesthetic that he could not bring himself to consummate the marriage. Effie wrote her father, six years later, that Ruskin had not been forthcoming with his "true reason" for not "making me his Wife" until quite late in the relationship. It was that "he had imagined women were quite different to what he saw I was, and that the reason he did not make me his Wife was because he was disgusted with my person the first evening April 10th." Ruskin, in his deposition, declared that "though her face was beautiful, her person was not formed to excite passion. On the contrary, there were certain circumstances in her person which completely checked it." And scholars have speculated on what those circumstances were. The best explanation I have encountered, which to be sure may just be Victorian scuttlebutt, is that Ruskin had been shocked by pubic hair, and having no examples of naked women to place alongside Effie and arrive at a suitable induction, he thought her a freak—since Venetian paintings showed nothing like it. Of course he had his own case to go on, but perhaps finding Effie haired may have seemed to him like finding her with other attributes he might have supposed masculine by definition. In any case, the doctors found that she was *virgo intacta*, with no obvious "circumstance" that might stand in the way of becoming wife to the Pre-Raphaelite painter Sir John Millais, with whom she had eight children. And Sir John, who worked from the model, can have had few illusions regarding the female body. I am in no sense a scholar of Pre-Raphaelite painting, but I would suppose a priori that if there were nudes in his *oeuvre*, they would be shown in a state of depilation, unless the pubis were occluded by some cunning studio prop—a leaf, a scarf, or, as with a *Venus pudens*, a cupped hand. Pubic hair is more a mark of nakedness than of nudity.

I am, at least, enough of a student of Pre-Raphaelite painting to know that the reason its practitioners turned to Ruskin for endorsement was that they supposed he would approve of their resolute commitment to visual truth—to what they surely would have designated the naked truth, of things as they truly are. It was their belief that painters after Raphael deigned, as Ruskin himself stated in his defense of the movement, "to paint fair pictures

rather than represent stern facts, of which the consequence has been that from Raphael's time to this day historical art has been in acknowledged decadence." But this, one would think (and contrary to their practice), would recommend in general the depiction of the naked rather than the nude. Yet the naked made its way into art very slowly indeed. "It is widely supposed that the naked human body is in itself an object upon which the eye dwells with pleasure and which we are glad to see depicted," Lord Clark wrote—in a sentence that will be glossed, by feminist subscribers to the thesis of "the male gaze," to mean that only men take that order of pleasure, and then mainly by gazing at the naked *female* body. But Clark immediately qualifies himself. "But anyone who has frequented art schools and seen the shapeless, pitiful model that the students are industriously drawing will know this is an illusion. The body is not one of those subjects which can be made into art by direct transcription." And finally, "We do not wish to imitate; we wish to perfect." Thus the taut body of Christy Turlington, with not an ounce of excess flesh, is perfection embodied thanks to the craft of photography (granted, the photographer had a lot to work with). It is clear, if this is true, that the object of the male gaze is an image in the male brain, for which the naked female is at best the occasion: In the human male, perception is prosthetic for fantasy. Published in 1953, Clark's book *The Nude*—whose subtitle appropriately is *A Study in Ideal Form*—makes scant use of the word "naked," save in the most neutral sense, and, being about art, makes little further use of the concept of the naked. It was pretty much Clark's assumption that until idealized as nude, the naked had no place in the visual arts.

In 1866, the self-avowed realist Courbet depicted a woman *à poil*, with her legs spread and her shift raised to display her vaginal opening, as well as her breasts from underneath. Courbet sought to transform nakedness into nudity by giving the painting a preposterously allegorical title—*L'Origine du monde*. Evidently, being beautifully painted was not enough to turn the trick, any more than the beauty of Mapplethorpe's photographs, just over a century later, was altogether able to overcome that in them which Mapplethorpe conceded was "pornographic." Courbet's painting passed, as if by preestablished harmony, into the collection of the French Freudian Jacques

Lacan, who would display it to favored guests. How little nudity triumphed over nakedness may be inferred from the fact that the painting was concealed behind a panel painted by his brother-in-law, the Surrealist André Masson, which had to be slid open to reveal the dark delta of coarse hairs and the red-tinged lips of the world's source. So we have Lacan's tacit testimony that the woman was naked, since nudity as such does not call for concealment, allegedly connoting sunshine, openness, and the innocent mind.

My immediate interest in "The Origin of the World" lies in the possibility that it is the chief exemplar of nakedness in high art until modern times, when it became morally acceptable to show such work but when, at the same time, painting abandoned its realist aspirations and was, accordingly, no longer easily able to do so. Picasso—or even Modigliani—was able to indicate sexual features of men or women without the latter being seen as naked, just because the figures in question were too stylized to be more than elegant, even decorative logograms, and hence nude by default. Nakedness becomes an artistic possibility only with someone prepared to erase Modernism in art while benefiting from Modernist moral attitudes, and so is in a position to show the human body the way it looks without the deflecting idealizations of nudity. And this is the main achievement of Lucien Freud. He shows us pictures of naked humans, and with enough painterly realism that we cannot use the conventions of nudity to treat them as beautiful, the way it was demanded of high art in Lord Clark's book that it do. It is precisely in suppressing Modernism in painting to make room for the rawness of raw flesh that Freud contributes to the art of our time. What Modernism contributes to Freud, perhaps, is the license it issues for awkwardness that would have been disallowed in the late nineteenth century, to which his style otherwise largely belongs.

More of course is required for the depiction of nakedness than merely an open show of genitalia. There is, to begin with, the coloration of genital tissue. Consider, for example, Freud's *Naked Man on a Bed* of 1989, to shift genders for a change. The scrotum has been depicted from Greek vases on, but usually as part of a triune assemblage of testicles and penis as an emblem of male identity, with no particular further need for anatomic exactitude. Greater exactitude enters with the more stringent demands of realism, but I

cannot recall seeing, until here, the scrotum painted in its natural purply hue, set off, as that organ in naked reality always is, from the ivories, lavenders, pinks, and greens with which Freud shows the rest of the man's bare skin. And the cleft between his buttocks clearly shows an anus as natively brown as Courbet's splayed female's vagina is pink. Throughout Freud's gallery of nakedness, there are red elbows and knees, purple veins, and soles the color of soles. Just compare the flesh tones here with Christy Turlington's perfectly pink body, with its flexible cooperative bones and its look of homogenous elasticity! Freud does not paint the skin in such a way that dermatological instruction can be based upon it. Rather, since the human skin is in part a kind of surface text written upon by our lives, from which can be read off the history of indulgences and misfortunes, his vision is essentially humanistic, and cold in a different way from the illustrations of a dermatology textbook. *They* imply the chill dispassion of science. Freud sees the skin as the soul laid bare, all the latter's shameful little secrets on display. It is as if Kafka's horrifying image from *In the Penal Colony*, of the punitive inscription of the criminal's misdeeds upon his skin, were in fact the truth of human nakedness. So Freud paints as a kind of judge.

In any case, this is the way we look with our clothes off. The naked man's penis lies slack against his thigh like the head of a sleeping bird. Its curved form is echoed by the curve of a limp black sock the man appears to have been just too tired to take off all the way. He looks like he could have used a bath. The nude body, if it smells at all, takes on the odors of the world in which it disports itself—pine, fresh air, thyme, the sea. The naked body smells of sweat, urine, bodily discharges, cheap perfume, deodorant, dirt. But nakedness has other connotations that nudity fortunately lacks. Thus nakedness is the natural metaphor for vulnerability, defenselessness, helplessness. The naked body cries out for cover not so much against cold and rain but against the eyes of the clothed. It is the ultimate humiliation to be stripped, so that only on a premise of trust will one voluntarily disrobe, putting oneself, through the reversion to nakedness, in the power of the other.

It is widely known that Freud's subjects are all personally connected to him. "Whom else can I hope to portray with any degree of profundity?" he asked John Russell, rhetorically. He has no use for professional models, who,

as John Richardson recently wrote in a reminiscence of Freud, in effect take on nudity as a vestment when they remove their clothes, changing one costume for another—like Christy Turlington, who looks all dressed up in her nude body. "I get my ideas from watching the people I want to work from moving about naked," Freud told Russell, which implies either great trust on their part or great power on Freud's—or probably some combination of trust and fear. These transactions of undress take place in what is clearly the artist's studio, but because of the moral relationship between artist and subject, there is an implied intimacy in the space that transcends the essentially public aspect of the studio. A model may object to a stranger walking in while he or she is posing, but that would be because there is an implied contract between artist and model in which the walker-in has no part. A stranger entering Freud's studio would be an intruder, violating an atmosphere of trust or of submission.

It was more or less the latter that I felt when I traveled down to the Hirshhorn to see an exhibition of Freud's work in 1987: I felt the artist's will, and the subject as having yielded to it, and in truth I felt the price of the latter going naked for the artist was a form of victimization. I felt, in fact, a kind of perversity in the canvases that bothered me, whatever their merits as painting (one cannot look at the painting of a naked person simply as a painting). There were predictable feminist objections to Freud's objectification of naked females. But it was more a concern over subjugation than objectification—or subjugation for the sake of objectification—and cut across gender lines entirely. This slightly gamy taste remains in the current exhibition of Freud's work of the past few years, at the Metropolitan Museum of Art. But in some way I have yet to understand fully, the art somehow has transcended it.

Possibly this is because the chief subject of the recent paintings is the curious Leigh Bowery, an immense hulk of a man, pillowed with fat, whose nakedness is aggressive in its own right, rather than the effect of an aggression on Freud's part. It is, moreover, rare though perhaps not unthinkable that there can be realistically obese nudes. Courbet's nudes are what Edwardian rakes would class as "fine women"—stout, fleshy females of the kind Courbet and perhaps men generally fantasized about in that era, "pleasingly plump," and implying, through their amplitude, fecundity, nurture, and sex-

ual engulfment. But they were not in any sense obese, save by the anorexic standards of today. They too were idealizations, and indeed virtually the first illustration one encounters in Clark's book is Courbet's *La source*—referring to the stream in which the fine woman, seen from the back, is about to bathe. But Bowery is obese by any standard. My thought is that any realistically represented obese person is ipso facto naked. So when one sees Bacchus in a classical setting, the belly folds and breast meat proclaim the fleshiness of the flesh too stridently for idealization to get a grip. But beyond that, Bowery projects his nakedness exhibitionistically, so that he cannot be humiliated through it. He is a performance artist by profession, a wearer of nipple rings (which can be removed for the occasion), and in the tremendous *Leigh Bowery (Seated)* of 1990, he glares back, confident, even confrontational in his enthroned bulk, with his opulent penis hanging like a truncheon between his legs. So perhaps Freud has met a will at the very least equal to his own. Bowery thus gives dignity to nakedness without taking refuge in nudity, and since nakedness is in large measure Freud's theme, Bowery at the same time confers a dignity and even a certain sullen grandeur upon the paintings in which he appears.

Lucien Freud is the grandson of Sigmund Freud, who would doubtless have a thing or two to say about having one's naked daughters parade back and forth in the studio, where it is not simply an equation of flesh with paint, as Richardson makes out in his appreciation, but *flesh of the artist's flesh* with paint. I am aware that under the auspices of nudism, families insist on the wholesomeness of playing together in the buff. But once again, Lucien Freud is insisting on nakedness, and that strikes me as a heavy psychological load to impose, even in modern times, when the way in which the sons avert their eyes from their father's nakedness in the great painting *The Drunkenness of Noah*, attributed to Giovanni Bellini, still speaks to us. Or at least two of the sons do—the third, Richard Wollheim observes in a marvelous discussion of the painting, wears a face "twist[ed] in a prurient smile." Freud's paintings do not seem especially prurient. But neither do we have your ordinary artist-model relationship here. It may be argued that this should be irrelevant to the appreciation of the art, but it somehow still enters into the way the figures are shown—vulnerable, shriveled onto the studio cot, as

helpless as pieces of meat on the table, to use an epithet I once encountered in some old Arabic poems. There is *this* resemblance between grandfather and grandson: The studio bed plays the role in Lucien's sessions that the couch played in Sigmund's. And the naked figures disclose all the repressed truths of what one might call the *bodily unconscious*.

It is through his paintings of naked persons that Freud makes a contribution to contemporary art. In a sense, it is the kind of innovation the Pop artists made in widening the subject matter of painting to include the packaging of consumer products just as we know them to appear. Yet even the Pop artists who represented human beings without clothes on, like Tom Wesselman in his series "The Great American Nude," did them as highly stylized nudes: Wesselman's females taking showers are like paper dolls surrounded by real tiles and actual plastic curtains. So I have concentrated on nakedness in reviewing Freud's work. There are, in the Met show, portraits, an occasional clothed figure, an amiable whippet, a really impressive painting of foliage, a sordid sink, a squalid backyard in Paddington. But it is through the depiction of nakedness that Freud will be remembered.

As American audiences are not particularly familiar with Freud's work, the show begins with a small anthology of notable examples, and one can trace his progress from the glazed surfaces and somewhat unpleasantly stylized persons—large-eyed women, a stunted bohemian figure smoking next to a large plant in a London interior, a group of young persons in a kind of *tableau vivant* based on a work of Watteau (and declared Freud's masterpiece by Robert Hughes), through to the heavily impastoed images of naked figures in the artist's studio, featuring the improbable Leigh Bowery. The impasto is not uniformly successful—at times one has to make up one's mind whether it belongs to the surface of the painting or the skin of the subject as a kind of eczema—but it is clear, upon coming to the final painting in the show, that Freud has identified himself with that technique. He stands naked, in unlaced boots, holding a palette knife in his painting hand and a heavily impastoed palette in the other, where the thick paint belongs both to surface and to subject. Laces are removed from the boots of prisoners who it is feared may do themselves injury if they are allowed to keep them, though it is anyone's guess as to what the symbolism here is. Freud poses himself

like some mad maestro, the knife his baton, and there he stands, in a kind of Lear-like wildness, ruler of the night studio, sovereign of naked souls. It is a very scary picture. But he is a very scary artist, all in all. The flesh indeed is text, but these paintings of it are text in which we read cruelty, arrogance, and obsession.

—January 24, 1994

ROBERT ZAKANITCH'S
BIG BUNGALOW SUITE

■ ■ ■

UNTIL LARGENESS OF SCALE BECAME A COMMONPLACE OF PAINTING in the past few decades, the selection of a canvas of more than ordinary size was a declaration on the artist's part of the intended importance of the work. Knowing, for example, that *Les Demoiselles d'Avignon* was in some unanticipatable way to change the course of painting, Picasso purchased for its execution an especially large and fine piece of canvas, and even had it relined. "In the manner of the French masters a hundred years before him," Lawrence Gowing writes, "Matisse at intervals punctuated his work with a demonstration picture, which was in the nature of a painted manifesto. With Matisse such pictures were not only large but largely conceived." It is especially striking that the "painted manifesto" that occasioned Gowing's observation was the 1908 *La desserte rouge*, titled in English *Harmony in Red*—a domestic interior in which a pattern of blue vines and baskets of flowers chases across the crimson-cinnabar tablecloth and up the walls decorated with the same brilliant red. The size of Matisse's painting might seem on the face of it to have little internally to do with the work's domestic content. The dinner table is the locus of ceremony and symbol, in France above all other places, but nothing more dramatic appears to be taking place here than the clearing of the table—*la desserte*—by the *serveuse* in white cuffs and apron, her handsome orange coiffure as disciplined as the orderly life she and her gesture embody. She could not stand in greater contrast with the *Demoiselles*, who occupy the other extreme of female identity in that era, since they are

prostitutes transformed by Picasso into embodiments of primal appetite, for which the use of African masks must be a metaphor. It is a matter of biographical fact that Carrer d'Avinyo (Avignon Street) was a street of whores in Barcelona, Picasso's home. But it is no less a matter of biographical fact that the woman in Matisse's painting had been his lover, Caroline Joblaud, the mother of his natural daughter, Marguerite. As Matisse was married to someone else when he painted *Harmony in Red*, it is impossible not to see it as an effort to weave his lost love into the pattern of his life, to make woman and home and art a single harmony and pattern. Both paintings are in their ways expressions of the artists' fears, hopes, memories, and cravings with regard to women, raised to a monumental scale by the size of the canvases. So the works are more than manifestoes of tremendous artistic agendas. They are personal, confessional, and celebratory of female force and meaning.

The Abstract Expressionists took up the large scale in part for formal reasons and in part for reasons of content. The big canvas evolved together with the heavy brush, the ample gesture, the gallon drum of house paint, the dripped and splattered pigment—the *accident*—and referred to the sweep of the entire arm in the impassioned action of swinging arcs and arabesques in a kind of improvised dance with the emerging image. But the artists also thought of themselves as summoning spirits from the vasty deep of the unconscious mind, so that spontaneity was a way of connecting with themes as universal in human life as sex, love, and longing were for the great French Modernists. As Adolph Gottlieb and Barnett Newman wrote in a letter to *The New York Times*: "Only that subject matter is valid which is tragic and timeless. That is why we profess spiritual kinship with primitives and archaic art." But because size itself went with the approach to the art of painting that members of the New York School evolved, largeness no longer proclaimed that the work it characterized was to be a masterpiece. The meaning of size was internally related to theme and execution, of course, but since bigness had become standard, it could no longer serve as manifesto or declaration. It became a commonplace of painterly style. And when painting took center stage in the art world again in the 1980s, it was simply expected that artists would paint big. Accordingly, size lost its proclamatory meaning, and an artist who wishes to employ this sign of intended significance—that a work is

to be addressed under the aspect of the *masterpiece*—must accordingly go beyond bigness, to the gigantesque or even the colossal.

The painter Robert Zakanitch has declared through the size of the four separate panels in his *Big Bungalow Suite* that this work is to be approached with the understanding that the artist has, in his own mind at least, undertaken a work of particular importance. If there should seem a dissonance between the concept of the masterpiece and the connotations of "bungalow"—snugness, coziness, domesticity, even architectural sweetness—it would be well to remember that there is nothing obviously heroic about the *salon à manger*, with its patterned wallpaper and napery, its fruits and mimosa and carafes of red and white wine, that Matisse chose as the setting for the artistic heroics of *La desserte rouge*. I shall endeavor to connect scale with content when I come to describe Zakanitch's work. But for now I am only interested in the *rhetoric* of scale, of what it means when an artist takes upon himself or herself the execution of a work in which the sheer magnitude of the dimensions proportionally to the human body implies an ordeal. The panels are eleven feet high by thirty feet wide, and hang unstretched in the temporary space the Jason McCoy Gallery has rented in SoHo to accommodate them all (at 129–31 Greene Street; no wall in its regular uptown quarters is large enough to display even one of the panels). Each of the four illustrations in the catalogue shows the artist in front of the canvas, wearing a house painter's cap but artist's pants: A house painter would never allow the clothes he paints in to be so dripped upon and smeared with paint—that would be a mark of unprofessionalism—whereas with an artist it is a mark instead of engagement and even passion. The figure in part gives the scale of the painting, but the fact that the artist has chosen to have himself shown in front of each of the four canvases implies a certain intimate bond between him and the work, and signifies that the work is his in a sense that goes beyond authorship. The identification is between the artist and the content of the work: The content is not just his but *him*.

This claim is based on a second act of meaning to put alongside the selection of size: The artist changed his name, as if to declare that he had found his identity in achieving this work, and that this discovery should be

registered in the name he is henceforward to be known by: He is now Robert Rahway Zakanitch, where "Rahway" refers to that city in Union County, New Jersey, with its industrial establishments and largely working-class population, which to most of us is a meaningless place pointed to by signs along the New Jersey Turnpike, undistinguished save by name from the surrounding urban sprawl. We have, in American English, a jocular way of indicating a particular degree of identification with something—baseball, say—by boasting that "baseball is my middle name." Names, after all, are never mere designations. Parents transmit their hopes in the names they give their children, or they memorialize what gives meaning to their lives, making the child through its name the bearer of such meaning. For an adult to take a new name is to perform an act of rededication, something that in a small way resembles the dubbing of a knight. So for Zakanitch to take "Rahway" as his middle name is in effect to say that Rahway is what gives meaning and substance to his life—that he and Rahway are somehow one. Or, since these paintings are the occasion for this act of renaming, that the meaning of Rahway for him is the meaning of these paintings for us. And the critical task is to establish what this meaning is.

The motif of each of the paintings is a floral pattern of the kind one might find printed on wallpaper, or on slipcovers or pillowcases—the patterns of someone (by convention a woman) bent on establishing exactly the kind of snug, cozy, sweet interior that the idea of a bungalow suggests, and that accordingly conveys the meaning such interiors have to those whom they sheltered and sustained. They are, one feels, the kinds of patterns that would have appealed to Julia Warhola—Andy Warhol's Slovak mother—and that his popular flower paintings of 1966 celebrate. Warhol made actual wallpaper as well, with a cow motif, and used it to transform one of the Castelli galleries into something rather homier than that austere precinct typically evokes. In my recollection, one entered and left the space almost immediately, feeling that there was nothing to see. Zakanitch helps me appreciate the power of a work I failed at the time to grasp. Wallpaper projects an aura of warmth and orderliness that the image of the cow augments—think after all of the tribute to the milk cow in *A Child's Garden of Verses*. Peter Schjeldahl, who went to France at one point because that's what poets were supposed to do, recalls seeing Warhol's flower paintings at Ileana

Sonnabend's in Paris and realizing with the force of revelation that he was in the wrong country. The flowers meant "home," as the flowers in Zakanitch's paintings do. And they mean as well the marvelous decorational impulses of the immigrant woman—his grandmother—who made the home in Rahway that the paintings celebrate. It is difficult to resist the thought that the wallpapers and fabrics that women from Central Europe chose to transform their homes into painted gardens bore patterns that echo the exuberant embroideries of blouses and aprons in the Old Country. Like Julia Warhola, Zakanitch's grandmother was Slovak. "His aunt and grandmother embroidered every available surface in the house," Brooks Adams writes in his sensitive essay for the catalogue. "By embracing the decorative, with its feminist implications of women's work (his grandmother taught him to sew at age six), Zakanitch brings male and female essences together." The decorative is the meaning of these works, what they are about and what decoration itself signifies in the domestic aesthetics of everyday life. The panels of the *Big Bungalow Suite*, if themselves decorative, are so in a very different sense: that of the defiant and polemical. They take an artistic stand on decoration that belongs to the art wars of twentieth-century aesthetic ideology, celebrating what belongs to one of the great impulses of human expression, invariant to cultures. But the artistic celebration of decorativity, rather than representing that impulse itself, arises from a certain philosophy of what art should and should not be. Zakanitch's paintings assert his oneness with an impulse that the women of his childhood home would have expressed spontaneously, so to speak, from out of their class and culture. But he stands at a distance from that class and culture.

It is a possible topic for those who believe in historical cycles that decoration should emerge as a positive aesthetic in our own *fin de siècle*, just as it did in the last one, after a period when the decorative had been virtually impugned as a legitimate artistic possibility. "Painting must above all be decorative," Bonnard declared in an interview in 1891. Two years earlier, the "heavily decorative surfaces" of Gauguin's paintings from Brittany and Martinique were invoked by Maurice Denis as part of the reason for the "dazzlement" and "revelation" he and his circle felt when they first saw them. Decoration had been associated with the "inferior arts" under the canon established after

the French Revolution by Jacques-Louis David, largely because, by contrast with the three *beaux-arts*—painting, sculpture, and architecture—the decorative arts carried the wrong kinds of moral and political messages: The "inferior" arts were ineluctably private, domestic, and feminine. The story and historical explanation of the transformation in artistic values that opened the Salon of 1890 up to the decorative arts is set forth in a wonderful book by Debora I. Silverman, *Art Nouveau in Fin-de-Siècle France* (University of California, 1989), and it is stimulating at the very least to reflect on the parallels between France in the 1890s and America in the 1990s from this perspective. The Greenbergian canon has its analogies with the Davidian one, and the rejection of decorative values by Minimalism in the 1960s is not all that distant from the attitude that art must carry the right social, political, and moral messages: The demand by the practitioners of studio crafts in America today that ceramics, glasswork, and furniture be judged by exactly the same criteria deemed appropriate to painting and sculpture is a *ricorso* of those same demands a century ago. Were the Whitney Biennial to open itself up to objects of high craft in 1995, that would not only be as innovative as the gesture of the 1890 Salon but would make a statement immeasurably more revolutionary than anything achieved by the radical political art that made up its 1993 exhibition. And, because we are a long way from decoration's being accepted by the critical establishment, it would probably elicit a comparable degree of vehemently negative response.

Zakanitch was a founding member of a movement designated "Pattern and Decoration"—P&D—that briefly flourished in New York in the mid-1970s. Many of its members, dissatisfied with the kind of art that earned the approval of the more advanced critics—the art of the Minimalists and the practitioners of the so-called "New Sculpture," with its uningratiating and in some sense antihumanist materials and forms—began to meet in his studio to discuss an art that celebrated precisely the values that "advanced" art had exiled to the margins. There can be little question but that feminism gave a certain impetus to the movement, just because pattern and decoration would have been perceived as attributes of traditionally feminine forms of expression, now ideologically embraced in a spirit of aesthetic solidarity with the kind of domestic arts practiced by women who would never have thought their work deserving of the awesome dignity of "real" art. Miriam Schapiro's

monumentalized *Barcelona Fan* of 1979 flaunts the shape and meaning of this feminine accessory, and Joyce Kozloff designed tiles for a subway project in Buffalo that appropriate what look like inspired quilt designs. The question of whether pattern and design are themselves expressions of some essential feminine aesthetic or whether they have been merely outlets through which women, prevented by social convention from becoming "real" artists, have expressed themselves as a *pis-aller*, is as difficult to answer as the question of whether gender differences themselves are social constructs or in some way internal and essentially differentiating. Whatever the answer, the association of pattern and decoration with femininity in our culture is a fact, and in endorsing these as artistic values, one is making a statement of the *human* values they reflect. And this is certainly true in the *Big Bungalow Suite*. The women of Zakanitch's Rahway childhood are as integral to these paintings as are the harlots of Picasso's young manhood to the *Demoiselles d'Avignon*, or Matisse's unforgotten mistress is to his *La desserte rouge*.

Decoration may be the theme of the *Big Bungalow* panels, but there remains a critical question of whether the paintings themselves are in any further sense decorative. Clearly they would not fit in the decorative schemes they show, and size alone would physically disqualify them from fitting in among the chintzes and embroideries that go with bungalow decor. It may be a function of their size that it is required in order to exalt—to heroize—the feminine values of home and haven. But at the same time it prevents the paintings from entering the promised land of the working-class domestic interior. Beyond that—this of course is not a criticism but an art-critical judgment—the paint itself is applied with that generosity and brio Zakanitch carries over into P&D from his years as an Abstract Expressionist: The drips and dribbles, which are standard Abstract Expressionist signifiers, are at aesthetic odds with the tidiness that would have been a precondition of the domestic arts, and would certainly have horrified the kinds of women Matisse at one point characterized as "country aunts." And since the pigmental swagger of Abstract Expressionism carries connotations of masculinity, the *Big Bungalow* panels are a masculine tribute to feminine values, a salute across the boundaries of gender and of generation and of class to what made the artist what he is, even if, as an artist, he no longer belongs to it. Think again of his paint-spattered pants.

Let us now look more closely at the panels themselves. Each has a different floral motif and a different palette, so that it might be possible to suppose the four seasons are marked, and hence the cycle of the year. Panel III, for example, is in oranges, yellows, and reds—autumnal hues—and the elements of the pattern, fruits and grains, appear as if, in their schematic way, they stand for the harvest plenty of the season. There are peach halves, or what looks like them, clusters of grapes, possible stalks of wheat and ears of corn. And then chrysanthemums and seedpods. The canvas looks as if it represents a stretch of wallpaper, with six rows of repeated images, each row about six feet wide. Pattern typically implies a surface, which perhaps connected P&D with the mumblings about flatness that characterized so much of critical discourse in the 1960s. But Panel III is not flat in this sense at all—it incorporates a certain degree of pictorial depth, since the wallpaper is set back by means of two large vases, one of which appears to be painted glass: At least there is a kind of illusionist effect in which the wallpaper is seen through the vase. Since the Abstract Expressionist style tends to embrace the viscosity of paint, it is not easy to adapt it to the illusionistic purposes the depiction of transparent glass requires, and I am uncertain of how successful this passage is. In any case, the vase is embellished with the kind of image one would see on hand-painted china, a Mitteleuropa landscape of a traditional sort, and probably in consequence a tribute to the women who prized such objects. The other vase is decorated with a kind of marbled pattern and has a Grecian molding as its base.

Panel IV is primarily in black and white, which encourages associating it with winter, and the wallpaper shows a pattern consisting of vases of flowers. To the left is a single Staffordshire dog, to the right a white vase with two birds, of the sort one might find at a yard sale. Panel II could be spring, or late spring, since the flowers look like petunias combined with some abstractly floral motif in caterpillar green. There is a "hand-painted" vase to the right, again showing what I would suppose to be a Slovakian village, while the vase to the left shows an opening in a woods, with a stream in the foreground. Panel I is summer, with gloriosas and goldenrod, lily of the valley and sweet william, and showers of stars, like the summer sky. I do not vouch for the botanical accuracy of these identifications, nor, for that matter, for the seasonal identification of the panels themselves—a device that at least

keeps the descriptions from blending into one another. Each panel has two or more vases in front of the wallpapery background, objects of a kind one can imagine someone prizing but which belong to the category of kitsch. It could not be part of Zakanitch's agenda to treat these objects with condescension or contempt. But it is possible to suppose that inclusion of kitsch in these profoundly felt and truly moving works is a sneer at a once-dominant aesthetic that contrasted kitsch with high art.

There is an exhibition of smaller works by Zakanitch at the uptown gallery of Jason McCoy, but it is the huge works in the downtown space that capture the imagination. I would like to close with a speculation on the connection between size and content, for what I have so far suggested really only touches upon the rhetoric of these works, and concerns their place in the ongoing conversations that define the narrative of the art world over the past some decades. My sense is that the patterns and vases are large because the implied viewer of the vases and the Staffordshire dog, the sheaves and bouquets of the wallpaper, is small, and in fact a child. Zakanitch is representing the lost world of childhood through the remembered eyes that saw it. Memory is a site of strange dissonances in scale. I once visited Maison de Tante Léonie in Illiers, which is of course the house of his aunt in Combray that the narrator in Proust's masterpiece describes with such aching affection. In the book, the garden in which the grandmother walked seems almost as grand as the Tuileries, but in fact it is a tiny triangular patch of grass and flowerbeds that one could cross in perhaps eight middle-sized steps. The adult Marcel describes it as the child Marcel saw it, and that I think is what Zakanitch has done in the *Big Bungalow Suite*. So there are external and internal meanings for the great scale of these works, and the artist himself, like Proust, is inside and outside them at once. The bungalow is a place we cannot return to, save in memory, and in art.

—*March 28, 1994*

ROBERT MORRIS:
BODY AND MIND

∎ ∎ ∎

"LET US NOT FORGET THIS," WITTGENSTEIN WRITES IN THE COURSE of investigating voluntary action: "When 'I raise my arm,' my arm goes up. And the problem arises: what is left over if I subtract the fact that my arm goes up from the fact that I raise my arm?" The traditional philosophical answer would have been: an act of will. "The motion of our body follows upon the command of our will," Hume stated. "Of this we are every moment conscious." But Hume went on to observe that "the means by which this is effected, the energy by which the will performs so extraordinary an operation—of this we are so far from being immediately conscious, that it must forever escape our most diligent inquiry." The "command of the will" was a mental event, while the movement of an arm was the translation through space of meat and bone. There was no conceivable site on which the two could come into the kind of contact required to move a physical body, so it was literally incomprehensible how the allegedly familiar happening could take place at all. "Is there any principle in all nature more mysterious than the union of soul with body," Hume wrote, not without irony, "by which a supposed spiritual substance acquires such an influence over a material one, that the most refined thought is able to actuate the grossest matter?" Wittgenstein's contribution was only to invite us to inquire whether we are in fact all that conscious of something called an act of will. "Are the kinaesthetic sensations my willing?" he asks in a sly parenthesis. Whatever the case with the will, something has to make the difference between raising one's arm and one's arm just *going* up, say, as the result of the Mad Scientist acti-

vating neurons in my brain with his fiendish device, turning me into a high-tech marionette!

The reader has every right to ask why a column on art should begin with this bit of philosophical boilerplate. There are two answers. The first is that the curators of the extensive retrospective exhibition of the work of Robert Morris at the Guggenheim Museum, uptown and downtown, have titled the exhibition "The Mind/Body Problem," probably because a certain number of Morris's works are animated by that old philosophical conundrum. The second answer is that there are some instructive analogies, hardly dreamt of before the 1960s, to what one might call the Artwork/Thing Problem. A work of visual art—paint and canvas, ink and paper, metal or stone—yields nothing in point of grossness to the fleshy matter of which our arms are framed. So suppose we try to perform a Wittgensteinian subtraction and ask what remains of the work of art when we take away its "body," viz., whatever has weight and takes up space and is subject to chemical action. One answer might be: nothing. When the painting is burned, the work goes up in smoke. When the sculpture is smashed, the work is smashed. "What you see," Frank Stella famously said, "is what you see." But then what about the difference between a red monochrome painting and a square of canvas merely painted red? What about the *Brillo Box* of Warhol as against the Brillo boxes of the supermarket? What (to cite an item in Robert Morris's *oeuvre*) about a pile of dirt and a work consisting of a pile of dirt? A traditional answer might be: an act of artistic will, the artist's intention that something be art. That begins to sound like the theory of volitions Wittgenstein sought to call into question. And as one begins to try to work out the difference between material objects that resemble one another as much as, say, one pile of dirt resembles another (but only *one* of which is a work of art), the parallels between the mind/body problem and the artwork/material object problem become more and more striking. In some way, the artwork is the dirt pile with whatever it is that does what the soul is supposed to do, in transforming a bodily movement into a voluntary action. And the mysterious union of "soul" with dirt pile is all the philosopher has to understand in order to say what art is (it need have nothing to do with what she or he likes). This is a problem philosophers did not even know existed until the conceptual breakthroughs of Duchamp, Warhol, Beuys, and Robert Morris himself. It is their work that explains why

the past few decades have been the best time to be alive for a philosopher interested in the deep questions of art. In fact, it is the only time to have been alive: Before Duchamp, no one knew what the real questions were.

In a book I devoted to this matter, *The Transfiguration of the Commonplace*, I invented an avant-garde artist whom I named J, whose works consistently probed the often faint borderline supposed to divide art from everything else. Among J's works was "what he regards as a piece of sculpture and which consists, as I recall it, in a box of undistinguished carpentry, coated with beige latex paint applied casually with a roller." In fact, I was appropriating to J's *oeuvre* a work characteristic of Morris in the 1960s, of the kind I saw in an intoxicating show of his at the great Green Gallery in 1964—the same vintage year in which I was awakened from my dogmatic slumbers by the Brillo Box of Warhol at the Stable Gallery. There is an interesting photograph of the Green Gallery installation in the catalogue for the Guggenheim show, which shows the laconic, uninflected plywood forms Morris exhibited as sculpture and described as slabs, beams, cornerpieces and the like (painted, I learn from the unfailingly informative catalogue text, not beige but Merkin Pilgrim gray!).

In his *Philosophical Investigations* (1953), Wittgenstein imagines what he calls a "complete primitive language," designed to serve the purposes of communication "between a builder A and an assistant B." It is "a language consisting of the words 'block,' 'pillar,' 'slab,' 'beam.'" The Green Gallery show looked like a 3-D dictionary for this undemanding vocabulary; as Morris is philosophically literate to an exceptional degree, he may even have been inspired by Wittgenstein's text. Whatever the case, Morris certainly was engaged with the kind of subtraction procedure articulated by Wittgenstein, seeing, in effect, how much could be removed from a three-dimensional object and still have it remain a work of sculpture. The slabs and beams really do look bland in themselves, and indeed somewhat empty, as critics unsympathetic to Morris's work complain even today. They have close to the degree zero of aesthetic interest. One cannot infer from their museum appearance the extreme excitement of the 1964 show: Nothing like his beams and slabs had been seen, at least not as sculpture. For anyone interested in intellectual as opposed to sensual pleasure, the works were intoxicating through the mere fact that they existed.

There was an early work I have only read about, a dance piece in which a rectangular box, again painted gray and called *Column* ("pillar" in slabese), was posed on a stage and allowed to remain upright for three and a half minutes. It was then pulled with a string over onto its side, and allowed to lie there again for three and a half minutes. (Curtain.) It was a minimal performance, with clear reference to Cage's *4'33"*, and had a certain affinity to the kinds of purified reductive gestures or "Events" that, according to Dick Higgins, one of its foremost theoreticians, the art movement known as Fluxus sought. In some sense, the Green Gallery exhibition was itself a performance, depending for its effect on the disparity between what one would have supposed sculpture must be and what one discovered it can get along without. Or what one supposed it must be and what one discovered it can get along without and still be art.

In the best of the interpretive essays with which the catalogue begins, W. J. T. Mitchell writes, I think wisely:

> Morris's early Minimalist pieces may now be, in the space of a
> retrospective, bombs that have already gone off, or that have been
> defused by the labels of canonization and art-historical explanation.
> Once one "gets the concept" of *Slab* or *Beam* (1962), we must ask, what
> need is there actually to *look* at the pieces? Hasn't their material and
> visual presence been made superfluous by the welter of discourse that
> surrounds them? Don't we already know, as a staple of everyday
> common sense, that simple polyhedrons take on different appearances
> from different angles? Why do we have to look at *these* constructions to
> test or confirm that knowledge?

In his *Lectures on Aesthetics*, Hegel proposes that art shares with philosophy and religion the purpose of bringing to our minds "the most comprehensive truths of the spirit." But it achieves this in a special way, "namely by displaying even the highest reality sensuously, bringing it thereby nearer to the senses, to feeling, and to nature's mode of appearance." Art is the *sensuous presentation of truth*, in Hegel's tremendous vision, and two things follow if we go along with that vision. The first is that to be a work of art is to be the

material embodiment of a truth: It is a way of presenting an idea in some sensuous fashion. (It does not follow that art must be sensuous in any further, aesthetic sense of the term.) The second is that the work ought not to be the illustration of an idea but rather must be the conscious *embodiment* of it. Roberta Smith, in her somewhat frosty review of the Morris show in *The New York Times*, is critically on target when she writes: "Perhaps his work is most interesting as illustrations—and not necessarily the most visually substantial and engaging ones—of the ideas that are his real interest." The criticism is devastating if illustration is all the works ever are, and if Morris has not found the material body for the thoughts or ideas that animate those bodies like souls. Yet in his best work, it seems to me, Morris succeeds, even if the material object of which the work consists might not have much aesthetically to recommend it. Smith writes of the pile of dirt that it is "luscious," a kind of e. e. cummings response to the dirt ("in Just-/spring when the world is mud-/luscious . . ."). Well, the dirt may be luscious but the work is *not*—because lusciousness does not go with the idea the dirt pile embodies. Rather, the idea goes with Morris's well-known anti-form philosophy—the notion that there need be no special way a work of art always has to be from moment to moment of its existence. A sculpture, rather than being a rigid geometrical structure (as possessed by slabs and beams) can be as hopelessly variable as, say, heaped-up dirt. It would be insane to try to get the pile "just right," and probably it would be a parody of the "original" work of art to insist that it always be the same soil from occasion to occasion of its exhibition. So the dirt pile embodies the idea of variability, and that is not really one especially compatible with the experience of lusciousness. In truth, it seems to me, the "form" of the work is the idea of anti-form (no paradox whatever), and the dirt pile embodies this to perfection. But so do the works whose material is industrial felt, which Morris used to great effect in a number of almost monumental works—hangings, for example, or piles, just so many scattered remnants of thick felt. Some of these felt-works are actually sensuous in the erotic sense of the term. But it is sensuousness in the connotation contrasting with thought that is all that is relevant.

Anti-form was intended as a great deal more than an exercise in conceptual subtraction. The intention was less to demonstrate that something could be

a work of art without a stable form than to attack the various institutions of the art world—the gallery, formalist criticism, the market, the collection— by making art that refuses to accommodate itself to these institutions. It was, in brief, a kind of political movement, one wing of the overall liberationism that defined political action in the late 1960s. It was in its own way Utopia Now, providing one were able to muster the overall hatred for formal art that the sans-culottes were able to generate toward the aristocrats, or the militant peaceniks of the era toward the warmakers. It was Utopia because there was only art; no market, no criticism, no collectors. It had been a mark of the intellectual left in the United States, in the posture, for example, of *The Partisan Review*, that one could be politically left wing and culturally elit- ist (not that far from the posture of *The Nation* today). Anti-form attempted to define the left in terms of a kind of aesthetic elitism, in that the art in question was, in the late 1960s, exactly the avant-garde. And Morris sponta- neously sought a position in the movement as ideologist, doxologist, and *chef d'école* somewhat parallel to that which André Breton enjoyed in Surrealism. The art was to be as paradigmatically unbeautiful as are felt scraps, shattered glass, dust heaps, spilled latex, splattered lead. It was to be democratic in the sense that no skill was involved in bringing it into being: Sweeping, smash- ing, flinging, spilling exhibit almost no skill. And process was to be cele- brated over product.

My own thought is that anti-form was the last of the dogmatic move- ments in American art of this century, the last manifestation of the impulse to aesthetic dictatorship, after which a certain benign pluralism settled over things. In the end, there was as marked a style in the anti-form art as in that of the Florentine Baroque. Morris's own felt pieces turned out to be subver- sively handsome, and so far as I can tell, marketable: I saw a show of them at the Sonnabend Gallery not so long ago, and there was of course a price list. But even at their most formally unredeemable, there the works are, looking a bit sheepish in the museum, surely the institution most of all that it was their purpose to overthrow. The anti-form works cannot today have the meaning they had when they were shaggy guerrillas in the wars of taste. They were never meant to be aesthetically enjoyed. So it serves them right that a critic finds them luscious, or complains when they are not aesthetically "sensuous."

This leaves Mitchell's question to be dealt with, namely, Why must we experience the work again? This certainly must be distinguished from the question of why must the work be realized through some material embodiment. The answer to the latter question is simply that it wouldn't be art if it were not an object. Not long ago the Guggenheim scandalized the art world by purchasing a number of Minimalist works from the collection of Count Buomo di Panza, making itself the chief center for this art in the country and probably the world. A good many of these works exist only as words and diagrams on paper, and it is difficult to know how many of them will in fact ever be materially realized. Still, each of them has a set of directions for realization—they are not simply thoughts about art but thoughts that become art when embodied. Why go to the trouble of making them? I suppose there can only be one answer to such a question: One wants to see the work. Why one would want to see the work repeatedly is, of course, another question. It is not work of a kind that grows deeper the more one experiences it, mainly because the principal part of such work is the encapsulated *thought*, and to grasp that is to grasp the discussion in which the thought emerged at a certain moment as a kind of conclusion, or comment, or observation. In some way, when those bare polyhedrons first appeared in gallery space, they meant what they meant because of the theoretical conversations they made concrete. One can of course repeat a conversation, as one does with the Socratic dialogues, and there are certain lines one loves to come upon again and again. (The actress Tammy Grimes once told me how much she loved saying certain lines, even though she said them time and again in the course of a play's run.) But that again means there is more than can possibly meet the eye in such works—a knowledge of the structure of the discourse into which the work fits, and which it carries forward. But that is true of any work at all—Dosso Dossi's *Jupiter and Mercury*, for example.

The cover of the catalogue approximately reproduces a work of 1962 called *I-Box*. That work has an I-shaped opening, into which a door of exactly that shape closely fits. The door invites being opened—one wants to see what is in the cabinet, transforming it, so to speak, into an "eye-box" or peep show. When one does open it, what one sees is—eek!—"I," a photo-

graph of the artist himself, grinning out like the bullfrog at the bottom of the beer mug, to use an expression of J. L. Austin's, naked, adorned only with his semi-erect penis. I guess the box advances a thesis, namely that I, for each I, is the body. As a Wittgensteinian riddle, the question might be: What is left over when I am subtracted from my body? And the intended answer would be: nothing—because I *am* my body. Is that true? Is that the mouth grinning or is it the artist? In any case, *I-Box*, clever though it is, has to be a lot more than just a box with its slightly comic photograph if it wants to do philosophy. At the very best it embodies, at the very worst it illustrates, a complex philosophical position. If there is an analogy to the mind/body problem, probably there is more to I than the body, especially when "I" takes sexual pride and pleasure in the body. But an artwork can only take us a certain distance in addressing a problem that requires argument, reason, analysis, and logical distinctions.

All of the works that fall under the defining category of "The Mind/Body Problem," conceptually brilliant as they often are, have thus a long way to go to become the philosophy that animates them. I tremendously admire *Self-Portrait (E.E.G.)* of 1963, which is a transcript of the electrical activity of Morris's brain during a session in which he "concentrated on himself," and for exactly as much time as it took to produce a graph as long as he is tall. It is a picture of the activity of the soul and of the brain, but it no more resembles the latter than it does the former. (Does the photograph of Morris naked really show the artist as he is?) It would make, nevertheless, a wonderful example with which to begin the discussion in a classroom, as would the inspired 1961 box in walnut with a memory of its own manufacture: namely, a cassette tape on which is recorded the sounds of sawing and hammering over the three-and-a-half-hour period it took to make the box. What must we add to the tape to make it into memory is a good question to end with, having begun with the question of what must we add to the raised arm in order that it be a willed action. The memorious box, like the self-reflexive thoughts transducted into the form of a wave, are philosophical toys for us to play with. This is true even of the intricate arrangements of mirrors of which the downtown exhibition chiefly consists. The mirror is after all a traditional metaphor for the mind—and here one

approaches the mirror to find one's reflection somewhere else. Visitors were having a wonderful time trying to catch up with their own images. That it should all come down to intellectual pleasure may seem a reduction, given the puritan intensity with which so many of the works were made. Still, I cannot think of another way to answer Mitchell's question.

—April 18, 1994

RICHARD AVEDON

■ ■ ■

*I*N THE PUBLICATION—MORE AN ALBUM THAN A CATALOGUE—THAT accompanies Richard Avedon's retrospective exhibition at the Whitney Museum of American Art, there is a snapshot of the photographer, taken in 1978, on the steps of the Metropolitan Museum of Art. Above him is a banner, with his signature in red against a blue field, and, in white, "Photographs 1947–1977." In a list of exhibitions at the end of this album, that triumphant show is identified as a "fashion retrospective," tacitly implying that other of Avedon's exhibitions were not quite so narrowly conceived. It was indeed as fashion photography that it was received at the time. That was the great excitement of the show: The Met had opened its galleries up to fashion photography, the mere presence of which in those precincts seemed to signal, as much as anything could, a transformation in the museum's conception of itself and of its role in the larger society. It was a kind of aftershock of the Hoving decade—though surprisingly, in view of the meaning of the event, there is no mention of it in Thomas Hoving's recent memoir of his years of cultural power, *Making the Mummies Dance*. Hoving's tremendous vision was to democratize access to high art, to overcome the exclusionary barriers that had tended to restrict the museum to a social and scholarly elite. His faith was that art was for everyone, but it was no part of that faith that artistic quality itself was to be democratized away: His program was to put as many people as possible in the presence of the best art he could acquire, and to make the experience as meaningful as enhanced strategies of installation and presentation allowed. The Avedon show represented

a different impulse, and aroused a different order of excitement. That impulse was to demonstrate that certain forms of commercial or applied art were aesthetically meaningful even if their purposes were those of visual rhetoric—to provoke certain attitudes and arouse certain desires. The excitement was that *Avedon* was at the Met. The name alone carried the glamour of certain labels—Chanel, Guerlain, Givenchy, Balenciaga, Schiaparelli, Dior—and it was almost certainly to be in the presence of that palpable glamour that a great many visited the museum who might otherwise never have set foot there. In its own way, it contributed to the Hoving agenda: At least those visitors had crossed the threshold. They—we—stood in line to see the great, seductive images.

For a good many reasons, some of them altogether personal, I have the most vivid recollections of the show. The images themselves were quite large, far larger than the reproductions through which most of them would have commonly been known, and they were hung the way works of art characteristically are hung in modern museums: simply framed, separated by ample spaces, handsomely illuminated. The image I, and I dare say everyone else, remember best is *Dovima With Elephants, Cirque d'Hiver, Paris*, which Avedon did in 1955, and by which he will in all likelihood always be remembered, in histories of photography, of fashion, of illustration, of art. It is a great image, and even if its original occasion was to present a gown from some designer's line of that year in a fashion magazine, it transcends the occasion without obliterating the point of high fashion illustration, or indeed of high fashion itself. *Dovima With Elephants* has the power of a dream, and might, all by itself, support the thesis that dreams are a form of wish fulfillment. It is a dream of power and magic and of promise: In that superb garment, with its marvelous cascade of satin sash, the woman who wears it draws onto herself a strength greater than that of the hugest animals, now docile to her touch or even to the nearness of her touch. If elephants are no match for the well-dressed woman, how can mere men hope not to yield, to obey, to adore! The fashion designer designs dreams, and that is the entire point of the subtle craft. What Avedon achieved was the objective expression of such dreams in a single image so dense with possibilities erotic, aesthetic, and psychological that it stands as a portrait of an inextinguishable wish and a metaphor of empowerment. That it may, in 1955, also have aroused the

desire for a particular garment by showing what it must feel like to wear it subtracts nothing from its artistry or communicative energy. The image defines the genre of popular art to which the kind of fashion photography practiced by Avedon belonged. It is the art of making wishes objective and myths explicit; its peers are certain movies, or ballads, or even styles of costume, all of them universalized through mass distribution. They service (as poetry evidently no longer can) longing hearts shortchanged by what Kant once called "the niggardliness of a stepmotherly reality."

It is no small thing to have achieved an image as unforgettable and potent as *Dovima With Elephants*, but it is also true that most viewers of the 1978 exhibition would be hard pressed to place a second Avedon image alongside it in point of immediate recall. I suppose those able to come up with another (though clearly it could not have been in the Metropolitan show) would cite the 1981 portrait of beekeeper Ronald Fischer, which shows bees all over his shaved head and bare skin, while he remains impassive, a whitish figure on a white ground, seemingly unaffected, like a Lazarus indifferent to his worms. This image too has the quality of a dream, but one driven less by wish than by certain primordial fears, and it is difficult to reconcile our recognition of its uncanniness with our knowledge that it is a photograph, which must have been taken of a real person passive under an ordeal of real bees. It is not in any immediate sense a fashion photograph, but only someone with the imagination that great fashion photography requires could have taken it. In truth, because of the sense of triumph over affliction as embodied in the bee swarm, this image could belong to the genre of religious photography, if there were one.

After the symbolic martyrization of the beekeeper, the images tend to blur into generic Avedons, of either of two kinds: models shown leaping in a way that is now a kind of cliché but which could only rarely have been a convincing idealization of what it would mean to wear the garment modeled; and heads, commonly of famous men though sometimes of women. Whether leaping models or intensely studied faces, the subject is shown almost always against an undifferentiated white ground, as characteristic of the Avedon photograph as the undifferentiated black ground is of Caravaggio. Photographs that fit into neither of these kinds belong to Avedon's periodic ef-

forts to break free of the stylizations and preoccupations that have made him famous as fashion photographer and as portraitist, and that, in my view, are never really convincing as photography. He is hostage to his own powerful but limited repertory.

When the art world received the news a couple of years ago that the Whitney's then-new director, David Ross, intended to mount a major Avedon exhibition, that perhaps the entire museum was to be given over to this photographer's work, exactly those limits struck me as unpropitious for so ample an exposure: A lot of Avedon looks like a lot of Avedon. I spoke with him at another opening at the time of the announcement, and he acknowledged that he had accepted Ross's invitation. "You've got time to sharpen your knives!" he called out, less to me, I imagined, than to the critical community at large, which he perhaps supposed would be prejudiced against him through associating his work with the frivolities of fashion and the stigma of commerciality. He may have had in mind the critical furor that exploded in 1990 on the occasion of the "High & Low" show at the Museum of Modern Art, which dared to bring into that temple of aesthetic austerity the advertisements, cartoons, and popular imagery upon which "high" art drew for inspiration and energy. "Even after the advent of Andy Warhol," writes Jane Livingston in an essay accompanying Avedon's current exhibition, "who seemed so decisively to undermine the myth of high art's necessary independence from popular art and commerce, it has remained difficult for many to reconcile the two false categories." Livingston credits Avedon's mentor, Alexey Brodovitch, with having refused to accept the "tedious and damaging little myth that photographers who make money at their trade by flogging dresses and perfume, etc., can't be as 'serious' as those who live on grants and the meager returns on books."

It is difficult to believe that Avedon himself is all that free of the "little myth," given his breakaway efforts into what one supposes he regards as "real" art—photographing drifters, the insane, the war-maimed, and bringing to these commercially unrewarded tasks the skills and gifts that have made him the great fashion photographer he is, and the portrayer of the famous and successful. And perhaps, because Avedon is a political activist in his life, it might strike him at times that there is a tension between photography as he is famous for practicing it and photography as it ought to be prac-

ticed—bearing witness to injustice and poverty, aggression and cruelty, awakening the conscience of viewers to squalor, horror, and the waste of human lives. As though he has to compensate, or atone. And—who knows?—that may explain the cruelty with which he portrays the famous and successful, the naked contempt with which he depicts aristocrats at a Venetian ball, the manipulative will with which he drove his models into leaps and flutters, or gets celebrities of the lower magnitude to look silly, like the Monty Pythons naked except for hats, clutching their genitals, or poor Candy Darling looking vulnerable and confused with a garter belt framing his sad penis. This at least would be a way of bringing the two sides of Avedon's art into something like a moral unity: The commercial art would be a kind of aside to the viewer, a way of dissociating himself from the world he is being paid to celebrate, beckoning us to join him on his platform of anger or disdain. Given the distance between the world in which he attained his great success and the world whose conspicuous problems are so clearly of concern to him, there is a lived tension in his work that is of an almost tragic dimension, particularly in view of the disproportion between the undeniable artistic merit of his best commercial work and the largely undistinguished quality of what he doubtless regards as his real art. One could imagine a novel, or even an opera, composed on the basis of so dilemmatic a hero. In any case, a lot of what one becomes aware of in the work is the space between the photographer and the subject, filled with the most complex confessions and drives: Avedon is a presence in every image he makes. He shows us realities as a way of disclosing himself showing those realities, so that we think constantly of him—except when, on rare occasion, he transcends himself, as in *Dovima With Elephants.*

In the end the Whitney show is confined to a single floor rather than given the entirety of the museum and, in candor, even that seems to me too large a space for what strikes the visitor as an astonishingly narrow range of photographic exploration. The show opens with some images taken in the 1940s of New York scenes, of couples in Central Park or in Harlem, of figures on the El. Avedon, writes Jane Livingston, felt that "he had somehow strayed into others' aesthetic territory—that every picture looked as though he had seen it before." He is right about this, though in the catalogue Livingston justifies their inclusion on the ground that one can see in them "ele-

ments that would appear later in his work." One can accept this without Avedon's own assessment having at all to be revised: They are general-issue New York images, with some Avedonian touches invisible at the time they were made. The show ends with a group of enlarged—I would say inflated—photographs taken on New Year's Eve, 1989, at the Brandenburg Gate in Berlin, ostensibly to mark the unification of Germany. The large sheets are hung, unframed, in a little gallery of their own, as if less a body of work than a piece of installation art, using photographs as elements. Whatever the case, Avedon's limitations as a photojournalist come out vividly in these crowded scenes, or shots of single individuals extracted from the crowd: They could be any crowd anywhere, even one watching someone jumping off a building, which one figure, bleached and bald against the night sky (he looks like the beekeeper) appears to be doing. There is no specificity of site or space or time or meaning, apart from what we are told by labels and other descriptions. This leaves us with the fashion shots (*Dovima With Elephants*, while given a full page in the catalogue, has been excluded from the show, which is like James Taylor giving a concert but refusing to sing "Sweet Baby James"), and with the portraits, which I greatly dislike, for reasons I will try to explain.

The portrait heads are extremely invasive. They are, to begin with, studio works: There is no effort to show—or, better, there is a concentrated effort *not* to show—the subject within the settings and among the objects that express his or her form of life. Avedon "tries to eliminate elements of incident or paraphernalia that might dilute the intensity or self-consciousness of a portrait session," Livingston writes, I am certain with authority. "He does this partly by using white backdrops and lighting that can seem unsparing but that is calculated both to reveal and to mitigate." The "white backdrops" are transformed into the signature white surfaces against which the heads are typically shown, and which carry, I suppose, the metaphorical meaning of a soul stripped bare and not allowed to hide:

By reducing so stringently the signs of environment or context, i.e., by letting clothing and hair style and gesture and the accidents of alertness

or fatigue carry the only clues to the sitter's social status or cultural place, Avedon challenges himself to find other than superficial means to signal psychology and personal history. In effect, the most minutely distinguishing elements of garb and expression carry an enormous freight of connotation.

The aim of this fierce scrutiny, a kind of visual interrogation, is ostensibly to "express through the portrait something about the sitter's meaning in his or her historic circumstances." In fact I think this is never achieved. There would be no way one could tell, say, from the photograph of "Groucho Marx, comedian," taken in April 1972, that the subject's meaning in history is that of Groucho Marx, comedian: He has been stripped of his leer and spectacles and his grease-paint mustache, and he looks blankly into space in a kind of exhausted resoluteness, with spots of age across his bald head. He has been robbed of his meaning, or he has exchanged it for the chance to be photographed by a famous portraitist. It is like a German fairy tale in which someone sells his shadow, or his soul.

In looking at these faces I felt that *I* was being invasive. Of what possible bearing on their meaning in human life and history could these blotches have, these facial hairs, these bags and wrinkles and discolorations? All they tell of is the way the human face looks under harsh light in abstract circumstances. Can that really be what or who the person is? And I was reminded of a very wise passage in a text by the moral philosopher Bernard Williams, published, as it happens, in the very year in which Avedon's portrait of Groucho was made:

> If the test of what men are *really* like is made . . . of how men may
> behave in conditions of great stress, deprivation, or scarcity (the test
> that Hobbes, in his picture of the state of nature, imposed), one can
> only ask again, why should that be the test? Apart from the unclarity of
> its outcome, why is the test even appropriate? Conditions of great stress
> and deprivation are not the conditions for observing . . . other
> characteristics of human beings. If someone says . . . to see what men

are *really* like, see them after they have been three weeks in a life boat, it is unclear why that is any better a maxim with regard to their motivations than it is with regard to their physical condition.

The only subject of these agonizing portraits whom I know at all personally is "Isaiah Berlin, philosopher," taken in 1993, and I can say flatly that the absolutely awful image of that marvelous man has nothing to do with who he really is or what his meaning for history really is. Isaiah's great attribute is talk, and to have had the benefit of his conversation—or to have heard one of his lectures—is to have experienced his speech as a force of nature, surging with great speed and urgency, rolling out like some immense tidal wave of brilliance, wit, learning, amusement that could be graphically depicted only with one of those ornamental baroque spills Saul Steinberg occasionally draws issuing from some speaker's mouth. If he is silent, it is only because he is poised to speak again. He has nothing to do with the sourpuss Avedon has turned him into, unless those pursed lips and resigned eyes are a stoic response to photographic torture. I know the Reverend Al Sharpton only as a public figure, but what on earth can it mean that he is shown in the catalogue as an ascending spiral of iterated heads—that his head is not screwed on straight? That he is all faces to all men? Or that in the end the darkroom trumps reality every time? It is beyond the viewer's power to make out: I know simply that these images strip their subjects of dignity and worth, and seem, as photographs, transcriptions of an aggression, a will-to-power, a cutting-down-to-size, a *ressentiment* on the photographer's part that demands an explanation quite beyond those in the art critic's repertory. A great deal of what I found deplorable in Lucien Freud applies no less to Avedon as portraitist.

The studio and the darkroom are sites of power, where the photographer is in complete control and the subject is rendered as passive as a victim. With the portraits by Avedon, one is tempted to an almost Foucauldian metaphor of domination and punishment. My sense is that Avedon has paid a terrible price for this power, and that it would be greatly to his artistic benefit if he were to leave the studio behind and return to the real world, where some of his best portraits were made. Think of the beautiful portrait of the poet Auden, for example, standing in the snow on a New York street in

1960, where some of the real world that gives meaning to the writer's life and poetry—"Under the familiar weight/Of winter, conscience and the State"—softens the ferocity of the unforgiving lens. Or the image of Charlie Chaplin saying farewell to America in 1952, grinning as he formed horns with his fingers next to his head, in part taking on the mock attributes of the devil that the fear of Communism had turned him into, in part aiming a *cornuto* sign at the ungrateful land he was leaving. It was a spontaneous gesture that would never have occurred to anyone save that comic genius himself, and Avedon had the wit to capture it and encapsulate the whole of a history in its terms. Reality is the photographer's greatest collaborator.

Avedon, recently turned seventy, has been showered with recognitions for the occasion: publications, exhibitions, prizes. A good way to look at seventy is this: It is the allotted lifetime, three score years and ten; so, having attained that age, one has entered a second life. I think he could do nothing better in this *vita nuova* than to re-engage reality, and maybe give up that blank white background that has become his signature and his crutch. It works wonders, graphically, but it also serves as a wall against the real world, for which even the most vivid photographic imagination is a paltry substitute.

—*May 9, 1994*

CLEMENT GREENBERG

. ∎ ∎

IN ITS AUGUST 8, 1949, ISSUE, *LIFE* PRESENTED TO ITS VAST READER-
ship images so at odds with what even those with some knowledge of ad-
vanced painting might ever have seen, that many must have suspected a hoax
of some sort—especially when the subtitle of the article asked regarding the
artist Jackson Pollock, "Is he the greatest living painter in the United
States?" He was, so the text declared, according to "a formidably highbrow
New York critic."

The formidably highbrow New York critic was, of course, Clement
Greenberg, art critic of *The Nation*. Greenberg, who died on May 7, had in
fact been attacked in *Time* in 1947 for his exalted views of Pollock, as well as
for the seemingly extravagant claim that David Smith was the only major
sculptor in the United States. It was perhaps for his early recognition and
advocacy of artists whose achievements were in time universally acknowl-
edged, as well as for his almost single-handed defense of what he termed
"American-style painting" at a time when it was almost categorical that the
School of Paris defined aesthetic Modernism, that gave Greenberg his un-
matched credibility. But it was the clarity, care, and urgency of his critical
writing, as well as his tireless efforts to come to terms with the most ad-
vanced art of his time, finding bases for making critical judgments when
there was very little by way of guidance in previous critical practice, that as-
sures him a place in the tiny canon of great art-writers, the peer of Diderot
and Baudelaire.

Greenberg's official view of art criticism—that it was almost entirely a

matter of visual response without any infusion of theory or knowledge—was the counterpart of the theories of painterly expression invoked to explain that style of spontaneous gesture commanded by the masters of Abstract Expressionism. But in truth he developed a very powerful philosophy of art history in which he sought to ground the formalistic principles he would invoke to explain what the eye intuitively sensed. By the 1960s, Greenberg's theories of aesthetics and aesthetic explanation defined curatorial, journalistic, and academic attitudes nearly to the point of orthodoxy. And when artists with agendas other than those stipulated by formalism endeavored to penetrate an art world fortified by Greenbergian dogma, it was inevitable that he should have been villainized: Greenbergian formalism had become the enemy to be defeated.

Clement by name though not by nature, Greenberg was a controversialist as well as controversial, and will be remembered for the quarrels, theoretical and ideological, that are part of the history he helped make. In 1951, he severed his connection with *The Nation*, which he accused—in a letter the magazine refused to publish—of betraying "its claim to be a journal of independent and principled opinion." By the early 1960s he more or less stopped writing criticism, and, characteristic of his historical vision, came to believe that art had become decadent; that nothing, as he said in a lecture in 1992, had really happened in the past thirty years. But his own writings, recently collected in four volumes and just a year ago the subject of a two-day colloquium at the Pompidou Center in Paris, will remain a monument and a model of serious thought about art, history, culture, beauty, and meaning, for all that their content was wrested from the fierce artistic and political dramas of his times. Ornery, sarcastic, dogmatic, and outrageous as he seems to have enjoyed being, his writing and example remain as important as the art he helped the world understand and accept.

—*May 30, 1994*

SALVADOR DALÍ
• • •

*I*T WAS A RECURRENT THEME IN ROBERT MOTHERWELL'S CONVERSA-
tion no less than in his writing that the movement then indelibly designated
Abstract Expressionism ought by rights to have been called Abstract Surreal-
ism. This, he felt, was because of the role "psychic automatism" played in the
kind of painting distinctive of the movement, as well as in the explanation
and justification of that painting. Surrealism was marked by a profound dis-
trust of rational processes, which segregate us from the deep sources of cre-
ativity to be found in the subconscious mind, if only we knew how to connect
with them. The Surrealists admired children, who had not as yet been alien-
ated from these springs of spontaneity, and cherished the art of primitive
people, who again seemed to them to live close to what Europeans must
struggle to reattain. Motherwell searched for what he called "an *original cre-
ative* principle," and he believed himself to have found this in a kind of auto-
matic drawing that he rather endearingly referred to as "doodling." ("When
Miró has a satisfactory ground," he wrote in an appreciation of the Catalan
master, "he 'doodles' on it with his incomparable grace and sureness.") Au-
tomatism was, as Freud once said of dreams, the royal road to the uncon-
scious: The will is in neutral and the brush transcribes the inner urgencies
and irrational concatenations of primary process. Motherwell learned about
the artistic potentialities of automatism from the Chilean Surrealist Roberto
Matta and became something of a proselytizer, converting Pollock and de
Kooning and Baziotes to the cause of "doodling." To whatever degree au-
tomatism in fact explains the great painting done under its banner, there can

be little question that the belief in it explains much of the form of New York School art in that moment when the Surrealists, in exile from Europe because of the war, were awesome presences in New York, and spoke with a cosmopolitan authority to American provincials about Freud, Modernism, eroticism, primitivism, and—something to which the American mind is hospitable—the deep pool of original truth each of us carries within.

With the exception perhaps of Miró, if Motherwell's description of him is true, and perhaps of André Masson, whose work bears an outward resemblance to Pollock's, the art of Surrealist painters does not have the appearance of automaticity, and my sense is that, unlike the Americans, the European Surrealists, whose leaders in any case were more literary than visual artists, did not seek a method of direct enactment of unconscious thoughts. (They did believe, though, in automaticity, discuss it and play semi-serious parlor games that gave it a modest venue.) It was the genius or perhaps the sheer literal-mindedness of the Americans that they sought forms and methods of sustained spontaneity and revolutionized painting in the process, while the European Surrealist painters—Dalí, Magritte, Tanguy, and others—produced canvases that were certainly strange and "irrational" in content but remained conventional and even traditional so far as the art of painting as such is concerned. So there really is no inconsistency in the fact that Clement Greenberg, who became the great spokesman and apologist for what he liked to call "American-type painting," had nothing good to say for Surrealism at all. For Greenberg, Surrealist painting was a retrograde movement in the era of Modernism, and indeed antithetical to everything he believed Modernism stood for.

Greenberg's vision of Modernism was one in which each of the arts sought a particularly pure form of itself, expelling from its products everything that did not belong essentially and only to it. And this meant, in particular application to painting, that painting must eliminate from itself the use of illusory space, the mastery of which was the triumph of traditional painting, with its discoveries in perspective, foreshortening, and the like. For Greenberg, space belonged essentially to sculpture, and painting that employed it was ipso facto impure. And as artists recognized this, beginning with Manet, they struggled to drain their canvases of illusory space—that is, of any visual hint of a third dimension—in the interest of producing pure

two-dimensional and inherently flat objects: "It was the stressing of the in-eluctable flatness of the surface that remained . . . more fundamental than anything else to the processes by which pictorial art criticized and defined it-self under Modernism," wrote Greenberg. This did not mean that Mod-ernist painting had necessarily to be abstract. It could be representational. But the objects represented could not be placed in perspectival space; rather, they were to be flattened out in order to enhance the flatness of the surface. Matisse's late papier coupé decorations would be Modernist and representa-tionalist at once. But all one has to do is visualize a typical Surrealist painting to see how incompatible with Greenbergian strictures it was. The generic Surrealist canvas will have biomorphic figures casting severe shadows on a plane that recedes under sharp perspective to a horizon. However little the forms may resemble anything we encounter outside our dreams, the space it-self is indeed the standard illusory space of Renaissance painting, only made more so because of the clarity with which spatial recession is made visible. It is as Modernist as Mantegna, and for someone who was, like Greenberg, Modernism's prophet, Surrealism by the nature of the case had to be de-nounced.

I thought of one of Greenberg's arguments, sketched in the pages of *The Na-tion* half a century ago, when standing in front of some paintings done by Salvador Dalí in the late 1920s, when that artist, himself in his mid-twenties, had arrived at what was to be his canonical vocabulary of forms and ideas and had attained the defining point of view regarding the qualities of paint and surface his pictorial statements were to require. These paintings culminate the ingratiating exhibition at the Metropolitan Museum of Art, "Dalí: The Early Years," which is, in its own way, until the artist arrives at his singular and familiar style, like a window into the early decades of this century, as we see the headstrong, indefensibly bohemian young genius take on and fling off avant-garde styles like a spoiled beauty in a *salon de mode*, seeking some-thing that expresses who she is. In any case, it was in front of *Apparatus and Hand* of 1927, a painting unmistakably Dalí, that Greenberg's interesting ar-gument returned to mind.

The main figure in the work is the "apparatus," which consists of an elongated pyramid, balanced on its apex atop the base of an inverted cone

that appears to be coming unfurled at its own apex: The cone is scored with what look like the boundaries of conic sections, and it is propped up by slender poles. The pyramid has a hole through it, and casts a sharp shadow on the cone's base; and pyramid and cone together cast a no less sharp shadow on the ground—which looks like some bipedal, humanoid figure. A hand, coral red, grows out of the base of the pyramid, with staccato light rays emanating from it in all directions. Does the hand refer to masturbation—as so many of the paintings appear to (and which figures as a prominent theme in *The Secret Life of Salvador Dalí*)? And does the color acknowledge the fact that the masturbator has been caught "red-handed"? And do the needlelike rays emblematize excitement? (Or could they refer to the hairs direly predicted to grow on the hands of the self-abuser?) There are gray arteries in the hand and red ones in the pyramidal part of the apparatus, which stands precariously on what appears to be a platform floating on gentle waves. A naked female torso levitates phosphorescently in the sky, doubtless a phantasm, as it casts no shadow. Neither does the headless horse rearing up at the platform's edge. But an androgynous classical figure, small in proportion to the apparatus, does cast a shadow, and so exists in the same space: It is perhaps she or he who has caught the latter in the act. It is quite possible that a somewhat geometrical organelle, sticking up out of the cone's base, is the apparatus's penis. Out of it shoots a humanoid shape evidently made of blood, preceded by a somewhat spectral simulacrum of the same shape, a kind of ghost, perhaps the person who might have been had the apparatus not spilled its seed. There are mountains on the horizon, implying that the scene is a bay, perhaps the bay at Cadaqués, where Dalí spent so much of his life. The stars appear to be wheeling in the luminous night sky, shown, one feels, as the light begins, faintly, to break above the mountains. It is the last dream of the night, perhaps, or the twilight sleep after the last self-induced orgasm.

It was while studying the apparatus, which looks like a model for some theorem in solid geometry, that I thought of Greenberg. "It is possible, I believe," he wrote,

> to construct faithful duplicates in wax, papier maché, or rubber of most of the recent paintings of Ernst, Dalí and Tanguy. Their "content" is conceivable, and too much so, in other terms than those of paint. But

the pictures of Picasso and Miró attain virtuality as art only through paint on a flat surface, and they would disappear utterly if translated elsewhere.

Greenberg adds, interestingly and rather more controversially: "Which is also true of the works of the old masters." It is impossible not to be impressed with this quality of thinking, as if Greenberg had invented a thought experiment in support of a great explanatory theory of painting, and indeed of Modernist art in general, and was practicing criticism as if he were doing science. And to a certain distance he is quite right. It would not be very difficult to fabricate the apparatus in a three-dimensional replica, and there might indeed be a brisk business in the gift shop were some entrepreneur to manufacture a line of Surrealist effigies. Dalí himself designed jewelry, as well as perfume bottles, not to mention his lobster telephone; and now and again one of his signature limp watches, translated into glass, comes up at auction. But try to imagine de Kooning's *Women* taken out of the paint in which they are embodied and given three-dimensional status in, say, colored plastic: It is impossible to imagine what a lateral view of one of the women would look like (de Kooning's lumpy statuary seems to me a demonstration of the incapacity of his vision to survive the transition from paint to object). And what would a three-dimensional Pollock be like? Or a Rothko? (Oddly, Barnett Newman executed sculptures that really seem to carry the spirit of his "zips" from pictorial into real space.)

But the quotation marks surrounding the word "content" in the passage from Greenberg, doubtless intended as punctuational sarcasm, implying that the works in question were pretty empty, alerts one to the fact that the Surrealist figures are *contained* in spaces altogether and probably inalterably pictorial. Those lines of perspective, converging on a vanishing point at the horizon, present in *Apparatus and Hand* but also found throughout Surrealist painting, convey a sense of space one might best find outside painting in certain architectural structures like immense piazzas, but hardly ever in sculpture. Deep perspective became a Surrealist device, and the fact that outside the framed space of pictures such spatial depth is rarely to be found—and not in sculpture—all at once suggests how mistaken Greenberg's argument that illusory space belonged to sculpture and not painting really was. The

meaning—the *visual* meaning—of Dalí's painting is a function of the figures and the space that contains them. And it would be the latter that would be lacking were you to bring home a plastic apparatus from the gift shop and set it down on your glass-topped coffee table. Only if you were to set it in a stagelike box, with all the visual cues of perspective, could you begin to get the effect of the painting. In essence, you would have to make a three-dimensional painting in order to mimic the illusion the perspective lines yield up, and, as Frank Stella has argued forcefully in recent years, there is all the difference in the world between a three-dimensional painting and a sculpture. So in the end Greenberg's ingenious conjecture raises difficulties for his theory of Modernist painting. Perspective refers us to the shape of the (typically rectangular) canvas. It is the rectangle that suggests the famous metaphor of a window. There is as great a justification for seeing the shape as essential to painting as in seeing the surface, hence equal justification for taking the painting as possessing depth as possessing flatness. There are two ways of thinking about painting, each equally valid; but there is a problem in thinking about surface and shape at the same time.

In a wonderful essay of 1969 on what he calls "the non-mimetic elements of the image-sign," recently republished in his collection *Theory and Philosophy of Art: Style, Artist, and Society* (George Braziller), Meyer Schapiro writes: "We take for granted today as indispensable means the rectangular form of the sheet of paper and its clearly defined smooth surface on which one draws and writes. But such a field corresponds to nothing in nature or mental imagery where the phantoms of visual memory come up in a vague unbounded void." This, I feel, draws attention to one of the most remarkable feats of the Surrealist painters, and of Dalí most particularly, namely, to convince the world that the space of dreams is precisely the deep-perspectival space of their paintings, as if our dreams took place in framed rectangles! There used to be a question as to whether we dream in color or, in fact, as people phrased it, "in technicolor," and my sense is that this was prompted by the prejudice that black-and-white cinematography was somehow more "natural." Surrealism's appropriation of the graphic representation of the dream might have raised the parallel question of whether we dream in perspective, though it would be singular if we did—there are too many cultures that never hit upon perspective as a device for rendering spatial recession.

Still, there must be something in dream experience that led to the ready acceptance of this Surrealist stratagem as the topography of dreams; but whatever the explanation, it is by now accepted that when a film shows something taking place in empty perspectival space, the audience accepts it as a dream rather than a flashback, or a cut to a different action. Dalí's contribution of the dream sequence to Hitchcock's *Spellbound* is a case in point. And unless my memory is off, the dreams in John Huston's *Freud* employ deep perspective as the signal to the viewer that we are now looking into the subconscious. Perhaps perspective is accepted as the dream-space par excellence just because it was recognized as illusory to begin with. But I have no good answer to my question.

Dalí experimented with automatism but found it unsatisfactory, as can readily be understood if we see how Abstract Expressionist canvases, which exploited automatism, look when we compare them with the highly polished, almost transparent surfaces Dalí required: There would be no way, for example, that we could imagine something like the Ghent Altarpiece of the Van Eyck brothers materializing on panels through an exercise of pure spontaneity. Automaticity lends itself to scribbles, splashes, sweeps, and dashes of paint or ink—to *doodles*, however fraught—and in any case Dalí found it a process altogether too passive for what he was after. He hit instead on what he called the method of critical-paranoia, and there is a subsection of his extraordinary confession, *The Secret Life of Salvador Dalí* (which Motherwell considered a masterpiece), titled "Critical-Paranoiac Activity Versus Automatism." The former must sound like a contradiction in terms: The paranoiac is typically under some system of internally coherent false beliefs that he (more rarely, she) holds immune from criticism. It is the beliefs of others that the paranoiac is convinced are false. As nearly as I can tell, Dalí was concerned as artist to suspend the beliefs that define normality in order to experience the world "with pure eyes," as he says in an essay of 1927. "People only see stereotyped images of things, pure shadows empty of any expression, pure phantoms, and they find vulgar and normal everything they are used to seeing often, however marvelous and miraculous it may be." So in a way his aim is to restore reality to marvelousness, and this meant depiction in the most luminously naturalistic way he could master: ordinary, usually

recognizable objects, in clear light, casting sharp defining shadows. The philosopher Husserl had a slogan, "zu den Sachen selbst"—to the things themselves—and the phenomenological method, which he invented, entailed a certain suspension of belief and a giving up of oneself to pure experience. The difference between the phenomenological and the critico-paranoid methods lies in this, that Husserl sought to catch the world as it shows itself to the unprejudiced eye, as if to an optical instrument; whereas Dalí, having neutralized the stereotypes of common sense, perceived the world as if out of his mind (hence *paranous*), allowing all his fears and anxieties, his repressed wishes and wild associations, to flood forth into reality, so the world becomes the scene of objective terrors and unspeakable fulfillments.

"My things . . . are anti-artistic and direct," Dalí wrote in the same context. "They move and are understood instantaneously, without the slightest technical training (artistic training is what prevents people from understanding them)." In fact, he said, "*Artistic* painting does not do a thing for me." And I think by this he meant to deflect the kind of insider appreciation of brush strokes and the like of which formalist art criticism makes so much. This meant that his surfaces were intended to be without interest or excitement, so that the eye goes straight through to the objects shown (the uninflected surface might be another example of a nonmimetic aspect of mimetic art), declaring, as it were, that it is what is shown that is important, the picture having nothing of its own to contribute to one's experience—the picture being nothing other than its content.

In *The First Days of Spring* of 1929, Dalí in fact used collage, including an early photograph of himself and a doll-like face of a girl. In a most illuminating catalogue essay, Dawn Ades tells us how the poet Louis Aragon "noted how Dalí, instead of using collage as an element that contradicted and conflicted with the unity of the picture surface . . . deliberately concealed it, and made the surface as uniform as possible, to such an extent that in reproduction it is often quite impossible to detect the pasted-on bits." In Motherwell's collages, scraps of paper are clearly *on* the surface, and so collage could be a strategy for drawing attention to the surface, and hence fit in with Greenberg's thesis on Modernism. Not with Dalí: The collage's scraps fuse into the mysterious space in which shadowed figures, grasshoppers, the heads of birds and of fishes, punctuate what appears to be a desert floor, with

parallel lines meeting at the horizon. In the foreground is what seems to be a portrait of the artist, gagged, fully and formally dressed, but in what I assume is a posture of masturbation, his grasped penis looking like a severed artery, obliterating a distinction between ejaculation and hemorrhage. The artist is gray as if, well, *drained*, and leans his mustached head on the shoulders of a somewhat scary female figure, whose breasts seem to be attached, like orna-ments, to the outside of her blouse and whose head is unmistakably a vagina, ringed with wiry hairs and from out of which birds, or what appear to be birds, ascend. We know from *The Secret Life of Salvador Dalí* that from early childhood, grasshoppers were embodiments of fear. But we do not need, one feels, any special lexicon to respond to the obsessive landscape meticulously rendered in *The First Days of Spring* if we look with "pure eyes." Dalí wrote, I think without arrogance, of how people at an exhibition were "glued in front of my pictures like flies . . . Why? Because the poetic fact held them, moved them subconsciously, despite the violent protests from their culture and their intellect."

The Metropolitan exhibition gives us an opportunity to exercise our own critical-paranoiac skills, to hold in abeyance all that we have learned about Modernism and, for that matter, about Dalí himself, who became for a while a kind of aesthetic clown and publicist, and to open ourselves up to these marvelous images of his early triumph as an artist. Try to look with pure eyes at *The Persistence of Memory* of 1931, one of the most arresting and familiar images of our century, with its soft watches and swarms of ants. In the interests of uninflected vision, I here withdraw, leaving it to speak to you directly, and instantaneously.

—August 29, 1994

JAMES COLEMAN,
SLIDE ARTIST
■ ■ ■

NOT LONG AGO I SAT THROUGH A PORTION OF ANDY WARHOL'S 1964 film *Empire*, screened at the Whitney Museum of American Art as part of a larger project that institution has embarked on to make Warhol's extensive filmic *oeuvre* available to a wider audience. *Empire* is a film of epic length—eight hours and five minutes—and it is marked by a singular lack of incident: The camera was aimed for as long as the film lasts at the Empire State Building, and what one sees is the illuminated tower of that monumental edifice against the night sky. I have often thought the title a perfect example of Warholian wit: It summons up an image of British soldiery, in pith helmets, expanding the mighty sway of Victoria's domain over desert and jungle. Or perhaps the saga of a family's fortunes over several generations as it acquires the banks or the newspapers or the factories with which the family name is synonymous. Instead, only the length of the film is epic, and what happens is nothing. And that too is characteristic of Warholian wit: You can't have a still picture in which something moves, so instead let's have a moving picture in which nothing moves. There is no soundtrack, but if there were, it would transmit only silence: The Empire State Building is as mute as it is immobile. But the difference between the silence of a soundtrack with no auditory incident and the absence of a soundtrack in what we retrospectively call "the silents" is analogous to the difference between a still picture and a moving picture in which the artist decides to show something that never moves.

This was only the second time I had seen the film, and on neither occasion did I endeavor to sit through the whole thing. In my recollection from

the 1960s, however, the film was grainy and flickering, as if only the idea of a film that long of nothing taking place was the important fact, and the actual cinematography was of secondary importance. On the present occasion, the image, projected onto a large screen as if the imperial connotations of the name were taken seriously, was almost breathtakingly handsome: The night sky was a velvety black, the tower and what looked like a single window were luminous. Once in a while some imperfection in the film would appear and disappear, abruptly reminding the viewer that it was a moving picture after all. And it is possible to imagine that one could construct an entire aesthetic on the accidentalities of the substance of film as film: perforations, scratches, bubbles, splices. They in any case are the only things that move. And if you did not know this was a moving picture, you might not notice them at all.

One of the viewers in our very nearly empty auditorium evidently did not notice them. Callie Angell, who is in charge of the Warhol project, told me about a man who, after sitting patiently for some time, walked out and asked the guard when the film was going to begin. He evidently thought that what was onscreen was a slide of the film he was waiting to see. Nothing is more delightful to the philosopher than the actual occurrence of what until then had been an imaginary example: I had once speculated on the difference between watching *Empire* and seeing a slide of the same view of the Empire State Building (you cannot, I think, watch a slide) with the images in fact looking exactly alike. Indeed, it is possible to set things up so that one would have the film image and the slide projection side by side, with nothing to mark the difference between them—like, to use a Warholian example, two slides of the *Mona Lisa*. Of course, two successive slides made of the same subject will differ in some slight way usually invisible to the human (but not the pigeon!) eye, unless we bear down and look for minute displacements. But the difference between a slide and a moving picture, one feels, ought to be more apparent than that. The real difference, however, need not be evident in anything the eye can register at all. It lies, rather, in the definition of the two media. Knowing I am looking at a moving picture, it is always legitimate to expect something to move, whereas it is irrational to have such an expectation when looking at a slide. *Empire* thwarts a natural expectation through an act of relentless artistic will. But if the image in a slide were to move, that would be outside the natural order of things altogether—as if

Mona Lisa were to wink. Were you to have such an experience with Leonardo's painting, it would have to be rationalized away as an illusion, or a momentary dream—though an animated film could show the *Mona Lisa* for eight hours and five minutes and have the lady wink ten seconds before the credits start to roll.

There is another way to think about the difference. The accidentalities in the moving film strip make it evident that it is a moving picture, but their occurrence does not count against the claim that in the film nothing moves. The accidentalities are not part of the content of the image, which is only and always of the Empire State Building at night. Something thus happens *to* the image, without happening *in* the image.

This may seem like philosophical hairsplitting, but in fact it becomes of some interpretive significance when it is unclear whether something like a fadeout happens *in* or only *to* the image. By convention, of course, the fade-out in a film marks the closure of an episode, and at least belongs to the narrative representation of events. Or it can correspond to the drawing of curtains, as when the lovers pantingly embrace and the fadeout draws a veil of privacy over the passion of consummation. But the lamp can be dimmed in a slide show, fading out an image in such a way as to inflect the scene with a certain meaning quite different from that carried by the flat description that "the light got dimmer." And indeed, an artist who chooses slides as his or her medium may greatly expand upon this vocabulary, doing things to the image that the viewer has to come to terms with, as if something in the image itself were changing, transcending the limits of the medium in order to achieve an enhanced expressiveness.

It has often seemed to me rather odd that the slide, which after all mediates, for most of us, the greatest proportion of our experience with works of art, should have languished as an artistic medium in its own right. The two-projector lecture has had a profound impact on the way countless survivors of art-history courses experience the visual arts formalistically, namely by calling attention to just those properties that can be compared and contrasted. But I have in mind the aesthetic qualities of the projected slide as such, a luminous rectangle in a darkened room, like the reflection of a stained-glass window on the cathedral floor, enhancing certain features of

the work shown and obscuring others. Recently I sat through some projections of the works of two different photographers and was struck by the difference the circumstances of projection made in their work. One body of work seemed vastly more luminous than the other, in a way that did not at all show up when one saw their images printed in albums, and I thought photographers—or any artists—who know that their work is likely to be judged on the basis of submitted slides might try to anticipate this effect, so that it becomes more important how an image projects than how it looks on its own. The aesthetics of the slide projection would then begin to define the aesthetics of artistic production. The Museum of Modern Art's Kirk Varnedoe once told how the artist James Turrell, who had studied art history in a West Coast college, was disappointed when he saw the actual paintings he had fallen in love with, and realized that what he really responded to was the transparency and luminosity of their slides. And this set him off on his own astonishing artistic course making those beautiful, impalpable oblongs of luminosity one experiences, as if mystical visions, in blacked-out gallery space. (What a slide of a Turrell would look like is quite another matter; one has to be in the same space as the oblongs in order to respond to their immateriality.)

Slides occasionally come up, often together with video monitors in multimedia works; but the only artist I know of who has made a serious artistic investment in the slide and its possibilities is the Irish artist James Coleman, whose work is the subject of a yearlong three-part exhibition at the Dia Center for the Arts in Chelsea. Only one of the works, INITIALS of 1994, which was commissioned for the occasion, will be on view in each segment of the exhibition, but in some sense it is the most mysterious and at the same time artistically satisfying of Coleman's works, though each of the works I have seen raises fascinating questions of its own, whatever one thinks of the individual artistic merits. The second segment will show his *La tache aveugle* (The Blind Spot), which, as I understand it, reverses the procedures of *Empire* in the following sense: Warhol's film is so structured that virtually any clip will resemble any other, so the moving picture has roughly the visual power of a continuously projected slide. *La tache aveugle* removes a clip, consisting of perhaps thirteen frames, from an existing film and transforms each frame into a separate slide. The slides are then projected sequentially, as if a

[80]

film were being projected frame by frame, but in agonizingly slow motion. According to Lynn Cooke, who has written on Coleman (and who is chief curator at Dia), the clip, which at the normal rate of projection would take about half a second, takes approximately eight hours (it would be uncanny if it took in fact eight hours and five minutes!) as slide dissolves into slide, where the slides are not obviously different from one another and the last resembles the first sufficiently that an audience might suppose there were only one slide, shown continuously, but with periodic fadeouts and dissolves. Because the clip is from a moving picture, something doubtless does take place in the image as well as to the image—but the degree to which this registers on the viewer is difficult to ascertain. It is made all the more difficult in that the images themselves are all but unreadable: "stubbornly blurred throughout, the scene illegible, the subject virtually indecipherable," Cooke writes. It helps, but probably not a great deal, to know that the slides correspond to sequential frames in a clip excised from the film of *The Invisible Man*, made in 1933.

The typical viewer of *La tache aveugle* will know nothing of the provenance of the images, such as they are, nor realize that they are of a climactic moment in the film, in which the protagonist is shot. The relationship between visibility and invisibility, film and slide, time and the order of images, which constitutes the artistic substance of the work, can hardly be inferred from what meets the eye. By contrast, as with most of Warhol's images, everyone knows the Empire State Building, and the insistent and largely unvarying image is identifiable instantly. Coleman, though, is exceedingly hermetic, and very grudging with information about his work, so one is greatly in the debt of those curators, like Lynn Cooke or Dot Tuer, who have undertaken to do the legwork and track the sources down, as well as to put together enough of an account of the history of the work that the viewer can begin to ponder the issues about perception and reality to which the images refer us. I have not as yet seen *La tache aveugle*, but I am inclined to anticipate that there would be no disposition on my or on any viewer's part to sink into the sort of contemplative aesthetic trance that *Empire* could easily occasion. For one thing, Coleman's work is typically exhibited in galleries rather than shown in auditoriums, so there is nothing like the collusive comfort of a seat. Viewers move restlessly about the space, lie on the floor, lean against

the wall. And then there is the click-clack of the slide projector in the same space, quite unlike the way the apparatus of the projection room is segregated from the viewing space, in which the image alone floods one's consciousness. And, at the Dia at least, there is the invasive noise to contend with of soundtracks from other works by Coleman on exhibition on the same floor.

The only work by Coleman I had seen until the Dia exhibition was one specifically commissioned for the "Places with a Past" exhibition at the Spoleto Festival in Charleston, South Carolina, in 1991. The artists invited to participate by the imaginative and energetic curator, Mary Jane Jacob, chose a historic place in which to install a work specific to the site. Coleman used the Parish House to install a work entitled *Line of Faith*, which initially met the eye as a projected image of a battle one took on faith, because of what one associates with Charleston, as referring to the Civil War—though, because of the baggy scarlet pants and short jackets of the Zouave uniform, one could as readily suppose one were viewing a scene in the Franco-Prussian War. I have seen a good many images depicting that war by French military painters, done in the smooth "photographic" style the artists favored. In fact, I once owned one, painted so smoothly on a mahogany panel that neither the dealer at the Puces nor I was certain whether it was an illustration cut from a magazine and pasted on, or an actual painting. Coleman deployed a number of individuals—many of them art students at the nearby College of Charleston—to form a *tableau vivant* of a Currier & Ives lithograph of 1861, ostensibly depicting the Battle of Bull Run (also known as First Manassas). I talked to one of the reenacters, whose role it was to lie, dressed in gray uniform and white leggings, under a dead horse. I learned that an astonishingly small number of dead horses—a dozen, perhaps, in all—serve as props in all the films made in this country requiring that particular prop, and these are rented as the occasion arises. My informant told me that he helped unload the horses when they were trucked in, and that they are rather the worse for wear, and had to be sewn up before they could be used. In any case, they look pretty convincing in the foreground. It does not take many dead horses to convey a sense of carnage: It was a skill the Old Masters learned, to gen-

erate the sense of a crowd with perhaps seven, or even fewer, drawn figures in a plaza.

In what way was the work specific to the site of the Parish House? The explanation, more tenuous than most of the external relationships one must know about to interpret Coleman's work—but not untypical of what one is up against in understanding them—is that the building dates approximately from the time of the discovery of photography (1839), and photography is central to Coleman's artistic agenda, in Spoleto as elsewhere. Perhaps less tenuous to the interpreting of the work is the knowledge that it is based on a Currier & Ives image that purports to show a battle in progress, and that the image is false: First Manassas was a Union defeat rather than the victory implied in the print, which shows blue-clad cavalrymen clearly in a tight corner, surrounded by Zouaves.

Line of Faith employed two projectors and emulated the principles of the stereoscope, in which a pair of slightly divergent images of the same motif are fused by binocular displacement into a single seemingly three-dimensional image. This evidently—again, the explanations are tenuous— refers to the way the wooden stereoscope had come to figure as a parlor diversion in the Civil War era, passed from hand to hand to allow 3-D experiences of the Piazza San Marco or the Cathedral of Rouen. Each of Coleman's projectors used a sequence of slides, somewhat in the manner of *La tache aveugle*, which, as they dissolved into one another, gave a certain instability to the projected image that was meant to convey a message of perceptual instability, as the falsified lithograph was meant to serve as a lesson in the way images falsify facts. It seemed to me an unwieldy and rather pricey way of making a largely didactic philosophical point about visual communication, and the Coleman piece was rather widely resented in Charleston: Viewers felt they were aware of the problem Coleman was getting at, and that the art was not strong enough to overcome the obviousness of its point. Recently the evidentiary authority of photography has been shaken with the wide use of digitalized composite images—but there are enough avenues to the truth that the doctored image induces about the same degree of cognitive distortion as the Currier & Ives print. After all, the North did not long remain in the dark about the outcome of Bull Run!

INITIALS, Coleman's most recent production, has a certain obscure narrative drive and verges on rather than distantly subverts the power of cinema. A story is being unfolded through a sequence of slightly portentous still images, in which the same characters appear and disappear, variously costumed and grouped, and up to it is not clear what. A wiry woman in her middle years, with dark eyebrows and white hair, sometimes appears in aerobic costume, sometimes in what seems to be a doctor's smock. The opening scene is a prolonged image of what appear to be hospital beds, stacked and empty, which reinforces the idea that the woman is a doctor. But then what about a man who wears an opera cape and frilled shirt front, and carries a walking stick? Are they both characters in a play or film? Or is it an asylum in which he is a patient, believing himself to be Dracula? A dowager in pearls, a bare-chested male, and two younger women complete the dramatis personae. The images dissolve into or abruptly replace one another, and as a sequence the entire work has some of the ambiguity of *Last Year at Marienbad*, if the latter had been directed by Chris Marker, whose *La Jetée* is almost in its entirety composed of still shots, with one somewhat unsettling but easily overlooked piece of moving imagery in the middle. Unlike the former, which uses voiceover and dialogue, and the latter, which uses voiceover narrating a fierce political allegory with great urgency, *INITIALS* is "narrated" in the voice of a child, who has difficulty making out words, which she first spells out—hence "the initials"—but the connection of which to the action is in any case exceedingly remote. She spells out, for example, "E-X-C-O-M-M-U-N-I-C-A-T-I-O-N." "I can't make out the initials!" she sometimes cries, always returning to the ordeal. Each time she makes out a word, it is a kind of victory, after sounds of great effort. After all, she is not spelling C-A-T. But neither is she clarifying the images. And one is left with the task of understanding both images and words, and then their interconnection. Dot Tuer, who accompanied me on my first visit to the show, told me that there is an intertextual liaison between *INITIALS* and a play by William Butler Yeats that I had never read. The word "bones" appears in its title, as indeed it does in the narrator's speech. The actors' faces could not be more expressionless if they were wearing masks.

It takes eighteen minutes to see *INITIALS* through. Not long, compared with watching a film; extraordinarily long, if compared with looking at a pic-

ture. Coleman demands a lot of his viewers, like identifying clips from obscure films, or obscure plays by famous poets. What does he give them in return? Some reflections on the boundaries between painting, photography, cinema, and slide, on the pitfalls of perception and the multiaspectival character of reality. And on the nuance of the fade, the dissolve, the break, the superimposition on stereopsis and the relationship between voice narrative and the narrative of sequenced images. If that seems like a fair trade, you will certainly want to see his work, especially *INITIALS*.

—*October 3, 1994*

CY TWOMBLY
■ ■ ■

Sometime in midsummer I had an unusually instructive con-
versation with one of my more amusing cultural confidants, the writer Jim
Holt. We were talking about the upcoming Cy Twombly exhibition at the
Museum of Modern Art, wondering what our responses would be. Jim said
that for his part he was tired of apologizing for "all those elegant whispers."
That, however, was not what I heard him say. I heard him say, "all those ele-
phant whiskers," and I must say I was overwhelmed by the novelty and exac-
titude of the image. What one might think of as the archetypal Twombly
painting formed in my imagination and there it was, exactly, a distribution of
elephant whiskers across a largely empty space. "Elephant whiskers!" I ex-
claimed, about to compliment him on his felicitous trope when he repeated
what he had actually said: "Elegant whispers." We congratulated ourselves
on the fortuitous mishearing, almost as if we had been playing one of those
Surrealist games in which an effort is made to flush surprising insights out of
the unconscious by aleatory means. But it also left a question in my mind as
to whether elegance especially belongs to the Twombly mode of address and
touch. In fact the most vivid example of a Twombly I carry in my memory is
of a decidedly inelegant work.

This was a painting I saw at a rather glamorous occasion at Sotheby's,
the great auction of the Warhol estate in 1988. We had been invited to a
party at the home of some collectors. The guests were driven in chartered
buses to the auction rooms, where many of them equipped themselves with
paddles and settled in for some serious bidding. The cookie jars, the col-

lectibles, the antiques, had all been sold over the past days to eager purchasers in the grip of Warhol mania. This evening was to be Warhol's art collection, with, among others, a Lichtenstein, a Lucio Fontana, a piece by Basquiat, a portrait of the artist by David Hockney and the painting by Twombly, expected to go for somewhere between three hundred thousand and four hundred thousand dollars. The painting, which you can see in the MoMA show, looks like a largish blackboard, with five uncertain rows of linked o's, as if by some backward pupil doing his level best to do the penmanship lesson. The rows are uneven and cannot stick to the guidelines; the loops are too flaccid even to be thought of as elephant whiskers, wobbling hopelessly from margin to margin, the awkward hand going on to the next line, where it makes an even sorrier show. It is in fact awful writing, which does not of course mean that it is awful painting—but neither did it look like anyone's idea of a painting that might get knocked down for somewhere between three and four hundred thousand. In fact it got knocked down for just under one million dollars that evening; it was the star of the auction and, as happens at those events, there was a round of applause when the gavel fell.

I thought at the time, as one used to when they were the currency of sophisticated wit, of a *New Yorker* cartoon—by Lee Lorenz, maybe, or Arnie Levin—in which an auctioneer is shown standing at the podium while a work exactly like Twombly's o's is displayed, the caption reading, "Going for nine hundred and ninety-five thousand dollars—who'll make it a million?" Nobody in the audience at Sotheby's would have asked whether it was worth a million, but the painting is almost paradigmatic of the kind that raises incredulity in the mind of those at any distance from the art world. Were the National Gallery of Canada, for example, to pay a million dollars for that painting, the uproar in the press would be deafening, as it recently was when a major work by Mark Rothko was acquired. The *Toronto Star* would certainly say that any child could do it and offer prizes for the "best Twombly" by anyone under eight. I have no insight into the secondary markets of art, though I can say that Twombly's blackboard—or "dark ground"—paintings have gone from height to height, and someone got a bargain that night at Sotheby's, it turned out: The price was not simply an artifact of Warhol giddiness. Anyway, what should it be worth? Would the *Toronto Star* suppose it was worth anything? And what in any case was the "it" that any child could

do? The letters are too big for your typical child, for one thing, and too high off the floor. Someone of a certain size and an adult strength had to have made the painting. Moreover, one has to distinguish, in a work such as this, what I call the "implicit hand" from the hand of the artist, just as we have to distinguish the implicit voice of the narrator in a novel from the author's voice. What does it mean that a major artist should have had an implied hand execute a kind of memorial to graphic ineptitude? What does the blackboard itself mean?

As it happens, I have been thinking a good bit about blackboards recently, mainly because they were used by the German artist Joseph Beuys, and I have had occasion to write about Beuys in various venues. In the 1993 exhibition of Beuys's drawings at MoMA, for example, the blackboards Beuys used as parts of his performances—or his "actions," as he termed them—were classed by the curators as drawings. There was a spectacular ensemble of three easels, each with a blackboard, surrounded by a lot of blackboards on the floor, perhaps as many as thirty. The curators considered this on the borderline of drawing and sculpture. There was a gallery given to Beuys at the Guggenheim Museum this past summer, one part of which related to a performance he gave in Vienna in 1979. There were a couple of blackboards, on which the artist had written the chemical formula for an alkali—sodium carbonate—together with certain words in legible German script: "acid," "base," "soap." And he also drew a heart. The blackboard notations illustrated some point Beuys was making in a lecture-performance regarding the colloidal character of soap, the colloidal character of human beings, and—"hence"—the feeling of warmth when we wash ourselves with soap. The details are unimportant here. The point is that blackboards are an identifiable and an important part of the Beuysian *oeuvre*. And indeed they have passed down in Beuysian circles as a symbolic accompaniment to public addresses. Not long ago I heard one of Beuys's chief lieutenants, Johannes Stüttgen, deliver a discourse on Beuys's philosophical system, using exactly the idiom of chalk flourishes (and a heart at the center) one sees in the typical Beuysian chalk-talk.

Blackboards are emblems of professorial authority, and would especially be that in the German system, in which Beuys was a professor of art and, as

an artist, played the role of a professor in his "actions." The scientific symbols (even if from elementary chemistry), the scientific terms, and the confident adult hand all proclaim that the writer is a person of some learning, enough learning to stand before a group in a posture of pedagogy. Yet the blackboard as used in Twombly's painting is the polar opposite of this, and it connects with a very common experience—not the experience of someone in authority but of someone without any power or authority whatever. Being sent to the blackboard haunts all our memories as a traumatic occurrence in the schoolroom, where we stand exposed to the ridicule of teacher and classmates as we endeavor to spell the word, add the figures, conjugate the verb, or demonstrate to what degree we have mastered the ordeal of the Palmer method of penmanship. Or is it the wall of discipline where we write fifty times that we will not whisper in class? The implicit hand in Twombly's painting is that of childhood agony, a picture of manual impotence, of wanting to do well but lacking the ability to do so. The treacherous line of o's that should be orderly, like a file of elephants parading across the space, slip and slop, covering us with chalk dust and demonstrating our incapacity for the world to see and condemn.

Twombly did a good many blackboard paintings in the late 1960s, more than one of them like the painting I have been discussing. Kirk Varnedoe, who curated the exhibition at MoMA, has an interesting explanation as to what these paintings may have meant in terms of the artist's biography. Twombly had settled in Italy in the late 1950s, had married well and was leading rather a princely life. In 1963, he painted a series dedicated to the Roman emperor Commodus, one of the mad, cruel Roman rulers. Needless to say, it would hardly have been a graphic representation of Roman excess, like the celebrated Salon painting by Thomas Couture we know so well from the Musée d'Orsay—*Romans of the Decadence*—which shows highly varnished female nudes lolling against couched gentlemen, eating grapes (though there may have been a disjoint nipple or two in Twombly's paintings). I have never seen them, and they are not in the show, but I surmise that if anything they would have sustained Jim Holt's "elegant whisper" assessment, which is a way of phrasing what one critic said at the time: "There isn't anything to the paintings." (That showed a certain lack of critical charity, to say the least!) Twombly has always had a certain literary dimension to his work. At the

Philadelphia Museum of Art, there is, for example, a singular installation of panels, *Fifty Days at Ilium*, based not just on the *Iliad* but, according to a museum publication, on "the eighteenth-century poet Alexander Pope, whose translation the artist used." In that publication, one reads that "the scribbles, rubbings, and scrapings, richly evocative of thought in process, also suggest the noisy clashes of battles fought long ago," which is perhaps too generous or literal: Twombly's paintings consist almost entirely of "scribbles, rubbings, and scrapings," and can be made to "evoke" whatever the title suggests—the jostling of Caesar's assassins, say, in a painting called *Ides of March*.

In any case, the show of March 1964 at Castelli was a critical disaster, chiefly in the eyes of the art world itself, from which the artist would chiefly have looked for support, and which refused to find in "scribbles, rubbings, and scrapings" visual counterparts to Roman excess. "It was really a flamboyant French kind of show that Twombly turned out," according to Ivan Karp, in those years Castelli's director. The New York art world was still in the grip of critical dogma (Clement Greenberg's) and in particular it was a time when a certain anti-sumptuary puritanism was demanded of any art that was to be taken seriously. Materials were to be industrial, forms were to be dour, colors were to be drab, and the minimal was the maximum allowed. And here comes Twombly trailing classical learning and some kind of School of Paris palette and a whole lot of expatriate airs. Who the hell does he think he is? It was not an easy moment to live through. That kind of negative criticism never is. The blackboard paintings were Twombly's atoning response.

They had, Varnedoe writes, "a chaste severity that suggested the artist had ceased being erudite and had gone back to school, renouncing former pleasures and submitting himself to a penitent discipline many Americans found more admirable and less discomfiting." The Sotheby painting suggests that the artist is being made to stand at the blackboard in front of a group of aesthetic Red Guards, who tell him he is still too elegant. "You have got to learn to write like a peasant," one can imagine them saying, and the scrawly, loopy, uneven, and uncontrolled lines of running o's are then Twombly's effort to learn how *not* to write—to unwrite, to get back to a basic unschooledness, to become one with the unlettered masses. And one of the more severe judges might comment, like Chairman Mao: Less of the elegant, more of the

elephant. Aesthetic correctness was the political correctness of the mid-1960s. Today, when the death of Roman emperors would not rub anyone the wrong way, it is the precise reverse: Political correctness is aesthetic correctness. By the 1970s, conformist pressures in the art world eased slowly off into the aesthetic pluralism we find today, under which anyone can do anything, except that painting itself has come to be politically suspect in the tribunals of multiculturalism.

I have stressed the blackboard painting because it induces a certain narrative structure into the MoMA exhibition, the works after and before not being remarkably different, once Twombly became Twombly: I mean, the dark-ground paintings aside, everything is instantly recognizable as Twombly. So let me now try to pin down what, beyond "scribbles, rubbings, and scrapings," this means. The truth is that Twombly's work has never been all that far from the zero degree of adroitness in drawing and writing. His appropriation of about the lowest level of mark-making available to us is what gives his work its energy and distinction. From that perspective, his politics should be impeccable.

There is a certain kind of drawing of which each of us is capable, that artistic drawing, as a learned skill, builds on and refines. I call this demotic drawing, and it is probably part of the human endowment, like speech. Scribbling is like babbling, the motor exercises that become demotic drawing in the one case and baby talk in the other. The images demotic drawing achieves are for the most part generic: We would not expect portrait likeness or landscapes that capture the look of a terrain like, say, the Mojave Desert or the Amalfi Drive. Mostly it would consist of line drawings, and good examples could be found near any building site, where the carpenter would draw a door or a window on a scrap of board or sheetrock, either to visualize it or to provide instruction for someone else to follow. Demotic drawing is practical in this way, and consequently economical. There may be some crawly lines to indicate a change of texture—"That's where the cement goes"—but there would be no great effort to shade or indicate textures save in the most conventional way, and then only as needed. Anyone is capable of drawing a tree, a flower, a woman's torso, a face, a penis, a heart, and these drawings would be universal in the sense that everyone would recognize

what they are of, and the style would probably vary little from age to age or place to place. There are cultural variations, of course: Demotic drawing has in its lexicon the conventional religious symbols—the Mogen David, the Cross—and certain everyday objects like daggers and guns.

Twombly's drawing is almost entirely demotic in this sense. It is the kind of drawing anyone can do and everyone can recognize. *Untitled (Bolsena)* of 1969 is in part very much like a surface on which some carpenter has made pictorial notations of an altogether practical sort. There are some loosely rendered rectangles, numbered 1, 2, and 3, and another one identified with the Roman numeral II. 2 is marked with diagonals and is lightly scribbled over, perhaps to indicate a color. 3 is darkly scribbled over, as a form of erasure. There are some other numerals, as if dimensions, and a diminutive grid. These are smallish markings on a fairly large canvas, made with pencil and crayon on house paint. These are not "the materials of the artist." House paint carries a certain connotation of the practical, the utilitarian, the everyday, the down-to-earth, and belongs to the same system of symbols the paint-stained jeans of the working artist do, or the heavy workman's shoes that were part of the accepted uniform of the artist in the late years of Abstract Expressionism. Demotic drawing on house paint is pretty proletarian: All that fails to fit the image is the fact that it is on canvas; if it were wallboard, the semiotic system would be complete.

There is more. Beneath the construction's figures—the doorways, say, or the windows (and maybe the tiles, if the grid indicates this), there is a bit of recreational drawing. Remember, we are talking about the virtual hand. The hand externalizes the carpenter's fantasies when he is not thinking about joists and beams, or openings. Or maybe—who knows?—the thought of such openings (doors, windows) awakens thoughts of others (anuses, vaginas), and the remainder of the surface is given over to gross anatomical notations for sexual parts. Holes or slits are marked with some heavy pressing of the pencil, as if drawing itself were already a form of penetration. There is a flaccid kind of penis, drawn with a pathetic stab at realism. What may be scrotums, what may be breasts are scratched in pink scribbles, then maybe erased, either out of an implied shame or hopelessness at getting things right. The implicit hand is that of someone who aspires to draftsmanship but is largely arrested at the demotic level where we all find ourselves when we

first try to draw (and where we remain for most purposes when we need to draw something). In the upper left-hand corner is written "Cy Twombly" (almost illegibly), and beneath that "Bolsena," where the work was executed. There looks to be a date below that, but it mingles with the carpenter's numerals. We know they are signature, title, and maybe a date because we know it is a painting. If it were a found object—a wallboard, say—these would be simply notations. The painting is as little organized as the drawings are unskilled. You would not consider a wall with these precise notations a "composition." If it were a piece of wallboard, "Bolsena" might be the name of the helper for whose benefit the doorways were drawn.

There is a form of writing that in its way corresponds exactly to demotic drawing. Call it demotic writing. It is on surfaces everywhere, not just on prison walls, as those who tend to romanticize graffiti like to think (and to romanticize Twombly because he appropriated graffiti). Yesterday I saw, lettered on the side of a cardboard carton by the guard's post at a museum:

FEDEX

AIRBORNE

DHL

The letters were crooked and crowded, the lines were uneven, there was a mixture of capital and lowercase letters. There was no effort made at what one might think of as *lettering*. A little later I saw, on a photographer's box, DO NOT X-RAY FILM. There was not enough room, once the writer had started, to get it all in proportionally, so toward the edge the letters got squeezed together. Later still I saw an inelegant sign on what looked like shirt cardboard that read PRETZELS, crude letters as large as the space would permit, jammed in together. You can find your own examples. They are on notepads, the sides of things, on improvised warnings, sometimes printed, sometimes written, sometimes half printed and half written. And they are in Twombly's paintings whenever he uses words.

The difference between demotic drawing and demotic writing is this: The demotic image is restricted to what everyone knows and what everyone can draw, however minimal one's ability. But anything can form the content

of demotic writing. The charm of Twombly's writing is that it is often lines of poetry, or Italian words, or literary references, in lettering that would more appropriately say something like LAST ONE TO LEAVE LOCKS DOORS. Just as you are about to enter the exhibition, you will notice a large painting of 1990 on which is written, as if in script a plumber would use if he could write just well enough for most demotic purposes: "I have felt the wind of the wing of madness" and then, as an afterthought and still in demotic lettering but in large capitals this time, "MADNESS." The phrase, we are indebted to Varnedoe for informing us, is from Baudelaire's *Journaux intimes*. It reads *J'ai senti passer sur moi le vent de l'aile de l'imbécillité*. The canvas is mostly white. There are some gorgeous scrapings in yellow and red up the left edge, a splotch of red and black on the right side, and two scribbled crescents in the upper right quadrant, each tipped in blunt red dots. The colors are autumnal. If I were cobbling together a museum pamphlet I might say these are fall flowers, chrysanthemums, perhaps, and remind my readers that Baudelaire's masterpiece was *Les Fleurs du mal*. It is oil this time, but also pencil and crayon on plywood. It is the sort of painting, almost certainly, that would have outraged purists in the art world of the 1960s.

Scribbles, scrapings, rubbings, uncoordinated on often-vast expanses of space. Demotic drawings, also uncoordinated, like the window in the terrific *Leda and the Swan*. Demotic inscriptions of poetic scraps, testimonial to a certain learning. The zero degree of writing, drawing, painting, composition, somehow achieving—at its greatest achieving—a certain stammering beauty, where the base elements are possibly even transformed into elegant whispers. There is an almost Taoist political metaphor here for those who seek such things: Out of the elements of human expression at its most basic, work of the greatest beauty is made. When you visit the show, take it all in rather quickly, then go back to bear down on one or two paintings at most. Buy the catalogue, do some reading, and then bear down some more. After that, try another painting or two.

—*October 31, 1994*

WILLEM DE KOONING
. . .

THE EXTREMELY MOVING RETROSPECTIVE EXHIBITION DEVOTED TO
the paintings of Willem de Kooning (at the Metropolitan Museum of Art)
was organized to mark and celebrate the artist's ninetieth birthday. But the
show inevitably memorializes the art of the New York School, which de
Kooning's work epitomizes, and provokes a number of thoughts on the reci-
procal relationships between individual artists and the large transformative
movements actualized through their work. These reflections are reinforced
by the fact that the show coincides with an extraordinary exhibition (at the
same museum) dedicated to the origins of Impressionism, considered as a
movement. For the individual Impressionists stood to that movement in re-
lationships parallel, in many ways, to those in which the Abstract Expres-
sionists, as the artists of the New York School have come indelibly to be
known, stood to their own.

Let's begin with one of those relationships. One singular effect of Ab-
stract Expressionism as an artistic movement was the way in which it trans-
formed the figures who belonged to its first wave from moderately gifted
picture-makers in one or another idiom of backwater Modernism into tow-
ering creators of monumental works that were, in Robert Motherwell's
phrase, "plastic, mysterious, and sublime." It was as if the style acted like
some tremendous tidal surge, lifting up the handful of individuals who were
to define the movement and depositing them on some unknown shore,
where the first footprints were theirs. Being part of a movement is nearly
always a piece of tremendous good fortune for an artist. One might, for ex-

ample, ponder what might have become of the artists who became Impressionists had the movement not swept them onto a fresh plane of painterly possibilities. Whatever their individual endowments as artists, it is difficult to believe that they would have become more than what the French call *petits maîtres* had they continued in a historically straight line, developing those endowments in ways their antecedent historical circumstances defined, becoming portraitists or landscapists or still-life painters in the styles with which they began, and of which they were already masters on the eve of Impressionism. But Impressionist and "pre-Impressionist"—to use a historical term unavailable before Impressionism came about—paintings are far closer to each other, for all the critical indignation Impressionism released, than are Abstract Expressionism and the relatively pallid modernisms its adherents left behind when the movement turned them into geniuses. No exhibition could in this respect be more instructive than a before-and-after-1948 show of Jackson Pollock, Franz Kline, Willem de Kooning, Barnett Newman, Mark Rothko, and Robert Motherwell. As luck would have it, the Pace Gallery has organized an exhibition of the early work of Barnett Newman, composed of paintings almost desperate in their searching and inconsequence, until the breakthrough, in 1948, of *Onement I*—a work that astonished the artist himself and that we can perhaps see striving to emerge in some of the works it otherwise cast into irrelevancy. The de Kooning of pre-Abstract Expressionism painted the sad single figures that were the currency of Depression art, and whatever their merits, these paintings have as interest only the fact that someone who became great doing something else executed them.

If we were to focus on the works of the "after" part of our before-and-after show, we would be struck, I think, quite apart from their disproportion with the show's "before" section, by a second singular fact: namely, the stylistic incommensurability between the works of the different artists the movement redeemed. Each of them exemplifies the essence of Abstract Expressionism, but always in the artist's own particular way, so much so that had de Kooning (for example) not existed, it would be impossible to imagine his paintings on the basis of the work of his peers. Had there been an Impressionist other than the historically given ones, her work would almost certainly look as much like theirs as they look like one another. The Met's

"Origins of Impressionism" conveys the sense that, with the exception of Cézanne, who fits awkwardly with the rest and almost looks crazy, the artists tended, with minor variations, to look at first very much alike: Bazille and Sisley and Monet and Renoir and Pissarro were painting the same kinds of things in much the same ways even after they had become Impressionists. The first Cubist works of Braque and Picasso look enough alike that it is all but impossible to tell them apart, a difficulty compounded by the fact that at that stage they refused to sign their works. So if there had been a third inventor of Cubism, one is reasonably certain that her forms, palette, and surfaces would resemble theirs to the same degree. But from Kline, Pollock, Newman, Rothko, de Kooning, and Motherwell, each so different, we cannot extrapolate the work of another of the first great wave. Abstract Expressionism is less a shared style than a disjunction of distinct styles evolved by artists who at best shared a philosophy of painting, and who responded to the same kinds of artistic and extra-artistic influences.

This requires some qualification. Some of these individual styles were so closely identified with their inventors that they were rendered unfit for use by anyone who followed. It was as if Pollock's flung skeins of pigment, or Newman's "zips" or Rothko's luminous floating rectangles or Kline's powerful sweeps of black paint across white grounds, were so autographic that in an art world that prized only originality and breakthroughs, anyone who attempted to use them would be instantly dismissed as a mere imitator, much as if someone were to attempt to "continue" de Kooning's *Woman* series with their fierce eyes and heavy breasts and displaced snarls. But the gestural slashes with which de Kooning built these commanding female presences became widely available as a kind of language, the way nested angles did for Futurism or geometrization did for Cubism. So compelling were de Kooning's brushstrokes that they defined the movement's Second Generation, all of whom would have been unthinkable without them, however powerfully its members learned to wield them. Joan Mitchell, who was the only significant member of the Second Generation to continue as she began, was a tremendous painter, but her style was an adaptation of what de Kooning had invented. The artist Al Held, who broke away entirely from Abstract Expressionism, said that "de Kooning provided a language you could write your own sentences with." And it was very largely the de Kooning brush-

stroke that Roy Lichtenstein lampooned as part of the movement—Pop—
that more or less aborted any possibility of a Third Generation.

There may be a third remarkable feature of Abstract Expressionism, but one
would not have known or perhaps even have thought about it were it not for
the special case of de Kooning. This has to do with the work of his very old
age. The exhibition concludes with some canvases executed in the artist's
(and the century's) eighties. It is widely known that de Kooning has stopped
painting altogether, presumably in consequence of Alzheimer's dementia;
but it is also understood that the dysfunction began to encroach upon his ca-
pacities in his eighties, and that the final paintings in this exhibition are typ-
ical of what de Kooning produced as a painter when his other activities and
responses were to a great degree altered by the disease. There is a natural
question of how relevant this fact is, either in explaining these works or in as-
sessing them. That is, does the fact that in every other way than in his paint-
ing the artist may have been in an advanced condition of senility mean that
the paintings themselves are to be appraised any differently? It is sometimes
supposed that only in the style of Abstract Expressionism, with its gestural,
impulsive, and physical mode of address, could someone continue to paint
while otherwise in as infantile a condition as advanced senility.

This supposition is given a particular degree of support if there is any-
thing to the reading of de Kooning's paintings done in the 1970s before his
Alzheimer's was first discerned—paintings the philosopher Richard Woll-
heim regards as among the artist's greatest works. He illustrates his thesis
with *Untitled III* of 1977 and *Untitled II* of 1979, neither of which is included
in the present show, though there are others sufficiently like them that it
would hardly be credible that Wollheim's interpretation should not apply to
them as well. The thesis is that in these late abstractions, the artist,
metaphorically at least, incorporated objects of "senses other than sight . . .
sensations of activity, sensations of moving the limbs or muscles, but all ex-
perienced in a heavily regressive mode."

The sensations that de Kooning cultivates are, in more ways than one,
the most fundamental in our repertoire. They are those sensations

which gave us our first access to the external world, and they also, as they repeat themselves, bind us for ever to the elementary forms of pleasure into which they initiated us. Both in the grounding of human knowledge and in the formation of human desire, they prove basic. De Kooning, then, crams his pictures with infantile experiences of sucking, touching, biting, excreting, retaining, smearing, sniffing, swallowing, gurgling, stroking, wetting. . . .

And these pictures . . . contain a further reminder. They remind us that, in their earliest occurrence, these experiences invariably posed a threat. Heavily charged with excitation, they threatened to overwhelm the fragile barriers of the mind that contained them, and to swamp the immature, precarious self.

Wollheim, it must be observed, is greatly indebted in his views of infantile cognition and pleasure to the psychoanalytical teachings of Melanie Klein, and it is precisely because the metaphorical content of these paintings exemplifies those teachings that he finds these works as great as he does. If we grant Wollheim his interpretation, it might be a natural suggestion that in the paintings of the 1980s, de Kooning really exhibits what he but metaphorically expresses in the paintings of the 1970s, having entered, so to speak, a "second childhood." But in fact the qualities on which Wollheim's extraordinary account rests, and which give it a certain plausibility, quite disappear from the final works; those have a spare and tranquil clarity about as distant from the visceral turbidities of the works Wollheim admires as it is easily possible to imagine.

On a recent visit to a Midwestern university, I inquired about the last years of a rather famous and formidable philosopher, a major if now largely forgotten thinker who had dominated his department in his prime. He too had sunk into Alzheimer's at the end, even to the point of suffering delusion in what we might suppose was a final mental twilight, in that he continued to carry on—vocally—philosophical disputations with another philosopher, no less formidable and famous, but unfortunately long dead. The delusion was

that his great opponent was alive and present. In every way other than conducting imaginary philosophical conversations, the afflicted philosopher was quite as incapable of taking care of himself as the standard victim of advanced Alzheimer's. His colleagues, alas, made no effort to record these "conversations," and so were unable to tell me whether he was generating novel arguments and objections. Still, being able to carry on philosophical conversation at all, even (or especially) with an imaginary adversary, would normally be testimony of a high degree of abstract intelligence, even if one were altogether infantile in the practical domains of life. I mention the case because there is an inclination to ascribe the capacity to paint to a different hemisphere of the brain from that invoked in connection with a highly verbal activity like philosophizing. Yet if one can, though suffering from Alzheimer's, argue philosophically at a reasonable level of competence, so can one paint at that level. It is, accordingly, reasonable that Alzheimer's should fall completely away in accounting for the paintings de Kooning achieved in his afflicted eighties, as well as from their evaluation.

I would at one time have supposed that Abstract Expressionism alone would allow its practitioners to continue painting well into their senescence, and that it would be absurd to imagine what we think of as a more demanding style allowing this at all. Could Leonardo's *Last Supper*, could Michelangelo's *Last Judgment*, could any work of the High Renaissance have been painted by someone who was otherwise as incompetent as the senile? I no longer think I know the answer, nor do I think anyone else does. In fact, it seems to me, one particular revelation of the present de Kooning retrospective is that it offers a possible demonstration that artistic creativity at a very high level may continue past that moment when a person is otherwise unable to assume responsibility for the most elementary demands of life. The final stage seems to flow with a kind of narrative inevitability out of the stages that preceded it, as if there were an irresistible internal development that the work went through as the artist lived out his remarkable life—and when the work achieved this goal or end-state, it no longer had need of the artist, who could then stop. The final paintings are marked by the fact that the famous and unmistakable signature, in a style of writing so continuous with the style of painting that it seems to carry the painting further in the form of angular

cursive strokes, has disappeared from them completely: They face the world, as it were, with only their own authority. It is the unfolding of this narrative that I find so moving a feature of the exhibition, which gives the sense of a total and achieved life.

It is a life that almost conforms, in part because of the intense eroticism of its climactic moments and in part because of the spiritual clarity of its concluding phase, to the ideal of a total life one finds articulated in classical Hindu teaching, with its two dharmas of sexual pleasure (kama) and spiritual release (moksha). "Two worlds alone are worth a man's devotion," wrote the Sanskrit poet Bhartrihari—I use the version of my late friend and sometime coconspirator, the great Sanskritist Barbara Stoler Miller—"The youth of beautiful women wearied by heavy breasts/And full of fresh wine's heady ardor for sport, or the forest." Picasso, to take de Kooning's natural parallel, since he lived into his nineties, did not as a very old man achieve the release from fleshly appetites he no longer was able to gratify, and his final paintings seem to me filled with an ineradicable prurience and a howling sense of self-loathing for having become a dirty old man. Picasso's attitudes toward women, so far as his paintings can be taken as a transcript, were tinged either with an uncomfortable mixture of sentimental idealization and self-pity or with a certain disdainful sadism, so that suffering, either theirs or his own, was the constant condiment of his attitude toward sex. In the tremendous series of drawings he did after his abandonment by Françoise Gilot, Picasso depicts himself as a ludicrous or contemptible figure, usually an artist, attempting to paint a woman who hardly acknowledges his existence. No one knows what to make of de Kooning's women, but they are all flesh and power, paroxysms of paint and pleasure, and one must concede to Wollheim that in these paintings sensations other than those of vision alone are given a visual embodiment. These are never, so far as I can tell, present in Picasso, where visual sensations are certainly heightened by emotions but at no point is there the synesthesia with bodily sensations of the sort it was the point of de Kooning's painting to make palpable. The body is present in the latter's works as something lived, so that when he said, famously, that flesh was the reason oil paint was invented, one feels that he was the first one to use it for the possibility it offered for the enfleshment of his feelings, and not simply

for its power to depict the flesh visually: It is flesh from the inside, as it were, rather than as it meets the eye of the beholder. De Kooning also said that it was silly to paint the figure, but then it was silly not to, overlooking in this witticism the degree to which, for him, the figure of the woman was a necessity for releasing the sensations with which he was able to fill his canvases, and accordingly for transforming a visual into a visceral art. Later, he was able to jettison the woman, to cathect, as it were, by eroticization, the landscape by depicting it from the perspective of a body moving through it. In Marla Prather's unfailingly informative catalogue text, de Kooning (who did not drive) loved being driven, and once spoke to the critic Harold Rosenberg of "the metamorphosis of passing things." And then, later still, at the end in fact, he jettisoned the body together with the signature. The final works are, once again, visual to the point of fleshlessness. So the entire show has the structure of a spiritual itinerary.

Abstract Expressionism is what enabled de Kooning to achieve this journey, first by enabling him to put sensations into his paintings to which the art of painting had until then been resistant, and then by enabling him to remove them in the act of disembodiment that marks his final works. I initially had a difficult time with the paintings of the 1980s, feeling, so to speak, their emptiness as a defect rather than an achievement. But the power of the show is that we are able to appreciate these luminous works as having been reached by stages of discarding. In the late 1950s, there was, as Prather observes, "a gradual reduction of pictorial means":

> De Kooning no longer used charcoal in wet paint, and he eliminated the crusty surfaces and intricate calligraphies of *Gotham News*. Color was pared down to a few hues, and the diminished number of strokes was countered by an enlargement of their scale. . . . Though these paintings reveal considerable evidence of scraping, they did not evolve through the repeated cancellations and revisions of earlier work. The immediacy of the initial gesture is retained, and the . . . result can be apprehended in a single glance. These compositions were among de Kooning's leanest before the 1980s.

It is imaginable but hardly plausible that this order could have been reversed—that de Kooning could have begun with something just like the late paintings and then, over time, added hues and complicated textures to produce paintings of the sort he achieved in the 1950s. That would simply go against the grain of what one might call spiritual growth. De Kooning said, in 1959, "It seems that a lot of artists, when they get older they get simpler." But certainly something like that reversed order marks the transformation with which I began—that with which de Kooning clawed his way through a 1940s modernism, sentimental and mannered in pinks and celadons, into something formidable and fierce. One can see, for example, the celadon and pink in the lower right corner of *Black Friday* of 1948, overlaid in dripping black enamel with awkward, distantly anatomical forms marked out in white. And then, through the late 1940s and into the 1950s, hues get added, the anatomical forms, still disjoint—like detached grins—begin to reimply the figure, slowly, through painting after painting, and converge on *Woman I* of 1950–52, where we begin to be able to retrodict to breasts and bellies in works that may have seemed at the time abstract. And the whole array of formal stratagems de Kooning invented to invest the female presence with the sensations she elicits in the artist are all at once in place. Women, and then landscapes, and then women again, until, bit by bit, references drop away, leaving the great abstractions Wollheim describes in such primordial terms. And then these slowly spiritualize into the final canvases, in pale yellows and blues, pinks and whites, which stand to the work of the 1940s as souls stand to bodies. I find them magnificent. As far as de Kooning's "silence" in the 1990s is concerned, the power of these works makes us wonder if stopping painting had not been, after all, the right next step to take, and whether it reflects an artistic, even a moral, decision, rather than one more sad symptom of his pathology.

Sometimes one has questions about exhibitions as formats for seeing art, wondering if it might not be better to look at just one work at a time. And it is, I think, almost always true that it is single works, experienced vividly, that yield the transformative experiences of which art almost alone is capable. There are certainly many of de Kooning's masterpieces in the show, and indeed I cannot offhand think of a painting of his that has meant something to me in the past that is not to be found here. Still, when one has a show like

this, in which the works are seen in the context of an unfolding life, they yield up meanings of a kind we could not have suspected were we to see them alone. Or better, perhaps: Now that we see their inevitability in the narrative of the artist's life, we are better able to deal with them when we experience them next, on their own.

—*December 5, 1994*

JAPANESE AVANT-GARDE ART

■ ■ ■

It was always easy, in the years when Dr. D. T. Suzuki taught his legendary course in Zen Buddhism at Columbia, to tell when his class was about to begin. The elevator would bring to the seventh floor of Philosophy Hall an assortment of persons whose normal habitat lay radically elsewhere. By contrast with the regular philosophy professors and their graduate students, buttoned down and buttoned up, Dr. Suzuki's followers were, to say the least, exotic, and I was told that they would come, year after year, notwithstanding the fact that the course itself varied little from one year to the next. It was clear that Dr. Suzuki was regarded as a presence and not merely as an authority, and that his auditors were not so much students as they were initiates in a hopeful, vivid set of beliefs and practices. Dr. Suzuki himself was an urbane man, and I have a distinct memory of him at a cocktail party, holding a cigarette and dealing with a certain wry forbearance with the cluster of enthusiasts who crowded against him in the hope of pressing out a drop of wisdom. In truth, it was the fact that he was at the same time a Zen figure and a man like any other that seemed to me exactly the point of Zen, so far as I understood his teaching at all. And in my first essay on the philosophy of art, I cited a passage from Ch'ing-Yüan, which I must have learned from one of Dr. Suzuki's books:

Before I had studied Zen for thirty years, I saw mountains as mountains and waters as waters. When I arrived at a more intimate knowledge, I came to the point where I saw that mountains are not mountains, and

waters not waters. But now that I have got its very substance I am at rest. For it is just that I see mountains once again as mountains, and waters once again as waters.

An essay for the catalogue that accompanies the exhibition of Japanese art since 1945 at the Guggenheim Museum SoHo cites a sniffily dismissive passage concerning the impact of Zen on Westerners: "They may think that their modern art has received immeasurable influence from Zen Buddhism and so on. From our point of view, what they are talking about is certainly, in most cases, a *soi-disant* Zen, little resembling the teaching of orthodox Zen Buddhism." Alas, that's the way it generally is with cultural influence: For all the Americans who were transformed by *Zen in the Art of Archery* or *Zen & the Art of Motorcycle Maintenance*—or by the texts of Alan Watts or Dr. Suzuki himself—there would have been at most a handful who tried to find the truth of Zen in some actual monastic order in Japan. That would be a commitment perhaps as urgent as undergoing a sex-change operation, when what most who were taken by Zen in those days found attractive was the idea that there is no special path to enlightenment, that the most commonplace actions can have the spiritual weight of religious gestures and, in the visual arts in particular, there need be nothing external to mark the difference between works of art and the most ordinary of objects. Perhaps the most one culture can do for another is to give it something it can creatively misunderstand and make its own. It was really no easier for a painter in Osaka to become an Abstract Expressionist than for someone from, say, Youngstown, Ohio, to manufacture koans. My own sense is that Zen bit deeply into American artistic consciousness not in any effort to paint Japanese-style images or to mimic calligraphic gesture but through certain attitudes toward everyday reality. The Abstract Expressionist were virtually arrested at the second of Ch'ing-Yüan's stages. They were truly interested in sublimity, in a higher reality, in an abstract truth. They were succeeded by the Pop artists, for whom the objects of daily life were as transfigurative as human beings require. For Pop, the actual world was otherworldly enough.

The first American painter to have an impact on Japanese artists after the end of the war was Jackson Pollock, two of whose paintings were shown at an

exhibition in Tokyo sponsored by Yomiuri, a newspaper publisher that continues to be a major sponsor of art shows in Japan. It was Pollock, rather than any of the European painters to be seen in the Yomiuri exhibition of 1951, who seemed to the abstract painter Yoshihara Jiro to have pushed back the limits of painting in two ways: by thematizing the materiality of paint, through the use of pouring, dripping, and splattering; and by incorporating the bodily gesture—the act of painting—into the product of painting. Through Yoshihara Jiro, Pollock's work became the paradigm for a group called the Gutai Art Association in Osaka. The word "gutai" is composed of two signs, "gu" meaning tool and "tai" meaning body, and it is variously translated as "concreteness" or "embodiment." My own sense is that it was precisely in their focus on materiality and on action that the Gutai artists exhibited the spirit of Zen, even if one gets the sense that they saw themselves as reenacting the impulses of the New York School on a larger scale and regarded themselves as transcending the barrier between East and West. An exhibition of their work at the Martha Jackson Gallery in New York in 1958 was advertised as "Japanese Abstract Expressionism," and, to the degree that the show was noticed at all, it would almost certainly have been dismissed as a form of imitation, which in any case was one of the stereotypes of Japan in the American mind at the time. And for those Americans beginning to steep themselves in Zen, New York–style painting was the last thing they wanted from Japan: It must have looked as inauthentic as New York Zen did to the dismissive authorities cited above.

The Japanese artist most widely admired in New York in those years was the great printmaker Shiko Munakata, who conveyed to a Western audience something of what it thought it wanted Japanese art to be. Munakata set out, he once said, to be the van Gogh of Japan—just as, though I am uncertain Munakata knew this, van Gogh moved to Arles intending to be the Hokusai of France. Munakata was master of the black-and-white woodcut, which he colored by hand, violating the rule that nothing belonged on the surface of a print that was not separately printed on it, and he made very large prints of Buddhist personages and goggle-eyed nudes. He was a man of immense energy and robust humor, with a vision at once religious and erotic, and I cannot look at one of his prints today, whatever its subject, without being

carried back to New York in the 1950s. A teacher of printmaking at Cranbrook Academy once told me about a demonstration given there by Munakata, in the course of which he cut the edge off a piece of paper and impulsively wrapped it round his head like a headband. The students were stunned by this gesture, which must have implied to them an identity between artist and work to which they all at once aspired, and it was instantly translated into a ritual at that school. Everybody at the workshop did the same for some while after that, and in some way the different meanings of the strip of paper strike me as a parable for cultural interchange. The problem was and remains how to make something one's own without becoming merely imitative. But probably the solution is easier than it at first appears: Today the art of Gutai could hardly look more Japanese!

It is the work of Gutai we encounter when we first enter the Guggenheim show, and it seems to me that Japanese postwar art begins in the 1950s, strictly speaking, after the end of the occupation, rather than in 1945, when the war ended; and I may as well get something off my chest before turning to the art, which I tremendously enjoyed (and for whose gathering together I am grateful to the curator of the exhibition, Alexandra Munroe). This is an important and a valuable artistic event, but it does not sustain in any way the theme of the show as enunciated in its title and the subtitle: "Japanese Art After 1945: Scream Against the Sky." The subtitle, in fact, is a profoundly distorting characterization of the work it ought instead to epitomize. "Scream Against the Sky" is appropriated from a work by the Japanese artist with whom Americans are likely to be most familiar, namely Yoko Ono, and it appears in its entirety as the epigraph to Alexandra Munroe's introduction. I reproduce it as it appears there:

Voice Piece for Soprano

Scream.
1. *against the wind*
2. *against the wall*
3. *against the sky*
 —Yoko Ono
 autumn 1961

"Voice Piece for Soprano" is an early contribution by Ono to Fluxus, an international avant-garde movement with centers in Germany, Switzerland, and New York and a spirit that appears to have made it especially attractive to a number of Japanese artists. It was relatively good-humored for a largely oppositional movement, and it featured happening-like events, street theater, performances, open-ended concerts of electronic music, ephemeral publications, and marginal works of art created in part to dilate or blur those margins. There is a certain comic edge to much of Fluxus, and certainly this is true of Ono's work, inasmuch as the screaming here counts as compliance with the instructions only if performed by a soprano, and becomes music—and theater!—by the same transformative factor through which silence becomes music, as in Cage's *4′3″*, only when "performed" by a pianist. It would moreover have to be an outdoor performance, for the soprano would need (1) the wind, (2) the wall, and (3) the sky to scream against. But it is quite enough to read the instructions to get a sense of the work, and Yoko Ono's art at the time often consisted of instructions for works that may or may not ever have been performed.

To extract "scream against the sky" from Ono's conceptual piece and use it as the motto for an exhibition that consists of work that is often in the same spirit of anarchist avant-gardism as hers is to misrepresent that work completely, transforming it from something light, playful, and mocking into something heavy and tragic. But the mischief does not end there. Reproduced just above the subtitle on the catalogue's cover is Yoshihara's beautiful abstraction *Red Circle on Black*, of 1965. As a piece of graphic design it could not be improved upon, but in terms of the semiotics of the cover, it subverts the spirit of Yoshihara's work entirely, for it looks like a stylized mouth screaming against the black sky. The third design component, the title "Japanese Art After 1945," seems to answer the question, Why is the scream against the *sky*? (Why not against the wind or the wall?) What comes from the sky in 1945, of course, is atomic bombs. And the implication, by graphic logic, is that the art in the show is thematically a scream, metaphorically speaking, against that.

To be sure, the design of the catalogue was in independent hands, but the title and subtitle were chosen by the show's organizers. In fact the show is essentially of postwar avant-garde Japanese art, beginning with Gutai,

which was almost completely an apolitical movement. And if Ono's Fluxus work was to have been mined for the title, it should have been "Scream . . . (3) against the sky," the elision and number preserving some of the dry absurdism that characterizes so much of what is in the show. A lot of it no doubt is polemical and *contestataire*, as one expects from the avant-garde everywhere. But the targets are of the kinds that avant-garde characteristically takes on, and as often as not the target is art itself—as if, as in Dada, by injuring art, the art obliquely attacks the middle class that values it. It exercises its power over the one thing it controls, namely itself. The atomic raid is doubtless a theme among many, but for the most part the Japanese artists turned against their own government and military, and Japanese artistic traditions were in disrepute, as symbolizing the old regime. If the Japanese turned eagerly to art forms from the West, it was less in the spirit of imitation than of repudiation.

Gutai does not feel as if its practitioners were bent on injury at all, however (least of all Yoshihara), or on screaming against anything—though Yoshihara praised "the scream of the material itself, cries of the paint and enamel" in Pollock's painting. There is in their work a collective quality of exhilaration that comes from the sense of having broken free into open artistic territory, and a marvelous sense of power, which was expressed in the title Gutai gave to its 1955 show: "Experimental Outdoor Exhibition of Modern Art to Challenge the Midsummer Sun." Screams imply victimhood; challenges imply confidence and courage. But beyond that, whatever the work may have looked like thirty years ago, it really has, to return to my point, an ineradicable Japaneseness when you see it today. Seen not as the cover logo but as a work in its own right, *Red Circle on Black* is strikingly beautiful. The huge, slightly compressed circle must have been painted in a single authoritative, calligraphic gesture with an immense brush. Iconographically, I surmise that it is the traditional O-shape that figures as the emblem of enlightenment, as in the famous ox-herding pictures Dr. Suzuki commented upon. What Yoshihara took from Pollock was the drip, which reminds the viewer that this is paint, with a life of its own. It is having its own life that seems to me to characterize this extraordinary image, and so much else in the downstairs section of the show, given over largely to Gutai. Murakami Saburo produced

works by bouncing a ball, first soaked in ink, against a piece of paper. *Work Painted by Throwing a Ball* of 1954 is luminous and almost spiritual notwithstanding its aleatory provenance: There is an oblate splat, where the ball glanced off the paper, preceded and succeeded by a spattering of ink, like a comet's tail, while another line of spatter takes off at an angle to the line of throw. And it looks like some miracle of calligraphy. Munroe tells us that for the Gutai artists, "painting was defined as an art form that recorded the process of its creation. It could be made of any materials, painterly or not, and executed by any means." One painting, of 1963, by Shiraga Kazuo, uses a boar's hide slathered over with clots of red pigment. Another shows the trace of that same artist's bare feet as he sloshed ornamentally through a puddle of paint. The hit of this part of the exhibition is the *Electric Dress* by Tanaka Atsuko, made of phallic light bulbs that flash every two and a half minutes. But I was most moved by her *Work* of 1958, an uneven grid of red and black circles—schematic light bulbs, perhaps—connected by what appear to be color-coded wiry lines.

Upstairs we are shown work that is more in the Dada or Fluxus spirit, for the most part more aggressive and clearly more political than that of Gutai, but at the same time more difficult to understand inasmuch as it deals, as art of that sort inevitably must, with vernacular objects and meanings. Think of what Man Ray's 1921 *Cadeau*—a flatiron with tacks fixed to its plate—would mean to you if you had no idea what irons were used for. When my writing gets translated, I often get a set of queries about vernacular references that define the boundary between cultures: What are S&H Green Stamps? my German translator wanted to know when I discussed a painting of them by Warhol. So what do Germans get out of that painting when it is shown there? Or the French? S&H stamps were once part of the compost of everyday life, the equivalent of frequent-flier miles for Americans in the early postwar years, and Warhol touched on the humble aspirations they connoted when he did a painting of them. I assume that the Japanese avant-garde stood in the same relation to everyday reality as their primary audience did, but we need interpretations, as one might need a joke explained. There are some beautiful pottery pieces by Deguchi Onisaburo (on the ground floor) of the kind that play a role in tea ceremonies, but (and that "but" has to be earned by someone who knows something about the tradi-

tion) his are painted "in a sun-drenched Post-Impressionist palette, lyrically evoking nature in bloom," when the culturally accepted coloration is dour and austere. These ceramics may, in terms of color and facture, be as political as anything in the show: The artist, feared as subversive because of his beliefs, made them when he was released from prison at the age of seventy-one.

One art form of extraordinary originality, to which so far as I know there is no counterpart in the West but which seems to me to obliterate whatever may separate us as members of different cultures, is Ankoku Butoh, or the "Dance of Utter Darkness." This is represented in the second-floor galleries by an installation that shows a performance, in black-and-white video, of *Revolt of the Flesh*, by Butoh's originator, Hijikata Tatsumi, as well as some of the costumes and appurtenances (including an immense gilded phallus) Hijikata employed in his work. It is somewhat difficult to make out what happens in the performance: Hijikata is carried in wearing a white bridal costume, which he strips off, revealing the gilded phallus; he goes through a number of convulsive steps, kills a rooster, and is carried aloft bound hand and foot into the surrounding darkness. I saw a remarkable documentary of Butoh by the American video artist Edin Velez, and I was spellbound by it. It seems to make contact with human thought and feeling that takes place below the level at which culture acts, and where meanings of the most primordial sort drive its performers to find ways to their embodiment. The Fluxus artist Nam June Paik recalls having seen Hijikata dance:

> I cannot describe it very correctly after thirty years, but my impression at that time was that it was quite original, fresh, and touched on the dark source of the deep Asian soul. . . . I use the German word *unheimlich* which combines the feelings of inscrutable, mysterious, profound, scary, and quiet.

I can only add to this that to the degree that Butoh touches the deep Asian soul, we are all Asians. I suppose the nearest one can think of the spirit of Butoh in Western art is what happens offstage in Euripides' *Bacchae*, outside Thebes at the Dionysian festivals when, believing she had participated in

killing a mountain lion, a woman realizes that she had torn her son, the king Pentheus, limb from limb, and is now holding his bloody head in her hands, deluded into thinking it a trophy.

I learned a great deal, obviously, from the careful scholarship behind this show, and from Alexandra Munroe's valuable reconstructions. She is a little too concerned with rebutting charges of imitativeness and with establishing claims to Japanese originality. In this way, she more or less accepts the principles it is one purpose of her remarkable exhibition to overthrow: The spores of cultural influence are borne by the winds of change, and they develop into different flowers wherever they happen to land. It does not take much to awaken the artistic mind to undreamt-of possibilities—a grainy photograph, a copy of *National Geographic*, maybe just someone's description. As the art historian Michael Baxandall has argued, "being influenced by" is an active verb: An influence is what the artist influenced makes of it. This is a rewarding and exciting show, and I urge everyone to visit it; my quarrels and quibbles with the catalogue notwithstanding, I feel we are all immensely in Munroe's debt. And who knows what effect it might have, given the ways cultures work on one another?

—*January 2, 1995*

FRANZ KLINE

• • •

THE PAINTER AD REINHARDT, WHOSE IDEOLOGY OF AESTHETIC AUS-
terity is embodied in a series of black, square, matte paintings done in the
early 1960s and articulated in a number of Zen-like meditations on the pu-
rity of art, was also a mean and clever cartoonist (such is the human heart's
hospitality to multiple traits of character) for the legendary weekly *P.M.* In
the issue of June 2, 1946, Reinhardt published a cartoon guide entitled "How
to Look at Modern Art in America," which has since become a historical
document of considerable scholarly value, for it locates the leading American
artists of the time as leaves on various branches of the tree of modern art,
with a trunk labeled Braque, Matisse, Picasso, and with roots identified, from
left to right, as Cézanne, Seurat, Gauguin, and van Gogh. The branches de-
fine a spectrum from Geometrical Abstraction on the left (on which the sun
shines), to a rightmost limb occupied by the names of artists whose work
ranged from realist to illustrational. This branch is weighed down with the
appurtenances of material success, like Marley's ghost, and shows signs of
breaking off the trunk of modern art: Reinhardt was an aesthetic scold well
before he found in his black squares the final answer to the question of art.
Half a century later, many name-bearing leaves have fallen into the oblivion
of the archives of American art (though the name of African-American
painter Horace Pippin, whose retrospective opened at the Metropolitan Mu-
seum of Art on February 1, flies above as a bird, whatever the iconographical
meaning of that may be). My interest in Reinhardt's illustration, however,

lies in the picture it gives of the American art world by someone who was part of it before the emergence of the New York School—before New York was the art capital of the world, when all there was were *petits-maîtres*.

Most of those we think of as members of that school—as "Abstract Expressionists"—have a place on Reinhardt's tree, though interestingly not on the same branches. De Kooning, for example, grows on the same branch as Lee Krasner. Pollock and Motherwell are on a different limb, which makes sense, given their interest in automatism and the ideas of Surrealism. Rothko and Gorky are on yet a third branch. One does not want to attach a greater degree of topographic precision to this ramified structure than the spirit of caricature demands, but it is striking that to Reinhardt in 1946, de Kooning and Krasner were twigged together with artists like Kepes and Knaths, rather than Pollock and Rothko, who are grouped with painters one would today not think of as especially close to them at all.

Franz Kline is nowhere to be found on the tree of art in 1946, though Reinhardt left some blank leaves in case "you have any friends that we overlooked." An eye informed by the future might see in Kline's work of 1946 the stirrings of enough promise to warrant pasting a leaf with his name onto the tree, though it would almost certainly have had to fit somewhere on the doomed, impure, sagging right branch, as figurative and illustrational. But without the benefit of historical perspective, Kline would have looked like any one of dozens of 1940s painters, his back to a wall he did not know existed. But by 1950, when he had his first one-man show, I would say he had become a great artist. He had discovered that remarkable and immediately identifiable style of black-and-white painting that defined him as an artist until his early death in 1962. That is often cited as the year in which Abstract Expressionism itself died, however that is to be understood. He was in any case the last figure to "attain a signature style," according to David Anfam in an essay for the exhibition "Franz Kline: Black & White 1950–1961" (at the Whitney Museum and then the Museum of Contemporary Art, Chicago). Kline's style, apart from the obvious black-and-white of it, in fact provided a sort of protective camouflage for the movement that replaced and perhaps put an end to Abstract Expressionism as the historical "next thing" in America. If one looks at the early works of Cy Twombly and especially of Robert

Rauschenberg, who had been Kline's students at Black Mountain College in 1952, one can see the continuation of what one might call Kline's philosophy of paint, if hardly his philosophy of art.

It would be fascinating to know at what point the New York School attained a consciousness of itself as a movement, and if its members ever held a collective image of themselves that corresponds to the one art historians began to form when the idea of a "second generation" emerged. Motherwell prefaced his memorial to Kline with a comment by someone named G. Jeanniot, on a thought of Manet's: "Art is a circle, one is either inside it or outside." Jeanniot added, "No one person in the circle resembles his neighbor, but at the same time they are all brothers." Doubtless he was exalting what one might think of as the fraternity of all artists; but Motherwell, one feels, must have been thinking of the circle to which he and Kline belonged, even if they were, to prolong Reinhardt's image, growths from different branches on the tree of modern art. But there is very little resemblance between Rothko and Motherwell, for example, or for that matter between Pollock and Kline. Or between Newman and Still. I suppose, consonant with the idea of fraternity, that the New York School members were united by what Wittgenstein speaks of as a *family resemblance* ("Don't say 'There *must* be something common . . .' but *look and see* whether there is anything common to all. . . . For if you look at them you will not see something that is common to *all*, but similarities, relationships, and a whole series of them at that. . . . I can think of no better expression to characterize these similarities than 'family resemblances' "). So perhaps we can find properties held in common between any two Abstract Expressionists, which a third would lack. The difficulty with the image of family resemblance is that we have a clear idea of what it means to say that someone was the last one to be born into a family—but why was Kline the last to enter Motherwell's circle? Was there some ill-understood factor that meant that Kline's was the last remaining stylistic option?

What we do know, I think, is that the differences between the members were sufficiently marked that no one could have anticipated work like Kline's even if, after it was there, it seemed by nature to belong. Motherwell certainly used the stark black-and-white format that Kline subsequently made his own. But Motherwell's black forms are fluid and blotlike—he explicitly

spoke of them as "doodles"—whereas Kline's have the quality of charred timbers. And Motherwell's forms stand as marks on a white background whereas Kline's blacks and whites are locked in some kind of collaborative struggle. The point is, I am still not sure that Reinhardt would have redrawn his tree so as to put all the Abstract Expressionists retrospectively on the same branch. Indeed, when Reinhardt redrew the tree for *ARTnews* in 1961, Kline is the last leaf on the still-threatened right branch. That means that Reinhardt, at least, saw him as part of the figurative, possibly part of the illustrational, sector of modern art. But it was abstraction that was supposed to have made Kline into the great artist he became! What was Reinhardt aware of that is difficult for us to see? In whatever way it was that Kline was an abstract artist, he was, no more than de Kooning or Pollock (or Picasso or Miró), indifferent to the figure. The problem was how to realize his figurative impulses consistently with the formal discoveries of Modernism. This is a question I shall return to.

But let us return first to Kline at the moment in his development when, on the evidence of Reinhardt's cartoon, he was not yet so much as a growth bud on the tree of modern art. There is a brush drawing, done in 1946—the year of Reinhardt's comic guide—of Kline's wife, Elizabeth, seated in a rocking chair. It is economical and urgent, almost like an ideogram in impulsive calligraphy, of the seated woman. The folded arms are crossed curves, as if held in place by an implicit straitjacket. Her head is driven into the round of her shoulders by a massive black rectangle that in itself looks like a component in the great black-and-white works to come. The interior of the rectangle is slashed with a few verticals, like bars, that echo the rather more gracious array of spindles that support the chair's arm but seem in the light of the facts of her condition to symbolize a barred window. The face is featureless. Elizabeth had been a dancer before she and Kline married, but typically in the mid-1940s she was represented as immobile, in the rocking chair. That year she was hospitalized for psychological disorders, and the pinioned arms and barred window take on a certain symbolic weight against the background of her suffering. Formally, the drawing has the look of one of Rembrandt's: There is a very moving picture of his wife, Saskia, on her sickbed, looking drawn and afraid, with a heavy black splash above her head and a sleeping nurse, seated at the foot of the bed, slashed in almost the way

Elizabeth is. We know that Kline greatly admired Rembrandt, and it must have been irresistible to see his situation and that of the Dutch master as parallels in suffering, through afflicted wives and financial need. The 1946 drawing could be a tribute to their common condition. Art writers like to explain art through art, but who knows whether Rembrandt's charged brush in his ink sketches was not rendered salient to a later artist by this human affinity as much as by formal acknowledgment?

Formal explanation can take you only so far. The 1946 drawing (not in the Whitney show) is so economical that one could easily count the number of strokes, and by means of erasure—or by white-out—achieve an abstraction by modest subtractions, and a work, moreover, in Kline's great style. So the question arises as to why it took Kline four years before he saw his way to the white-out, and why, in the interval, he did so many stylistically retrograde 1940s paintings. He had terrible expenses in connection with his wife's illness, and was actually lucky to have patrons willing to commission portraits and various other subjects that kept him afloat in those harsh years. There is even a synagogue interior, done in conscious emulation of Rembrandt's golden light. Without question there is a thesis to be written on the influence of Rembrandt on Abstract Expressionism, but to explain the influence one has to account for what made the later artists open to it, and there is nothing like domestic problems and material needs to reinforce the circle of fraternity between artists of different eras who discover deep identities through the exigencies of their lives.

At one point during my second visit to the show, I was standing before one of the very last and certainly the largest of the paintings in the show, *Mahoning II*, of 1961, paying close attention to the surface. It felt more like asphalt than paint, and at points more as if the surface were paved rather than painted on the wallboard Kline used as his support. By 1961, Kline was fairly well-off, owned real estate, and had just purchased a silver Ferrari, so his use of homosote was not dictated by poverty but perhaps by some need to convey a certain rhetoric of directness and honesty and down-to-earthness. Or maybe linen canvas had too much spring for the weight he wanted to give the paint. In any case, I found myself addressed by someone who must have mistaken my close peering for a desperate search for meaning. "They call

this modern art?" he said, with that tone of rising interrogation that signals irony, superiority, and disdain for the referent of "this." I knew it would be impossible for someone who felt the awe I felt to communicate with the speaker, so I merely indicated the date on the label, as if he were asking a flat question, odd for someone in the precincts of the Whitney, to which the polite answer was "Yes." "I'll take Rembrandt any day," he said, moving on; and while I had nothing further to say, I was struck by the fact that it was Rembrandt that crossed his mind rather than, who knows, Renoir or Michelangelo. Rembrandt does not figure in the soil whence springs Modernism's tree, where Reinhardt had itemized as nutrients Manet, Poussin, Ingres, and others. But so much of Kline's work is Rembrandtine! The wonderful *Cupola* of 1958 has what feels like a shaft of light splitting the shadows, as if from the oculus of a domed interior, and read that way the whole painting has all at once shafts of light alternating with heavy darks. Kline was the baroque master of Abstract Expressionism, his world one of stunning lights redeeming heavy shadows, keeping it from going all dark even when the work is in response to death, as in the great *Requiem* of that same year, Kline's memorial to Jackson Pollock, where one has to make up one's mind whether the black cloud is lifting or darkening the forms beneath it. "I don't feel mine is the most modern, contemporary, beyond-the-pale, *gone* kind of painting," Kline said, the year these works were made. "But then, I don't have that kind of fuck-the-past attitude."

The relationship of titles to paintings in Abstract Expressionist practice is never clear-cut. Kline's are named after trains, ballets, figures in Wagnerian opera, subway stops, and places that had some meaning for him, without the paintings necessarily bearing any specific pictorial relationship to the bearers of those names. Possibly the kibitzer who dropped Rembrandt's name may have thought I was looking for a clue to what connection there might have been between *Mahoning II* and Mahoning County in eastern Ohio—or the Mahoning River, which runs through its seat, Youngstown. Franz Josef(!) Kline was born in Wilkes-Barre, Pennsylvania: Pennsylvania place-names had a meaning of some sort for him, and it is a fair inference that Mahoning did as well, since there are two paintings bearing the name. In scale and in presence, *Mahoning II* feels more like a continent than a county—a blunt bootlike black form cropped at the top and right, sharing

the space with three whitish shapes and touched with a streak of rust. But the reason I was examining the painting had nothing to do with this. The exhibition is installed in such a way that one sees *Mahoning II* through a door into the gallery to one's left upon entering the show, and it is almost impossible not to take in, with the same glance, a small work on the near wall that almost looks like a study for the larger one, albeit with a central shape that is a rotated counterpart. The small painting is from 1954 and titled *Painting No. 1*, and in fact there is no direct connection between the two works at all. That bootlike shape recurs in Kline's work—the whole left side of *Cupola*, as well as the study for it, is dominated by the boot-form, and I daresay one could spot more instances than that if one thought it worthwhile. Anyway, I had wondered if *Painting No. 1* were in fact a study for the large work, then decided that there was no such connection and was thinking of the differences when the kibitzer distracted me. But the value of having been wrong was that I began to pay attention to the fact that Kline typically made studies for his large canvases, and then began to think of how different this made him from the paradigmatic Abstract Expressionist who in popular imagination flung paint at the bare canvas. Kline worked like an old master, and one of the revelations of this show is the number of studies it puts before us together with the larger works that came from them. On the occasion of a 1953 studio visit, Richard Diebenkorn was "impressed that the several current large paintings in his studio were exact blow-ups of very small sketches (telephone-book pages), accidents and all. I was surprised, having assumed that his ideas evolved in terms of the scale and size of his canvases." This is a striking testimony against the celebrated episode, recorded by Elaine de Kooning, that it was seeing one of his drawings blown up by means of a Bell-Opticon projector that converted Kline to abstraction. What the episode meant instead, according to the Kline scholar Harry Gaugh, may have been that "black and white could stand alone at the scale of a painting rather than a drawing." On the other hand, there is a considerable difference between the study and the painting, which is the difference between drawing and painting, and this deserves some comment.

The black-and-white format of Kline's work suggested calligraphy to his early viewers, perhaps unavoidably in the 1950s art world, where Japanese,

and especially Zen, ideas were so widely admired. But Kline insisted on a difference: "The Oriental idea of space is an infinite space; it is not painted space, and ours is. . . . People sometimes think I take a white canvas and paint a black sign on it, but this is not true. I paint the white as well as the black, and the white is just as important." Kline is right: The white of the Oriental drawing is the white of the paper, but the whites in his paintings are built up in such a way that the difference between drawing calligraphically and painting becomes dramatic. Let's consider a work like the tremendous *Untitled* of 1954, a very large horizontal painting, composed of three diagonals, two of them parallel to each other and connected by a stroke, overlaid, on the left, by a heavy black piece of brushwork of the sort Rembrandt would use in a drawing to fill in a hurried shadow or create a large dark gesture. Remember that Kline used house-painter's brushes and the kind of black enamel that came in gallon cans. So the forms have the quality of having been rapidly brushed on, with those wonderful bristled edges and ends. And, because the brushes were probably not wiped on the edge of the can, there is a lot of dripping. The drip, as we know, was greatly prized in Abstract Expressionist work, and is the basis for its entire aesthetic, not to mention its mythology. Kline's paintings do more than show drips: His edges literally drizzle, and there is a rhythm of paint driplets beneath each of the forms. But these drizzles are not just on the surface, as they would be on a drawing. Kline allowed them to dry and then brushed over them with white, through which they are visible as pale submerged marks. The whites of the paintings are in complex interaction with the blacks, and sometimes black covers white, sometimes white covers black. The painting is built up in a very complex way not to be found in the studies at all. That is what I think Kline handed down to his followers like Rauschenberg. Next time you see one of Rauschenberg's works from the 1950s, a work like *Canyon*, for example, of 1959, try to think of the way Kline uses white to occlude and reveal, to submerge and disclose, the underlying images.

To your right in the first Whitney gallery, and just behind you, is a painting I have thought about since I first saw it. It is *Black Sienna*, done in 1960. Part of the joke of the title comes from painterly nomenclature, since sienna is an earth pigment that comes in two forms, burnt and raw, but never black so far as I know, though the painting is black on white. When I first

saw it, I felt it was an image of a horseman, under a black cloud, and I could not help but feel that if it was intended that way, then this would be the way Rembrandt might have done *The Polish Rider*, had he lived in our times and been the Abstract Expressionist he merely anticipated being. But I felt somewhat abashed to be seeing a horseman in the work of an abstract artist unless as an accident—what the artist and scholar Sidney Geist calls a "cryptomorph." But I am now inclined to believe my eyes: Kline toured Italy in 1960, and made a stop in Siena to witness the Palio. The other part of the joke is that the title refers not only to the pigment but to the place. It is a very poetic image of a black horseman, and it may be the kind of painting that convinced Reinhardt that Kline was after all not an abstractionist to be trusted.

I wrote about Kline, whom I have always loved, when I first began to do my *Nation* columns, and I have since wondered what I would ever do were there to be another Kline show. And on the basis of that worry I had another: How would I deal with the inevitable recycling of artists over the years? I need not have concerned myself; there is always more to say. With great art one never touches bottom.

—February 27, 1995

R. B. KITAJ

. . .

THE FIRST TWENTY-SIX PAGES OF GIAMBATTISTA VICO'S DARK AND
crooked masterpiece *The New Science* of 1725 are devoted to explaining the
symbolism of an engraving that he has placed as frontispiece and, in a sense,
as pictorial introduction to his volume. "We hope it may serve to give the
reader some conception of this work before he reads it, and, with such aid as
imagination may afford, to call it back to mind after he has read it," Vico
writes, proceeding to compose forty-two paragraphs of what would be wall
text were the engraving to be exhibited today, telling us how the symbols and
their placement relative to one another are to be read. One picture is here
vehemently worth some thousands of words, at least in terms of occupied
space. But without those words the picture is not worth much, or is a mere
visual puzzle. What is the lady in the winged headpiece doing, balancing like
an acrobat on a sphere, itself precariously balanced on a truncated cube,
against which a rudder and perhaps a distaff lean? And who is the bearded
man with the sexy legs, standing on the base of a column with another—is it
his?—winged headpiece lying nearby on the ground? The engraving is dense
with emblems, and a zigzag of light beams unites it compositionally, con-
necting an eye in the sky to the lady's heart, the latter with the man's shoul-
der, and that, via the distaff, to an alphabetic tablet on the ground. This
much is clear: If Vico had not explained, symbol by symbol, what each thing
meant, there would be no way of inferring to the tremendous original vision
that is *The New Science*.

The arcane graphic density of Vico's engraving goes no distance whatso-

ever in transforming it into a work of art equivalent in artistic value to the philosophical value of the text that animates it. But the complex interpretive functions that map verbal texts onto pictures generally leave the artistic merit of the latter unaffected, even if the texts themselves are works of undoubted genius. It was, for example, the decoding of a relatively mediocre set of frescoes representing the months of the year in the Palazzo Schifanoia in Ferrara that vindicated the science of "Critical Iconology" invented by the remarkable art historian Aby Warburg, who founded a school of interpretation based on such analyses. The artists responsible for the Ferrara frescoes were able to translate the wishes of their patrons into pictorial equivalents without adding much creative energy of their own; but since the relevant texts are lost, Warburg had to negotiate himself, by delicate inference, to the system of astrology in favor at the court of Ferrara circa 1470, through which the meaning of the frescoes is restored to us. (It is hardly typical for an explanatory text to be as ready to hand to its pictorial counterpart as is the written introduction to *The New Science*.) But sometimes the picture will transcend its explanatory text, as Botticelli's *Primavera* leaves the humanist promptings of the poet Poliziano far behind, even if there is a great deal in Botticelli's masterpiece that would be obscure, or at least puzzling, without benefit of Poliziano's ideas. Warburg's working principle was *Das Wort zum Bild* (From word to image), even if the actual direction of inference ran in the other direction.

Warburg's interest in artistic merit was secondary. He was drawn to the vanished forms of life that pictures make available to us, and the successful exercise of Critical Iconology simultaneously decodes the pictures and opens up the forms of life that explain the art. There is, however, a certain price attached to using Critical Iconology as a method: The pictures it is exercised upon are tacitly transformed into fields of symbols, each of which has to be read and all of which have to be systematized into an implied text. That works reasonably well when the picture really *is* a field of symbols, like Dürer's *Melencolia I*, the analysis of which by Erwin Panofsky was one of the triumphs of the Warburg methodology. But it can be, in my view, distorting, as when a still life by Picasso is treated as a tableful of dark Christian symbols when it may be simply a robust celebration of domesticity and dinner. The

most innocuous images of Picasso have been treated as if the ghost of Poliziano were whispering in one ear and the bearded astrologers of Ferrara in the other, freighting the poor canvases with a load of meanings as heavy as the one the frontispiece of *The New Science* is condemned to bear.

The painter R. B. Kitaj, when at Oxford in the late 1950s, studied with art historian Edgar Wind, an extraordinary and illuminating iconologist (even if his proposed reading of Giorgione's *Tempesta* has not survived criticism). I imagine it was through Wind that Kitaj discovered "the Warburg milieu and their version of art history," as the artist reports in the Chronology section of the catalogue *R. B. Kitaj: A Retrospective*, which accompanies the exhibition of his work at the Metropolitan Museum of Art. "He bought the entire set of *Warburg Journals*, from 1937 on, and Fritz Saxl's Lectures, etc., which he still uses," the Chronology goes on to say. Kitaj uses the Warburg "version of art history" as a kind of pre-emptive Critical Iconology, playing, so to speak, Poliziano to his own Botticelli, stipulating in print the programs to which his paintings are to conform, and then executing them. The catalogue prints the *Wort* alongside the *Bild*, and I think it may be allowed that in many cases the images would be as obscure as the calendric frescoes of Ferrara without the glosses Kitaj supplies. They would be even more so, perhaps, since the meanings are in most cases personal and come out of the artist's history, and so would be unrecoverable unless one knew a great deal about his life—a great deal more, for example, than we know about the lives of most painters whose works we are required to enjoy without benefit of so much iconological help. But then, it is very rare to find a painter whose work embodies, to the extent that Kitaj's does, so much personal history. "Self-love and its vanity seem to me so much what painting is about," he disarmingly confesses in his commentary on the painting *Rousseau* (1990), "that one must consider Rousseau's theory that a social deformation may have replaced our more natural selves when we press our absurd pictures on society." Whatever Kitaj's "natural self" might be or have been, his actual self is the result of having internalized, at a minimum, the Warburg agenda, which he has taken as an imperative for making art. His work is about the making of an art conscious of its own symbolical intentions. The catalogue has the

function of making *us* conscious enough of those intentions that we can understand the paintings, or at least understand them art-historically.

These elucidatory "prefaces," as Kitaj calls them, were displayed as wall texts in the show's first venue at the Tate Gallery in London. This would not have been quite as disproportionate as hanging the introduction to *The New Science* alongside the raggedy Neapolitan engraving that puts it all in a pictorial nutshell. But then Kitaj is not Giambattista Vico, and I cannot help but feel that the tremendous trashing he was administered by Britain's critical establishment was in large measure a negative response to the "self-love and its vanity" that his texts, far more than the pictures themselves, exude. It is clear that Kitaj has to attach an extraordinary significance to events in his life if he is going to make his corpus a running allegory of his enthusiasms, his friends, his loves, his failures, his disillusionments. The Chronology is like a Leporello list for an intellectual Don Giovanni, itemizing all the poets he has met and the philosophers he has read and the artists he is pals with. And there is, for someone so exceedingly self-absorbed, an astonishing blindness in ascribing the critical frenzy to anti-Semitism, when I am certain the feeling was spontaneous and irresistible on the part of critics (Who the hell does he think he is?) who felt they were being overbearingly patronized by an artist I am equally certain meant only to be helpful. It was a colossal curatorial fiasco with tragic consequences for an artist whose painting entitles him to something better. His is a crabbed, eccentric talent, but it is a real one.

Kitaj's pictures are often as baffling as Vico's frontispiece would be, if we had no text to read it through. And his titles add to the bafflement by implying that there exists a reading such that, were we to know it, the meaning of the picture would be clear. The pictures, in effect, keep sending us away from themselves as we seek some explanatory hypothesis that will make sense of what we see. General knowledge will carry us only so far, and often it will carry us in the wrong direction entirely. The pictures are rarely rewarding enough to stand on their own, but in any case it is difficult to know just what it would mean for them to do that: Like Vico's frontispiece, they present themselves almost as rebuses to be solved, and it is equally difficult to know what it would be for a rebus to stand on its own. The catalogue texts, from

this perspective, really do give us information we could not have furnished out of our own resources. The question remains to what degree this information serves to do more than "solve" the picture. Rarely, I think, does the painting, once interpreted, carry enough visual energy of its own to transcend its reading. But in some cases it certainly does, and I will offer a few examples of works in this show that require (as almost all the works require) a piece of iconology, but then do something beyond that, once all the meanings are in place. A lot of the world's great art, after all, needs a certain amount of iconological clarification, but is clearly more than a presentational riddle.

Take the 1984 *Self-Portrait as a Woman*. No one would know, I think, that it was a self-portrait unless one were told. The painting shows us a woman, naked rather than nude, since she is wearing green high heels and red socks. We see her from behind, her hands somewhat defiantly on her hips, her head in profile. She is standing outdoors in the midst of what looks like a Mitteleuropa village, and there is no one else around. The sky is dark enough to be night, which could explain why she is alone. The ground is red, and there is a somewhat incongruous face painted on it, as if by a sidewalk artist. Some sound seems to be issuing from the woman's mouth, in comic-strip style, but what sound she is making is left unspecified: There is only a red streak. "Self-portrait as . . ." implies that the artist has chosen to take on the bodily attributes of a woman for some metaphorical purpose the painting itself does not clarify. Indeed, nothing visually shows the difference between a painting of a naked woman standing outdoors and a portrait of the artist as a woman. Were it not for the title we would see it as no doubt symbolically charged in some way, but have no clear sense of what specifically it might mean. From the title we could perhaps infer that the artist wanted to see what it would be like to visualize himself as a woman. Or he wanted to show his solidarity with the cause of women by taking on their fleshly attributes. It could go further than this: Christ took on the attributes of human beings in order to suffer redemptively. The difficulty we have in recognizing Kitaj in the shown woman is matched by the standing artistic problem in the West of representing Christ as a divine being in human form. A painting titled *Portrait of God as a Young Jewish Male* might just look like a picture of Jesus, with

nothing to tell us visually that God was being portrayed, which we would have to take on faith. Kitaj's title complicates our attitude, but it does not complicate the picture enough to help us understand why it is a self-portrait as a woman. Perhaps there is no way to tell what has to be told visually, without benefit of an explanatory narrative. So Kitaj tells us how the painting came about.

The story is this: He had an affair with his landlady, when a student in Vienna after the war, who told him that she had been caught in bed with a Jew. She was stripped, forced to parade naked through the streets wearing a placard and yelling out that she had slept with a Jew. Now, the story does explain an otherwise unaccountable gray rectangle that we now see is a sign. And it explains why she is shown from behind: To show her frontally would be to show the placard, leaving it possible that she was wearing something underneath. And we are told what the red streak issuing from her mouth says. Perhaps it explains the emptiness of the streets as well: The artist has compassionately removed the jeering Nazis, the pointed fingers, the shaken fists, the smirking faces. There are no witnesses to her intended humiliation. Moreover, the woman is given a striking dignity by the size and shape of the canvas. It is about eight feet tall and quite narrow, and she is given a certain monumentality by being the only figure in that space. So the story does not altogether leave things as they were. But the picture thus structured leaves the crucial relationship of moral identification unregistered: I am that woman, I take on her humiliation, I am one with her victimhood, her suffering is mine. Knowing the story, looking at the picture in the light of its disclosures, gives a basis for criticism the picture alone does not provide. It falls short of the promise and the problem of the title. It remains a painting of a woman in the middle of a city, naked under the night sky, poetic enough but hardly the tremendous moral achievement the artist wanted it to be. Still, it gives us a sense for his ambitions.

There is another canvas of exactly the same dimensions, again dominated by a single figure, called *The Sensualist*. It shows a male figure this time, executing what seems to be a kind of hornpipe: The left hand is placed on the head, the right hand on the hip, and he seems to be wearing dancer's tights that have slipped down under his belly. His face is red (from the exertion of the

dance?) and he is wearing glasses. There are some paintings on the wall, and on the floor a pink female head delicately drawn in the manner of Matisse, which encourages the view that the figure itself *is* Matisse, an interpretation reinforced by the title and the glasses, by the knowledge that Matisse was a sensualist—and by the fact that so many of the paintings in the exhibition seem to have references to the history of painting. But then how do we explain what is going on in the painting? A victory jig over a drawing? What justifies the scale, if one appeals to that in restoring some of the stripped dignity to the woman who slept with a Jew? As it turns out, the figure has nothing to do with Matisse. It is in fact the figure of Marsyas, the satyr whom we last saw in an overpowering late painting by Titian, hung by his hooves and flayed by Apollo, to whom he lost a foolish bet, while a small dog laps a puddle of blood on the ground. Kitaj has cut the ropes, as it were, and put Marsyas back on his feet. What looked like black tights were just the satyr's goaty legs. The red in the face is probably blood. There is no connection between the figure and the drawing of the woman's head—the latter was just left over from another painting, which had been turned upside down in order to paint Marsyas right-side up. Between the discarded woman and the dancing satyr had been an effort to copy the monumental male bather of Cézanne owned by the Museum of Modern Art, whose akimboed left arm is inherited by Marsyas. So there are three superimposed paintings with no apparent thematic interconnection, though the viewer is left trying to make visual sense of the face on the floor, the dancing pose, the bespectacled face, the studio interior, the title. Kitaj's text has no internal connection with what meets the eye, even if it explains how various things arrived on the canvas. "All too artful," he concedes, "so I wrote ART over the mean street doorway, for Art's sake." But the painting transcends its explanation and insists on fusing elements that the artist's story tells us have only a sequential connection. Still, I was glad to discover that it was Marsyas rather than Matisse I was dealing with: That explains the otherwise unaccountable power of the work. One does not set a skinned satyr dancing in a studio with aesthetic impunity, after all, and a work of art begins when we have come to the end of its historical explanations.

The knowledge that the central figure is, or was, Marsyas, then, makes a certain difference in how we respond to the painting—or it explains why our

reaction is as powerful as it is. But typically, I am afraid, the iconology Kitaj provides arises from and returns to his biography in such a way that the elements in the painting are assigned meanings without anything happening to the painting, as viewed, at all. Consider *The Ohio Gang* of 1964, rather a typical Kitaj work. The mustached man wearing a hat is Jack Wandell—"an actor I knew in the late forties when we lived in the same rooming house near Union Square." The bearded man with the squint is the poet Robert Creeley. The yellow ribbon is a pledge on the part of the nameless naked woman to one or the other of these men, and its provenance is the John Ford movie. The pram was bought for a second child, who died. And so on and so on and so on. Each element in the painting is logged into the symbolic register, and everything is accounted for, even a Warburg maenad in the corner that Kitaj must have learned about from Wind's lectures at Oxford. "There was no rational plan for this picture, no programme to speak of." There is a conjunction of meanings that do not converge. Small wonder there is no effort to get the symbolism to work visually: The painting could hardly be more empty, Kitaj might just as well have painted an abstraction.

David Hockney, who was at the Royal College of Art when Kitaj entered it as a late student, recalls having been encouraged by the bookish American to paint the subjects he felt deeply about, to bring his art and his life into some sort of relationship. This was in 1959. Not long afterward Hockney began to paint those marvelous homoerotic works like *The Most Beautiful Boy in the World* and *We Two Boys Together Clinging*. It is perhaps interesting to his biographers but of no relevance to the pictures to know who the most beautiful boy was, or with whom the artist was clinging. The images are accessible to us all, and we can identify with the feelings they convey. It is a criticism of Kitaj that he does not manage to achieve this, so the art remains a kind of rebus, documentation or no. The Critical Iconology carries us back, always, into some person or event in the artist's life of no interest to us or consequence for the art. The works are like pages from a scrapbook: poets I have known, pictures I have loved, places I have seen, women I have slept with, books I have read; me in the merchant marine; me losing my virginity; me in the yarmulke.

But there are also drawings in the exhibition so exquisite that one will forgive a great deal for their sake. *The Dancer (Margaret)* of 1978 shows the

subject unclothed but for leg warmers and ballet shoes. Her pubic thatch is not so much drawn as rendered, with a tenderness that matches the pensive radiance of her look. There is no "preface," and one is grateful for the reticence. The drawing conveys visually what loving someone feels like, and as with great art always, the visual tells us everything we need to know. Kitaj has a great, but squandered, gift.

—April 3, 1995

BRUCE NAUMAN

· · ·

WITTGENSTEIN BEGAN TO TALK ABOUT "LANGUAGE GAMES" IN THE late 1930s, and conceived of these as very primitive forms of language that went with correspondingly elementary forms of life. He conjectured that these games "are the forms of language with which a child begins to make use of words," but he meant to use them as tools for analyzing what goes on when we engage in linguistic interchange: "When we look at such simple forms of language, the mental mist which seems to surround our ordinary use of language disappears." In *Philosophical Investigations*, he offers an example of a language game used to serve for communication between a builder, A, and an assistant, B. They use a language consisting only of the words "block," "pillar," "slab," and "beam." Here is a play: A says "Slab" and B brings a slab. So in addition to a vocabulary, the game consists in commands—clearly "Slab" here means "Bring me a slab"—and compliances, which are nonvocal. Bringing a slab is as much a move in the language game as uttering the word "slab." Hence the language game is made up of words and actions.

A great deal of the work of Bruce Nauman consists in issuing commands, and since Wittgenstein's views on language are said to have had a marked influence on Nauman's art, it is perhaps helpful to consider those works as having at times the framework and logic of language games—which means, since the commands are often directed at us, that we are meant to do something in response. That is to say, by contrast with works of art that evoke only an aesthetic response, Nauman's are conceived to require some-

thing more strenuous, and in a way more active, on our part. Designed as plays in language games, they address us less as viewers than as participants. To experience a Nauman is to interact with it in some way that goes beyond appreciating it as a work of art.

Let's begin with a special kind of command, one that the "assistant" has no power to resist, once the command is understood. (This is clearly very different from one of Wittgenstein's primitive scenarios in which A calls out "Slab" and B brings it, and where, though such contingencies rarely arise in these reduced scenarios, it is within B's power to say to hell with it and walk off the job.) As in baseball, striking is a way of not playing the game. So I am thinking of what we might call strike-proof games, where it is, as Continental thinkers like to say, "always already" too late to refuse to do what one is asked. "Read this sentence!" is perhaps a case in point: To read the sentence is ipso facto to have satisfied the obedience conditions it lays down. Alongside such commands one might think of logically non-nondisobeyable ones, like "Don't look!" (Oops, too late!) or "Don't read this sentence!" (ditto). The next time conversation flags, you might try to think of some examples of your own. The point is that such commands contrast with the typical orders and directives of everyday life, like "Open the window," where one must do something in order to refuse or comply with the command, other than merely understand it.

Nauman has come up with a nondisobeyable command and fashioned it into a work of art that his devotees admire extravagantly: PAY ATTENTION! Well, this in fact comes in more than one version. There is a lithograph in which PAY ATTENTION MOTHERFUCKERS is printed backward, one word per line. Of this the critic John Yau writes: "By describing both our experience and our specific existence, 'PAY ATTENTION . . .' successfully integrates our awareness with our sensations. We do what we see." This work is not in the show of Nauman's work at the Museum of Modern Art, but a kinder, gentler version is: PLEASE PAY ATTENTION PLEASE, a collage this time. Of this, the show's curator, Robert Storr, writes, "By reading the words on this collage, one automatically grants their plaintive request. Much of Nauman's work . . . draws the viewer into its constructs and often controls the way it is absorbed, either by demanding feats of concentration or imagination or by limiting the viewer's movements." Paul Schimmel, a cocurator, similarly writes:

"Throughout Nauman's career he has baited, controlled, bored, infuriated, scared, insulted, angered, imperiled, experimented with, and manipulated us—his viewers—into experiencing his work within his parameters. . . . The meaning of the piece is what it does to us."

I am struck by the persistence of the word "viewer" in these glosses, which implies a greater continuity between normal museum experience and the rather more peremptory demands upon us that these works are praised for making. We "do what we see," remember. And our so doing is "the meaning" of the work. So "viewing" is but a stage in our response, and the rest is something the philosophical cross-examiner will force us to admit was an action. Admittedly, a fairly mild and tepid action, even if, once in front of the work, we could not help performing it. We did pay attention.

It has often, in the history of art, been hoped that works would entail effects that went beyond mere aesthetic gratification. The great ecclesiastical art of the Roman Baroque, for example, was specifically commissioned to strengthen the faith of those who viewed it. So artists were instructed to represent Christ and the martyrs as suffering, and it is reasonable to suppose that the tremendous expressiveness of these representations was calculated to arouse feelings of compassion in the viewers that could not help but strengthen the latter's bonds with those subjects of torture, humiliation, and crucifixion. I have deliberately lapsed into the idiom of "viewers," but of course those upon whom these works were to have had the desired effects were first of all Christians, and then were usually engaged in some religious activity like praying before an altarpiece when they experienced it. The altarpiece was composed in such a way as to enhance the bond between the saint prayed to and the supplicant. Whether or not this worked out was a matter of how astute Baroque psychology was and then how manipulative Baroque artists were capable of being. But the hope was something religious art often and political art always aspires to: that some change of state would be induced by seeing the work. And certainly that happens sufficiently often that only against a formalist aesthetic would it be remarked upon at all. We approach works of art as viewers but leave them as altered beings, whether the alteration was something calculated in or not.

Still, this alteration is something that may happen or not; it is not something *entailed.* Like the ordinary game of command and obey, in which there is space for insubordination, the soul may not respond: The work looks too contrived, or too cold, or one is simply not in the mood. How grateful the Baroque patrons would then have been for a form of response that cannot go wrong, where simply to view the work is to be in the altered state, however one may want or try to resist—where resistance is, strictly speaking, unthinkable. To see "Pay Attention" is to pay attention. Still, the question cannot but nag as to what, beyond having been trumped in a forced language game, has been achieved. What have we been paying attention to? To the command and to nothing else. The moment we pay attention to the lettering, to whether the lettering goes forward or backward, to whether the command is plaintive or ugly, we are no longer in compliance with the directive but rather are attentive in the ordinary way in which we regard works of art in galleries—we are outside the horizons of the language game. So the artist's victory is fairly trivial. It is a kind of joke. Like writing "Behold!" when there is nothing to look at but the imperative itself.

PAY ATTENTION may seem a rather minor work for this degree of critical examination, but it typifies the Nauman corpus. It is peremptory, invasive, aggressive; it uses coarse language (in its lithographic version); it straddles (in the collage version) the boundary between a work of art and a poster—an admonition on the wall of the machine shop to watch what one is doing—and hence raises the deep ontological questions that have been with us since at least Duchamp; it similarly straddles the boundary between writing and image that has come to define an entire genre of art-making; and it uses (again in the collage version) unprepossessing, even proletarian materials, which defined the Minimalist movement with its various ideologies and established an aesthetic axis between American art in the late 1960s and such European art movements as *Arte Povera,* which gave Nauman a widely appreciative audience on the Continent. (PAY ATTENTION was borrowed from an important Italian collection for the MoMA show.) All this has made Nauman the cynosure—the focus of rapt attention, to make an internal connection between artist and work—of our advanced curatoriat. Four outstanding curators have collaborated in bringing this exhibition to their respective institutions.

Critical opinion is by contrast considerably more divided, and I must admit to a certain division within myself. I have seen works by Nauman that seemed to me simply tremendous. One was the monumental *Anthro/Socio:Anthro/Socio* exhibited at MoMA in 1991, in which the head of a rather fierce bald man is projected on various scales and in various orientations—he is sometimes upside down—chanting, Hare Krishna style, over and over, in unison with himself, "Feed me/Eat me/Anthropology. Help me/Hurt me/Sociology." Standing in the vast gallery among these talking heads, one felt moved and powerless, and in some crazy way the chanter's seemed to be the Voice of Humanity. In a show of works on paper at MoMA the following year, called "Allegories of Modernism," there was a photomontage of animal forms called *Model for Animal Pyramid II*, as well as a drawing of what looked like a suffering animal that was delicate, beautiful, and, in its own way, as moving as *Anthro/Socio*. . . . There is, in the catalogue to the present show, a photograph of *Animal Pyramid*, a kind of acrobatic formation of animals (Nauman uses taxidermy forms for these), with deer at the base and smaller animals as one ascends. I have no idea of the intent behind that piece, but it conveys a sense of overwhelming meaningfulness, and I must say, on the basis of these works, that I was prepared to regard Nauman as a very major artist indeed. When asked to write a citation to go with a major prize to be awarded him, I wrote, in part, "He is an avant-garde artist whose theme is the human condition, and whose aim is to make us conscious of our limits and our needs."

Not one of these works, save for the photomontage, is in the present show, which is in the aggregate so inconsistent with the above appraisal of Nauman as an artist that I am constrained to ascribe this to a division in his own artistic persona, between the humanist I believed him to be and the smartass perpetrator of aesthetic practical jokes in which this noisy, awful exhibition consists. Either that or there is a division between the curatoriat, who seem dazzled by the artist who made these works, and me, who is repelled by them. It is possible that the revulsion, which made me want to flee the museum, was compounded by the high expectations I had had, based on partial evidence. That evidence had also caused me to explain away a number of other Nauman works I had seen—a chain-link cage, a constricting passage

between walls, and some jejune wordplays in neon—rather than to construct a more realistic picture of his achievement.

The *pièce de résistance* at MoMA is Nauman's celebrated *Clown Torture* of 1987, which, like *Anthro/Socio . . .* , is made up of a number of video images, though the spirit could hardly be more different. The images are of clowns doing, with one exception, fairly clownish things, like holding goldfish bowls against the ceiling with broomsticks and making a lot of racket. Whatever they do, they do over and over, so that repetition is as thematic here as in the chant of *Anthro/Socio. . . .* Part of the cacophony consists in a tiresome joke one clown tells as his routine, a joke with a certain logical kinship to PAY AT-TENTION. It goes: "Pete and Repeat were sitting on a fence. Pete fell off. Who was left? Repeat. Pete and Repeat were sitting on a fence. Pete fell off. Who was left? Repeat. . . ." The joke never comes to the point—or its not coming to the point *is* the point, but the clowns never learn. (If they allegorize the human condition, as can be argued, human life is the same thing over and over, and *we* never learn.) Another part of the racket comes from a clown who, lying on his back, waves his feet furiously in our direction, crying out, as if he were about to be tortured, "No! No! No! No! No! No! No! . . ." And finally there is "Clown Taking a Shit," on a large screen to one's left as one enters the clamorous, shrieking, clanging alcove where the repetitions take place on different screens.

I am uncertain what the iconography of the clown in the toilet stall is, though one may get a hint of its meaning in a large work called *One Hundred Live and Die*, which is made up of that number of paired fatalistic sayings, written in neon tubing, which flash on and off at different intervals, and of which "Shit and Live" and "Shit and Die" are but two. (Others are: "Speak and Die," "Laugh and Die," "Cry and Die"—the whole repertory of basic human doings on the left, and alternatively "Die" and "Live" on the right.) We live or die, and the regularity with which we move our bowels is invariant to the difference between life and death, like the regularity with which we eat or drink or sleep or make love. The overall feeling of *One Hundred Live and Die* is distantly Kierkegaardian: "If you marry, you will regret it; if you do not marry, you will also regret it; if you marry or do not marry, you

will regret both; whether you marry or do not marry, you will regret both."
"My life is absolutely meaningless," the narrator in *Either/Or* states at one
point, and perhaps from the perspective of life and death, everything we do
is meaningless. Something like that is the intended implication of the incan-
tatory declarations of *One Hundred Live and Die*. Robert Storr recalls that
when he first saw the work, two girls, in complete spontaneity, began chant-
ing the words, "Feel and die. . . . Fuck and live. . . ."

On the other hand, this may be a rather more exalted interpretation of
the clown in the toilet than Nauman intended. The artist communicated to
Storr the thought that the times when it is difficult being an artist are very
like the times when one is constipated. "Then the image of a clown taking a
shit (not in a household bathroom but in a public restroom—a gas station, an
airport—places where privacy is qualified or compromised) can show a useful
parallel," Storr notes. (So how, to continue the parallel, are we to think of
the art that comes out after the difficulties are resolved? Asking a rhetorical
question is also a kind of language game. So you said it, I didn't! The paral-
lel in any case is not mine. But what view can an artist have of his art if his
favored image for artistic blockage is constipation?) There is in any case a
certain callow consistency between this image, which is a somewhat unfortu-
nate metaphor, and a set of images from the late 1960s in which Nauman
photographs mostly himself enacting certain charades, where the picture is
to be understood—is to be "solved"—with a cliché. Thus he shows his feet
covered with clay, which means—you guessed it—"Feet of clay." Or we see
the artist eating some bread cut out in the shapes of letters which spell out
w-o-r-d; it is titled *Eating My Words*. Or he applies wax to the cutout letters
h-o-t, painted red, which is *Waxing Hot*. Or he photographs some drill bits
ranked in their holder and gives it the title *Drill Team*.

In 1967 Nauman made a cast in waxed cloth of a region of his body that
included his hand, arm, part of his neck and chin, and his mouth, which has
the inevitable title *From Hand to Mouth*. That very year, he made a cast of his
crossed forearms, cut off at the biceps, out of which some heavy ropes extend
that are knotted at the top. This one, in the spirit of the charade, is titled
Untitled, meaning we are to find the cliché, which is, I would guess, "Knotted
Muscles." These, too, I suppose, are in the nature of language games, or at
least a certain sort of wordplay, in that we are to understand the image by

finding the cliché that fits it. Storr writes of *Eating My Words* that it "transforms a worn-out phrase into a powerful one-liner," but I find the transformations limp and pretty silly. And it is difficult to see what has been achieved by finding a visual pun for "From hand to mouth," which, as a cliché, does not refer to a stretch of the body, where the hand is at one extreme and the mouth at another, but to a condition of marginal existence where the hand and mouth are in contact because the person of whom it is true has little to show for his expenditure of energy but the food he puts in his mouth. At the very least Nauman's transformations seem to show a certain blindness to meaning or a will to subvert it.

There is another way of looking at it, perhaps, which refers us to certain views of language considerably more primitive than anything Wittgenstein had in mind by language games. In *The Interpretation of Dreams*, Freud writes as follows:

> The dream-thoughts and the dream-content are presented to us like two versions of the same subject-matter in two different languages. Or, more properly, the dream-content seems like a transcript of the dream-thoughts into another mode of expression, whose characters are syntactic laws it is our business to discover. . . . The dream-content . . . is expressed as it were in a pictographic script, the characters of which have to be transposed individually into the language of the dream-thoughts.

Often, in classical dream analysis, one goes from dream-thought to dream-content by finding the pun that makes one the transform of the other in a way that makes no sense until the double entendre is found. A psychoanalyst I know told me that when she undertook her training analysis in German, her analyst asked her what she had dreamt the night before. She said she remembered dreaming about a fresh rose, and was told that she had dreamed about her neurosis. What can the connection have been? Only the German pun between *neue Rose* (new rose) and *Neurose* (neurosis). As with puns always, it only works in the language(s) in which the sounds are interchangeable. Someone dreaming of a fresh rose whose language was French would

be dreaming of something else. Freud's interpretations, like Lacan's, are often like solving rebuses, and indeed Freud explicitly talks of dreams as "picture puzzles." Nauman's pictures and sculptures in any case stand in this kind of relationship to one another, with this difference: Solving them takes us nowhere. PAY ATTENTION: The solution opens nothing up.

The above assessment can be extended to the other primitivism I find in Nauman's wordplay. The ancient Sanskrit thinkers used to try to elicit the secret of things by cracking open words. There is a lot of fairly crazy wordplay in the Upanishads, e.g., that since the word for chant—*saman*—contains *sa* (she) and *ama* (he), chants themselves must somehow connect men and women. The inference goes from the shape of the word to some deep truth about the universe. The shape *saman* also contains the shape *sama*, which means "equal," and hence the chant is said in the Upanishads to be equal to the world. "He who obtains intimate union with the Saman, he wins its world," the Upanishads proclaim, as if something had been discovered. In general, the argumentation proceeds as it would were one to observe that "he" is contained in "she" and deduce from that the truth that there is a masculine side to femininity. It is a very old kind of verbal magic, but at least the pundits (as they were called) had a theory that they were doing things by finding words within words and (hence) things within things. Nauman proceeds this way as well. Thus he finds the word EAT in DEATH. Or he finds that EROS spelled backward is SORE. He discovers shapes within the shapes of words or expressions, and presents them to us as if they mean something beyond the fact that one shape occurs in another. One genre of his work consists in neon signs, in which, for example, we are to join him in seeking the connection between VIOLINS and VIOLENCE and SILENCE, to refer to a work of 1981–82. Is there a connection? Other, that is, than at the level of sound? How about at the level of meaning? There could be, I suppose. Someone in ACT UP could say that SILENCE = VIOLENCE if indeed SILENCE = DEATH. But would this follow from the phonemes being what they are?

There is a work from 1988 titled *Learned Helplessness in Rats (Rock and Roll Drummer)*, which shows, among other things, videos of rats in a maze and of a drummer. The concept of "learned helplessness" initially had reference to what happens to rats in an inescapably painful situation. Shocks are

administered in such a way that there is nothing the rats can do to keep them from happening. The rats are rendered helpless for the duration of the conditioning period, by contrast with rats in a control group who are in a more manipulable environment and thus are capable of learning to avoid the shocks. In subsequent experiments, the helpless rats learn much more slowly than the others, and, whatever the connection, show an elevated level of steroids in the blood. Some years ago, "learned helplessness" was generalized to humans to refer to pathologies believed to be the result of an individual's diminished capacity to control his or her environment. Depression, for example, was considered a form of learned helplessness, in at least some cases, and possibly this indicated a therapeutic direction.

Whatever the current state of that discussion, I somehow felt that the situation of the visitor to the Nauman show was a kind of learned helplessness, in that we are subjected to a certain series of shocks over which we have no control except that, unlike the laboratory rat, we can leave—after we pay attention, undergo torture, etc. Our learned helplessness may be a metaphor for the human condition as suggested by *One Hundred Live and Die*, with its fifty pairs of conditions that, though in our power, nevertheless leave life and death as independent variables over which we have no control. So the show may imply a kind of philosophical meaning grander than that carried by the works creating the sense of helplessness, though this is probably too charitable a view. The show is aggressive and nasty, cacophonous and arrogant, silly and portentous. It made me feel, overall, that I had better not think too much about those works of Nauman I really have admired, lest they too slip into language games, sophomoric puns, or the artistic correlative of whoopee cushions and gongs: clown torture.

—*May 8, 1995*

THE WHITNEY BIENNIAL, 1995

▪ ▪ ▪

NOT LONG AGO I WAS SENT A BOOK MADE UP OF ROY LICHTENSTEIN'S comic-strip-panel paintings of the early 1960s. It is called *Brad '61*, and its clever author, Tony Hendra, has turned the tables on Lichtenstein in a benign way. He has returned the panels, so to speak, to the genre from which Lichtenstein first appropriated them, and has arranged them into a kind of comic-book romance in which an artist, Brad, who lives in Tenafly, New Jersey, finds true love with Vicki, the girl next door, as well as artistic glory in New York, across the river. Brad and Vicki are the 1960s ancestors of Julio and Marisol, whose steamy narrative of dubious fidelity and sexually transmitted disease has kept us all descending dank stairways into the subways of New York in the hopes of finding out what happens next (we may never know, as those marvelously drawn Latino lovers have, at least for now, been bumped by gentrified advertisements). The central panel in the story of Brad is a famous painting, Lichtenstein's *Masterpiece* (1962), which shows Vicki exclaiming over a canvas, of which we see only the back: "WHY, BRAD DARLING, THIS PAINTING IS A MASTERPIECE! MY, SOON YOU'LL HAVE ALL OF NEW YORK CLAMORING FOR YOUR WORK!" Beneath the speech balloon, Brad gazes confidently into the future. And if the painting Vicki alone is privileged to see were to have become as clamored for as the painting that shows her prediction, Brad today would be a very celebrated artist indeed.

I thought of *Masterpiece* when I saw the cover of *The New York Times Magazine* for February 26, 1975, which showed Klaus Kertess, curator of the Whitney Biennial, holding a canvas of which again we see only the back,

somewhat smaller than Brad's and affixed to its stretcher by means of staples rather than tacks. Kertess is wearing a dark shirt with light pinstripes of the kind that had all of New York clamoring for Frank Stella's paintings in the Brad era. Kertess looks cryptic and I would say glum: The photographer has said "Smile," and he has obliged with a minimal displacement of his lips. Just above the canvas is text worthy of Vicki, if we can imagine her as cynical: "The Next 15 Minutes in Art Are in His Hands." Beneath the canvas is a description of the story on page 30: "Klaus Kertess and the Making of the Whitney Biennial." The strained smile is no better evidence for the fact that Kertess was being cooperative in the shoot than is the canvas he holds; it is so much smaller than anything likely to have been in a show made up of works one could not hold in one hand, let alone lift with two, that the photograph has the quality of a cartoon. Paintings that size belong perhaps to the Whitney Biennials of Brad's first giddy fame, if then. The canvas indeed is of the dimension one might encounter on Bellport Lane in Bellport on July Fourth, when artists come from far and wide to sell oil paintings of wharves, bouquets, beguiling dogs, bowls of fruit, old salts. It is not the kind of art all New York clamors for.

There is another way to interpret the disproportion between Kertess and the painting. The image can be read as an allegory of the ascent of the curator in the contemporary art world and the corresponding demotion of the individual artist. Or, correlatively, it is an emblem of how the exhibition has replaced the work as the least unit of artistic significance. Curatorial ascent has come with a transformation in the curator's role, from that of caregiver (Latin *curatus*, derived from *cura*, care) to a collection, with primary responsibility for preservation, inventory, authentication, and acquisition—to that of organizer of the exhibition construed as a creative act. The original concept of the curator is captured by the British term "keeper," as used in such titles as "Keeper of the Queen's Drawings," but there is no sense in which the current concept of the curator corresponds to that of the keeper, for often the curator has no collection to which to minister. The creative curator is characteristically an independent agent with an agenda and a talent for raising funds for mounting exhibitions which may, and in certain spectacular instances do, take place outside museums: I am thinking especially of two remarkable exhibitions organized by the independent curator Mary Jane

Jacob—"Places with a Past," in which works were commissioned specific to certain sites in Charleston, South Carolina, during the Spoleto USA Festival; and "Culture in Action," in which a variety of groups in Chicago, each at a great social distance from the art world, were encouraged to produce "an art of their own." But even within the museum, the primary advantage of having a collection today is to have control of artworks one may use as bargaining chips in getting loans from other institutions for the exhibitions one wants to mount. The first school explicitly dedicated to curatorial studies has been founded, like so many other innovative things, at Bard College. The Center for Curatorial Studies there is built on what one might call a training collection, consisting of works of contemporary art that serve the students as a base for organizing exhibitions, the nature and content of which are limited only by the fledgling curator's imagination. Curatorial studies are but distantly related to art-historical studies, and the sorts of shows projected are remote indeed from those that fall under the standard categories of the art historian, though conceivably the new exhibition formats may change the whole way we look at art history. One would not expect the new curators to mount the monographic sorts of exhibition devoted to single artists or groups of artists. Instead, if I may restrict myself to an actual example that is scheduled at Bard, there are plans for a show dedicated to the art of the Diaspora, which will bring together works from various diasporic peoples in different periods in the hope of seeing what art means for people under that rootless condition, and what it means for the rest of us.

On the basis of publicity such as that conferred by the cover of *The Times Magazine*, Kertess's name is almost certainly more widely known than that of any of the artists in the show he put together, evidence of the transformed status of the curator. Whether his current fame will survive the next fifteen minutes, to use the somewhat cynical phrase of the *Times* headline, is probably up to him. But the conditions are in place for curatorial reputation to exceed, perhaps by a considerable degree, artistic renown; and while it cannot have been with the intention to glamorize his staff that David Ross, as newly appointed director of the Whitney Museum of American Art, decided to put the Whitney Biennial into a single pair of curatorial hands, it is difficult to resist the view that his decision reflected those conditions. Up to then, the composition of Biennials was the collaborative product of a group

of Whitney curators. But when the time came for designing the 1993 Biennial, the idea of the exhibition as a work of art in its own right, with a meaning, a unity, and even a message of its own, and of the curator as a kind of artist who expressed himself or herself in the medium of works of art that inevitably resonated against one another in the framework of the other works selected, had begun to establish itself in art-world consciousness.

By tradition, the Biennial had a meaning and a message that gave a basis for criticism of the show: It was to represent the state of art in America in the two-year interval since its previous mounting, giving viewers some sense of trends and movements, of what kind of work, in collective curatorial judgment, had attained distinction or shown promise of that, and in particular which artists were or ought to be of major interest to other artists, as well as to other art professionals of various kinds and orders. And the inevitable response, which took the form of asking why this or that artist was left out or included, why there was so little or so much abstraction, installation, assemblage, and the like—or, in recent years, why the proportion of women artists or artists of color was as it was—served, in the manner of dialogue, to modify the picture in such a way that by the time the dust settled, there was some overall sense of how matters currently stood in the world of art. The Biennial was a probe that, together with the elicited discussion, came as close to an objective representation as one was likely to get—a far better representation, say, than an army of social scientists, equipped with questionnaires, could possibly arrive at. And the use of the curatorial team was close to an ideal means of arriving not so much at a balanced as at a true representation of how things stood. There would be trade-offs, compromises, tensions, together with a fair distribution of competence, of enthusiasms, of interests. A better system might involve a network of nominators together with a curatorial selection committee that would arrive at the final menu.

It is far from clear, however, that the considerable methodological advantage of the curatorial team survives into the era of the single virtuoso curator. And in consequence it is unclear what the form of criticism appropriate to this show should be, for it is no longer transparent that the intention is to represent the state of art. At best it might be to present one reading of the state of that art which expresses the tastes and interests of the single

curator who chose it. And the response to any criticism can then consist in saying that, well, this is the way I see things. These are the things that I like. This is what strikes me as interesting, or amusing, or important. And maybe this is the best that, in a pluralistic art world, can be hoped for. But this not only changes the nature of the Biennial. It raises the question of why we should have Biennials any longer.

It should be clear that what happens when one puts the next fifteen minutes of art in the hands of a single curator is that it is the single curator who enjoys those fifteen minutes, since the criteria of selection refer inevitably back to that individual's taste. Even if the art world finds delight in a work by Nancy Rubins, consisting of a large cloud of mattresses trussed together with a lot of cakes and suspended from the ceiling by steel cables, it is the curator who is the ultimate recipient of that delight because he or she has selected the artist and the work. Leave it to Klaus, the art world might murmur, knowing a bit about Klaus Kertess's tastes and preferences in art. But these predispositions would be even better known to whomever selected him as curator of the 1995 Biennial, and this suggests a dimension to the single-curator phenomenon I have so far not touched upon. I am not, let me emphasize, criticizing Kertess's tastes. I am, rather, concerned with the institutional change that has made these central to this exhibition.

Many readers will recall an episode made famous by a discussion of it in a widely read essay on existentialism by Jean-Paul Sartre. The philosopher was approached during the occupation by a young man with a dilemma. He wanted to join the resistance but that would mean abandoning his aged mother, who was altogether dependent upon him for her needs. He was torn between filial and patriotic duty, and wanted to know what he should do. Sartre's answer was this: "You're free—choose!" And then, in extenuation of what the philosopher recognized as the seeming unhelpfulness of his advice, he told the young man that he had to have known that this was the kind of thing Sartre would say. Had he gone for advice to the local priest, he would have gotten advice of a different sort. He had, in effect, chosen already in asking Sartre what to do. The same is true of exhibitions. We get the ones we want by asking the curator we know is going to provide it. So in a certain sense, it is the director who chooses the exhibition. And that is very different

from charging a group of curators having presumably diverse agendas with the task of picking a show that will be as representative as possible of where things have been going in the visual arts over the previous two years.

There can be little doubt that the 1993 Biennial was a response to the desire, perhaps never explicitly stated, to mount an exhibition of politically engaged art with strong multicultural credentials. No one could claim that the kind of work chosen for the exhibition was not being made, for of course it was. What anyone with the slightest knowledge of the art world *could* claim, on the other hand, was that the work was not monolithically as political as its reflection in the medium of the Biennial pretended, and that the show was in fact a curatorial decision to put on one of a particular kind. Here and there, of course, there were works that could not easily be thought of as politically engaged—Peter Campus's impeccable but dull digitized photographs of leaves and branches, for example. But these simply underscored what most of the critical establishment perceived as the determination of a new directorate, fresh from the Institute of Contemporary Art, Boston, to show what it felt contemporary art ought to be under the guise of the Whitney format, which had to that point been merely to show contemporary art as it is. But by the same token, it is difficult to avoid the inference that Klaus Kertess was chosen because he would select an exhibition of a very different sort, as indeed he has. Conservative paranoia has naturally seen through what it takes to be disguises, into the political core of the exhibition; but to those unafflicted with that order of pathology, Kertess has chosen exactly the kind of show one is convinced he was expected to. Kertess is a widely respected representative of the art world, with known tastes and a history of having discovered and nurtured, as a dealer, a number of first-rate talents. His adjunct connection to the Whitney goes even further in distancing his show from the critical debacle of 1993. The Biennial of 1997 will be the responsibility of Lisa Phillips, who was a member of the curatorial team that chose several of the Biennials in the period preceding Tom Armstrong's forced departure as director of the museum in 1990 and David Ross's appointment to that position. And in the symbolic language of curatorial appointments, this has to be read as a gesture of further reassurance to the art world, as well as an indication of returning to a period in which the Whitney did not, by taking upon itself the prerogative of moral and political instruc-

tion, alienate itself from its constituency. No institution can thrive, let alone survive, that does not learn when it has moved too far in that direction. Whitney publicists have jocularly characterized the Biennial as "The show you love to hate," but that preemptive effort at collusive jollity would sound increasingly hollow in the face of shows as hateful as 1993's was felt to be. In this sense Kertess has done what was wanted. No one hates the show, partly because it is so quirky and somehow personal that that would be tantamount to hating *him*. But everyone knows that it is no more representative than the last Biennial, simply more obviously idiosyncratic.

Consider the case of painting, until relatively recent times the mainstay of the Biennials and the annuals before them, largely because what was going on in art *was* mainly painting. There were five paintings in the 1993 show, chosen, one felt, through quantity and quality, to demonstrate the leftish thesis that painting had died. Painting had been demonized through the 1970s and, after an uncertain reprieve in the 1980s, villainized afresh as the chosen art-form of the oppressing class. There are by contrast twenty-seven paintings in the 1995 show, and while Kertess's choices are at times eccentric, no one can argue that the proportion of painting to other forms of art has actually quadrupled in the intervening two years. What the difference in numbers as well as kind shows is that Kertess really likes painting, and has special tastes in it. He likes quiet, austere paintings like those of Agnes Martin and Brice Marden, or he likes really funky paintings like those of nobody you have ever heard of, but that, like jokes, are likely to be funnier to some than others.

Or take the difference in catalogues. The 1993 catalogue featured an essay by the writer Homi Bhabha, a well-meaning obscurantist who almost exemplifies through the amiable murkiness of his prose the difficulty of one culture understanding another. Colonialism was but one of the kinds of abuse expressed in the texts and in the gathered works. The front matter of Kertess's book could hardly be more different. After his own whimsical preface, in which he offers the unexceptionable thesis that all art is metaphorical and then undertakes to justify why the work he has chosen is somehow especially metaphorical, there is a poem by John Ashbery which is, well, a poem by John Ashbery; a chapter by Lynn Tillman, "Reveal Codes, or Life Is a

Joke," from a novel in progress that treats of the malheurs of living in a dirty building in a noisy neighborhood with a man who has a joke for every occasion; an essay, by the neurobiologist Gerald Edelman, on works of art as wordless metaphors and the brain as a noncomputer, which it must be left to another occasion to discuss critically. Only the essay by John Hanhardt, who was responsible for the video art in the show, bears any resemblance to traditional catalogue writing. Meanwhile, one approaches the section of texts through a suite of interesting photographic images: a woman's hand holding a pencil and resting on her tattooed arm; an aerial view of Manhattan; what appear to be survivors of an accident gazing on some not so lucky; a branch of coral; a collection of wheels or perhaps gyroscopes; what looks like a tantric pair in fornication intense enough to require a bit of support from obliging assistants; the Tower of Babel as shown in an old engraving; and, finally, the Whitney Museum itself as, I suppose, the Babel of today. Kertess's text is titled "Postcards From Babel," and it is clear that this is the way he sees the show—a diffuse sampling from the art world as Babel. And I suppose the implication is that if indeed the art world is that, any selection that implied a greater order would be a misrepresentation.

Still, postcards imply sites and sights. While there is no question that what Kertess has chosen to send us as images, along with a cheery "Having a great time. Wish you were here," records stops along the winding ramp of the great old tower of incoherence, the question remains, as it always must with the single curator, whether this tells us something about Babel or something about him. There is, for example, a fair amount of what I think of as *fin de siècle* sexuality—sexuality in the mode of Aubrey Beardsley's *Under the Hill*; or *The Story of Venus and Tannhauser*, though of course in the medium of photography rather than drawing, and in the contemporary world a flamboyant way of having safe sex—a lot of touching, cross-dressing, bodypiercing and tattooing, and erotic ritual. Among the dark glossy images of Nan Goldin's *Tokyo Love*, for example, a man, seemingly bound with red velvet ropes, prostrates himself before a woman wearing black fishnet stockings, whom we saw in another shot wearing a shiny red plastic penis. Catherine Opie shows a self-portrait naked to the waist, wearing a leather S&M mask, enough pins stuck in her to equip a team of acupuncturists, and a tattoo reading PERVERT (which may or may not be real—who knows in this age of

computer enhancement?) across her chest. Alongside the generous helping of sexuality, there is a lot of frivolity, some of it spectacular. Most of what we see fits under the three categories of frivolity, sex, and quiet painting. So we are a long way indeed from 1993, when everything fit pretty much under the one category of hortatory multicultural politics. But how close are we in fact to the American art world of 1995? The lesson of two years ago was that simply having serious themes does not ipso facto make serious art. The lesson of today is that not having serious themes does not ipso facto make serious art either.

Are there any masterpieces for which all New York will be clamoring? I thought the mural-sized photograph by Jeff Wall was mysterious and worth viewing, and in truth I remain haunted, as I almost always am, by Goldin's unflinching photography of the sexual underground. I would keep my eye out for Nicole Eisenman for her impudence and fun. The hit of the show is a wall-painting just by the entrance to the museum's restaurant, which shows her painting on a wall amid the ruins of a Whitney Museum demolished as completely as the federal building in Oklahoma City. Various figures are being carted away on stretchers, and those waiting for their tables have been treating it as a kind of *tableau à clef*, trying to identify who, other than Nicole Eisenman herself, is who. It is a marvelous exercise in literal deconstruction. The Biennial will deconstruct itself piecemeal, gallery by gallery, beginning June 4. If you want to see it in its entirety, you had better have turned up by then.

—*June 5, 1995*

SOFONISBA ANGUISSOLA

▪ ▪ ▪

It WAS FITTING AND PROPER THAT THE MUSEUM OF WOMEN IN THE Arts in Washington held the first exhibition in America of the works of the marvelous late Renaissance painter Sofonisba Anguissola—one of the wonders of her age—but that does not explain, let alone excuse, the fact that the show, now closed, went nowhere else in America. I believe in artistic pilgrimages: It should cost some effort to put oneself in the presence of art. But I am also a realist. Sofonisba's works are widely scattered—her masterpiece, for example, is in Poznan, Poland, and a recently discovered self-portrait is in that country's Museum Zamek in Lancut—and, given the difficulties in assembling enough of her production to give a full sense of her achievement (together with the inevitable interest the work of one of Michelangelo's female contemporaries, whom that paradigmatic Great Artist held in high regard, must arouse), it seems odd that a New York venue was not more vigorously pursued. The show traveled to Washington from the artist's native Cremona, with an intermediate stop at the Kunsthistorisches Museum in Vienna; it is difficult not to suppose that resistance of the sort an art activist might complain of accounts for the fact that Sofonisba showed only at what one of the Guerrilla Girls' recent posters somewhat scornfully refers to as "The Women's Museum." If only out of curiosity, American audiences would have an interest in viewing the work of a woman who was, as Vasari tells us, "regarded with admiration" by the court of Philip II in Spain, where she taught painting to the Queen, Isabel de Valois, with "every one considering the excellence and distinction of Sofonisba as something wonderful."

Quite apart from the intrinsic merits of her work, Sofonisba helps us appreciate certain of the constraints under which a woman artist of her time—and for some centuries afterward—labored, which kept women from achieving a recognition only male artists could attain, namely as producers of historical paintings in which the human, and particularly the male, figure was shown in heroic action. There was simply no way a woman was able to train herself by drawing the male figure, and this meant, externally, that women were restricted to what would have been regarded as lesser categories of art, like portraits and still lifes. What it may have meant internally is brought out by Vasari in discussing the work of a Sister Plautilla: "It is manifest that she would have effected admirable things if she had been able to study as men do, from the life, and had been furnished with the advantages of various kinds which the student in design acquires in drawing from nature." He seeks to demonstrate this by pointing out that "the figures and faces of women, whom she could study at her pleasure, are much more satisfactorily rendered in her work than those of men, and have a much closer resemblance to the truth of nature." Though Sofonisba's fame was such that it is hard to imagine she was greatly affected by the external limit—to have been appointed an official painter of Spanish royalty was a pretty high distinction—there is no doubt that the internal limit induced a certain awkwardness in her work. But my sense is that, in compensation, she observed certain expressions more keenly than anyone else had done, expressions of a kind there would be no great use for in historical or religious paintings. And this gives her work a quality one would not find in paintings by male artists. In brief, it could be argued that part of what made her so extraordinary an artist was the fact that she transformed her limits into a vision that would have been available only to a woman. That we do not find a parallel vision in other women artists of her time is a mark of her tremendous originality.

Let us consider the bewitching *The Chess Game*, an elegant and amusing depiction of the moment of victory in which one of Sofonisba's sisters, Minerva, signals her defeat to another, Lucia, who looks slyly pleased with herself, while Europa, still a girl of perhaps eight, grins in great glee at Minerva and a maidservant looks on sympathetically. The girls wear elaborate coiffures and are dressed in heavy brocades; the game has taken place in the gar-

den, with a distant view of hills and chateaus, and the artist has inscribed on the inlaid chessboard, itself placed on the kind of oriental rug we see covering tables in Dutch and Flemish interiors, SOPHONISBA ANGUISSOLA VIRGO AMILCARUS FILIA EX VERA EFFIGIE TRES SUAS SORORES ET ANCILAM PINXIT MDLV.

Sofonisba must have been about twenty years old when she achieved this classy picture, and it shows her at once as both extraordinary and limited in the ways I have indicated. The figure and face of Lucia, who engages us with a look of self-satisfied complicity, are beautifully modeled, though Sofonisba evidently did not want to lose the dark left side of her sister's face in the oak leaves behind her, a problem she solved, awkwardly and rather artificially, by painting a cuticle of blue sky between the cheek and the leaves. Minerva is in full profile, raising her right arm in a gesture of surrender, and one feels Sofonisba had problems in visualizing the connection between the arm and the shoulder, so that the action is rather wooden. There is a further clumsiness in getting the servant into the picture: The artist does not succeed in integrating her with the sisters, who form a natural group. But all these failings dissolve in the light of the extraordinary expression on Europa's face, unlike anything I recall ever having seen. It is a look of absolute mischievousness and glee, a child's innocent pleasure in the discomfiture of an older person. The arpeggio of feelings registered across the three youthful faces makes the painting wonderful, but it is Europa's expression that makes it great.

We can get a sense of Sofonisba's originality by situating *The Chess Game* in the art-historical context in which she acquired her craft. Scholars have postulated a relationship between the painting and an allegorical chess game depicted by Lucas van Leyden, which Sofonisba could have known about through an adaptation of it by her teacher, Giulio Campo. The relationship would be neither one of influence nor of copying in any passive sense but rather one of Sofonisba seizing and making her own, altogether in the manner of the sixteenth-century painter, certain figurative and compositional elements she found in other artists. There is a fascinating exhibition in the East Section of the National Gallery entitled "Imitation and Invention: Old Master Prints and Their Sources," in which one can perceive Dürer and Rembrandt appropriating to their own ends features from the prints of van

Leyden or Martin Schongauer. Engravings were repositories of transmissible visual resolutions: An ornamental building in a print of Dürer's all at once will appear in prints made by Italian artists, even if the building has no architectural counterpart in Italy. This was not plagiarism: There is a marvelous text reproduced for the show from Van Zander's *Schilder-boeck*, which advises artists to steal arms and legs and entire bodies that, when well cooked, "make a good stew." A pictorial stew is a fusion of someone else's ingredients and one's own integrative finesse. I have seen some scrapbooks of Mark Tansey's in which he has cut pictures of figures in various postures from magazines, to form the conjugation of a complete action—a kind of pictorial verb that he draws upon for his paintings. But pictures were not as readily come by in the sixteenth century, and as opportunities for observation of the figure were limited, copying was a necessity as well as a tribute to those copied. A powerfully rendered nude by Rembrandt, seen from the rear, in fact derives from one of van Leyden's engravings, of which Rembrandt owned a great many. And while Rembrandt certainly had the opportunity to observe the female behind, it was plain that he found what he wanted in van Leyden, even if there could be no mistaking the difference in treatment. Sofonisba herself was widely copied: Her portrait of Isabel with a "flea-fur"—the pelt of a marten worn to attract the fleas that might in its absence have attacked the wearer—was the most widely copied portrait in Spain, most famously by Peter Paul Rubens, who visited her in her old age in Genoa. Alas, the painting is known only through its copies: Like a Platonic form, it is available only through its appearances (including a copy by Sofonisba herself). In any case, the practice of copying compensated, though clearly not entirely, for reduced opportunities to draw from life. Copying was a prosthetic for the imagination, but no substitute for the discipline of drawing from nature when paintings were judged by mimetic standards.

Lucas van Leyden's *Chess Game* is an allegorical contest between a knight and a lady, where presumably the stakes are the traditional ones of her virtue against his life. It is an elaborate composition with eight kibitzers as well as the two contestants, and a lot going on. The grossly featured knight looks smug and even bored, as if certain of victory, and mentally comparing him with Lucia is delicious. The lady is delicately lifting a chess piece between thumb and forefinger, and the rather heavy man beside her, evi-

dently a guardian who has an interest in preserving her chastity, seems as if he is trying to stop the move, which I read as a sly, deliberately losing one: What good is a dead knight to a lusty lady? Campo's *Chess Game* has fewer kibitzers, but the lady's lustfulness is made manifest in the opulence of her flesh, and her flower is already symbolically on the table. As she makes her move, her gaze is directed not at the heavily armored knight, whose back is to us, but at a fool who squats in the lower right-hand corner. These are worldly and allusive paintings, replete with symbolic references and an unmistakable prurient undertaste: Each of them brings us into the action with a figurative bawdy wink. Sofonisba has substituted the maidservant for the fool, and moved her into the upper right corner, where nobody, least of all the loser, pays her any heed. I cannot help but feel this is a reference to her teacher's work and a way of stigmatizing the maidservant as a fool—after all, the circle of those who appreciated paintings in Cremona cannot have been large, and a lot of local allusions would have been for its benefit and pleasure. Pictures, here as always, were about other pictures as much as they were about the artist's world. Sofonisba's *The Chess Game* was not painted *en plein air*. The sisters, who had busy schedules, did not in all likelihood hold their poses while Sofonisba got them down right. It was composed on the basis of disjointed observations. She has reduced the number of kibitzers to one, in part out of weakness—she probably could not compose that many figures into a coherent group, as we can see from the failure with the maidservant—but in part out of strength. She gives to her sister Europa the role of commenting on the comedy of the two older girls playing at being Mars and Venus. And she has given her as well that wonderful expression of merriment and mild malice that was entirely her own. Sofonisba's comedy was cooler than that of her predecessors. She was making fun of them quite as much as she was painting a minor episode in the life of an intellectual family.

In sixteenth-century religious or historical painting, the expression of grander, more operatic emotions than Europa's would occupy an artist's physiognomic gifts: rapture, agony, devotion, adoration, pity, anger, terror. But Europa's is a look that registers someone's response to absurdity, silliness, indiscretion, or dottiness, and expresses amusement, mockery, derision. We could not imagine the Virgin wearing such a look at the Annunciation, or John the Baptist as he pours water over Christ. It would be radically out of

place at a Descent from the Cross, an Agony in the Garden, an Expulsion from Paradise, a Last Judgment. So it falls outside the physiognomic repertory of the male artist, bent on high pictorial business. It belongs in the intimate play of expressions that define family life, and as I see it, it would be the kind of look to which a woman artist, then confined to draw her subject from domestic reality, would have been especially sensitive. It belongs in the world to which giggles belong. It belongs in the world of fun.

Yet one also feels Europa's face expresses Sofonisba's essential personality, as if at any moment, in one of those prim self-portraits she made of herself painting or playing the spinet or holding open a book, she might suddenly stick her tongue out at us. One feels that, left to her own, she would restrict herself to the small comedies. It was Sofonisba's drawing of a girl barely stifling her laughter at an old woman she is trying to teach to read that won Michelangelo's admiration. Indeed, Michelangelo challenged Sofonisba to make a drawing of someone crying, and it was characteristic of her marvelously impudent nature that she did not depict a Mater Dolorosa or Apostles weeping by the sepulcher but—the description is Vasari's—"a little girl, who is laughing at a boy, because the latter, having plunged his hand into a basket of crabs, which she has held out to him, is caught by one of them, which is pinching his finger, and the boy is weeping and bemoaning his pain." This drawing was sent by Tomasso Cavaliere, a young man on whom Michelangelo had something of a crush, to Cosimo de Medici, together with a drawing of Cleopatra by Michelangelo.

Sofonisba's life changed when she left her family to join the Spanish court, and though it was a tremendous recognition, I am not certain it was to her advantage artistically. Her output was largely confined to official portraits executed to the somewhat rigid Spanish taste, and there was little outlet for the comic spirit of *The Chess Game*. One senses a certain repressed merriment in her portrait of Philip II that Velázquez would not have allowed to show through in *his* portraits of Philip IV in the next century. Her paintings of Isabel de Valois and of her successor, Anne of Austria, are luminous and alive, and an immense amount of energy went into rendering the intricate gowns and elaborate jewelry essential to the royal presence. I am not sure whether any of the Spanish paintings were known directly by Vasari, though he was aware that the fame of her work "moved Pope Pius IV to

make known to her that he desired to have the portrait of the . . . most illustrious Queen of Spain from her hand," which Sofonisba duly sent.

Vasari devotes two discussions to Sofonisba, the first of which concludes a chapter of his *Lives* and uses the occasion of a critical account of "Madonna Properzia de Rossi, Sculptress of Bologna" to talk in general about women in the arts. He had at that time seen only the drawing of the crying boy, of which he thought enough to place it in his famous album of drawings "as a memorial to Sofonisba, of whose works, since she is dwelling in Spain, Italy possesses no copy." When he next wrote of Sofonisba, he had seen *The Chess Game* in her father's house in Cremona, as well as a portrait of Minerva with their father. This time he writes of Sofonisba not as one of the "women artists" but as an artist in her own right, a representative, along with her sisters and the Campo brothers, of the School of Cremona. That is the kind of progress in perception women artists today are asking be made general, and one wishes, as a matter of symbolism, that Sofonisba's work had not been exclusively shown at a museum dedicated to women's art, grateful as one might be to the latter for the initiative.

The external limits that until relatively late in the nineteenth century kept women from drawing the male figure in life class, which became the monopoly of the academy, necessarily kept them from high attainment in painting as defined by the academic hierarchy that accorded historical painting the highest excellence. In a fascinating study, "Male Trouble," Abigail Solomon-Godeau recently observed that "of all the winning Prix de Rome entries from 1793 to 1863, most of which feature nude or partially draped male figures, there is only one painting depicting a female nude." So how was a girl to compete? The preponderance of male over female nudes perhaps calls into question one of the dogmas of feminist aesthetics, namely the "male gaze," which turns out to have been fixated on the male rather than the female body during the long ascendancy of historical painting. "In fact the female nude," Solomon-Godeau writes, "whose classical lineage is considerably less venerable, has historically occupied a far more equivocal and indeed marginal position." In 1863 an edict was issued that more or less cracked the academy's monopoly and stressed originality rather than "finish." Once women were allowed access to the male nude, there was no

longer much institutional reason for learning to draw it! In any case, Modernism was about to begin when the academy underwent reform, and a whole new class of reasons had to be invented to keep women in their place.

As part of this year's Ritual of the Overlooked, enacted whenever the Whitney Museum discloses the artists selected for its Biennial exhibition, the March issue of *ARTFORUM* devoted a column to what its author, Jeffrey Slonim, wittily designated as 1995's *salon des refusés*. From the thirteen people he interviewed, 172 overlooked artists were mentioned by name, and an indeterminate number of artists were mentioned by gender. A spokesperson for the activist collective Guerrilla Girls, who identified herself as "Alice Neel," had this to say: "Looking at this list, it seems that less than a third of the artists are women. There's no excuse for this anymore. We want to expand the vision of the art world beyond that of white men to include more women and people of color." I must admit that my first response to "Alice Neel" was a certain impatience. I am a great admirer of the Guerrilla Girl as a superordinate being, like Hobbes's Leviathan or General Motors, who expresses herself with an ingenuity, creativity, and wit rarely encountered in the art world, where one might have supposed such attributes commonplace. The Guerrilla Girl is known for political theater, where clever representatives, dressed in full gorilla masks and in fishnet stockings worn sardonically, engage in mocking repartee with members of the audience. "She" is even more widely known for vivid posters that hold a mirror up to the art world's inequities. And she has just published a kind of collective self-portrait, *Confessions of the Guerrilla Girls*. So I expected something rather more pungent from one of its *porte-paroles*, especially one who had taken the name of Alice Neel, an artist known for her edge. What does Guerrilla Girl want? I asked myself, echoing Freud's famous question. Thirty percent is already something!

But as my responses to the Biennial, when I finally saw it, sorted themselves out, I began to think the Guerrilla Girls were right. There may have been moments in the recent history of art where the best work was undoubtedly being done by men: Female Abstract Expressionists in the first generation were marginal, and there were no women Pop artists to speak of. But in today's pluralistic art world, there really is no excuse for anything less than full parity. Whatever relevant criterion anyone can name must be met by at

least as many women artists as by men, even by the daunting criterion of "quality," which cannot have played a major role in the Whitney's 1995 choices. It should be part of the charge to future Whitney curators that equity be sought. Whether this will "widen vision" is something nobody really knows. How much of what might be classed as "women's vision" is due to the kinds of limitations equity would erase is probably an imponderable, though that is no reason not to erase them. We are in any case the beneficiaries of the limitations that defined Sofonisba's vision. She was, in the memorial words of her second husband—a sea captain she fell in love with while sailing from Palermo to Genoa—"although small for such a woman, great among mortals."

—August 7, 1995

TV AND VIDEO

■ ■ ■

A DEDICATED COLLECTOR OF CONTEMPORARY ART TOLD ME, NOT long ago, that she had become enthralled by video now, perhaps to the exclusion of everything else. "The next time you visit, maybe none of this," she said, sweeping her arm demonstratively around to take in the large sculptures and paintings with which I identify her taste, "will be here." And then, leaning toward me confidingly, she added: "I am thinking of having nothing in my home but video." There is a flourishing branch in the visual arts that consists in the modification of tapes and discs, transduced into images on the television monitor through the mediation of the VCR; but the sweep of the collector's arm made it clear that she was not bent on acquiring a library of tapes and discs but a collection of objects on the order of sculptures and installations in which video images are focal. The television set itself can be regarded as a kind of sculpture in this sense—a three-dimensional cube with a flickering face—but in a great many examples of video sculpture the television set has largely disappeared, and the images, liberated from the cube, attach themselves to objects that convey meanings other than those associated with the familiar purveyor of home entertainment. So two models for her future collection came up on the monitor of my mind, though I imagine that both would find space in the collection she intended to form.

The first model was exemplified by an extravagant constellation of television sets I once saw, an entire wall in effect, alongside a swimming pool at the home of a no less dedicated collector in Honolulu. It was a work by the avant-gardist Nam June Paik, who has, more than anyone, made an artistic

vocabulary of aggregated and modified television sets, often arranged with reference to a kind of sculptural syntax. The Honolulu work was composed of perhaps a hundred such sets, in different sizes, sitting in a tangle of wires and showing different moving images, some iterated and flickering, sometimes in unison, much in the way in which we have all become familiar with the bank of monitors in the television studio behind Lynn Russell as she leafs through her notes for the next half-hour segment of *CNN World News*. The curator who was showing me through the collection obligingly switched the work on, and for a time there was a dazzle of color and movement, too much to take in and keep track of, but whose iconography was probably as complicated as that of some heavily carved stupa at Amaravati, showing Buddhist personages and events in the Buddha's life. I wondered if there were not some distant affinity between such oriental profusion and, since Paik is Korean by birth, the sensibility one sees in at least his larger works like *Electronic Superhighway*. It consists of television sets massed to represent the continental United States, whose form in neon tubing is superimposed across the whole work, which is more than fifty feet long and proportionately high. Video images that emblematized various states—California, Alabama, Texas—played across that segment of the work corresponding geographically to those regions, and the work cleverly situated itself in New York, since it showed, via closed circuit, those in Holly Solomon's New York gallery viewing themselves viewing it.

In any case, Paik's work in some sense celebrates the physical fact of the TV set. Well before video art was invented as a medium of artistic expression (interestingly enough by Paik himself), Paik was modifying television sets experimentally. His first exhibition, in 1963 at Wuppertal in West Germany, showed thirteen sets, altered in the same spirit in which John Cage altered pianos, but to make aberrant images rather than deviant sounds. And Paik, who has degrees in aesthetics and in musical composition, in fact also exhibited some "prepared" pianos of his own. The altered television set and the prepared piano perhaps belong to a different aesthetic altogether from that genre of video art based on my second model. There, the emphasis is less on the television set, considered as a mechanism and an article of furniture highly charged with a set of social meanings, and more on the image itself,

which makes no reference to the physical circumstances of its projection, and which, in some of the most powerful examples of the art form I know, seeks entirely to transcend the material conditions of television—wires, rasters, casings—in which an artist like Paik revels. So let us distinguish "TV art" from "video art," to give names to the models I have in mind. TV connotes primarily a form of life—a room in the middle-class household, a frozen dinner—that the television set symbolizes and facilitates, so that in modifying "the tube" one is in a certain sense engaging in a gesture somewhere between social criticism and outright iconoclasm. It could be a comment on commercialization and mass culture, condemnatory or celebratory, as in a work shown at the Venice Biennale this year by the Swiss artists Fischli and Weiss, regarding which a correspondent wrote, "The Swiss pavilion is filled with monitors presenting over eighty hours of mesmerizing images so inordinately ordinary as to be out of place." This leaves "video" to refer to images that owe their provenance to the same technology as television but that make no internal reference to their origins. Video images, when detached from television sets, belong to the world of dream images, which, though caused by brain circuitry, do not refer to it in any obvious way: We dream about sex, success, fear, and flight but never, or rarely, about our brains. Video art, by contrast with TV art, is characteristically spiritual and poetic. TV art is often raucous, and fits artistically with performances of a certain sort—at one extreme, perhaps, with the artist smashing the glass tube with an ax, and at the other, with the late lamented Charlotte Moorman (Paik's great collaborator) playing a cello while wearing Paik's "TV Bra for Living Sculpture," a miniature monitor over each breast, showing images that may or may not have something to do with their provocative siting.

My paradigm of video art is a piece I saw in the underground gallery of the American Center in Paris, by the American master Bill Viola, which had a profound impact on me. Admittedly, its unexpectedness played a role in that: I was being taken for a tour through the building, from the top gallery down, and all at once was led into the underground space where I was hit with a burst of spiritual energy that would not have been out of place at the Sainte-Chapelle, or one of the catacombs. The American Center was designed by Frank Gehry, and though it is somewhat untypical of his work, inasmuch as it uses expensive and even luxurious materials when Gehry is

identified with the most demotic of construction materials—cinder blocks
and chain-link fencing—there is an affinity between Gehry's aesthetic and
TV art, if only because in contemporary culture TV is what Hegel would
designate as the demotic. Viola's work is universally human, but in no sense
demotic.

The work is titled *Stations*, and there would be a wild incongruity in
imagining it in the same space with one of Nam June Paik's more typical
pieces. It would be like seeing Sarah Bernhardt together with the Keystone
Kops, she declaiming Racine while they fling custard pies at one another and
fall down in heaps. Or like Ariadne on her island with commedia dell'arte
buffoons in the last act of *Ariadne auf Naxos*, she singing her heart out while
they make mocking obscene gestures. *Stations* consists of five projected pan-
els, three on one wall, as I remember, and two on the opposite side. I esti-
mate the panels to be about nine feet high. The images, which are of human
bodies, are reflected in a highly polished black stone slab, like some form of
grave marker, placed in front of each of the projected panels—and these
slabs are nine feet long by five feet wide. The images can thus be seen
twice—once projected and once reflected—and the combination of reflec-
tion and projection plays a certain role in Viola's work. They constitute dis-
tinct modes of insubstantiality: Like shadows or mental fantasies, in neither
of their modes do the images have thickness. So in a way we are free to think
of them as souls, if we roughly follow Wittgenstein in saying that the human
body is the best image we have of the human soul. They are in black and
white, which gives them a kind of ectoplasmic impalpability, but at the same
time they are images of the human body, sexed and naked, and bearing the
form and feeling of flesh. In my memory, one of the females was pregnant.
The figures are upside down, submerged up to their necks in water and sur-
rounded by bubbles. But we do not see their heads. We see only the bodies,
with undulating limbs, and bellies, breasts and genitalia. And we hear the wa-
ter burbling and gurgling as they move. Sometimes one of the panels grows
dark. There is a time, between cycles, when they are all dark, which means
that there is nothing but the walls and the slabs, so that the underground
gallery has the form of a crypt. Then, all at once, there is a rush of noise, of
the kind a body plunging into water makes, and one of the figures is vehe-
mently back, its limbs waving like underwater fronds. Then, one by one,

with a similar rush, the figure is joined by another and another, until the full array of five tread water around the spectator, and the noise of moving water, as if a fountain were listened to from beneath the surface, fills the space. And then one by one they leave, returning the space to the status of a crypt, and after an interval the cycle begins again. It is a very powerful experience.

Naturally, we all know that something is being done with computers and switches to create this art, but this is like the knowledge we have about the chemistry of paint when we look at a masterpiece. The interpretation of the work has no room for such knowledge, which forms no part of the intended experience of naked and inverted bodies, submerged in water, and headless, which relate through meaning to the polished slabs but not to the wiring and electrical energy that make the work physically possible: *Stations* addresses us not as nerds but as needers of the kind of spiritual assurance, at the margins of religious disclosure, that is conveyed through the swimming movements of the immersed figures. Naked, headless, and inverted: This description could be satisfied by beings who had undergone dreadful martyrdoms—but these figures do not look as if they have been martyred. There is no visual inference that they have been decapitated, or humiliated by stripping, or hung upside down like Saint Peter or Benito Mussolini and his mistress after they were killed. Nor does the fact that they are shown upside down seem arbitrary, as in the signature paintings of Georg Baselitz (at the Guggenheim Museum). Baselitz has sought to block the inevitable effort to vest upsidedownness with symbolic meaning, by saying that *he* paints upside down in order to underscore the autonomy of painting, so that, to invert a famous theorem of Spinoza, the order and connection of marks on his surfaces need not be the order and connection of things in the world.

Viola is not, so far as I can tell, concerned with the autonomy of video. His interests are through and through symbolic, so that the upsidedownness, nakedness, and headlessness (unless taking away the head conduces to an ultimate nakedness) are to be grasped as metaphors. The viewer doubtless does grasp them that way without necessarily knowing what they are metaphors of. But water is a powerful symbol of rebirth, as the ritual of baptism demonstrates, and one is certain that in some way the figures are undergoing a transformation into a state of purification and renewal. So there is

a quality of promise and hope, whatever one's actual beliefs on such matters, and it is difficult to imagine that anything like this could be achieved in another medium. My daughter and I walked in silence to the Bercy metro stop, our silence a sign that we had both been touched by something of great power and beauty—not quite what I had anticipated in entering the *sous-sol* of Frank Gehry's sly and allusive building.

It has since struck me that no other medium has gone from such inauspicious beginnings to this degree of artistic greatness in so short a time: Video is about thirty years old; it began in 1965 when Sony first shipped portable video recorders to America and Nam June Paik rushed uptown to buy one with the same artistic urgency that, in the 1940s, brought downtown painters to Brentano's to get the first copies of *Cahiers d'Art* to arrive from Paris. There was a traffic jam that day, caused by Pope Paul VI, and Paik climbed out of his stalled cab to film the passing motorcade. The tape was shown that very night at Paik's exhibition at the Cafe à Go Go, "amid a flurry of proclamations," David Ross (now director of the Whitney Museum) wrote, "including the now-classic line: 'As collage technique replaced oil paint, the cathode ray tube will replace the canvas.' " I don't think even photography traversed such an extraordinary trajectory: *Stations* is monumental, with the scale and intensity of a great *Last Judgment*. (It is perhaps impossible to imagine Paik as monumental, however high he stacks his sets.)

Viola is the United States representative this year at the Venice Biennale, where he installed five new works in the United States Pavillion. The choice was a recognition of his stature as an artist, and of video as a mature rather than a marginal medium. I have mixed feelings about not having been able to see Viola's work there. I am not certain that work that aspires to monumentality and, to use an eighteenth-century term rarely applicable to the art of our time, *sublimity* is seen at its best among displays of several pieces. My experience in Paris would, I am certain, have been seriously diluted had *Stations* been part of an exhibition in which it was just one of the works on view. In fact, I have come to have serious reservations about the exhibition as an appropriate format for experiencing art other than that which defines itself in terms of being seen along a gallery wall, work after work, like portraits or comfortably sized landscapes. For example, I suspect that the works of Bruce Nauman, distressing when aggregated noisily and invasively,

as in the recent Museum of Modern Art exhibition, might have been found powerful and perhaps even convincing if taken in one installation at a time. I think the widely resented works that composed the Whitney Biennial of 1993 were just not meant to be experienced all together and at once, since each work was intent upon addressing the viewer along different and not necessarily compatible moral planes. And this is perhaps always true of work that demands a different relationship with us than as "viewer"—when it is meant to dislocate, or transform, or even convert those who come within the circle of its power.

One of Viola's major works is on exhibit, along with works by seven other video artists, in the show "Video Spaces: Eight Installations," at the Museum of Modern Art. I did make the trip to the Institute of Contemporary Art in Philadelphia, where *Slowly Turning Narrative* had its first venue, and in fact our paths crossed on two other occasions in which I experienced the work on its own terms rather than, as at MoMA, as an *example* of video installation (some of the other works in the MoMA show are decidedly not in its class). *Slowly Turning Narrative* is installed in a darkened space, in the center of which a large panel, one face mirrored and the other opaque and matte, rotates on a pole. The panel describes a circle nearly the width of the room, and one feels, especially when first entering, as if one has to squeeze in quickly, before it comes round next. Various images are projected on the panel, which reflects other images as well, including mirror images of the spectators lining the walls, and these belong to the content of the work. One face of the panel displays a large head, presumably of the artist himself, who witnesses and comments on the narrative, which comes and goes in resolving and dissolving images, e.g., scenes of children playing or of someone being operated upon. The commentary is a kind of incantatory, iterated identification of what one supposes is the subject of the narrative, namely each human being in his or her humanity: "The one who . . ." where the blank is filled with a verb, usually of one syllable: "The one who calls," "The one who stands," "The one who laughs," "The one who . . . ," all uttered without affect and as a kind of heartbeat, the diastole and systole of ordinary life. There are other sounds against this regular percussive rhythm—cascades of children's voices and the like, fading in and out—as the panel itself presents face

and obverse, and the images reflected onto the walls dissolve into visual noise. Youth, age, sickness, health is the "slowly turning narrative" in which our images are taken up and covered over and rotated away. Nothing in the show aims quite so high or succeeds at so philosophical a level.

There is a great deal of philosophy *in* the work of Gary Hill, one of whose pieces is included in the MoMA show, without this guaranteeing that the work itself attains a philosophical level. There is, for example, a video-tape of a girl of about ten years of age reading aloud from Wittgenstein's text on color. The girl stumbles over difficult words, but presses bravely on, covering forty-five minutes of reading time in forty-five minutes of real time (reel=real). I was uncertain what the point of having the text read by a child was—I was reminded of Milton being read to by his daughters in languages they did not understand, like Greek and Hebrew. Readings, recitations, even displayed pages of Heidegger figure in other works, each of which has to be considered to see to what degree the language, being philosophical, contributes to overall meaning. Hill's work is situated somewhere between TV and video art, in the sense that one is often conscious of monitors as monitors, in various sizes and variously arranged, as well as of electrical wires being carefully regimented and treated almost ornamentally.

Let me describe Hill's piece at MoMA, *Inasmuch as It Is Always Already Taking Place*. "Always already" is a phrase one finds in the writing of Jacques Derrida, used, I think, to deny that something has a beginning; one might say that human language did not have a beginning, that there was no moment when human beings did not "always already" have language, etc., etc. But let's consider the work, which in fact is really quite beautiful, in the way something quite precious and small, like a set of jeweled ornaments, is beautiful. It has the look of a brilliantly installed window at Tiffany's, in which sixteen monitors of various formats and sizes—some are as tiny as cuff links, some as large as a large photograph—are arrayed tastefully. The black wires, which look as if they make the monitors wearable, exactly like pieces of jewelry, are carefully arranged on the window's floor. On each of the monitors a different fragment of a man's body is shown, one of which consists of what is vulgarly known as "the family jewels" (the man is Hill himself, so the piece is a kind of disjointed self-portrait). The body is shown in some kinds of minimal movement, from fairly reflexive ones like swallowing to the voluntary

movement of a thumb turning the corner of a page. I can make out the words

> Seemed to me
> the future
> present
> k at he

The thumb moves the page, then moves the page, then moves the page. Future and present are one, and since it is clear that this is a loop, the thumb always already moved the page when it moves it. I eavesdropped on two women discussing the work, who told me they were trying to identify the body's parts. I offered to help. They had trouble with something that looked "like a breast." It did indeed look that way, but the shadowed knob moved in ways nipples don't. I felt triumphant when I was able to tell them it was an Adam's apple. I studied the piece for a while after they left, but we met up in the Viola installation, where our images mingled and became submerged in the slowly turning narrative. Hill is a gifted artist, but his work vacillates between the sensibility of Radio Shack and that of the philosophy seminar, and it is never easy to decide which side he is really on, and hence what anything really means.

There is a lot for my collector to choose from in New York and Venice this season, and for my readers to experience here at hand. I want to close by singling out the work of an intriguing artist, Tony Oursler. His work at MoMA is not, I feel, fully baked, so I will describe the part I found so singular, and which can easily be imagined detached from the installation. It is a sort of rag doll on the face of which is projected an exceedingly expressive human face. This is the extreme liberation of the image, which is projected onto an external object with which it becomes integral. The face is baleful and suspicious: The eyes look from side to side, the lips are pursed. All at once the doll screams like someone being tortured, "O God, No, No, No . . ." and then resumes that extraordinary expression. The screams and the expression seem disconnected, as if the person they characterize were mad. Video makes the doll a great deal more alive than a ventriloquist's dummy; the doll's body

makes it somehow less. There are two pieces by Oursler in a wonderful show given over to portraits, installed by Donna De Salvo at the Parrish Art Museum in Southampton, Long Island, which you will certainly want to visit if you drive out that way. There, faces projected on the dolls' heads are quite ordinary as human faces go but not as dolls' faces go. They are personages with dolls' bodies, and of course souls. One of them says such things as "I enjoy cooking." Or: "I fear doing something evil, to myself or to others." The dolls are in some unaccountable way uncanny, as dolls endowed with life always are, and I am uncertain my collector would want to live with one. But they seem to me to define the threshold of a new age of the video image.

—September 11, 1995

FLORINE STETTHEIMER

■ ■ ■

LATE LAST SPRING I HAD AN INTERESTING DISCUSSION WITH THE painter Elizabeth Murray at an opening, at Paula Cooper's gallery, of the work of Jennifer Bartlett. Bartlett appeared to have taken rather a new direction, in that her paintings showed a number of small figures somewhat malevolently engaged with one another, and a certain moral darkness suffused the scene of their admittedly ambiguous interactions. The works seemed to imply some kind of narrative connection with one another, as if each marked an episode in an unhappy story, if one only knew how to unfold it. Bartlett's work had always been simultaneously cosmic and cheerful, though schematic enough at the beginning that critics thought her impulses altogether mathematical, since she deployed dots of paint as points on Cartesian grids. The grid remained a signature element, but the points were replaced with objects—houses, trees, hills, and bodies of water in her famous work *Rhapsody*, and then with large numbers of natural creatures in her series devoted to the Aristotelian elements of fire, water, and air. It was as though she were re-creating the sequence of creation, beginning with some kind of mathematical structure, then fitting in the basic things a livable world requires, then populating it with fauna and flora, and now she is creating the human denizens. But everything seems to have gotten bleak with the coming of humankind. The grid remains, but as a sort of gray drizzle over the surface, a kind of scrim through which we are shown some rather doll-like humans up to no good. Murray and I both agreed that—*toutes proportions gardées*—there was a certain similarity between Bartlett's figures and those of

Florine Stettheimer, who worked in New York in the 1920s. And we were both somewhat taken aback by the comparison. It had, Murray observed, been a very long time indeed since one could cite Stettheimer as the basis of a favorable comparison to a cutting-edge artist in an advanced New York gallery. Just a few years ago, Stettheimer's name would have been unmentionable in the precincts of serious, ambitious art. So some deep transformation has taken place in the art world, of which the acceptability of this correspondence made us all at once aware. The fact that we would mention the two remarkable artists together was more interesting, perhaps, than the comparison itself.

I have always had a certain proprietary interest in Stettheimer's work, since quite a bit of it is owned by Columbia University, where I taught for a good many years. But beyond that I have gone out of my way to see her paintings, which I actually relish. This would not have been the kind of thing one confessed to in an art world that defined artistic greatness in terms of abstraction and tragedy, heroism and gesture, monumentality and formal truth, sublimity and the absolute—and the quest for purity and essence. Alongside the arduousness of the artistic quest this connotes, Stettheimer's work appears frivolous and even flossy. That it has become acceptable to mention her approvingly testifies, at the very least, to what Nietzsche would call a transvaluation of artistic values: It is not that our values are now urbanity, femininity, archness, hedonism, elegance, dreaminess, and swank, to cite some surface attributes of Stettheimer's work. It is rather that there is no overarching set of aesthetic properties that critically acceptable work must now embody to the exclusion of any other. We are living in a pluralistic art world now, in which it is possible even to admire Stettheimer extravagantly for her individuality, her wry touch, her surprises and put-downs, the deliciousness of her celebrations, her decorative enthusiasm, the lace-and-candy atmosphere in which she depicts her friends and family, her edgy compositional snootiness, and her intellectually astringent taste. Moreover, Stettheimer was widely admired as a paradigmatically modern artist in the 1920s and 1930s, when the features just enumerated were not regarded as in any way inconsistent with Modernism. We can see in this transvaluation an index of changes in the concept of Modernism since her death in 1944. The Modernism that marginalized her has itself been marginalized, in large part, by a

renewed appreciation of the revolution in the concept of art achieved by Marcel Duchamp, who was a mover in the memorial exhibition of Stettheimer's work at the Museum of Modern Art in 1946. (You can get a sense of this change in the status accorded Duchamp himself, by observing the prominence given his work in the hanging of MoMA's permanent collection by curator Kirk Varnedoe.) So we can enjoy Stettheimer without feeling aesthetic guilt: If the Modernist puritanism of yesterday were still in effect today, to say that one actually *liked* Stettheimer would be taken to signify a kinky constellation of dubious preferences fit to be aired on shows like *Real Personal.*

The gritty squalor of talk-show divulgences—abuse, molestation, incest, domestic violence, infidelity, abandonment, clandestine burial, eating disorders—seemed alluded to in Jennifer Bartlett's narrative series, but that is a moral reality (ours) that could not differ more from the one implicit in Stettheimer's world of picnics, birthday parties, summer vacations, entertainments, amusing dinners, sophisticated gatherings, tennis matches, and art shows.

Consider just one of the marvelous paintings on view in the exhibition "Florine Stettheimer: Manhattan Fantastica" at the Whitney. It depicts an elaborate lawn party the Stettheimers held in honor of Duchamp, a member of their circle (as well as Florine's French tutor), and is called *La Fête à Duchamp*, a play on the guest of honor's name and a genre of outdoor entertainment—the *fête champêtre*. It takes place outside the city in a property rented for the summer by the Stettheimer women—Florine, her two sisters, Ettie and Carrie, and their mother, Rosetta—and it is marked by the leisurely passage of time, from afternoon to evening, as we see the same personages engaging in various genteel recreations from the moment of Duchamp's arrival to the dinner itself, held under lanterns in an open tent at the back of the property, where one of the sisters raises a toast to Duchamp, who lifts a glass in acknowledgment. He appears four times in the painting, much in the way Saint Bernardino makes multiple appearances in a Siennese panel, marking the progress of a miracle—hearing the prayer, performing the resuscitation, receiving thanks. Barbara J. Bloemink, who cocurated this exhibition with Elisabeth Sussman, has just published an absorbing text, *The*

Life and Art of Florine Stettheimer, in which, among other scholarly achievements, she has identified each of the figures in these pictorial transcripts of episodes, real or imagined, in what is presented as a charmed life. The title of her book is exact: Stettheimer's work is her life, alembicated into art. Thanks to Bloemink's research, we are able to see four stages of Duchamp navigating a *fête champêtre* rather than four distinct individuals engaged in different activities simultaneously. He drives up, waving from a red runabout driven by his fellow artist Francis Picabia; he salutes Florine as he stands at the gate; he amuses a female guest on a canopied swing; and at the climax of the evening he accepts the good wishes of his hostesses. The art critic Henry McBride, who was to become part of the Stettheimer entourage, commented on this painting when he saw it at an exhibition in 1918, "The more I think of it the more miffed I am that I wasn't asked to that party." I think all of us who admire the painting feel some of McBride's chagrin.

The figures in *La Fête à Duchamp* are slender, elegant, and indolent, and the afternoon unfolds into evening like a ballet. They have indeed the very doll-like quality of little figurines that Stettheimer fabricated for an unproduced ballet she designed around 1912, and for her immensely successful sets and costumes for Virgil Thomson and Gertrude Stein's opera, *Four Saints in Three Acts*, first produced in 1934 and regarded as the very epitome of modernity at the time, since it fused modern music, modern poetry, and modern art. I would speculate that the defining art of 1920s Modernism was probably the ballet as reformulated by Diaghilev, who enlisted such painters as Picasso as collaborators, and these in turn adapted their style to the overall idiom of the ballet theater.

Stettheimer had been dazzled by Nijinsky in Paris before the First World War forced her family to return to America, and the weightlessness, the bonelessness, the seeming effortlessness of the Nijinskian leap pretty much fixes the limit of her idealizations of the human figures we see, between parted curtains, quickstep or cakewalk across flowered carpets or golden lawns to join one another for gossip, flirtation, light conversation, cocktails, or tea. So my thought is not merely interpretive but explanatory: The paintings are interpretable as ballets of modern life, but they also derive their modernity from the aesthetics of the ballet of their time. *Four Saints in Three Acts* had its debut at the Hartford Atheneum, then the most advanced

museum in America, and it was to Hartford that Lincoln Kirstein brought George Balanchine when he undertook to form an American ballet company. The Modernism that displaced Stettheimer also displaced ballet with the avant-garde dance of the Judson Memorial Church crowd and the like: stark, minimalist, Wittgensteinian, and moralistic, verging on performance art and the kind of consciousness-raising that goes with it. In a famous philosophical work, *The Sense of Beauty*, George Santayana defined beauty as "pleasure objectified." One could not find a better formulation of Stettheimer's paintings. But the Modernism that displaced *her* Modernism would not give pleasure the time of day.

More than one reviewer has commented on the striking affinities between the typical Stettheimer painting and the *New Yorker* cover in the classical period of that magazine, by such artists as Edna Eicke and Constantin Aladjalov, where tiny figures are depicted in the activities, urban and suburban, that define an idealized New York life. Stettheimer's brilliant painting of 1921, *Spring Sale at Bendel's*, would have slid smoothly onto the coated paper of the magazine, which was not to exist for another four years. The red velvet curtains open to reveal a chorus of ladies in a large changing room, with mirrors and spindly screens. The perspective is from above, the precise angle from which Eustace Tilley, once a year, gazes aloofly down on a butterfly— and the ladies are indeed like so many ornamental insects, sloughing off their outer garments and standing about in flimsy slips, pulling frocks over their heads or holding them against their bodies to see how they look, sitting down to straighten their stockings or admiring themselves in their new outfits. A solemn eunuchoid male stands guard; a saleslady greets customers with an armload of rejected garments; a small, improbable dog sits on the first step of a red staircase, wearing a kind of varsity sweater with the artist's monogram. It has exactly that touch of condescending and forgiving wit that marked the *New Yorker* cover. But in truth, *The New Yorker* was as much an emblem of Manhattan Modernism as Stettheimer's paintings, or the sculptures of Elie Nadelman or Gaston Lachaise, or for that matter the Chrysler building. When Virgil Thomson wrote Stettheimer requesting some sketches, he proposed a collaboration for a new ballet by "the Russians," who

were already considering a work by Cole Porter and Peter Arno, and another by George Antheil and Alexander Calder.

It was a single cultural spectrum, and it is valuable to consider Calder and Arno and Stettheimer as situated in different places along it. It was not an affectation that *The New Yorker* used the word "artist" when another publication would have used "illustrator" or "cartoonist," and Arno, of course, was the star cover artist of the magazine: Harold Ross somewhat extravagantly declared him greater than Rembrandt. *The New Yorker* continued to encapsulate Manhattan Modernism as what the Germans call a *Zeitstück*—a complex belonging to one historical moment that survives into an altogether different historical moment—until its recent editorial transformation, evidently by people who found its blend of innocent insouciance and dapper wit unconnected with the surrounding culture, and changed it into something closer to the voice of talk-show existence. In a foreword he wrote to a collection of *New Yorker* covers, John Updike commented on how current events cast not the slightest shadow on the bright world of the covers. And this was certainly true of Stettheimer's paintings. The family "sailed through" the Depression, Bloemink observed, and little by way of shadow fell across the face of Stettheimer's work. It remained a world of friends and flowers to the end.

There is something mythic in the idea of three talented sisters living the smart Upper West Side life in the Manhattan of fifty years ago, remaining single but also worldly enough to have crushes and entertain romantic fantasies, in constant artistic interaction with the representative painters, sculptors, writers, and theater people of their time, and with money enough to travel, entertain, and cultivate their gifts. The family was abandoned early on by the father, but nothing like a lost-father syndrome appears to have manifested itself in the dense femininity of the household; nor did the fact that it was a single-parent family wreak any particular emotional havoc, unless—to protract the talk-show litany—in the evident inability of any of the sisters to form enduring meaningful relationships with significant others. Ettie was the philosopher and the novelist, Florine was the painter and the poet, Carrie was the hostess who found a certain creative outlet in a dollhouse, which is on permanent view in the galleries of the Museum of the City of New York.

Many of their friends contributed miniature examples of their work for the dollhouse, including Duchamp, who painted a tiny version of his notorious *Nude Descending a Staircase*. There is in the current Whitney exhibition a portrait of Carrie of 1923, standing beside her dollhouse and wearing an ermine train and a black lace shawl that, combined with the curious antennae-like ornaments of her hat and her attenuated waist, give her the appearance of a glamorous insect. Ettie is shown, in her portrait, in the reclining posture of a siren, floating in a kind of dream, together with a metaphorically burning Christmas bush, amid a constellation of stars. Florine depicts herself in a black beret and diaphanous garment tied at the neck, holding a swag of flowers, and hovering beneath the sun, looking, Bloemink suggests, like an exotic dragonfly.

I suppose one might think of the Stettheimer circle as an American Bloomsbury, with three sisters as against the two Stephen sisters, and Duchamp corresponding to Roger Fry as the artistic theoretician, and Carl Van Vechten possibly corresponding to Clive Bell as cultural adventurer. *The New York Times Magazine* ran a fashion section a month or so ago under the title "Doll House Party," which showed worldlings dressed in clothing inspired by what one sees in Florine's paintings, mingling with dolls of her design displayed against cleverly manipulated photographs of Carrie's dollhouse. It, together with the long lines at the Whitney, may be a straw in the winds of taste. It would be deliciously ironic if the magazine that traded its Modernist birthright for a diet of grunge should find that the readership it sought is instead interested in the top-hat-and-tails sophistication it discarded in pursuing them. Those who live by the market perish by the market.

Stettheimer evidently did not attempt to sell any of her work, though she exhibited in major shows throughout her life, including many prestigious invitationals, and she was solicited by important dealers to allow them to represent her commercially. She requested, somewhat wildly, that her paintings be destroyed upon her death, but did not exactly specify that in her will. Ettie distributed them to various institutions, which is how they fell into Columbia's hands: It was rumored that the university was about to acquire a museum of its own. Her family was somewhat doubtful in regard to how good she was, but that is the way of families. *The Nation*, it is gratifying to

note, counted itself among her admirers. Its critic, Paul Rosenfeld, wrote on May 4, 1932, that "the canvases of Miss Stettheimer, indeed, stand well among the exceptional works of art now being produced," and he had particularly acute things to say about *Spring Sale at Bendel's* and its peers. "They are full of marvelously chic and quite diaphanous persons; and if these puppets . . . are all exalted and pompous about ridiculous things, they also have an elegance and elfishness which is not quite of this world." Between Rosenfeld and the present moment fell the shadow of a Modernism that made admiration of Stettheimer a closet affair and pleasure in such painting forbidden. Most of those who throng the Whitney know nothing of this. The paintings are filled with sly rewards for those who pry into the visual detail, however little they may know of Joseph Hergesheimer or Baron de Meyer and other nearly forgotten notables of the Age of Florine, and however lost much of the precise iconography of the unfinished *Cathedral* paintings may be on them. It is a tribute to Jennifer Bartlett that when some of us sought to penetrate the strangeness of her recent work, it put us in mind of Florine Stettheimer.

—October 30, 1995

CONSTANTIN BRANCUSI

. . .

*I*N A DEFINING ANECDOTE OF MODERNIST ART, ALMOST TOO MYTHI-
cally perfect to be historically true, the painter Fernand Léger is reported to
have claimed that he, together with Marcel Duchamp and Constantin Bran-
cusi, attended a Salon of Aviation in Paris in 1912.

> Marcel walked around the motors and propellers without saying a
> word. Suddenly he turned to Brancusi: "Painting has come to an end.
> Who can do anything better than this propeller. Can you?"

Aviation furnished a stirring metaphor for the early Modernists—Picasso
and Braque saw themselves as the Wright brothers of a new artistic era—but
the vignette of three artists, almost as Magi, gathered in adoration of the
propeller, has something of the aura of a fable. And this seems all the more
true when we reflect upon the way in which the propeller had to mean quite
different things to these three different artistic temperaments—as art after
the end of painting to Duchamp, as painting congruent with a new machine
age to Léger, and as sculpture that embodied the idea of flight to Brancusi.

Duchamp's thought that painting had come to an end may have meant
that science now furnished the kind of aesthetic excitement for which up un-
til then one had looked to art. He had, in 1912, completed *Nude Descending a
Staircase*, the subject and title of which were disapproved of by the group of
artists Gertrude Stein referred to dismissively as the "Little Cubists," with
whom Duchamp had up to then been associated. "Even their little revolu-

tionary temple couldn't understand that a nude could be descending the stairs," Duchamp said later. So he withdrew the painting from the Salon des Indépendants but went on to show it at the Armory Show in New York the following year, where it became notorious. The painting seemed impudent and irreverent, somewhere between a hoax and a joke, but there is reason to believe that Duchamp saw it as embodying scientific ideas. And while the *Nude* explosively proclaimed a new era in art, Duchamp indeed had effectively abandoned painting: In 1913 he began to sketch the outlines for a theory of measurement and time-space calculation that "stretches the laws of physics a little," and this perhaps explains what the propeller meant to him. "He was very strongly attracted to these precise objects," Léger went on to say, making plain that Duchamp did not see in the propeller a precocious "readymade" as he came to call those inauspicious objects he declared to be artworks—bottle racks, snow shovels, bicycle wheels, urinals. The propeller was far too aesthetically distinctive to qualify as a readymade.

If Duchamp saw in the propeller the embodiment of scientific truth in pitched blades, Léger saw it as an emblem of the aesthetics of the machine. And in 1924 he stated that "the manufactured object . . . clean and precise, beautiful in itself . . . is the most terrible competition the artist has ever been subjected to." For him, the machine was the paradigm of what painting should be.

It was, oddly, Brancusi who went on to create a work of art—*Bird in Space*—that, in 1927, after it became notorious because U.S. Customs refused to grant it the status of artwork, was said to be "like nothing so much as, say, half of an airplane propeller" by the *New York American*. I say "oddly" because Brancusi had interest neither in the philosophical spirit in which readymades were pivotal, nor in machinery and the spirit of applied science. That *Bird in Space* should have looked like part of a machine was irrelevant to his project as an artist.

Brancusi's interest, indeed his obsession, was with flight itself: "All my life," he said on one occasion, "I have only sought the essence of flight. Flight! What bliss!" And, on another occasion he declared that

As a child I always dreamed that I was flying through the trees and in the sky. I have kept the memory of that dream and, for forty-five years,

I make birds. It is not the bird that I wish to express but its gift, its flight, its élan.

If flight was a metaphor for Picasso and Braque, it was never really part of the content of the early Cubism they together invented, which could scarcely be more earthbound, in feeling and in tone. But it is the very core of Brancusi's sculptural vision, nowhere more than in the work that made him famous in the eyes of people far from the art world, within which, of course, by 1927, he was very widely acclaimed. It is something of an irony, then, that it should have been one of his birds—polished as only brass fittings but never works of sculpture (which aspired to the patina of antiquity) had been polished before—that raised the question of the boundaries of art we associate with Duchamp, and that, because it looked so much like a mechanical instrument, seemed to many to embody the machine aesthetic of Léger. But it was no part of Brancusi's intention to redraw the boundary between art and reality, and the machine aesthetic could have meant little to an artist bent on reducing bird-flight to its essence.

There is an important difference between getting an ordinary object accepted as a work of art and having a work of art taken as an ordinary object. The latter is simply a mistake, whereas the former entails a philosophical revolution in the very meaning of art. So it is interesting to contrast Duchamp's failure to get a urinal accepted as art with the successful effort to get Brancusi's sculpture so accepted, even if, to the eye of the Customs Office, it looked, in point of ontology, to have no greater claim as art than that fateful urinal Duchamp wickedly sought to enter as a work titled *Fountain* and crudely signed and dated "R. Mutt, 1917" in the exhibition of the Society of Independent Artists of that year. The exhibition was to have neither prizes nor jury, but even so, *Fountain* was rejected by the Hanging Committee, which claimed it did not meet the minimal conditions of admission, since it was not a work of art. So far as I know, this now-legendary event did not make the newspapers or elicit signed petitions or protest meetings.

Bird in Space, by contrast, had been purchased by the photographer Edward Steichen, who was charged duty on it when he attempted to bring it into the country. Like the Hanging Committee, insisting that a urinal is a

urinal and not a work of art, the Customs Office insisted that this particular piece of polished brass was not a work of art but either a kitchen utensil or a hospital supply, under which categories it was allowed to enter the United States. As an artwork it would not have been subject to duty, but as "a potato masher," as Duchamp, using Customs Office criteria, counterfactually described it, it was so subject. The 1927 trial of *Brancusi v. United States*, which vindicated *Bird in Space*'s claim to be art, was widely and jocosely covered in the press, and one wishes there had been a comparable trial of *Duchamp, Plaintiff v. Society of Independent Artists*, if only to see what the legal argument would look like.

There is of course the difference that Duchamp did not make the urinal but bought it ("readymade"), while Brancusi designed and finished *Bird in Space*. Suppose he had made and finished something that looked exactly like half a propeller: Would his labor and craft have made it an artwork, when he could simply have bought a propeller half? The attorney for the defense argued that there was no difference between the work and a mere piece of curved and polished brass—say, an up-market potato masher. In the end it was accepted that *Bird in Space* could be said to represent a bird, even if it did not look, feather for feather, beak for beak, like those creatures in connection with which we as children learn to use the word "bird." What precisely could *Fountain* be said to represent other than concretely what it was, and abstractly the concept of art? Thus *Fountain* survives as a philosophical case and *Bird in Space* as a legal one. If there is a problem with *Bird* today, it is perhaps that it is too easy for us to see it as a bird in space. We postmoderns would be philosophically more at home with a propeller, or even half of one, bearing the same title or no title, where the beauty would be incidental rather than inherent to its appreciation as art: *Bird in Space* is almost blazingly beautiful. That is why, among other reasons to be sure, we need exhibitions of Brancusi's work such as the magnificent one recently at the Philadelphia Museum of Art.

Brancusi certainly conceived of his birds as metaphors for spiritual liberation rather than ornithological specimens; and the fierce polish he imparted to their surfaces was an auxiliary metaphor for luminescence rather than a salute to the machine. If evidence more than what the works themselves present is required in support of this, one might consider his photographs of

these sculptures. He learned photography in order to be able to show others how the sculptures were to be looked at, but only relatively recently has it been recognized how central a part of his artistic achievement his photographs are, even if they are mainly of his sculptures. As photographs, in fact, they look amateurish—dotted and spotted and over- or underexposed. But in truth I think Brancusi was able to show things in photographs of sculptures that the sculptures themselves were incapable of showing. In a photograph of his *Golden Bird*, taken sometime between 1919 and 1922, he focused an intense light on the sculpture, which reflected off its polished surface back to the film in the form of what in a professional photograph would be a glaring imperfection: There is a white blur, an effect rather than a picture of light. That blur is only in the photograph, however; it is not on the surface of the sculpture or in the space in which it stands. And it really is very much as if the bird has turned into pure light. The photograph shows, if the sculpture alone does not, the way in which the "bird is a symbol of flight liberating man from the narrow confines of lifeless matter." Of course, this requires us to treat light itself as a symbol rather than a physical reality, but that is what looking at art after all requires. Over and over in the photographs, the physical limits of speed and exposure are stretched to convey interpretive information about the work.

Beyond the puzzles and practical problems caused by seeing real things as art and seeing art as mere real things, there is enough settled ambiguity in Brancusi's reduced and elegant forms to give rise to occasionally startling ambiguities both of perception and of interpretation. Consider *Princess X* of 1915, which exists in both marble and bronze. It was said to be of Princess Marie Bonaparte, who went on to become a disciple of Freud as well as a writer on female sexuality. One does not tend to think of Brancusi as having in any particular degree an insight into the human soul—his horizons were cosmic and metaphysical—but in view of Marie Bonaparte's endorsement of Freud's idea of woman as lack, the artist must be credited with an uncanny degree of prescience. *Princess X* is what one would in my youth have called a *modernesque* effigy of a woman. Her inordinately long and curving neck rises out of her stylized breasts, and culminates in a featureless knob of a head, small in proportion to the diameter and certainly the length of the neck. In Bran-

cusi's signature polished bronze, the sculpture seems to belong to the decorative style of the 1920s. It was shown without incident in the Salon des Indépendants exhibition of 1917, which was so inhospitable to *Fountain*. But it caused considerable stir there because it looks enough like a stylized set of male genitals to have gotten expelled on grounds of obscenity. There is, indeed, an arch watercolor by Charles Demuth showing a group of figures in an art gallery, gathered around Brancusi's piece much as the three artists must have done round the propeller in 1912—only their perspectives are sexual: One man is peering at another's crotch, while a woman wearing a swanky dress cools hers with an ornamental little fan borrowed from another of Brancusi's works. (As if by preestablished harmony, the work is called *Delicate Air*!) Brancusi, outraged by his expulsion, insisted that "it is 'Woman,' the very synthesis of Woman. It is the eternal female of Goethe, reduced to her essence." It is not as if Marie Bonaparte, in her Freudian mode, would have disagreed, taking the work's other identity as what was essentially lacking.

It is a matter to meditate upon that the sculpture of one kind of being, abstracted and reduced to its essential form, should all at once turn into its opposite. And while it would in consistency be too optical a conceit for Brancusi to have created an illusion near of kin to the Necker Cube or the Old Woman=Young Woman figures of the psychology textbook—now you see it as woman, now as phallus—he was not without a certain impish humor. Anna Chave, in an astute text of feminist hermeneutics on Brancusi, is particularly sensitive to issues of gender and sexuality. She sees his *Torso of a Young Man* of 1917–22—a polished cylinder rising up from between two truncated cylinders very nearly the same diameter but hardly the same length as it—as again a set of male genitals, and again something of a joke. The torso could be pure in view of the fact that it lacks genitals—until, as she observes, one recognizes that it *is* nothing but genitals. The ambiguity of *Princess X* fits poorly with the austere and Platonist vocabulary brought out to characterize Brancusi in art appreciation courses, where he is celebrated as "The Mondrian of Sculpture" (I am not even certain that Mondrian is "The Mondrian of Painting") and concerned with the "self-contained perfection of the egg" and the "pure dynamics" of the bird form, to cite a standard textbook. Consider the works used to illustrate these two descriptions, *New Born*

of 1915 and *Golden Bird* of 1919–20. These works certainly look, respectively, egglike and birdlike, and either in polished marble or bronze they seem formally, no less than metaphorically, pure. But the egg form has a sharp, flat lapidary plane, as if something had been lopped off one of its ends, and the bird is sharply notched, not only as if it had a beak but as if the beak were open. It very quickly becomes obvious that *New Born*'s lopped surface is a mouth open in an infantile yowl, and that the open mouth of the bird could as easily be connected with eating as with song: The stretched neck and the rounded tummy go perfectly with the swallowed worm, as if the work illustrated Santayana's beautiful thought that spirit goes aloft only on material wings. Brancusi was an earthy man, a man who loved food and drink and dancing and sex, mad for parties and good times. But a myth of spirituality, doubtless encouraged by him but at the same time representing something that people wanted artists to be, has deposited a cataract of purity over his works. The viewers of the Armory show, who found his *Mademoiselle Pogany*—with its heavy arched eyebrows and its huge egglike blank eyes and flipperlike hands folded as if in prayer—nearly as hysterical as *Nude Descending a Staircase*, were not necessarily blind to its merits. Why could a work not be beautiful and comical at once?

I have made a particular effort to yoke the art of Brancusi and of Duchamp together here, however incompatible their projects might appear: Duchamp the erotic comedian, Brancusi the pure Platonist; Brancusi is the paradigm of the modern, Duchamp the thinker whose contribution exploded the aesthetic premises of Modernism and set the scene for art of the postmodern era. But the two men were intricately linked in their lives—Duchamp indeed made a market for Brancusi's work in the United States, and supervised at Brancusi's request the installation of the latter's work in a major exhibition. And the initial legal appeal in the *Bird in Space* case went in over the signatures of Steichen and Duchamp. Moreover, both artists were collected in depth by Louise and Walter Arensberg, who were among the leading patrons of New York Dada and clearly saw no particular incompatibility between the two masters. Indeed, the Arensbergs' collection—including some forty works by Duchamp and eighteen sculptures by Brancusi—was bequeathed to the Philadelphia Museum of Art in 1950. It was Duchamp who

judged that the Philadelphia museum had the appropriate "air of permanency" for their work. "In Brancusi," Chave writes, "Duchamp eventually recognized a fellow missionary, if from another sect."

In candor, I have not paid particular attention to the Brancusi works on my various expeditions—pilgrimages, really—to the Philadelphia Museum to see what fresh revelations Duchamp might disclose. I am all the more grateful, accordingly, to Margit Rowell and Ann Temkin, the curators responsible for the great exhibition of Brancusi's work; it dissolved the overglaze of cliché that had occluded his power for me and I daresay countless others. Brancusi was deeply preoccupied by the question of how his work was to be seen, and was shaken when it was installed against the grain of his vision of the work and the affinities between the various pieces, which somehow all belonged together, the question being how. Temkin, working with the architect Richard Gluckman, found a way of making the exhibition a totality rather than an aggregation of pieces. The show itself curved upward, from the egg forms and heads closed in sleep to a tremendous *Endless Column* at the end, which touched the ceiling. It managed, by curatorial miracle, to express the artist's spiritual aspirations and at the same time bring his work back down to earth.

—*January 22, 1996*

VERMEER

. . .

*A*N OBJECT IS PERCEIVED AS BEAUTIFUL, ACCORDING TO KANT, WHEN we experience it as purposive without our being able to say in what its purpose consists. This famous, obscure thesis formulates nearly to perfection the enigma of beauty in the work of Johannes Vermeer, whose paintings seem fraught with a kind of meaning they also refuse to disclose. Consider to begin with two paintings in the central gallery of the tremendous exhibition of Vermeer's work briefly at the National Gallery in Washington, each of them showing a woman alone, obviously captured by some perturbation of life, minor or momentous it is impossible to say. One woman, her left hand on a fiercely polished pitcher, is looking out a window, and the question arises whether she is momentarily distracted from some household routine or is waiting for someone in connection with whom the pitcher may acquire a meaning in the ritual of hospitality. The other woman, wearing an elegant blue smock fastened with wide ribbons, is reading what we spontaneously assume is a letter. Has the letter come in place of the individual she is dressed and coifed to expect? Her lips are parted, whether in surprise or because she is reading aloud we cannot say. But the painting could be a kind of Annunciation, the woman anticipatorily pregnant and the magical luminosity of the room the presence of the Holy Spirit. The woman with the pitcher may be preparing to lave the feet of the Awaited One. Are these paintings religious metaphors or transcriptions of domestic realities? Did women of a certain class routinely wear such fine clothing, or did the artist present them garbed

in a way suitable to the awesomeness of the narrative in which they are caught up? It is integral to the beauty of Vermeer's representation that it escapes our explanations without releasing us from the desire to understand.

Vermeer lived out the entirety of his nearly unknown life in Delft, leaving us thirty-five paintings (of which twenty-one are here on view) and nothing else—not a letter, a diary, a studio note, a drawing. So there are no grounds for ascribing an intention, other than what is found in the paintings themselves. The reader may ask why one might treat what could easily be simply a lovely transcription of domestic reality, so far as subject matter is concerned, as spiritual embodiments of female roles in a great religious narrative. Well, the exhibition begins with three uncharacteristic Baroque paintings, one of which shows Christ in the home of Mary and Martha and another of which shows a woman washing the feet of the goddess Diana. The third painting, only recently attributed, deals with the theme of Christian martyrdom. The last painting one sees upon exiting the exhibition is an Allegory of Faith. Treating the first and last of the paintings as brackets, so to speak, it is difficult to suppose that everything they enclose is merely secular, domestic narrative. Moreover, there is the evidence of the way everything is shown. How would one explain the gorgeousness of the representations if the reality itself were totally disproportionate to the glow and glory of the work? It is as if the paintings were themselves devotional images. Or, if they are not, then the gorgeousness becomes one more mystery.

In part, one feels, a primary vehicle of their meaning is their light. But one wants to draw a distinction between light *of* the paintings and the light *in* the paintings: between the light they have and the light they show. Let me begin with the latter. The personages in Vermeer's paintings, as well as the objects that define their actions—pitchers, for example, or pearls, or pages of a letter, or musical instruments—reflect or refract a warm steady light that invariably comes in from the left of the picture, though the rooms often seem to contain more light than they receive. In seven paintings in the Washington show, the light comes through windows composed of panes separated and joined by lead mullions, which gives the rooms something of the stillness and solemnity of church interiors; and in those cases where the windows are

not shown, we infer their presence from the effect. For what it is worth, there was a genre of paintings of church interiors in Delft, and while it is in no sense my task to speculate on influences, the windows in Dutch churches were large expanses of much the same sort of small panes of glass Vermeer shows us, and which enabled those large Gothic structures to be filled with a bright clarity very like that which penetrates Vermeer's interiors. The Gothic system of architecture was designed to afford a maximum use of glass, since the walls were not required to bear weight and the tremendous windows were able to interact with light to transform it into something that possessed certain meanings and bathed celebrants in metaphorical glory.

It is valuable to think of the difference in metaphor projected by the stained glass of the Île de France and by the clear glass of the Dutch Reformed churches. In the marvelous paintings of Delft churches, whose unembellished interiors enhance the dreamy reflections on stone columns of the unbroken illumination from without, under which nothing is concealed, the light is a metaphor perhaps for truth, a concept that Martin Heidegger once analyzed as "unconcealedness" or openness. The two kinds of church light, conferring glory or disclosing truth, are equally metaphysical, although in different ways, and both are what we might call bestowed light—light through which some higher being makes itself palpable and present. The light in Vermeer's interiors is close in kind and meaning to that church light peculiar to the Netherlands, as we see it in the great paintings of Saenredam and de Witte, though Vermeer himself was a convert to Catholicism.

Remarkable and meaningful as the light in Vermeer's paintings is, it must be distinguished from the light *of* those paintings: They have their own light, which is one of their miracles. It is the kind of light we find in gems, which is what makes precious stones precious. It is the light of halos, as we see them in religious paintings, around the heads of personages who live on two planes of being at once—who, on the model of Christ, are simultaneously flesh and holiness, human in form but belonging to a higher order, which the halo betokens. The light in gems, or in halos, is a self-contained luminescence, which does not warm or illuminate anything other than itself, nor create any shadows. Vermeer's paintings, to a far higher degree than

those of Saenredam or de Witte, possess this order of light, though possession of it is the mark of Old Master art.

Though the light in and the light of Vermeer's paintings are distinguishable in theory, they are indissolubly mingled in our experience of individual paintings. If we consider his interiors as consecrated, like those of churches—and in Holland at that time the Catholic rituals could only be performed in the privacy of homes—then we might think of the paintings as showing the kinds of spaces in which they, as self-illumined objects, belong. They belong there the way pearls belong, which reflect the light but also have their own. Or the way flesh does, if we think of what we see of it in these paintings as both reflecting the light from the windows and as having lambency of its own. In a recent interview with Michael Kimmelman, the British painter Lucien Freud said, "The people in Vermeer aren't humans. I don't mean they're subhuman, but they are objects governed by light. They're there for the picture. It's not a lack in Vermeer, precisely, but it is one of the strange things about him, this way of treating humans." I think this astute observation reveals as much about Freud as about Vermeer. Vermeer really does see us as creatures not merely drawn to light but possessing a light of our own. Freud sees us as dark and as drawn to darkness.

Vermeer's paintings have the luminosity of visions, and there is a complex relationship between the scenes they show and the real life of men and especially of women in seventeenth-century Holland. We know of Vermeer's life only what "course of life" historiography has been able to turn up from the registration of births and the inventory of worldly goods made after the artist's death, together with chance, sparse, tantalizing references to him by contemporaries. He and his wife had fifteen children, of whom eleven survived, and we are able to infer enough from the paucity of his output to know that he hardly can have lived on the opulent scale many of his interiors imply.

Our conception of clean, cozy domestic interiors is a contribution to civilization Dutch architects made, but the actual rooms lived in by Vermeer and his wife, Catharina Bolnes, their tumult of a family, and such servants as they

could afford can hardly have exemplified the quiet, the dignity, the elevated and sublimated eroticism, the spare luxury of the rooms in which he depicts the soft, indolent lives of his figures. His is the polar opposite of the rowdy vision of Jan Steen, who shows fat, sensual, noisy, swilling figures making music and feeling one another up—not that Steen shows us the reality of which Vermeer's is the idealization, since one makes a special point, even to-day, when one says, in Holland, that someone lives "in a Jan Steen house-hold." In fact, Vermeer's early *The Procuress*, in which a boozy soldier, his hat awry, cups a woman's breast with one hand as he lays a coin in her opened hand with the other, belongs, with one qualification, to Jan Steen's vision. The qualification is this: The woman is set apart from the dissolute company in which she sells her favors by the elegance of her costume—a scalloped head-cloth and yellow jacket—and by her clear superiority to her compan-ions; a *Giaconda* smile hovers beneath lowered eyes. She is of the company of superior female beings with which Vermeer populates his paintings, in which the artist furnishes these female presences with worlds, and finally with male companions, fit to occupy them with her. Of his portrait of Doctor Johnson, Boswell wrote, "I draw him in the style of a Flemish painter. . . . I must be exact as to every hair, or even every spot on his countenance." The lucidity of Dutch painting seems a guarantee of visual truth, as, abstractly speaking, it is. But Dutch paintings are not exact transcriptions of visual reality. Vermeer even took liberties with his city in the overwhelming *View of Delft*. Dutch in-teriors, whether Vermeer's or Steen's, are, as much as the fabricated land-scapes of Surrealism, made of the stuff of dreams.

Vermeer is, I think, explicit on this. Let us consider *The Music Lesson*, as the painting these days named *A Lady at the Virginal with a Gentleman* was once called—a thrilling work, which I want to describe quite closely. It is a painting rarely on public view, as it belongs in the British Royal Collection, and was lent by Queen Elizabeth II.

The lady is standing at the instrument, her back to us. She is beautifully dressed in a pale lemon shirt with wide sleeves, and a salmon-colored skirt with some sort of heavy half-length overskirt, cut on a bias, bunched at the waist. The warmer yellow of her instrument has a dark border, and the arrangement of rectangles bordered in gray or black—the virginal, the mir-

ror, the cropped painting—forms an almost abstract, one might say an almost musical, composition of verticals and horizontals, which expresses the kind of formal intelligence we associate with Mondrian, against the light-blanched wall. The dark of the borders against the wall echoes the dark pattern of two curved and two vertical lines, which overlay the lady's shirt. The room has far too much and far too uniform a light for it to be the result of the illumination permitted by the windows: This is a case where the showing and the having of light are hopelessly intermingled. The gentleman, thinly painted, is in black, with white cuffs and collar, and some sort of sash across his breast. One of his hands rests on the instrument, the other holds what appears to be a walking stick. What we presume is his own instrument, a viol, lies on the floor, occluding the edge of the lady's skirt. The two figures stand as far back in the deep space of the painting as possible. The space is exceedingly optical, as if we were looking into a box. The effect of depth is enhanced by the table in the foreground, which we see in its full height, covered by a marvelous oriental rug, the fringed edge of which lies on the diagonals of the tiled floors; and by the diagonals of the floor itself, consisting of white marbleized squares separated by wide dark bands. It is difficult to rectify the geometry of the floor with the implied space of the room: The farthermost tile seems, across its diagonal, about as wide as the virginal is deep. But we see only five tiles together, implying a rather small space. It is as if perception and geometry conflict. But that is a minor mystery. Let us now look at the major mysteries.

It is difficult to say in what relationship the man and woman are united. His mouth is slightly open, and he seems truly mesmerized by the lady, on whose fingers his eyes appear to be focused. Certainly it is not the look or posture of a music teacher. There is, rather, between man and woman a communication that could be love, but that in any case is on a most refined plane of being. There is a white ewer on the table, but there are no glasses, and one feels it is there not as part of the relationship between man and woman but as part of the painting: Its almost blazing whiteness confers a certain atmospheric distance on the scene by the wall. We see the lady's face reflected in the mirror. She too is looking downward and sideways, toward the gentleman, as if returning his glance. Gentleman and lady are as tightly in-

terlocked in the geometry of feelings as are the rectangles, vertical and horizontal, that form the exquisite composition of balanced forms against which they enact the drama of their mysterious sympathy.

The mirror does not reflect the lady's face alone. We see the pattern of floor tiles, and the table, but also something otherwise invisible in the painting, namely an easel, set back from the table by about the distance of a single white tile. It is where we are. We occupy pretty much the position the painter may be inferred to have occupied. But with this a truly deep ambiguity is introduced into the scene. The figures all at once are transformed into models, placed as they are not by any internal relationships between them but because the artist gave directions as to how their hands should go, how their faces should be composed. And we realize we are looking less at a scene of refined feelings than at a representation of a representation—a picture of a man and woman representing a lady and a gentleman caught up in the feeling we try so diligently to decipher. It is theatrical through and through. By means of a reflection in a mirror of a piece of the artist's equipment, Vermeer unlocks a little of the secret of his art. It is an art of heightened imagination, a dream of an idealized world rather than a depiction of the lived world. After all, this painting, done between 1662 and 1664, is nearly contemporary with the masterpiece through which these kinds of questions are more commonly addressed—*Las Meninas* of Velázquez, circa 1656.

Like *Las Meninas*, Vermeer's *A Lady at the Virginal* is a meditation on the art of painting, and on the double identity of paintings, as in our space and as having a space of their own (as with the light, in Vermeer's case). Velázquez stares imperiously out of his picture, and from behind the painting of which we see only the back, leaving us to ponder whether the painting he has been working on is identical with the painting we are looking at. Vermeer's *Allegory of Painting*—like *The Procuress*, not included in this exhibition—shows an artist whose back alone we see, facing a canvas on an easel much like the one reflected in *A Lady at the Virginal*. We look over his shoulder, so to speak, and so we can see that the painting on which he is working is not the painting in which we see him at work. He is painting a young woman, in laurel wreath and a blue garment, holding a book and a trumpet. She is the Muse of History, and the painter has so far managed only to get down a few laurel

leaves. He is transforming a girl into a muse. The artist is creating a world, just as Vermeer, in having made this picture, has made a world in which the artist belongs. Why is the artist dressed in a sixteenth-century costume? In any case, his canvas will not be large enough to contain everything that Vermeer's canvas shows us. But the proportions are such that we can infer that when it is finished the Muse will dominate her space, just as Vermeer's women, together with their consort, Light, dominate theirs.

The show is to close on February 11. My advice so far as the crowds are concerned is to plant yourself in front of each painting that holds and draws you, until you have gone as far in its tense aesthetic as you are able. You should exit in the exultant bafflement that is the mark of having experienced Vermeer truly. Someone has recently written of the healing tranquillity of these works; I cannot believe we were looking at the same artist.

—Feburary 19, 1996

ABSTRACTION

▪ ▪ ▪

*I*T SOMETIMES SEEMS TO ME THAT THE HISTORY OF MODERNIST painting can be read as the history of traditional painting put into reverse, like a film shown backward: a regressive, systematic dismantling of that entire system of illusionistic devices built up over the centuries to make convincing pictorial representations of Christianity's painful triumph and narratives of national glory. Thus transparent surfaces become clotted with paint, spaces become flattened, perspective arbitrary, drawing unconcerned with correspondence to the real outlines of figures, shading eliminated in favor of areas of saturated hue that disregard the edges of shapes, and shapes themselves unrepresentative of what the eye actually beholds in perceptual reality. The monochrome canvas is the logical terminus of this collective depictorializing procedure until it occurs to someone to attack the canvas itself physically by slashing.

Each of these eliminativist moves can, of course, be regarded as painting's discovery of its own physical identity, concluding with the disclosure of canvas as fabric by slashing, and indeed the story of Modernism has been understood by some as the progressive self-discovery of the material bases of art. This was, with qualifications, Clement Greenberg's construction of the development. "Realistic, naturalistic art had dissembled the medium, using art to conceal art," he wrote in a great summarizing statement of his views in 1960: "Modernism used art to call attention to art." By art Greenberg had in mind "the medium of painting—the flat surface, the shape of the support, the properties of the pigment." All these had been "treated by the Old

Masters as negative factors which could be acknowledged only implicitly or indirectly. Under Modernism these same limitations came to be regarded as positive factors, and were acknowledged openly." Modernism, so understood, is the progressive unconcealing of the material truth of paintings as physical objects. That left, of course, the philosophical problem of distinguishing a work of art consisting of an evenly brushed square of red paint from a mere physical object consisting of an evenly brushed square of red paint—a table top, say. One possible solution was to suggest that the minimal art work, and Modernist art in general, was about its material conditions, while the mere physical objects that the works outwardly resembled were not about anything at all. Modern art was ultimately about itself; the subject of art was art.

There is another way to read the same history. That is that Modern art arose through the systematic and progressive elimination from the illusionist tradition of whatever constituted a basis for distinguishing Western from non-Western art. Van Gogh turned to Japanese models, Gauguin to Asian ones, Picasso went back to Catalan paradigms, Braque drew inspiration from Egyptian modes of representation. And before them the Pre-Raphaelites turned against an academic tradition defined by Raphael but that seemed to them to militate against visual truth. Kandinsky and Malevich looked to peasants for artistic guidance. And artists and critics alike found in the art of peoples widely considered backward and savage an art so far in advance of anything the West had attained that we could catch up at best by emulation. So Modernism was achieved by erasing cultural boundaries as artistically expressed in favor, one might suppose, of an aesthetic universal. One cannot but feel that these artistic reversions were accompanied by a disdain for the religious and political narratives traditional art was invented to depict, in lieu of beliefs more cosmic and universal, for which the old illusionism was decreasingly adequate. The blank white canvas, on this reading, was less a celebration of its own physical flatness than a representation of infinite space—less an object about its own bare materiality than an icon charged with a dizzying vastness. The philosophical question of distinguishing between an expression of infinite space and a mere whitewashed panel parallels the one raised by a red square that is about itself and a square table top

painted red. Modern art, however it arose, made perception of itself problematic in a way that remains with us today.

The second, spiritualist reading of the Modernist narrative would have been far more credible to the artists themselves than Greenberg's materialist account. His reductive analysis would have seemed too paltry to justify the tremendousness of expelling from pictorial space the whole familiar world of human life and form and history, and unlearning, so to speak, the skills of drawing and painting. On either reading of the Modernist epic, the story was largely over by the beginning of the second decade of the twentieth century. Kandinsky began to paint pure abstractions around 1912, and by 1915 Malevich had produced his epochal *Black Square*. Both artists had the sense of having broken through to a new world, on whose edge they stood as if explorers confronting unknown seas. Both felt that they had brought art to a stage at which it must serve in the spiritual transformation of mankind, and it would have dismayed Kandinsky, who felt "our epoch is a time of tragic collision between matter and spirit," to have been told that his work was—ultimately—about matter. Malevich declared, "My new painting does not belong solely to the earth. The earth has been abandoned like a house." He saw *Black Square* as the symbol of a new religion, and it was, on its first exhibition, hung near the ceiling, diagonally between two walls, in the traditional position of the Russian icon.

So far as a developmental narrative is concerned, the monochrome canvas seemed as far as Modernism could go, and Malevich's critics did not hesitate to cite it as evidence for the death of painting. From their position in 1915, it must have seemed that the entire history of dismantling must itself be undone, and painting returned to its traditional narrative functions, for which the old academic disciplines seemed necessary. Socialist Realism was an effort precisely to achieve an erasure of Modernism, to which the Russian artists had made so singular a contribution. Abstract art, indeed, was stigmatized as "criminal and degenerate" under National Socialism, and the same form of aesthetic rollback took place under it. Abstraction, for reasons unconnected with the internal history of art, became politicized in the late 1930s and 1940s, so that when the Second World War ended, German artists took it up as if it were a moral force (and of course, "the figure," asso-

ciated with the art favored by Hitler and Stalin, was regarded as politically unacceptable). The conjunction of political force and values with the religious and spiritualist meanings conferred upon abstract painting by its founders meant that paintings that may have looked like squiggles and squoggles, on the one hand, or circles and triangles, on the other, were vested with so much moral energy that it ought to have been a matter of amazement not to be knocked flat when in their presence. Only later were abstract paintings objects of aesthetic delectation or formal pleasure; the fact that we now can look at them without taking a political stand or feeling our values shaken or our spirit awakened by vast horizons of fulfillment—that we see them merely as art, and art itself as something we go to museums to see—is a sign of a transformation very different from the one hoped for by the movement's founders. Abstraction, which set out to change the world and redeem the human spirit, ended by merely filling the museums.

I can imagine no more vivid way of thinking of this transformation than by contrasting the massive, linear presentation of abstract works at the Solomon R. Guggenheim Museum with the way that same institution showed abstract art in the first phase of its existence. The Guggenheim, as perhaps no other museum in the world, is internally related to the history of abstraction, and the way it shows this art is itself part of that history. In a way, the present exhibition constitutes an act of particular piety, understood in Santayana's sense as the "reverent attachment to the sources of [its] being." The Guggenheim is unique in that the source of its being was specifically abstract art, or, to use the expression of its spiritual founder, the Baroness Hilla Rebay, "non-objective" art. So on this occasion at least, transformation of the museum is co-implicated with the transformation of abstract art itself. Just as abstraction has, at century's end, become merely another style, the Guggenheim, for all its quirky architecture, has become just another museum.

The present institution grew out of the Museum of Non-Objective Painting, established in 1939—a product of Guggenheim philanthropy and Rebay's exalted aesthetic vision. Since Rebay presided over the architectural translation of the institution from what had been an automobile showroom at 24 East 54th Street (since demolished) to Frank Lloyd Wright's inverted ziggurat on upper Fifth Avenue, great as a building if often vexing as a mu-

seum, something of the spirit of non-objectiveness is given embodiment in the familiar ramped space around which the external history of abstraction unwinds. One can get some sense of Rebay's ideal of a museum from the fact that she refers in an early document to a "Temple of Non-Objectivity." As if in recognition that piety involves what Santayana further speaks of as a "sentiment of gratitude and duty," the present show incorporates into itself, as a special exhibit, a reconstruction of the interior space of the Museum of Non-Objective Painting, with works by the Baroness herself and by her mentor, lover, and nemesis, the awful and empty Rudolph Bauer.

The encapsulation within itself of its earlier incarnation demonstrates how great a transformation in attitude toward art separates the museum of 1939 from the present-day Guggenheim. Abstraction, the soul and essence of the Museum of Non-Objective Painting, is merely one of the forms of twentieth-century art the Guggenheim exhibits. So the museum's architectural form, conceived almost certainly as the Temple of Non-Objectivity, has no internal relationship to most of the art exhibited within its difficult spaces. The Baroness had addressed the art from within an awed perspective, and thought of the non-objective artist as a kind of god, which in some way clarifies the meaning she attached to the idea of non-objectivity. It did not mean "subjective" but specifically *gegenstandslos*, "free of objects." And that must be further clarified. Traditional painting represented objects of an altogether recognizable sort—men, women, animals, plants, mountains, clouds, trees. The artist transcribed but did not create those objects. In non-objective painting, artists *created* the objects with which their paintings were filled, which accordingly did not show but instead *were* realities. Rebay felt that "great art" reenacts the framing of the cosmic order itself, and that it brings "health to the soul as the sun does to the body." So one entered the Temple of Non-Objectivity with the promise of something rather more exalted than aesthetic pleasure. It was a redemptive promise of a kind very few publicity offices of major museums would advertise today as among the expected benefits of attending an exhibition.

That feeling was palpable in the marvelous museum Rebay presided over, which for many of us who came from the hinterland seemed to radiate what defined the hinterland by its aching absence. It was a world of gray vel-

vet walls and boxy ottomans covered in the same luxurious material, of Bach and Chopin, and the cosmic presence of non-objective paintings by Kandinsky, Bauer, Rebay herself, Moholy-Nagy, and others now forgotten. It is difficult to suppose that there were postcards for sale, or a gift shop, let alone a cafeteria. But it was a wonderful place to meet people one hoped would be special in one's life, to settle into the unreality of the place, hold hands and sit on those bedlike seats and let the music wash over, while trying to figure out what was going on in a nearby picture. I must confess to a wave of nostalgia as I left the necessarily hard floor of the Guggenheim ramp to enter the carpeted space, filled with soft familiar music that sought to convey its predecessor's atmosphere and feeling. I could, on the other hand, appreciate the reaction of a much younger friend whose enthusiasm I sought to enlist in a later conversation: She found it stifling, and could hardly wait to get out. And my sense is that whatever abstraction means to my friend, it cannot be what it meant to Baroness Hilla Rebay or the artists she idolized. The present show belongs to the very history it tends to flatten out, in the Guggenheim's celebratory but largely curatorial and entrepreneurial atmosphere, by showing a number of paintings in the order of their appearance on the stage of world history. I suppose showing the art this way projects as much of an attitude as showing it in the predecessor museum did. To the degree that present-day abstractionists share the attitude, they have very little in common with those for whom Non-Objectiveness was a credo of near-religious intensity. In truth, the history of abstraction is not a linear chronicle with Malevich and Kandinsky at one end and Gerhard Richter and Ellsworth Kelly at the other. That it is treated as such demonstrates how much urgency has been drained from the practice of abstract art since its beginnings.

When Frank Stella delivered the Norton Lectures at Harvard in 1983–84, he introduced the interesting concept of "working space"—spaces projected in front of paintings, which differ from the interior, illusional space of the paintings in which the shown actions transpire. Try to imagine a working space in front of the abstract paintings (or surrounding the abstract sculptures) when you visit the Guggenheim, in which each work exerts a special transformative force on you as you enter it. Do not, that is, see the paintings simply as surfaces, variously articulated, but as instruments for changing

one's life. This, admittedly, is a very strenuous demand. For the most part—this is the tragedy of an art that aspired so wildly—few if any of the works will visually define the "working spaces" required to experience them in the way the artists had hoped they would be. Reading about the art will help a lot: After all, most of the artists wrote about what they were doing, or talked about it with other artists. The fact that we are numb to intended transformative energy, or that the museum has in its present incarnation transformed us into *amateurs* of what Michael Baxandall calls "visual interest," is an index of the degree to which abstract art has shrunk into the materiality that Greenberg surmised was all there was in the first place. But try, even so, to imagine the marvelous model of Tatlin's *Monument to the Third International*, shown in the alcove gallery just up the ramp, as the structure Tatlin intended, soaring into the clouds, higher by far than the Eiffel Tower, which was his metric. If your imagination works it will not be difficult to empathize with the artists of the First International Dada Exhibition in Berlin in 1922, who in the same breath declared the end of fine art and wished long life to the "machine art" of Tatlin. His monument is one of the century's great works, but then abstract art nearly always aimed at sublimity—our own Abstract Expressionists did so no less than the daunting Suprematists and Constructivists. The working space shrinks pretty much to the face of work like Robert Ryman's, which is claimed by the artist to *be* the reality that other art is merely about.

Museums—and not just the Guggenheim—do what they can to trade sublimity for formal beauty, and there is a certain irony in the fact that art has indeed achieved a kind of universality today, even if it is not the universality of which the founders of Modernism first dreamed. It is what I would call an institutional universality. The same kind of art is shown everywhere in museums, which, however they may differ architecturally, are pretty much all alike, in terms not only of content but of expected museum attitude and conduct. The works in the Guggenheim exhibition, especially the more recent ones, travel from venue to venue, in Asia, Europe, Africa, and here, wherever art is shown. But art, through most of the history of abstraction, was made not to play an ambassadorial role but a prophetic one; not to be a series of counters in homogenized aesthetic space but to point to new spaces altogether. Still, while the works are almost pathetically insufficient for the

ambitions of their makers, there is something touching in the idea of seeing them lined up next to one another, all passion spent. Given the history of the century of which abstract art is the most distinctive expression, this is not a bad kind of ending. If we could all coexist politically that way, art would after all have served a model for a better form of life.

I have not sought to criticize the show, but *eight* Rymans and not a single Motherwell or Mangold? But then I thought how appropriate a Ryman would look in the Museum of Non-Objective Painting, and decided eight of them were a subtle tribute to the willful spirit of the Baroness, who would have hung no one but Bauer were it wholly up to her.

—April 8, 1996

MEYER SCHAPIRO,
1904–1996
∙ ∙ ∙

*I*N 1952, AS PART OF THE CELEBRATION OF LEONARDO DA VINCI'S 500th birthday, Meyer Schapiro gave a lecture in the Great Hall at Cooper Union. A legendary figure talking on a legendary figure was certain to be a legendary event, and the vast space was thronged by those curious to see how Schapiro, who brought the scholarly authority of a great medievalist to the study of modern art, would address Leonardo's genius. It was not the typical two-projector art history lecture to which audiences have grown accustomed, drawing attention to formal analogies and visual similarities. There were no slides at all. Schapiro was a lean figure with the features of a prophet and the look of someone inspired as he spoke. Behind him was an immense replica of the famous bearded portrait of Leonardo, and the disparity in size between speaker and subject gave the occasion a kind of David and Goliath disproportion.

Schapiro's birthday offering to the paradigmatic Renaissance man was a piece of moral criticism. Indeed, it was of Leonardo as a Renaissance man that he addressed us, by pointing out Leonardo's limitations. Instead of celebrating the many things that Leonardo knew and did, Schapiro spoke of all the things in which his multidimensional intellect took no interest whatever. Leonardo took no interest in politics, or in things that the so-called *Geisteswissenschaften* study, concerned as they are with the factors that make human beings human. It is impossible to forget the power of Schapiro's list of negatives. Out of it he fashioned a very different portrait of Leonardo and his

work than any of us had ever seen before. It was a portrait of a skewed genius, and it explained the costs of Leonardo's achievements.

Leonardo famously said that every painter depicts himself—*Ogni dipintore dipinge se*—and in depicting Leonardo, Schapiro was certainly portraying himself. It could never be said of him that he was numb to the human determinants of what he was interested in as an art historian. As a critic, Schapiro displayed an unquestioned sensitivity to the formal structures of the art he described. But the power of his analyses of works of art derived from the way in which he situated them in the larger human complexes that they illuminated, and through which they must be understood. He lectured in the spirit of Rodchenko's motto of "Art into life!" and nothing could have been at once more intoxicating to those who listened to him in the lecture hall and more dissonant with the atmosphere of gentlemanly connoisseurship that defined the art-historical establishment of his time, which grudgingly opened itself up to him. He was too brilliant to ignore but, from the perspective of the establishment, too radical to accept. It was distinctive of him to take modern art as his main subject but to recognize that modern art was not something taking place in a world to which its scholars were external. It was happening not in the irremediable past but *now*—and to be interested in it as a scholar meant to participate in the life of art as a living person.

One of the excitements of Schapiro's lectures at Columbia University was the way in which they addressed the art being made concurrently with them, and the way the art world itself became part of the audience, listening to the great man talk about it, acquiring a certain historical consciousness of itself. The seats were filled with artists, with representatives of every imaginable discipline, as well as by students of art history as such. The winds of reality blew through the classroom. The boundaries between the university and the city were open. Schapiro's life was not a distraction from his specialty but fed into those spectacular discourses he conducted in front of us, connecting and connecting and connecting. It has been said of art historians that the one who has seen and remembered the most images is the one who wins—a view presupposing that art is what explains art. For Schapiro, though, what explains art is everything that the quirky canon of Leonardo's mind left out.

The joy of Schapiro's lectures lay in the way he made astonishing connections between art and other things. The standard art-historical way with a work like Seurat's *Les Poseuses*, which shows three women undressing and undressed as they pose or prepare to pose, is to trace the treatment of three nude female figures back and back—through the Three Graces to the three goddesses and the Judgment of Paris as represented in paintings and carvings and drawings down the centuries. Schapiro talked of Seurat's handling of the three women against the background of the so-called three-body problem in physics. Whether reference to the law of inverse squares in fact clarified the painting is less interesting than the way in which Schapiro took us outside the artwork to the larger world of thought and back again, and transmitted the idea that art is not an isolated endeavor. It was his attitude toward art as a human enterprise, more than anything he may have said about this work or that, that remains in the memory. But who can forget his marvelous analysis of Picasso's *Woman with Mirror* or his essay on Willem de Kooning's epochal *Woman I*? He showed us things in paintings we would never have seen without him, not because our eyes were inadequate but because our knowledge was deficient in the way things outside the art explained what was in it.

If openness marked Schapiro as a thinker, there was another mode of it that defined the format of his lectures. This was his welcome of the associations that might be awakened by the subject at hand, which brought him as great a pleasure when they occurred to him as they brought his listeners when, in some marvelous riff, he linked things we have never imagined conjoined. Once, in talking about Picasso's interest in other artists, he told of something the philosopher G. E. Moore had remarked about himself—that it was what other philosophers said that provoked his own philosophical work. One would never have imagined Moore being brought into a discussion of Picasso, nor a certain kind of artistic and a philosophical mind being bracketed together in that way. And there cannot have been many art historians who had ever heard of Moore, though Moore's example and writing had a profound impact on the Bloomsbury crowd and the attitudes toward art expressed in the writings of Roger Fry and Clive Bell, not to mention Virginia Woolf. Schapiro was always open to such sudden surprising juxtapositions,

to something he did not bring to class but that happened there, to his own astonishment as much as to everyone else's. This must be the explanation of why he was so retentive in regard to his writing—he was reluctant to close things off, in the irrevocable medium of print. And perhaps it explains why the writings themselves have nothing of the joy, the sparkle, the inventiveness—*the genius*—of his talk.

The lecture on Leonardo, so far as I can make out, was never published, and except for the fading memories of those who heard him, the originality, the playfulness, the dazzle of the lectures have congealed into anecdote and quip. There may be recordings. But without the sound of Schapiro lecturing with clarity and rapidity, in a soft New York accent—without the sight of him, with his head thrown back, his eyes sparkling, and an almost erotic smile on his face whenever he paused—the words, however intelligent, are only words, from which the spirit is somehow drained. He wrote some marvelous and some important texts. But he loved to dazzle, loved to see the reaction of an audience—so different, after all, from the covert responses of readers. What was greatest about him died when he died. He was an intellectual performer at a time when the beauty of the creative intellect was what his world cherished above all other values. New York was like Athens, a world of mythic talkers. That world died before he did.

—April 29, 1996

EDWARD KIENHOLZ

■ ■ ■

COMMENTING ON AN EARLY WOOD RELIEF BY EDWARD KIENHOLZ—
an artist often classed with the California Expressionists of the 1960s—
Rosetta Brooks writes that the artist "applied paint with a household broom,
creating a deliberately ugly and unprocessed effect, explaining that if
he 'could make something really ugly,' it might help him to 'understand
beauty.' " The broom, as an improvised paintbrush, implies an entire inter-
referential system of other tools and materials, as well as a modified concep-
tion of the artist and the work of art. One is not dealing with the likes of
Édouard Manet, in frock coat and high hat, transferring brilliant dabs of ex-
pensive pigment from a suavely curved palette to a stretched canvas poised
on an ornamental easel, all the while exchanging bons mots with Charles
Baudelaire. One can only use a broom if one pours paint from can to panel
and sweeps it across the surface, or dips the broom into a can large enough
to hold paint in a liquid state, in a quantity large enough to make the effort
possible. The panel will be on the floor, a mess will be created, the artist
himself will get smeared in the process and the loaded broom will be heavy
enough that it will cost even a heavily muscled painter too much by way of
strain to think of holding conversation at the same time. Rock music and sta-
tic from a tinny radio more likely accompany grunts and curses. Manet and
Kienholz stand at opposite ends of Modernism's century, which Kienholz's
broom helped sweep into history. But in 1955 he was still a Modernist be-
cause he was concerned with beauty, however scruffy his means.

The work itself—*Untitled* (1955)—is certainly not ugly, and Kienholz's

remark may have expressed a sense of paradox in the way in which a "deliberately ugly and unprocessed effect" should all at once yield up something the eye finds pleasing enough. Kienholz (whose work is currently installed on two floors of the Whitney Museum of American Art in a major retrospective) had affixed to a piece of stained and paint-splotched plywood some curved white shapes that set up the kind of rhythm very large saw-teeth might create. To the left, a set of drips runs right and left, as if the artist had turned the panel quickly in opposite directions while the paint was still fluid enough to run. There are some further smears, smudges, drips, lashings, and spatters, and across the face of the work a number of wooden bits and fragments have been attached. The basic panel would be an eyesore, were it seen before becoming integrated into a work of art, but all the accidents that made it ugly somehow get transfigured in the process of working it over, and contribute to the power, energy, and handsomeness of the achieved piece. It is a kind of beauty unavailable to the artist who resorted to varnish glazes and impasto dabs and dashes, and the transformation in artistic processes from Manet to Kienholz—from painting as a fine art to the proletarianization of artists' materials under Abstract Expressionism—is the biography of artistic beauty from 1865 to 1955, when it largely stopped being a relevant consideration. Certainly it stopped being of any concern to Kienholz as he pressed across one of history's invisible borderlines and began to make art defined by the irrelevance of beauty. He put his art to the ends of moral and political criticism, in which making beauty out of unpropitious materials took a secondary place to the transformation of the viewer's consciousness. It must be admitted that Kienholz's mastery of grit, funk, and visual squalor abetted him in his new mission. He had learned to create pain: The appropriate response to any one of his characteristic works is a wince. For the remainder of his creative life (he died in 1994), he enlisted visual ugliness in the war on moral ugliness. Beauty simply fell out of the equation, unless it was there to hurt.

The connection between art and beauty remains sufficiently tenuous that there can be art that legitimately puts beauty aside, and mobilizes all its energies to the rhetorical aim of arousing anger. Since anger impels intervention, this is an art that endeavors to change the world or to create shame in

those viewers who do not try to intervene. And the deliberate use of "ugly and unprocessed effect" can, in the case at least of Kienholz, serve as a kind of visual growl, a flaunting of good taste and aesthetic manners, a mode of presentation appropriate to the moral ugliness it became the point of his art to reveal. The spilled paint, the rusty nail, the splintered wood, the charred burlap, the broken chair, the shattered glass, the torn lampshade, the greasy rag—these are outrage made palpable, like the whine in the voice of the singer of protest songs, a way of injuring taste, a deflected way of rubbing the viewer's face in the moral mess the art presents. Once Kienholz discovered his mission as a moral critic, the ugliness he learned to make when he was interested in transcendence became part of his means—the content of his art subverted any propensity for the ugliness to become transfigured into beauty. Perhaps what the creation of ugliness taught him about beauty is that beauty has a way of enlisting ugliness to its own effects, and putting viewers in a mood of aesthetic pleasure. And this would be the wrong mood for someone bent on moral change. Beauty, one might say, became the enemy to be defeated in order to defeat the political and moral outrages he exhibited in a medium composed of untranscendable squalor.

It has become a critical commonplace that an art that has as its moral mission to change the world has no business being beautiful. Conservative critics, eager to separate art from political agency, have naturally sought a tight connection between art and beauty, making the even stronger claim that since beauty and commitment are antithetical, commitment and art must be antithetical to each other as well. And so they would be content to say, of whatever it is that Kienholz does, that it is not art, which was one of the natural responses elicited by his most famous piece, *Back Seat Dodge '38* (1964). The body of what the catalogue refers to as a "truncated 1938 Dodge"—the opposite of a stretch Dodge—in that work is more or less reduced to its backseat, in which we see, through an open door, a couple engaged in sexual groping amidst the beer bottles. It would be disingenuous to pretend that a couple shown in heavy foreplay was not the real reason for museum trustees not to want to deal with a work, even if that couple—they share a head, his body is made of chicken wire, and the male seems to have a spark plug for a

penis—is pretty funny. In any case, there are those for whom the humorous
can no more be art than the ugly. Certainly, if you are eager to arouse indig-
nation in viewers, beauty and comedy are things to be avoided, in part
because both serve to put whatever is shown in an almost philosophical per-
spective. Beauty and humor alike serve healing functions, and the moralist in
art is not interested in healing the viewer but in healing the world by arous-
ing one to its moral blackness. Think of the difference that might be seen
between an ordinary funeral service and the funeral service of, say, the slain
political leader of a group fighting a cause. In the first, music, elegies, and
flowers surrounding the bier might mute the loss with beauty, and in a sense
translate it into the poetry of the universe. For just this reason, beauty would
have no place in the second funeral, perhaps marked by brandished weapons
and shaken fists and shouts for revenge. Beauty helps the bereaved accept
loss; the rhetoric of revenge serves the opposite function. No one laughs at
either funeral—a minister who cracked jokes at the gravesite would violate
the seriousness of the occasion. But humor could serve the same rhetorical
function of diminishing the intensity with which one responds to the event.
Sex is rather rarely regarded a laughing matter, even in our supposedly en-
lightened era, and it was as much the comedy of Kienholz's piece as its con-
tent that perhaps bothered those keen to suppress it. To reduce a car to its
backseat underscores that the whole point of a car for young people *was* its
backseat, in the years before it became customary for parents to accept the
boyfriend or girlfriend brought home to share Sister or Brother's bed.

In view of the visual sexual comedy, even ugliness seemed gratuitous: The
paint Kienholz allowed to dry over the car windows became a piece of irrel-
evant squalor and even a kind of mannerism, with no role to play in deter-
mining viewers' attitudes toward a kind of reality Kienholz only wanted
them to acknowledge. The uglification becomes non-gratuitous only when
used to define the kind of feeling the work is intended to arouse toward the
subject shown. With beauty and humor alike ruled out, this of necessity puts
a special kind of pressure on the artist. If the work fails, it is not just an artis-
tic failure: It is a moral failure in its own right. If, for example, a work has an
effect the opposite of what was intended, then it is probably true that it

would have been better not to have been made in the first place. The committed artist exposes himself to an augmented schedule of possible blame, because he has taken on this extra responsibility.

Let's begin with one of the failures, *The Psycho-Vendetta Case*, the title of which is meant to strike an analogy with the Sacco-Vanzetti case, but which actually cheapens both cases (Kienholz often relies on puns and verbal play like this). The work refers to the execution of Caryl Chessman in 1960, and consists of a wooden case, with a mock "Seal of Approval of California" on the outside door panel. When the door is opened, there is a sort of shrine, with miniature U.S. and California flags on one side and a fleshy effigy of Chessman's sagging balls and visceral buttocks on the other, seemingly spread by the prisoner's shackled hands to reveal his anus. One can look through the anus, in fact, and there see written, "IF YOU BELIEVE IN 'AN EYE FOR AN EYE AND A TOOTH FOR A TOOTH,' STICK YOUR TONGUE OUT—LIMIT 9 TIMES ONLY." A work like this is a surly gesture, an expression of ineffectual contempt, like a finger pointed in the air or a shout of "Fuck you." It implies weakness and ineffectuality, and while it may be excused if we think the artist felt he had to do *something*, as committed art it comes to little, for it confesses that there is nothing now to be done except vent rage. It is pure punk. And because it expresses impotence—as calling names always does—it is worse than nothing in mobilizing attitudes against capital punishment.

By contrast, *The Illegal Operation* (1962) is an artistic success because it is a moral one. It shows a split sack of cement, wheeled into a tawdry parlor on a shopping cart. The contents of the sack leak out of the split, just where a woman's vagina would be. On the floor is a filthy basin with some surgical tools and soiled rags, and alongside that a bucket of something nameless and awful ("offal"). A rickety lamp, its shade awry, illuminates the scene, and there is a little stool on which the abortionist sat in performing the "illegal operation." Symbolizing a woman as a torn sack, the content of her body spilled out, shown with self-symbolizing instruments is effectively to say, "Make abortion legal," or, today, "Keep abortion legal." It is a piece that reinforces the stance of pro-choice viewers, and demands some modulation of the stance of pro-lifers: Do not force women to undergo this. It is eloquent, aggressive, and effective in ways *Psycho-Vendetta* fails to be, and it exemplifies

what this kind of art must attain to if it is not to wither into mere grunge or simple bad taste.

A lot of Kienholz's rage is more diffuse. *John Doe* (1959) is a male mannequin cut in half at the waist, with the owner's two halves placed back to back, set into a stroller evidently rescued from the junkyard. Brown paint is poured over John Doe's head and down his torso, which could express compassion for John Doe's being shat upon, but could also express the artist's contempt for John Doe. The latter reading is prompted by a riddle on the stroller's footrest: "WHY IS JOHN DOE LIKE A PIANO? ANSWER: BECAUSE HE IS SQUARE, UPRIGHT AND GRAND." There is a hole in John Doe's chest where a cross has been placed and blood runs down his lank stomach. Armless, covered in filth and blood, his heart carved out and replaced by a cross, his body cut in two, John Doe has the look of a martyr. By whom, to what? Is the stroller part of this meaning, so that John Doe is the victim of family values? Or is it simply an improvised way of pushing a humiliated victim around? (The pushcart in *The Illegal Operation* is a far clearer symbol.) As an image, *John Doe* is probably the sum of its ambiguities: It represents the common man both as an object of compassion and of contempt, victim and executioner—but in neither dimension particularly admirable. Are we supposed to find a man cut in two ridiculous or scary?

Kienholz's work often leaves us unsettled in this way. *The Beanery* (1965) is a case in point. It is a reconstruction of an authentic diner in Los Angeles, presented with a certain affection for the unselfconscious squalor and greasy warmth, cluttered with dusty bottles along the shelves, signs and photographs on the walls, a television set at the end of the counter, and customers seated on stools. All the patrons have clocks for faces, and all the clocks tell the same hour—ten past ten. The substitution of clock face for real face and the significance of the hour do not convey an obvious meaning, but it is difficult to suppose that whatever may be the target of intended criticism, we are dealing with a moral issue on the same level as execution or abortion. *The Beanery* emblematizes the kind of boozy hangout artists are fond of, and it seems appropriate that it should be housed in a museum: I felt a surge of at-homeness when I first bumped into it, rounding a corner in the Stedelijk Museum in Amsterdam, where it is evidently a favorite of Dutch

schoolchildren. The human figures were made by wrapped casts of Kienholz's friends, somewhat in the manner of George Segal. Segal is an artist with a moral vision as well, but he infuses his environments with a kind of philosophical and visual clarity rather than anger. Had Segal done a beanery it would have held exactly the same kind of beauty Kienholz finds inimical, even when, as in *The Beanery*, he has no specific ax to grind.

In 1972, Kienholz married Nancy Reddin, and from that point on she was acknowledged as his collaborator and given equal billing. Nancy Reddin Kienholz worked with him on a piece called *The Art Show* (1963–1977). It shows art worlders in their natural habitat, a gallery, milling about with the protective glass of wine. They have vents for faces, rather than clocks, and the implication is that they fill the space with hot air. They converse, stand in front of pictures or sit on benches, studying the work before them. There is a receptionist, of course, a shelf of expensive books, a typewriter (which dates the work a bit, as the garments will in time). It seems a graceless work, since after all Kienholz owed his livelihood to just the sort of figures he impales here, and a bad case of biting the hand that fed him. But there is another way of looking at it. *The Art Show* represents and even celebrates a way of relating to art—aesthetically and conversationally—that could not contrast more forcibly with the way of relating to art for which Kienholz's work stands. His art is confrontational and unforgiving, and the appropriate response is to take some kind of action. He was not in the least interested in murmuring aesthetic platitudes into one's chardonnay.

Sometimes, when a piece of mine appears in *The Nation*, I read through everything else in the magazine, in the order in which it is printed, before seeing what my own review looks like in hard type. Often enough, the questions I address seem so remote from the injustices and agonies with which the other writers concern themselves that it must seem strange that I am in the magazine at all. Readers who feel this disparity must ask what connection there can be between the art I write about and the social and political issues that engage them. They might find in Edward and Nancy Kienholz exactly the kind of art that answers that question: It brings the front and back of the book together.

—*June 10, 1996*

LETTER FROM VIENNA

▪ ▪ ▪

*T*HE ANTIQUATED FERRIS WHEEL, SINCE *THE THIRD MAN* AS MUCH
the emblem of Vienna as the Eiffel Tower is of Paris or the Colosseum of
Rome, still defines a portion of the city's skyline, and trigonometry permit-
ting, can be glimpsed over the tops of buildings from the west side of the
Danube Canal. There are very few high-rises in Vienna—two, to be pre-
cise—which is, according to a Polish philosopher, one of the benefits of the
Russian occupation that ended only in 1955. The Russian presence made in-
vestors wary, and so the city escaped the architectural expression of Ger-
many's *Wirtschaftswunder*—the "economic miracle" of the immediate
postwar years—which, according to my informant, whose every word was in-
flected with the irony his nation's intellectuals have developed to cope with
brutal realities, did at least as much to destroy Germany's cities as the war it-
self. The faceless office buildings of Western Europe are capitalism's coun-
terpart to communism's soulless workers' flats.

Vienna today is a comfortable, prosperous place, whose population uti-
lizes its considerable amenities with a sense of personal security that has
vanished from urban centers nearly everywhere else. Its brilliant system of
public transportation, with shining subway cars and red buses fluttering
flags, arouses envy in New Yorkers. The Social Democratic Party has for
thirty years treated housing as a basic right, and there are no panhandlers to
speak of. There are no zither players, either, though the unavoidable musi-
cians in Grinzing's wine gardens will tear into the *Third Man* theme when
they weary of "The Blue Danube" or "Edelweiss." It is certainly not the

dark, scary Vienna Harry Lime and his chum looked down upon from the swinging gondola of the Riesenrad half a century ago.

Glimpsing the Ferris wheel one day recently, I thought of Harry Lime's discourse on violence and art when he sought to justify his own unspeakable trade in false antibiotics. Everyone remembers the contrast he drew between the state of warfare in Italy as the Renaissance's background, and the "five centuries of peace and democracy" in Switzerland, whose chief cultural product was the cuckoo clock. It was as though he were making Leonardos possible by racketeering, fertilizing the fields of genius by the pain and death of innocent victims. If Lime's thesis were true, we might all look forward to the Bosnian Renaissance, made possible—or even inevitable, given the quantity of suffering—by ethnic cleansing, rape, and mass graves. But even if the casual determinants of artistic greatness were far clearer than they are ever likely to be, so that one could seriously consider inflicting suffering for the sake of great art to come, it would always be open whether the means were morally thinkable. Ethicists debate the case of Gauguin, who abandoned his family in order to dedicate himself to painting, asking whether the artist's undeniable artistic achievement justified the pain he caused. Does art excuse what would be inexcusable if it had not led to the art? Gauguin had the moral luck to make the question seem open, but suppose he had been second-rate? Giacometti—one of the products of Swiss culture to place alongside the cuckoo clock—is reputed to have said he would rescue a cat from a burning building, if he had to choose between that and rescuing a Rembrandt.

Whatever the case, Vienna did not see much of an artistic flowering after the war that made Lime conceivable, and its great age in painting came around the turn of the century, after many decades of relative peace. One of its three bright stars, Egon Schiele, died at twenty-eight from the influenza epidemic that swept Europe after World War I, so wartime conditions deprived us of the paintings he would have done had he lived on. But we can form no conception of what these would have been like. Oskar Kokoschka lived to be a very old artist, but the more or less creditable watercolors of his late years scarcely extended the tremendous surge of his early portraits in his great creative moment, which coincided with Schiele's, and one wonders

whether Schiele might have outlived the genius of his youth. The works of the third master, Gustav Klimt, seem so involved with the cultural moment to which he contributed that it is really difficult to imagine a Klimt from a later period. Art may indeed be long in proportion to the brevity of life, but history is longer than art, and Klimt might have been pathetic had he gone on painting kissing couples in golden robes when everyone else was painting Cubist guitars or geometrical abstractions.

I pondered these counterfactuals while looking at the *Beethoven Frieze* that Klimt painted for a 1902 exhibition in the Secession building, the elegant modern space created by and for those artists who, circa 1897, seceded from the Academy in order to make art in a fresh way, free of the obligatory baroque extravagance that is the official defining style of Habsburg Vienna, with statuary spread as thick as whipped cream up staircases and across pediments. "To the age its art," it says in gold lettering over the Secession's entry; "To the art its freedom." (*"Der Zeit Ihre Kunst; Der Kunst Ihre Freiheit."*) Klimt's fresco, meant to last only as long as the exhibition for which it was produced, was in fact taken down and stored, and has been available to the public since 1985. I am afraid it is dated in ways the building itself is not. It is composed of two lateral panels, joined by a frontal one in which Klimt depicts the forces of darkness: emaciated gorgons, signifying illness, madness, and death; an androgynous figure whose large breasts sag over its belly, which in turn sags over ornamental harem pants; and all figures dwarfed by an immense gorilla with beady eyes and *Jugendstil* teeth. The left panel shows some slender, elongated female wraiths, intended to express a longing for happiness; a pretty kneeling couple, expressing "the sufferings of weak mankind," pleading with a knight in golden armor to fight for human happiness. The monsters on the facing wall have evidently been vanquished by the time we get to the right panel, in which "The Longing for Happiness finds Satisfaction in Art." According to my brochure, the concluding scene is one in which "The Arts Lead us into the Ideal Realm where we may all find Pure Happiness, Pure Bliss, and Pure Love." The frieze ends with a handsome chorus of angels, making music as a couple kisses. The work is a transformation into visual terms of the "Ode to Joy" section of Beethoven's Ninth Sym-

phony, and there is something moving, if ridiculous, in the idea that art is the instrument for overcoming horror and securing human happiness—a formula that, if true, might earn Harry Lime a serious hearing.

Klimt's work is so connected with the ornamental style of the *Wiener Werkstätte* that his figures seem designs for jewelry, all gold and gold enameling, with ribbony floral motifs of the kind one finds on the facades of Otto Wagner's houses farther down along the same street. His knights, monsters, and harmonizing angels are near of kin to what Aubrey Beardsley drew to illustrate Wilde's *Salome*, which, thinking in terms of style cycles, represent the baroque phase of the Pre-Raphaelite movement, with its impossible yearnings for a different historical age. Whatever art is capable of, it is too much to ask that it bring us to Pure Happiness, Pure Bliss, Pure Love, which is the stuff of religious promises. "To the age its art" is a rather merciless slogan. Klimt's art is not for our time because its beliefs about art cannot possibly be held today. How much suffering would we exchange for a piece of art like his *Beethoven Frieze*? That the answer is obvious does not mean we are not glad the work was saved—but it is not a *Kunst* for our *Zeit*.

What brought me to the Secession on this occasion was in fact a caption underneath a photograph in the indispensable tabloid *Der Falter*—"The Folder"—which carries listings of everything of cultural interest going on in the city, together with a lot of slangy *Village Voice*-like commentary and criticism. The photograph showed what looked like a gun, and the caption read "Is it art if it looks like a gun and happens to be made out of Lego blocks?" One does not expect a "But is it art?" question raised in a publication quite as culturally cool as *Der Falter* sets itself up to be, least of all in a city that has known as extreme an avant-garde scene as Vienna's. It was the scene, for example, in which "action artist" Hermann Nitsch had himself fastened to a cross, nude and upside down, while assistants poured blood by the bucketful over him, and in which Rudolf Schwarzkogler is widely believed to have died in lopping off his penis in a performance in 1969 (actually, he died by throwing himself through a window). It is possible that the sacrifice of life stifled the "But is it art?" reflex in Schwarzkogler's case, whereas the idea of art made of components available at any good toy store provoked it. In any case, I was motivated by the caption to see where the Viennese art scene might

want to draw a line. I was ready to consider as art the four works by Manfred Erjautzt, which indeed were guns in three out of four cases, but assembled with a skill those who standardly play with Lego blocks are unlikely to achieve. The guns were sleek, lethal looking, and absurdly colorful—they look in fact like modernistic sculptures in the bright reds, blues, yellows of Lego blocks—and I felt that in associating playthings with killing, they had as good a claim to the status of art for our *Zeit* as Klimt's fevered connection of art and salvation had with his: The Secession continues to fulfill its mission. The fourth piece, by the way, was a life-size electric chair, something that exists only as art in Vienna.

The most widely known contemporary artist in Austria is beyond question Friedrich Hundertwasser, probably the only living artist ordinary Viennese know by name and can recognize—though everyone officially connected with art made a point of saying how much they hoped I did not like Hundertwasser, since they *hated* him. Hundertwasser was invited to decorate Vienna's chief heating plant and incinerator, which now looks like something fabricated from a drawing in a marvelously illustrated children's book. The artist painted crooked make-believe windows in what I may as well call Lego colors, on what would otherwise have been vast unbroken industrial walls, and decorated the remaining spaces with fragments of irregular checkerboard patterns. He found ways of transforming the space into crazy angles, with pinnacles ornamented with shiny gold balls. Finally, the artist designed an immense golden sphere to fit around the functional black chimney, which now looks like a fanciful minaret against the sky, periodically emitting clouds of black smoke that would otherwise be perceived as pollution. The plant is assertively visible from almost any point directly north of the Ring, and I was impressed when a very ordinary man, sitting across from me on the U-Bahn, pointed to it and said, "Hundertwasser!" and the woman he was with said, "Ah! Hundertwasser." I was no less impressed when my wife and I went on a crowded tram to see the so-called Hundertwasser Haus in the Third District, and discovered that everyone else was bound for the same destination. It is a piece of public housing predictably decorated with bright colors and golden balls, and patterns that shun straight lines and right angles, of which Hundertwasser is the sworn enemy. The crowd, snapping photographs, was clearly impressed by the originality of the idea.

Hundertwasser-like components—bulbous columns like stacks of heavy beads, ornamental patches in colored tile, curved courses of ornamental brick—have cropped up here and there in the streets near the Haus. But the art museum nearby is the genuine article, housing of course a permanent exhibition of the paintings whose popularity gave the artist his fortune and his name. They are certainly not unpleasing, composed of heavily outlined circles that have the look of polychrome onion slices, meant to be trees, set against houses very much in the architectural spirit of Hundertwasser's public projects. As a builder, Hundertwasser owes a great deal to Antoni Gaudi, but his paintings seem to me loosely patterned on the decorative sections of Klimt, and thus carry forward some of the inventiveness of Viennese *Jugendstil*. It is clear that he paints too much, and no less clear that he appeals to those with no special claims to artistic sophistication, both of which explain his rejection by aesthetic cognoscenti, who tend to admire grunge. An awful lot of official postwar art in Vienna was scruffy, scrubby, and dour—distantly related to the squalor of smeared paint and broken furniture used to whatever expressive ends by Robert Rauschenberg or Edward Kienholz in the early 1960s—and probably felt more suited to the memory of war and defeat than Hundertwasser's gay dreamscapes. A young curator I admire felt that Hundertwasser is Vienna's Jeff Koons in his constant exploitation of the possibilities of kitsch. In my view, the parallel is inexact: Koons uses kitsch to make artistic points, whereas Hundertwasser really just is kitsch. But I am far from convinced that Klimt's gold-clad lovers clasped in ornamental kisses are that many notches higher on the scale of artistic purity.

When I asked whom critics admired in Vienna today, I was told that Franz West, a sculptor, is one of Austria's best, and as luck would have it there was a show of his work at the Museum of Twentieth Century Art. West's work has the raw look of late-twentieth-century creditability; there were some plaster heads on an Easter Island scale, whose chief feature was gaping untoothed mouths, but West's most interesting works are his "Adaptables"—typically pieces of cast iron such as pokers and tongs, at one end of which are large lumps of some plaster-like substance, giving the impression of clunky golf clubs. The public is invited to "do something" with these, and visitors diffidently overcame the internalized barriers that separate artworks from

viewers and swung them gingerly for their own or their companion's amusement. West is inventive in designing objects that are open to be worn or swung or carried, as the interactive viewer wishes, in a manner in which nothing is especially achieved other than art having unsatisfactorily broken through the wall separating it from life. The works were gentle and ludic, not that distant in spirit from Hundertwasser's, though more austere.

Vienna's really swinging museum is the revamped "MAK"—the Museum of Applied Art—whose enterprising director has invited various leading artists to intervene in the display of objects from the permanent collection. The most inspired contribution, I thought, was Jenny Holzer's deployment of Biedermeier furniture, with a long row down the middle of the vast gallery of chairs facing in alternate directions and a frieze in red LED notation of her truisms *auf Deutsch*. MAK's restaurant is the smartest eating place in the city, patronized by local artworlders who check one another out as they seek a free table. In its own way it is a living, changing, interactive exhibition that serves high-class fare at moderate prices. At the moment there is also an exhibition of food as art in one of MAK's galleries, which features a dress made of meat, somehow in the Schwarzkogler spirit, as is the major temporary exhibition of Chris Burden, who took some Schwarzkogler-like risks in his early years, having himself nailed, Jesus-like, to a Volkswagen. I was told that the actual nails have been borrowed for a forthcoming exhibition.

As elsewhere in Europe—and to some degree in America—I found curatorial inventiveness somewhat higher than artistic imagination in Vienna. The only artist likely to change reality very much is Hundertwasser, whose gilded smokestack, visible from the windows of the Liechtenstein Palace, where the Museum of Modern Art is installed, is in serious competition with the Ferris wheel to be Vienna's defining symbol. It certainly distills a good many ideas from the *Jugendstil*'s past—overcoming the distinction between art and decoration, between pure and applied art, between fine art and craft, between aesthetics and utility.

—*July 29, 1996*

PICASSO AND THE PORTRAIT
. . .

I HAVE BEEN READING RAY MONK'S BIOGRAPHY OF BERTRAND RUSSELL, and find that I cannot help but think of parallels between the great logician's life and that of Picasso, whose portraits are the subject of a remarkable exhibition at the Museum of Modern Art. Both men lived into their nineties, both transformed their respective subjects in ways that helped define the twentieth century, both were driven by immense sexual energies and a terrifying need for love. Russell's greatest work, the colossal three-volume *Principia Mathematica* (1909–13), was achieved with the collaboration of Alfred North Whitehead, whom Gertrude Stein regarded, with herself and Picasso, as the only true genius she had known. Picasso's greatest achievement, the invention of Cubism, was also a collaboration (with Georges Braque) from about 1909 until 1914. My dictionary defines Cubism as "the geometrical reduction of natural forms," while the aim of *Principia Mathematica* was the reduction of mathematics to logic (there was to have been a fourth volume on geometry, but Russell wrote that he and Whitehead turned away from the project with a feeling of nausea).

"Assessing what was achieved by the Herculean labours involved in writing *Principia Mathematica* is difficult," Monk writes, and as much could be said of the labors involved in rewriting the natural appearances of the world in the Cubist script. To be sure, Russell saw mathematics as beautiful, and Wittgenstein compared Volume II explicitly to music. Would these exalted assessments survive the discovery that the reduction failed, or that the entire project was somehow false? Are there parallel pitfalls for Cubist analysis, or

do the questions of truth and adequacy simply not arise for art? These questions notwithstanding, logic, which had been regarded as a finished science late into the nineteenth century, was reopened as a field of investigation and adapted as a model for doing philosophy in the twentieth. Picasso opened for painterly representation radical possibilities never dreamt of before, and became the model against which painters sought their own measure until sometime in the 1960s. A. J. Ayer described Russell as "the Picasso of modern philosophy." I am perhaps the first to call Picasso the Russell of modern art.

Russell's first philosophical masterpiece, "On Denoting," was published in 1905, the year of Picasso's first masterpiece, *Family of Saltimbanques*, in which he portrayed himself and his mistress Fernande Olivier as street acrobats, a beautiful metaphor. It would be difficult to see the slightest reference to himself or his own life in Russell's brilliant demonstration, in "On Denoting," that the logical form of propositions is distinct from their grammatical form. My sense is that Picasso lost his virulence as an artistic threat for later artists when it became possible for an appropriationist, Mike Bidlo, to paint up a show of all the major Picassos. There is no such thing as appropriation in philosophy, but Russell's daunting stature also lost virulence as analytical philosophy became a mere style and the philosophical bearing of mathematical logic as obscure as the point of Cubism.

Russell did write a magnificent autobiography, but it would be difficult to deduce much about his life from just his philosophical writings, which are technical and professional, whereas with Picasso the situation is the reverse: His artistic *oeuvre* is one vast pictorial autobiography, though it would be hard to infer from his life much if any understanding of his formal achievements as an artist. Because of this, critical scrutiny of these achievements has tended to treat them autonomously and in abstraction from the life, fascinating as the latter has been in terms of the artist's loves and friendships. The great issues raised in Russell's work—the theory of descriptions, the theory of types, the semantical paradoxes, the virtues of logical atomism, our knowledge of the external world, the analysis of mind, and the plausibility of Neutral Monism—pretty much specify the curriculum of professional philosophy, and call upon structures of thought that have nothing to do with the

farces and tragedies of Russell's long and bumpy life. And in a way this has often seemed true of Picasso's works as well: Cubism appeared to involve formal and analytical discoveries of a public and universal nature, available to artists whatever their temperament and national identities, much in the way, I suppose, that Joyce's stream-of-consciousness techniques seemed to provide novelists with a way of treating the interior lives of their characters. Analysis is analysis, and the resolution into geometrical forms must seem to have as little to do with its inventors as linear perspective did with Brunelleschi, Alberti, or Piero della Francesca. And no doubt the tendency of cultural critics to bracket Analytical Cubism, the theory of relativity, and the fourth dimension as corresponding redefinitions of reality tended to reinforce the view that modern art was like modern science somehow, each transforming our picture of the world in parallel ways. The great virtue of the exhibition of Picasso's portraits is that it causes us to wonder what truth, if any, there is in this view. Cubism may after all have become less a tool of visual analysis than a Modernist mannerism in the legions influenced by Picasso, for whom it may have had a subjective urgency peculiarly his own. Why would someone bent upon discovering a universal visual language address and readdress the face, form, and figure of those to whom he was emotionally attached? It would be as if Russell's strategy for overcoming seeming contradictions by logical analysis were motivated by the personal dilemma of being greatly attached to two women at once.

I have a very clear notion of what philosophical analysis was intended to achieve. In effect, it sought to resolve sentences, which looked simple enough grammatically, into a conjunction of component sentences that could be analyzed no further. One performed such a resolution when the original sentence seemed to commit us to the existence of things we had no independent reason to believe existed. Russell was inspired by mathematical strategies developed in Germany, which showed how to handle quantities as small as might be required, without committing oneself to the existence of infinitesimals. He wanted to show how one could speak about the Golden Mountain without having to admit the existence of the Golden Mountain into one's inventory of the world in order to do so. But I have no correspondingly clear idea of what Cubist analysis was meant to achieve. One

could simplify forms, as Braque did in the paintings that inspired the invention of the term "Cubism." A house could be represented as a plain, unadorned cube, with a pyramid for a roof. A tree could be represented as a green sphere atop a brown cylinder. A mountain could be a cone, a woman's breasts a pair of cones. But the portraits at the high point of Analytical Cubism were in no sense simplifications of this sort. They seemed to be an arbitrary faceting of forms, which, when carried to a certain point, evoked the kind of jocular description Duchamp's Cubist *Nude Descending a Staircase* did—"an explosion in a shingle factory." Today, one might see these portraits as analogues to the overlay of multicolored squares used in television to conceal someone's identity. Yet I have the sense that the "shingles" were not intended to conceal but to reveal. The questions then would be what, and why.

I have seen drawings by Poussin in which limbs are treated like elongated blocks, and surfaces reduced to planes. This may be a notation for handling lights and darks, a means to something rather than a declaration. But Picasso's portraits, particularly his portraits of dealers like Wilhelm Uhde, Ambroise Vollard, and especially Daniel-Henry Kahnweiler, feel curiously like declarations. It is as if they were assemblages of cards—but what does this say? In the slightly earlier portrait of his mistress Fernande, done in 1909, the planes seem hewn and the subject uglified. In the slightly later portraits of Eva Gouel, the love, evidently, of Picasso's life, the subject is dissolved into scoops and jiggles, curls and cup-forms, and the artist has written *J'aime Eva* in pubic cursive, just above what is unmistakably her vulva, indicated, like a hieroglyph, with a straight line just where the cleft would be, and a rhythm of curved lines like combed hair. It really does feel like a form of writing, just as Kahnweiler proposed that Cubism was—an array of pictographs that register at once the artist's feelings and what occasioned them. Eva is tenderness, her body an architecture of caresses. Fernande is harshness and love turned cold. "He did this out of purely plastic motivation," Pierre Daix writes in the catalogue essay. "To see in this either aggression or sensuality is to misread Cubism. He used this device simply because she . . . was, so to say, there." But so was Eva, so were the dealers, "so to say, there."

How exactly does this idea of "purely plastic motivation" connect with the truer characterization Daix then makes that Picasso "objectively records,

in clinical detail, Fernande's plumpness, her fatigue, and the first signs of age on her face"? If Cubism is indeed a script, it allows Picasso to register a change of affect between an aging mistress and *Ma jolie*. The great portrait of Eva in the 1913 *Woman in an Armchair* shows her as an aggregate of soft openings and silk underwear and cascading hair and pointed, detachable breasts. Whatever these portraits are, they are not "reductions to geometrical forms." Try to imagine achieving this change by means of strict photographic portraiture! Picasso did not develop Cubism to disclose an outer structure in the world but to project an inner structure of feelings and attitudes toward that in the world which claimed his emotions. Picasso, William Rubin writes, "could only make great art from subjects that truly involved him. . . . Unlike Matisse, Picasso had eschewed models virtually all his mature life, preferring to paint individuals whose lives had both impinged on, and had real significance for, his own."

Consider the *Portrait of Daniel-Henry Kahnweiler* of 1910. The subject is almost totally dissolved into a scaffolding of overlapped planes, though there would be general consensus on the sitter's character were one to conduct a survey. Picasso portrays him as the embodiment of dapperness, with his hair primly resolved into four neatly curved furrows, and his hands holding what one supposes are his attribute, a pair of yellow kid gloves. He boasts a double chin, a pleated shirtfront, smart lapels, and a jaunty cravat. There is what seems to be a bottle to the sitter's right, and the space surrounding the figure is embellished with Cubist markings. Perhaps they are there simply to give the space visual interest, or perhaps they allude to wallpaper or (my view) they, like the witty bottle, are to be referred to Cubist paintings with which the sitter is surrounded. After all, Kahnweiler dealt in Cubist pictures, and it would be quite suitable to portray him as one of his own images. Poussin portrayed himself amid pictures in a work of anticipatory Cubism, in which the self-portrait might be seen as fitting within the set of pictures it shows, inside and outside itself at once. So Picasso could have portrayed his dealer as one of the canvases with which he identified.

This interpretation has the merit of converting Cubistic pictorial noise into Cubist signals, but it can hardly pretend to be more than that. One cannot discount what Daix speaks of as purely plastic motivation, which is a way

of warning us not to read everything in a Cubist painting as having referential meaning. There are repetitions, reversals, and amplifications in the portrait of Kahnweiler, as if it had the texture of a musical composition. And there may be marks that serve the same function as whiz-lines in a comic strip. But the overall intention is to render felt reality in terms of some visual equivalent. It is an exceedingly personal transformation, in which the real world is metabolized and presented to the viewer as emotional energy transcribed and made visual. Picasso painted his love, his anger, his contempt, his despair, his loss, his affection, which is why an exhibition just of portraits is the best way into his world. It is like living his life with him.

In a widely cited passage, Picasso explained to the photographer Brassaï why he dated his pictures:

> Because it is not sufficient to know an artist's works—it is also
> necessary to know when he did them, why, how, under what
> circumstances Some day there will undoubtedly be a science—it
> may be called the science of man—which will seek to learn more about
> man in general through the study of the creative man. I often think
> about such a science, and I want to leave to posterity a documentation
> that will be as complete as possible. That's why I put a date on
> everything I do.

It is certainly of some interpretive value to register the fact that two paintings were done on the same day, such as the pendant portrayals of two women, Marie-Thérèse Walter and Dora Marr, on January 21, 1939, in nearly identical formats. Both women are shown reclining, each holding a book. Marie-Thérèse is curved into herself, as comfortable as a cat, her eyes, like fish, swimming back and forth across the pages. Dora by contrast seems restless and somewhat dangerous, all points and angles. Marie-Thérèse's pale pink lips are slightly pursed and pensive; Dora's teeth are bared and her eyes are wild. Her face is green while that of Marie-Thérèse is the color of skin. Her fingers are natural and clasped, but Dora has knife-blades for fingers—a biter and a scratcher in the act of love, whereas Marie-Thérèse is a soft engulfer. It is a commonplace that Picasso invented a new style each

time he fell in love with a new woman, but to the degree that this is true the style belongs to the woman in question as her attribute, as what she is to the artist who loves her. So Marie-Thérèse is nearly always curves, softness, and orifices; Dora Marr almost invariably shards and spearheads. Even Dora's frequent hat looks like a crown of axheads. By 1939, Picasso had been Marie-Thérèse's lover for a dozen years, and had a daughter by her. His relationship with Dora Marr was four years old but still fascinating to him. There is a palette hanging on the wall, acknowledging her as an artist. And the windows are open to the world, for through them we can see trees in full bloom. The same windows, in the painting of Marie-Thérèse, are opaque, closing the world off. Marie-Thérèse is a world unto herself, which has its rewards but also its limitations. For all the dangers, Dora is part of the outside world, someone who shares Picasso's interests in subjects other than sex, a companion if a rival; not passive, like cushiony Marie-Thérèse, but sharp and challenging. In the two paintings Picasso is comparing two modes of love, two forms of life, two ways of being female, and putting them side by side, stating the impossibility of choosing between them. The juxtaposition also shows that if Picasso were to find a woman who somehow was both a Dora and a Marie-Thérèse, he would abandon them both. In some ways he appears to have found that unlikely fusion in Françoise Gilot, whom he painted as a fragile flower—a plant with breasts—but who turned out to be tougher than he.

Even without Picasso's envisioned "science of man," we can almost deduce the state of his existence in 1939 from the paired portraits of the two women, though we would certainly need such a science to draw from *Principia Mathematica* much about Russell's troubled passions. What we could not do is deduce the paintings from what we know of the life: Picasso would always surprise us, giving each of his subjects his or her own pictorial language, expressive at once of his feelings and of the psychic reality of the sitter. I cannot imagine what a portrait by Picasso of Bertrand Russell would look like. They never met, though they could have. Russell's collaborator, Whitehead, evidently impinged sufficiently on Gertrude Stein's consciousness to ring the bell signaling genius. Russell became a (not, unhappily for him, *the*) lover of Lady Ottoline Morrell, the somewhat absurd "Ott" of Virginia Woolf's di-

aries. The night Ott promised not to break off the relationship, she went to bed with Roger Fry, who was the following year (1912) to mount the epochal exhibition of Post-Impressionist painting at the Grafton Galleries, in which Picasso's work featured prominently. Russell lectured at the Barnes collection, where he was embarrassed by the nudes. As near as I can tell, he had no interest in painting, though Lady Ottoline adored going round to galleries and even had painters as lovers. If their liaison had not been as furtive as that between Picasso and Marie-Thérèse, she might have taught the enamored logician something about the senses, and made the relationship less agonizing.

Picasso really only once met someone who was his match, intellectually and creatively; this was Gertrude Stein. The portrait he did of her, dignified and powerful, shows his admiration and respect. It is, of course, one of a kind: He never did another like it because he never again met her like. We will never encounter Picasso's like again either, nor, for that matter, Russell's. But we can learn, I think, a lot about logic, art, and life by putting them up, side by side, like Marie-Thérèse Walter and Dora Marr.

—August 26, 1996

Nan Goldin's World

• • •

FROM AN "UPTOWN PERSPECTIVE," WHICH VIEWS THE HISTORY OF art in terms of the succession of movements and the creation of masterpieces, the decade of the 1970s still seems, as it did at the time, something of an artistic blank. The 1980s appeared to have ended this creative drought explosively, with the huge, sticky figurations of Neo-Expressionism. Neo-Expressionism generated a relieved excitement, and the belief that the art history we had learned to take for granted was back on course. From the uptown perspective, happy days were here again. Whatever the felicitous economic consequences, at least momentarily, of this belief for artists, it proved to be a mirage: While a number of impressive individuals have certainly emerged in the past twenty years, this period has been far closer in spirit to the 1970s in its absence of artistic movements and lack of any defining artistic style. The historical demiurge, which drove modern art urgently forward from revolution to revolution to revolution, appeared to have gone on holiday.

It has dawned on me more and more strongly that this seeming stagnation may be an artifact of the uptown vantage itself, that the convulsive artistic transformations of the 1950s and 1960s constituted the standard rhythm of art history in Modernist times, and had merely transferred itself from Europe to the United States after World War II. Suppose we replace it with a different one (which we may as well identify as the downtown perspective), from which the art world may be seen as a deeply pluralist, highly cosmopolitan arena of activity, defined by no overarching historical direction at

all? From the downtown perspective the 1970s, far from barren, may have been the most interesting and important art-historical decade of the century, mainly because the foundations were then laid for what I call the Post-historical period of art. Modernism had been the history of manifestoes, of proclamations, of aesthetic imperatives. In the Post-historical art world, anything goes. Modernism was believed to be an adventure in purification, in which each medium sought to realize what was proper and exclusive to itself. Post-historical art glories in its disregard of categories.

From the uptown point of view, painting was the primary vehicle of artistic change. From the downtown perspective, painting, if not altogether marginal, is but one of a large number of genres of art-making that combine and recombine in ways the uptown perspective stigmatizes as impure. It was from the uptown perspective that Neo-Expressionism seemed to have brought painting and art history back together. The downtown perspective would have focused on the cracked crockery in Julian Schnabel's painting—or on the odds and ends of furniture affixed to the paintings of David Salle—as evidence that these works incorporated different genres and were paintings only in part. An exemplary work from the 1970s might have been a slide show with patches of music keyed in and an interchange between artist and audience that made its projection a form of performance.

The center of the art world of the 1970s was, initially at least, a sector of Manhattan known to the tourist itinerary primarily through the Bowery: an area of scary streets, decrepit residential buildings, bars, lunch counters, and a sunk population. In a way, it was a scene that emblematized the overall unraveling of New York in that era, on the brink of bankruptcy and over the brink of societal disarray: a bit of urban ruin prefiguring a greater ruin to come. New York in fact touched bottom in those years, but the area in question—the East Village, as it came to be known—inevitably lagged behind in the recovery, if only because it had been so far ahead of the larger metropolis in point of desuetude. It knew a certain tacky glory in the mid-1980s, with galleries, clubs, and restaurants in which those who were not resident there took an interest; but by that time its period of great social and artistic invention was pretty much over. It had been a paradise for the legions of the young who converged there and who evolved a utopia compounded of drugs, sexual experimentation, and artistic creativity, made possible through cheap

rents, an indifference to amenities, and the absence of censorious elders. Joseph Beuys said, later in that decade, that everyone is an artist, and the settlers of the East Village seemed determined to confirm this sweeping enfranchisement. Everyone *was* an artist, even if this meant, or perhaps only if this meant, that art itself had to be reinvented. The conditions of art-making were made sufficiently flexible and accommodating to enable anyone to practice some form of art.

Photography was central to the 1970s' reconceptualization of art, in part, I suppose, because the camera had become something everyone could in some way use, like the home movie camera or, later, the camcorder, and so it was relatively simple to step into the role of artist. This did not mean that the individuals became photographers. That was not the intention. Rather, they often used the camera, and the photographic effects it made possible, in the creation of works that only superficially resembled the photographs of photographers. They were artists first, and had little interest in learning about exposure times, lighting, darkroom technology, and the like. I speak of such artists as photographists. The overcoming of artistic boundaries also paralleled the overcoming of social and even moral boundaries in the artists' lives.

Wittgenstein has said that to imagine a language is to imagine a form of life, so if we can imagine the 1970s' reinvention of art as a new language—a kind of creolization of Modernism—then it went perfectly with the reinvention of social life on the part of those who participated in it. And since art was a form of life more than a set of objects, the point was to live it rather than to make money by its means, and the reconceptualization of art and of life mirrored each other perfectly. Boundaries of every sort were felt to be oppressive, most particularly those of gender. Persons could take on the attributes of a chosen sex by dressing or acting the part, or could achieve composite sexual identities beyond homo- or hetero- or bisexuality, it being no more mandatory that one be a man or a woman than that an artwork be a painting or a sculpture. Why not both? Why not everything at once? And why not let love determine the forms of its realization, if art is polymorphously realizable? The unit of love need not be restricted to the couple or the biological

family, any more than artistic creation required dedication to a single medium.

When Nan Goldin presented her slide show *The Ballad of Sexual Dependency* it would characteristically have been for an audience consisting of people who knew—or were—those whose portraits formed its content. The interchanges would be of the kind everyone is familiar with from watching movies of the family. And, like home movies, it would have a meaning for those portrayed that it would not have for those outside their circle. Goldin's photographs record and embody that moment of social history when everyone was an artist and love and sex found hopeful ways of transcending boundaries and building new habitations for the heart. She belongs to it as an artist in that she found ways of reinventing the snapshot, not in the sense that her pictures look like something taken by a point-and-shoot camera but because there is some internal bond between photographer and subject. Her photographs celebrate that bond. We take snapshots of persons and places that have some personal, immediate meaning for us; what they are *of* is part of what we ourselves are. Such snapshots are universal precisely because of that: my sweetheart, my best friend, Mom and Dad, my best friend's wedding, where I live, my new look, me horsing around with my boyfriend/girlfriend, etc. This is what gives any snapshot a poignancy, even if we know neither its subject nor who took it. We are seeing into someone's world.

Goldin really is a photographer as well as a photographist. Her pictures, typically large glossy Cibachrome prints of a kind of Caravaggesque intensity, monumentalize the spirit of the snapshot as an intersection of the personal and the universal. What gives them their edge of fascination when seen at the Whitney, is the discontinuity between her world and the worlds of anyone not part of the social reality the pictures embody. We grasp the kinds of relationships they portray, but the world they project is remote from viewers distanced from the Lower East Side of Manhattan in the 1970s. The snapshots show us that world from within, as lived. They are almost shatteringly intimate, to the point of transforming us into voyeurs. It is perhaps a condition of being a subject for Nan Goldin that one does not care who looks on in what would generally be the most private moments—as if the only viewer who matters is one from whom the subject would keep no se-

crets. Or as if being photographed outweighs whatever embarrassment might be caused if someone outside one's circle happened to see the picture. (It is unclear if we are being taken into the circle or expelled from it by the subjects' indifference to us as onlookers.) The closed dark interiors in which most of Goldin's subjects are pictured are metaphors for the boundaries that exclude from her world those who are not within it. The surface of the photograph is like a glass wall through which we can see person engaging with person in acts of, well, sexual dependency.

So "me horsing around with my boyfriend" comes out as *My hand on Brian's dick*—where Nan's braceleted hand comes into the picture's space from outside, as in a marvelous early self-portrait by Robert Mapplethorpe. And "my sweetheart" shows Brian an instant later (we can tell that from the clock by the bed) in *Brian after coming*, with a flower-shaped puddle of ejaculate on a sullen blue sheet. Later, in that same sexual-photographic séance (we read from Nan's wristwatch, since the clock is hidden by Brian's hip), we see Brian and Nan together in *Self-portrait with Brian having sex*. Brian and Nan, in each other's arms, are kissing, and Brian is clutching Nan's breast. *My best friend* shows blond, skinny Suzanne naked on a bidet somewhere in New Jersey, or ecstatic as water courses down her pale body in a shower stall, or crying, in 1983, for unexplained reasons, in New York. Bobby's intense expression in New York, 1980, is easily enough explained in *Bobby masturbating*, as is Brian's post-coital collapse. But who is Bobby or Suzanne, and why is Suzanne crying? Those who constitute Goldin's world would know, as they know whose brutality explains "my new look"—*Nan one month after being battered*, 1984, an extraordinary self-portrait of Nan with her eyes blackened, her right pupil still blood-filled, staring at her own puffy face in the mirror, shattered into a blank impassivity despite the brave lipstick, the new hairdo (a wig?), and silver earrings. (Nan is further brutalized by the placement of this great picture in the show's catalogue, for the book's gutter splits her face in two.) We know who beat her up, because the pictures of and with Brian form a narrative—a kind of synchronic slide show, culminating in the beaten Nan. Somehow Brian's character is inscribed in his face: We can tell that he is going to do something violent.

Siobhan, the next sweetheart, has an affecting face, but we know as little about her as about Suzanne, and after seeing her through various shootings,

in bed with Nan and by herself, she fades, or seems to fade, out of Nan's sight. Nan embodies her world because love trumps gender in her sexual quest, as it does for so many of her friends. The photographs show nipples, penises, pubic hairs, bruises, scars, tears, smiles. The people in Nan's world show one another (Nan of course included) everything, just the way members of a family might who no longer register one another's nakedness. It is a kind of gift, and an act of complete trust.

It remains family portrayal since those of us outside the extended group know almost nothing save the most generic facts about those within it, and the photographs rarely show us anything about individuals outside of their relationships to one another as lovers, friends, or victims. If they are all artists, we would remain ignorant of it because, except for the transvestites, we can infer little about what they do outside the dark interiors in which they live. We see them where we see only those who are very near to us, in bedrooms and in bathrooms. We can deduce something about them from the objects with which they surround themselves, and the states of their intimate spaces. They are not good housekeepers: In *Brian on the toilet*, 1983, the floors are filthy. Beds are unmade. In *Nan at her bottom*, 1988, we feel the artist is making a desperate phone call. The vials of medicine visible convey its content as well as the state of her being. I do not know what to make of the crosses. In *Cookie on my bed*, there are small, curling pictures on Nan's wall, including a Bronzino. The pictures-within-pictures seem as significant as those in Vermeer's paintings—there is a Vermeer, in fact, in *Writing on my wall*, 1988—and perhaps even now dissertations are being written on the pictures-within-pictures in Nan Goldin's *oeuvre*.

Goldin's world was included in Peter Galassi's 1991 exhibition at the Museum of Modern Art, "Pleasures and Terrors of Domestic Comfort." Galassi complains of the thinness of "the record of home life . . . within the aesthetic tradition of American photography." And he contrasts the "freedom and anonymity" photographers enjoy as external observers. What is remarkable about Goldin's work is the way she records the life of a particular, extended moment in American life as what anthropologists term a "participant observer." Everybody has a sexual life, but we rarely observe the sexual activities of strangers. We know what they are doing from our own experience, but we

do not have the experience of seeing them do it—we know such activities primarily from within. That inevitably puts a distance between us and those we see so engaged, unless they are doing it for entertainment, as in sex shows or pornography. This distance implies a similarity, only external, between Nan Goldin's work and that of Diane Arbus. The difference is that Arbus had precisely the "freedom and anonymity" Galassi speaks of vis-à-vis her subjects, while Goldin sees and shows her world from its inside. That difference in perspective translates into the difference between the faintly pathological curiosity Arbus's work reveals and the passionate sense Goldin expresses of someone holding her world and herself together by getting it all down on film.

For different reasons, of course, one might compare Goldin's work with that of another great artist of the 1970s, Cindy Sherman. Just as Goldin internalized the moral aesthetics of the snapshot, Sherman appropriated the narrative fiction of the film still. There is no such thing as "Sherman's world" to be gotten out of her photographs, nor is she in her photographs either, except as an ironic commentator. We never really see Sherman as Sherman because she is always playing the part of someone else, and what seems to be her nakedness is an illusion achieved by false body parts, worn like masks. Nothing is masked in Goldin's work: What you see is what she is.

The lower Manhattan youth culture of the artistic 1970s knew a halcyon moment, bounded by the end of the Indochina war as its beginning and the emergence of AIDS as its end. For those who lived it, hard drugs were cheerily regarded as the generation's equivalent of alcohol, no better and no worse. The hospital bed and the casket join the bathtub and the bed in the intimate furnishings of Goldin's extended family. The pictures of death and dying retain the intimacy of snapshots. Death is universal but the deaths of these individuals are like the sex of others. We may be saddened by the one as we are aroused or repelled by the other. The title of the show is "I'll Be Your Mirror." We are reflected in Goldin's mirror only in the common human attributes we share with the photographer and her friends. They may see themselves reflected in a one-way mirror that we see through. It is hard to separate the art from the reality it encodes. Goldin's pictures are indissolubly both universal and other.

—*December 2, 1996*

JASPER JOHNS

■ ■ ■

JASPER JOHNS'S 1955 PAINTING *FLAG* SO EXACTLY FITS THE DESCRIP-
tive content of its title that it might appear to the innocent eye as if the title
were a label, designating something so entirely familiar that the need for la-
beling it is altogether perplexing. It would be like labeling a doorbell as
"Doorbell" when, to speak in the American grain, any fool can see that's
what it is—and no one would be fool enough to take it as a title, since (we are
speaking of innocent eyes) a doorbell is not a work of art. The fool plays a
momentary role in Johns's *Fool's House* of 1962, a canvas to which are affixed
certain common objects not commonly, as of that date, to be found as parts
of works of art: a broom (worn), a towel, and (hanging off the bottom edge
of the canvas) a cup. The objects are labeled, with arrows drawn to them.
There is also a canvas stretcher labeled "stretcher." Only a fool would
mistake the labels in *Fool's House* for titles, since—again, as of that date—
brooms, towels, cups, or even stretchers would not have made the grade as
works of art. True, they are painted. But they are painted only in the sense
that objects in the commonplace world are given coats of paint. The inhabi-
tant—the Fool, let's say—shows a singular ineptitude in covering things with
paint, since it is brushed on as if a painting were being made by someone
with an elegant touch. Would that make them works of art? It certainly
made *Flag* one, even if *Flag* looked to the innocent eye enough like a flag
that its title might pass for a label. The title/label ambiguity matched the art-
work/object ambiguity, and the interplay between linked ambiguities defined
Johns's agenda for the first phase of his remarkable career.

The career is remarkable in part because eyes are a lot less innocent today than when *Flag* was painted, and this is due in no small measure to Johns himself. I do not merely mean that *Flag* became so definitive an icon of twentieth-century art that scarcely anyone, seeing it in a case of its own at the threshold of the exhibition dedicated to Johns's art at the Museum of Modern Art, would think that they were looking at a displaced piece of folk art or a fading trophy from some forgotten battle on loan from a military museum. Even a displayed quilt in the form of a flag executed by the wife of a patriotic farmer or a venerated Stars-and-Stripes brought back from the shores of Tripoli by a proud company of Marines would initially be seen today as a Jasper Johns by (to change our paradigm) any schoolboy. Johns claimed it as his own in the same spirit of successful appropriation with which his peers colonized other pieces of vernacular culture as their own: *Steve Canyon* panels by Roy Lichtenstein, Campbell's Soup labels by Andy Warhol. The knowledge of certain masterworks of postwar art has so thoroughly penetrated the common consciousness that it is a wonder American flags have resisted being slangily designated "Jaspers" the way Wellington bombers became known as "Wimpys" or life preservers as "Mae Wests." Yet the loss of innocence to which I refer is the conceptual innocence regarding the limits of art that defined even (or especially) critics and artists at the time the work was made. Johns's flag invalidated the aesthetic—or part of the aesthetic—of the most esteemed members of the advanced painting culture of the time. It was so in violation of what was allowable as art that it had no real precedents. Indeed, Johns has claimed that it came to him in a dream. Since it so successfully transgressed the rules and not only survived but triumphed as a work of art, it signaled the end of an era. It marked, with qualification, the cusp between the Modern and the Contemporary. It opened up the present in which we all exist artistically. It is a present in which the imperatives of aesthetic tyranny in the era of Abstract Expressionism collapsed at once, as much through the agency of Johns's flags and targets as through anything. *Flag* reconnected art with reality. It showed how it is possible for something to be at once an artwork and a real thing.

Flag achieved this by virtue of being at once a representation and the object of representation—a painting of an American flag that was in truth the American flag. It was, in effect, like what Marcel Duchamp once referred to

as a "reverse readymade." (The "readymade" is a utilitarian object transformed into a work of art—a urinal into a sculpture, to cite the famous example.) A reverse readymade is a work of art transformed into a utilitarian object—using a Rembrandt as an ironing board was Duchamp's suggestion. One could fly *Flag* or salute it. Or use one of Johns's targets for archery practice. *Flag* met reality halfway by claiming the image's edges as its own: Since the image fills the pictorial space from edge to edge, the surface of the pictured becomes one with the surface of the picture. A painting of a flag is in general no more a flag than the painting of a flower is a flower; but the logical miracle of *Flag* lies in the way in which it is a painting of a flag that becomes a painted flag.

Through the 1960s, Johns explored the borderlands between representation and reality with this transformative principle in mind. His subjects were drawn from the class of self-representational entities, in which representing them and making them were simultaneously executed: not only flags and targets but maps, letters, and numerals. And he exploited as well one of the most primitive modes of representation we possess, namely, allowing something drawn from a class to stand for the entire class to which it belongs. So the broom—or cup, or towel, or stretcher—in *Fool's House* represents the class of brooms (or cups, towels, or stretchers). This is what makes the labels in *Fool's House* at once appropriate and, because of the utter familiarity of the objects, ludicrous. The representation/reality ambiguity for this class of objects made Johns's work of this period intoxicating, witty, and brilliant. It is an ambiguity he continues to exploit throughout his work: a picture of a picture is a picture, as when he incorporated a *Mona Lisa* or a Leo Castelli into his *Racing Thoughts* of 1984. A painting of an optical illusion remains an optical illusion, as in the "Young Woman/Old Woman" he began to incorporate into his paintings around that time. That the young woman transformed through a perceptual switch into an old woman is something of a *memento mori*, like the skull that appears in Johns's later work—naturally as the logo of a skull but serving the iconographic function of transforming the work into a kind of *vanitas*. But I am ahead of myself.

The relationship between the picture of an optical illusion and the optical illusion itself is not like the usual *trompe l'oeil* illusions in which something is

painted with such cunning realism that viewers are visually persuaded they are looking at reality. For one thing, the typical optical illusion has no existence to speak of outside its pictures, and in some cases would be impossible to realize in three dimensions. But more important (perhaps), it is not the eye that is fooled in Johns's works but rather the intellect, unable to apply a fixed philosophical distinction between representation and reality. Johns is a most skillful illusionist, and probably could paint anything in an optically convincing way. Still, the representation/reality ambiguity applies, it seems, primarily to things that exist as two-dimensional objects, like letters, maps, pictures, targets, logos, and the like; and they work best when they claim as their own surfaces the surfaces of the paintings that represent them. Since this requires bringing the objects represented flush with the surface of the work, Johns's canvases have exactly the kind of flatness the great *trompe l'oeil* painters required in order to achieve their effects. Johns's objects are either coincident with his surfaces or (when used as samples) affixed to them. This means that there is typically an implied wall, parallel to the painting surface but set back by about the thickness of a piece of paper or, as in *Flag*, a piece of cloth. There is an illusory space, but it is minimally deep, as in the paintings of the arch illusionist William Harnett.

If the central ambiguity of Johns's enterprise, the art/reality ambiguity, put him on the cusp between Modern and Contemporary art, it also left him like those visionary figures who lead their people to the Promised Land (if one may be permitted to consider Contemporary art in those terms) but do not enter it. This has made Johns if not altogether an outsider, then a kind of loner in the present he opened up.

What made *Flag* a work of art, given that it fully met the criteria that made it a flag, and in view of the fact that not all flags are works of art? The answer, in the early 1960s, would have been that it was the paint and the way the paint was put on, which was then the touchstone of art. Johns's handling of paint was simply marvelous. He could have been an Abstract Expressionist if he had wanted to; the brushwork had the lyricism of its greatest exponents. Simply as painting, *Flag* is delicious. The difference between it and the canonical Abstract Expressionist canvas was the discipline Johns imposed on himself to respect the edges of the stars and the stripes. A decade earlier, de Kooning had broken the interdiction against painting images by creating

his volcanic women. But the boundaries of those female presences were slathered over with thick swaths and scrubbings of pigment, so much so that the figure could not be separated from the medium. One could subtract the flag from *Flag*, say, by tracing, leaving the paint behind. In the pictorial metaphysics of that era, the paintwork stood to the artwork in the relationship of soul to body: To remove the form from the paint, again by tracing, would be to leave the art behind.

Johns has never relinquished his Abstract Expressionist credentials in the subsequent adventure of his art, and his brushwork remains one of the aesthetic glories of our time. Art has since, of course, undergone profound internal transformation, and the question of what makes something art no longer can be answered with reference to the kind of buttery brush marks that make Johns the master painter he is. It does, however, confer upon his work a further ambiguity—the Modern/Contemporary ambiguity—that makes it somehow difficult to situate in the present scene. The *contemporary* dimension of the ambiguity was defined through his subject matter of the 1960s, the objects from daily life, from what phenomenologists call the *Lebenswelt*—objects, the meaning and identity of which are immediate and obvious to whomever participates in that life (which is what makes Johns's use of labels so arch and comical). The American flag is part of the common consciousness of humankind today, an emblem recognized everywhere, like the dollar sign, in the sense that no one has to ask what it is or what it means. Johns's was what one might call the iconography of everyday life, which is why he was so naturally classed among the Pop artists. His sculptures, novel primarily for the way they expanded the range of objects from the *Lebenswelt* for realistic representation—his *Flashlight*, for example, or his *Light Bulb*— were not as philosophically brilliant as his paintings. His marvelous Savarin coffee can with paint brushes, in bronze painted to look like tin, made an allusion to the workplace of artists, since Savarin cans were the receptacle *de choix* in downtown New York lofts for soaking brushes in turpentine. Similarly, the Ballantine ale cans, again in bronze disguised as painted aluminum, made a sly reference to Leo Castelli's commercial prowess and the claim that the dealer could sell a pair of beer cans. This distinction between an initiated and an ordinary audience, somewhat like the distinction Leo Strauss imagined with reference to certain important texts between esoteric and exoteric

readings, still left those possessed of the common consciousness of the *Lebenswelt* to identify ale cans as ale cans, light bulbs as light bulbs.

In the 1960s, then, culminating in Johns's great exhibition in 1964 at the Jewish Museum (in those years the showcase for the most advanced art being made), he appeared to combine the aesthetics of Modernism with the realities of common life, and to appeal artistically to nearly everyone within the art world as well as outside it, although insiders got more of the allusions.

Since that time, however, without losing either his philosophical intuitiveness or his marvelous touch, Johns has made increasingly esoteric objects, so that even if we are able to identify the objects he shows, this recognition comes with the further sense that we cannot be certain what they mean, even if we are certain that they mean something important to him. And it is difficult to put aside the feeling that somehow certain personal demons are being fought. There are detached body parts (including what appears to be flayed human skin), skulls, and sexual emblems drawn, along with the skulls, from the iconography of late Tantric Buddhism. These are mingled together with the flags, the ale cans, the Savarin cans, and the optical illusions from the artist's earlier vocabulary. It is as though emblems of the largest human preoccupations—mutilation, death, sex, and redemption—vie with the emblemata of daily life. This tension, too, may carry forward the tensions between Johns's Abstract Expressionist heritage and his fixation on what Hegel spoke of as the prose of the world. The Abstract Expressionists saw themselves as shamans, in touch with the forces of the cosmos. The Roman soldiers asleep by the Sepulcher of Christ in Grünewald's altarpiece are traced and superimposed upon a blueprint of Johns's childhood home (*Untitled*, 1992–95) as he has been able to reconstruct it from his own memory and the memories of others. As if, by dint of superimposition, that home were the sepulcher from which he rose, whatever in spiritual fact that may mean.

It might at this point be best to shut up: Johns did an uncharacteristically unkind (and callow) sculpture in 1964, portraying a pair of mouths where eyes would be behind a pair of glasses, calling it *The Critic Sees*. Of course, at that time the content of his work was considerably more accessible than it has since become, and he was perhaps sick of critical yammering when, well, any fool could see what the work was about: flags, brooms, targets, and the

like. But it is hard to believe that any fool can see through work that has moved into the domain of the esoteric; nor, with such powerful symbols and juxtapositions of symbols, is it enough to let the eye be pleasured by the sweetness of the paint and the beauty of touch and color. It is difficult, given the power and even the universality of the imagined meanings, to believe that Johns's work over the past thirty years is an extended pictorial journal, painted for private illumination only. The viewer feels addressed in some way, and I will conclude with a small interpretive suggestion.

One will be struck, entering the downstairs section of the Johns exhibition, by the use of a certain crosshatch pattern that became his signature motif for a period in the 1970s. He uses it over and over, in various hues, and in every instance the painting is exceedingly beautiful. Legend has it that he saw an automobile painted that way, and adopted it as his own—as a kind of ready-made abstraction, so to speak, in the manner of the pattern of flagstones he often in those years conjoined with the crosshatching. It was as though he sought to solve the tensions between abstraction and figuration— between pure painting and the reality of things—by means of these ready-made abstractions, even if their ready-madeness would not be transparent to those uninstructed in their provenance. In an uneasy triptych of 1971, he places next to a crosshatch panel and a flagstone panel a third panel with body parts distributed upon a sort of scaffolding, as if challenging the viewer to see *that* as an abstraction too, swallowing the fears of life through art and beauty. That is too much for art or us to do. And now begins a certain spiritual struggle that continues to this moment between art and spiritual darkness. I count that heroic.

—January 27, 1997

OUTSIDER ART

▪ ▪ ▪

LIKE THE CONCEPT OF THE MASTERPIECE AND THE IDEA OF QUALITY in art, the category of "genius" has been consigned to the *index prohibitorium* of politically discreditable notions, the primary use of which has been declared elitist. We would be hard pressed, if this were all there were to the matter, to account for the fact that the same triad of politically suspect terms has application to what, since 1972, has been designated "outsider art": The Watts Towers, by Simon Rodia, is a masterpiece by any criterion; the drawings of Bill Traylor have artistic quality that sets them apart from the art of other outsiders; and the reclusive Henry Darger was a genius of stammering achievement. This triad accordingly cuts across, and in that sense obliterates, the boundary between outside and in, which cannot therefore have quite the political function its critics claim. The distinctions it enshrines belong instead to the nature of artistic creation, and would remain in effect even if all the political inequalities believed to affect the art world were dissolved and access to its institutions opened up completely. My sense is that outsider art, for all that the term suggests a state of excludedness, does not correspond to a political boundary between enfranchised and disfranchised. The true outsider is someone deeply outside the institutional framework of the art world.

According to the *O.E.D.*, the earliest citation of "folk art" dates from 1921, and though one supposes the expression had currency before it appeared in print, the date must correspond to a general awakening by the American art world to the visual qualities of quilts, weather vanes, and paintings in a rural vernacular, encountered by Modernist artists who left their

own urban habitats for summers at the shore or in the mountains. The history of Modernism is the history of appropriations. There is an internal connection between the first acknowledgment of folk art as art in the 1860s and the first episode in the history of Modernism—Manet's effort to exhibit his *Déjeuner sur l'herbe* at the Salon of 1863. Manet began the deconstruction of the traditional representational system of Western art, which went hand in hand with the aesthetic accreditation of art from outside the academies and even outside the culture. Van Gogh modeled himself on the Japanese master Hokusai; Gauguin found inspiration in Egypt, China, and the folk idiom of Brittany; Matisse and Derain found license in African sculpture to reinvent "planes and proportions" in their own work. Picasso borrowed forms from early Catalan decoration and, famously, from the African and Oceanic art he encountered in the Musée d'Ethnologie at the Trocadéro in Paris—and after discovering a portrait by *Le Douanier* Rousseau in a bin of used canvases, went on to collect the work of the most celebrated *naif*. It would have been in that spirit that the summering artists at Ogunquit, Maine, in the 1920s, began to see in folk art something more than decorative touches lending local color to their painting shacks. It showed them a means to a less academic, more personal and emotional mode of representation. Klee did not simply admire, he actually preempted the art of children; and in 1945 Jean Dubuffet began forming a collection of what he termed *Art Brut*, much of it produced by institutionalized psychotics, which he presented to the city of Lausanne.

In view of this history, it is difficult to credit the proposition, advanced in an editorial in *The New Art Examiner* of September 1994, that "the community of artists and theorists engaged in the politics of identity—women, people of color, lesbians, gays, and others—have created a favorable atmosphere in which to consider the work of self-taught artists within the larger purview of art history." The thought is that these artists "share common characteristics of Otherness with their academically trained colleagues—ethnicity and gender, to name two." Dubuffet sought to distinguish makers of *Art Brut* from those sufficiently within the mainstream of art to aspire to official art-world recognition. The latter may indeed be Other in whatever way gender and ethnicity may make them. But the *deep* Otherness of the white male Henry Darger is of another order altogether. It belongs, one would surmise, to

what Dubuffet had specifically in mind by *Art Brut,* "as springing from pure invention and in no way based, as cultural art constantly is, on chameleon or parrot-like processes."

It somewhat abuses the motivation of artists like Matisse and Derain, of Klee and of Dubuffet himself, to speak of them as emulative of the arts of primitives, of children, of "folk," or of the insane. The great Modernists really were engaged in the same deconstructive effort Manet began, to find a role for art other than in illusionistic representations of the natural appearances of the world. What it is that detonated this collective undertaking, which was nothing less than a crisis of confidence in the values of Western civilization, is scarcely well understood, but I have often argued that anyone who believes that art is a frill, of interest only to an elite, might ponder the powerful political transformations in the world, which the transfer of objects from ethnological museums to museums of fine art—from things we may study to mark progress, to things we admire as beyond our powers—emblematized.

Still, Modernist art remains centrally an art of representation. Cubist and Fauve canvases hardly generate illusion, but they are recognizably pictures, and even abstract painting, when it was developed, was considered pictorial, of a non-objective reality. The Surrealists sought strategies for representing a super-reality we cognize through our dreams—and with which the psychotic may be more consistently in touch (which is why the Surrealists believed they had something to learn from their art). But Picasso, astute as always, insisted that the masks he saw at Trocadéro "weren't like other kinds of sculpture. Not at all. They were magical things . . . intercessors. . . . They were weapons. To help people stop being dominated by spirits, to become independent. Tools." And Picasso felt (he told André Malraux) that the *Demoiselles d'Avignon* was a "tool" in this sense as well—not in terms of forms appropriated but of function intended: "It was my first canvas of exorcism." The aesthetics of Modernism had little to do with such matters. In his great 1920 review of an exhibition of "Negro sculpture" at the Chelsea Book Club in London, Roger Fry praised these effigies at the expense of British sculpture in terms of what he called "expressive plastic form." And whatever he may have meant by this, it corresponded to what Matisse as well as the

Ogunquit artists looked for: a language of expressive representation, rather than the kind of dark power Picasso sensed in African art.

There is a question, with the art of psychotic patients, whether it parallels what Picasso sensed in African sculpture as intercession—as dealing with spirits and forces to which they feel themselves privy. It is clear that the same question can be raised, and is everywhere today, with regard to the art of women, of lesbians, of gays, and of various ethnic minorities. An affirmative answer would require us to say that the art of the West has in that same sense been an art of white straight males. There have certainly been many who have not hesitated to draw these conclusions, though no one, I think, knows the truth in such matters, nor has anyone a clear idea of how to find out. It would, if true, give some basis to the community-of-Otherness thesis, whose supporters, not coincidentally, are not wild about terms like quality, masterpiece, and genius. Dubuffet in any case would have been skeptical: "There is no art of the insane any more than there is an art of dyspeptics or an art of people with knee complaints," he declared. But he would have *had* to say that, because, as a Modernist, he appropriated the outward look rather than the internal motivation—the "expressive plastic form" in the art psychotics produce—which puts him, after all, among the chameleons and parrots. His art was visual through and through. And the same spirit of appropriationism would make it possible for the despised white males to appropriate feminine or gay or ethnic art with the same alacrity with which Pat Boone appropriated "Tutti Frutti" from Little Richard.

The widening of the scope of art through Modernism, to include what would earlier have at best anthropological or psychiatric value, has on the other hand made it possible to appreciate, in visual terms, a good bit of what outsider artists produce—and by "outsider" I simply mean those who produce art without being part of a given art world at a given time. I recently visited a marvelous exhibition at Harlem's Schomburg Center for Research in Black Culture precisely labeled "Bearing Witness: African-American Vernacular Art of the South from the Collection of Ronald and June Shelp." I was struck by the works of Mary T. Smith, a former tenant farmer and cook, who began painting in 1978. Part of what struck me was how much her work looked like Dubuffet's. This is not to raise questions of influence on the

artist but on us: Dubuffet opened our eyes to painting that might very well have been the same whether Dubuffet had existed or not, but which is acknowledged as art and even very good art in part because of transformations in vision that are due as much to Dubuffet as to anyone. I could not think of an outsider whose paintings looked especially like Ronald Lockett's 1989 *Homeless People*, where three isolated figures are wetly painted black in an otherwise empty field of thick whitish paint. But had I seen a painting just like it by a graduate of the Rhode Island School of Design or Columbia University, I would have been unsurprised. Lockett could have influenced such an art-world artist; in fact, there was probably not a single work in the Schomburg show that could not have been painted by an art-world artist, with academic credentials, rather than by an artist defined as an outsider. There is nothing miraculous in this: It is not as though recent graduates of R.I.S.D. or Columbia paint like the brothers Van Eyck. It is that Modernism has made available all possible styles and modalities of art to trained artists, and that so far as the objects themselves go, with their "expressive plastic form," there would in general be no obvious way to tell whether the artist is a former short-order cook who took up painting or someone who graduated with highest honors from Cal Art.

The Schomburg show was one of a garland of celebratory exhibitions held in conjunction with the Fifth Outsider Art Fair, held at the Puck Building. The fair offered a sort of eye test for artistic quality, irrespective of provenance, and I was pleased to see a remarkably good piece by Mary T. Smith, in reds and greens, of two brushy figures. But in the bazaar of displayed works, two artists stood out, as one would have known they would simply from seeing a single one of their works. I saw an exhibition of Bill Traylor at the List arts center of M.I.T. a few years ago, and knew immediately that he was a marvelous and unique artist; and when I saw some panels by Henry Darger at an exhibition in Los Angeles called "Parallel Visions," I knew with the same immediacy that he was a great artist. Both these are what I have in mind by deeply outside artists, in that the art world does not enter into any explanation of their work. Or: Each was an art world unto himself.

Henry Darger's is an astonishing story. He lived a life of total obscurity, working at menial jobs in Chicago. When he had to be taken to a nursing

home, his landlord discovered an immense body of writing in his solitary room, an epic of about 15,000 densely written pages called *The Story of the Vivian Girls, in What Is Known as the Realms of the Unreal, of the Glandeco-Angelinnean War Storm, Caused by the Child Slave Rebellion*. There were several hundred illustrations, a good many of them done on scroll-length horizontal panels, made of newsprint sheets pasted together. These panels are populated by numbers of preadolescent girls, wearing party dresses and Mary Janes, which Darger traced from illustrations in clothing advertisements, comic strips (*Little Annie Roonie*), and the early Oz stories, with their marvelous *Art Nouveau* pictures of Dorothy or Ozma. Sometimes the little girls have horns, and, when shown naked, they typically have penises. Darger compiled a dictionary of bodily gestures, in order to achieve narrative meaning; and he collaged flowers, animals, even landscapes onto the same sheets. In a curious way, he seems driven by the same order of artistic vision as Joseph Cornell (who had a personality similar to his in many respects). Cornell also did not draw but used photostats and collage to achieve his effects. But Cornell's art has genuine art-world explanations: He came across one of Max Ernst's books of collaged snippings from old engravings, juxtaposed in a kind of dream-syntax; and his own early collages were shown in Surrealist exhibitions. Darger seems to have come from nowhere, and his vision, by contrast with Cornell's, was narrative rather than lyrical. The Vivian Girls are constantly menaced by a sadistic militia, and the pictures can get quite violent. But the overall sense is one of peace and domestic security, in which the Girls indulge in innocent amusements in parks, or in airy or cozy interiors, and are protected by ornamental and benign dragonlike animals Darger named Blengins. There is a clarity and exactitude in the complex groupings, and an intoxicatingly improbable matching of style to content, as if Kate Greenaway had illustrated the *Mahabharata*. Sixty-three of Darger's drawings, as well as a valuable videotape and some helpful background materials, are on view at the Museum of American Folk Art, and you "owe it to yourself" to see this wonderful show. It illustrates what Dubuffet had in mind by *Art Brut*, though there is nothing *brut* about it.

We are fortunate that Darger's landlord was a photographer who recognized his tenant's genius and preserved his work; it could so easily have been

tossed out like old newspapers. I am not certain that the recognition that has come and which will come is in any sense a fulfillment of Darger's ambition, mainly because I do not think he had any institutional goals in mind. I had a brief discussion with the critic Peter Schjeldahl at the Outsider Art Fair, in which he said, with characteristic intensity, that he had no idea *what* was behind Darger's work, even if he could see its immense merit. As with Roger Fry, we respond to the visual qualities Modernism has made us sensitive to, without knowing what it meant to the artist, knowing only that the usual art-historical explanations have no great bearing. That is what deep outsiderness implies.

That is implied for Bill Traylor as well, fifty or so of whose wry and antic drawings are on view at Hirschl & Adler Modern. Traylor, who was born in slavery, began drawing when he was in his mid-eighties. Charles Shannon, a painter, discovered Traylor in the 1930s, drawing in the street, and began to buy the work, more in the spirit of a friendship than of collecting. The drawings are simple, brilliant, and funny. A goggle-eyed woman, her hat askew and her skirt aslant, is waving one hand while the other holds a bottle to her mouth. She is feeling no pain, as the expression goes, and is unmindful of a child (I read as) pulling at her apron string. Traylor captured this tipsy lady in a crisscross of pencil lines that expresses her condition, and it typifies his graphic commentary on the passing scene in Montgomery, Alabama. Traylor's drawings have some of the sharp observation and spontaneity of figures on Greek vases, and in truth they could have been done anywhere humanity is to be found, if one had a pencil stub and some shirt cardboards to draw on. Shannon (who died last year; Traylor died in 1949 at the age of ninety-five) organized an exhibition during Traylor's life, which evidently was of no great interest to Traylor himself, exactly as Dubuffet would have predicted in the case of the true *Brut* artist.

Clearly, we need a better term than "outsider art." "Self-taught artist" will not serve, since there are too many good self-taught artists who by no stretch of the term's extension could be counted outsiders. If we were Germans we could frame a nice Heideggerian compound such as *Ausderkunstweltkunstleren*—"artists-not-of-the-art-world"—which I do not especially

recommend for any forthcoming dictionary of art. Whatever the case, the proportion of masterpieces and genius, and the incidence of quality among outsiders, is about what we would find within the art world. The causes, explanations, and meanings, of course, differ from what the art world understands and teaches.

—March 10, 1997

TIEPOLO AT 300

▪ ▪ ▪

THERE IS A CURIOUS DRAWING BY FRANCESCO GUARDI IN THE EXHIBITION "Around Tiepolo: Eighteenth-Century Venetian Drawings" at the Pierpont Morgan Library (along with "Tiepolo and His Circle: Drawings in American Collections"). Guardi has filled a piazza in Venice with his characteristic squiggly figures, wearing cloaks and tricorn hats, which the artist, like a film director, uses as witnesses to whatever events he records—a fire, say, or a festival. The event here is given in the title, *Ascent of a Balloon in Venice*, and the wall text gives us the exact date of the ascension—April 15, 1784—as well as the balloonist's name and that of his backer. It took place less than a year after the first manned balloon flight over Paris.

I suppose the drawing caught my attention because ballooning was— well—much in the air this past January, as contemporary balloonists were meeting difficulties in rounding the globe. I was also intrigued to learn what must have been the origin of the term "gondola" as applied to the basket in which the balloonist swings beneath the air sack: The Venetians had ingeniously used an actual gondola for the purpose. But chiefly what struck me was the secularization of the skies above Venice's lagoons, until that moment filled with saints and angels, the Holy Virgin or Apollo, or some leading Venetian family that had hired an artist to glorify them on the ceiling of their palazzo, surrounded by figures in fluttering garments playing musical instruments or declaiming from scrolls. It was curious to see instead an airborne object obeying the laws of nature, sustained by physical forces rather than occult energies from the spiritual domains. Giambattista Tiepolo, who

used the sky as a metaphor in most of his painting, had been dead for four-teen years when Count Giovanni Zambeccari rose in his balloon over the Canal Grande, and so could not have witnessed the boundary line the flight drew between two periods of history—one in which the sky was peopled with mythological beings using clouds as perches, and one in which clouds were disclosed as mere aggregates of minute water drops. The first scientific study of cloud formation was not to appear until 1803, but the flight re-corded by Guardi, doubtless perceived by his witnesses as mere spectacle, was in fact the beginning of the modern age.

Tiepolo was a master at depicting clouds, which were essential to his vision of the universe, but how much of the truth of clouds could he have known? Consider the daunting altarpiece *The Madonna and Child with Saints Catherine of Siena, Rose of Lima, and Agnes of Montepulciano*, of 1748, in the great retrospective of his art (at the Metropolitan Museum of Art), which, together with the show of drawings at the Morgan, marks the tricentennial of Tiepolo's birth. It shows the three Dominican saints of the title, one of them holding the Christ child and one of them wearing a crown of thorns, holding a crucifix. They seem mysteriously more beautiful than their presumably austere and disciplined lives would have led one to expect, but perhaps Tiepolo meant to show them from within, as brides of Christ, worthy of their Betrothed in beauty as well as piety. Catherine's garment is almost stylishly slinky beneath the elegant crown of thorns she wears with dash, as if fitted out for the occasion in a bridal salon. The saints are poised, as in a vision, on an illusory cornice. They share their space, somewhat uncomfort-ably, with the Madonna herself, a vision within the vision perhaps, of whom the saints seem altogether oblivious. Tiepolo has placed her on a brownish cloud, which, though it belongs in the sky, has been brought into the space of the chapel to proclaim her divinity and give her a heavenly seat. What I found interesting is the way a tassel, to our right, swings into the painting and rests on the cloud, conforming to its curvatures as if it had fallen against a rock. Now we know enough to realize that a cloud would no more resist the weight of a tassel than it would dash the brains out of any hapless bird that flew against it. And the question that faces us is: Did Tiepolo know that? Is he being rational, thinking, Well, if the cloud can support the Virgin, surely it would support a mere rope? The rope is after all not in any sense

necessary to the composition, or to the program of the altarpiece. Its only purpose seems to have been to demonstrate the cloud's solidity. So is this ignorance of the kind balloons would soon dispel, or is it a sly metaphor for the boundary between natural and supernatural, which had begun to bother artists whose command of appearances was as total as Tiepolo's? Or is it a kind of visual joke? Like showing female saints as hot numbers?

In the presence of the pomp and bombast of so many of Tiepolo's official paintings, executed on commission and so required to accommodate the sensibilities of rich and powerful patrons, it is a particular pleasure to observe his subversive comedy. There is a delicious drawing at the Morgan of a group of seventeen (by my count) Punchinellos preparing a meal of gnocchi and parmesan cheese for a hungry Punchinello sitting disconsolately on his hat, looking as if dinner will never come. Tiepolo's gifts as a draftsman are nowhere better demonstrated than in the way he is able to bring to life an object as visually uninteresting as a lump of hard cheese, or make a dish of gnocchi as much the dramatic focus of a drawing as the Holy Infant in an Adoration: All the straight lines formed by the Punchinellos' tall hats converge on it. Appropriating a figure from popular culture—and multiplying it with the wit with which Warhol iterates *Mona Lisa*s in his *Thirty Are Better Than One*—illustrates a dimension of Tiepolo's artistic personality that helps keep his entire enterprise in perspective. Punchinello embodies enough of the Venetians' spirit that he may be used as their emblem in an allegory of greed. Tiepolo's son, Domenico, in fact made an industry out of drawing Punchinellos, in parodies of the cosmic dramas and theatrical allegories that Venetian artists were required to carry out in the waning years of Venice as a political power.

Now consider Tiepolo's marvelous early self-portrait as the legendary artist Apelles, shown painting a portrait of Campaspe, the mistress of Alexander the Great. According to legend, the artist fell so in love with Campaspe that Alexander gave her to him as a tribute to his art. Tiepolo used his wife, Cecilia Guardi, as model for the famous courtesan, and the work is a tribute to Cecilia/Campaspe's beauty, for the artist's face is twisted around in a near caricature of what today is called the male gaze—as avid as

Punchinello's hungry look at gnocchi. Peering backward over his shoulder, the artist alone sees Campaspe's nakedness. *We* see her nakedness only in the painting he is doing, for Campaspe/Cecilia has her back to us—and to Alexander as well, who is as much fixated on the painting of the woman as the artist is on the woman herself. The artist's long brush touches the left nipple of the painted woman, showing the focus of Alexander's gaze as accurately as the Punchinellos' hats draw our eye to the gnocchi. The painting is filled with visual puns—I even had the thought that the artist's improbable fur hat is a pun on the name Apelles—*a pelle*, meaning "in skins" in Italian—but for all its robust comedy the work is an allegory of the power of art.

The comic touches are to the more imposing works what Punchinello is to the public persona of Venetian culture, in what I would propose is Tiepolo's vision—not that I want entirely to ascribe the currently fashionable status of "subversive" to an artist who enjoyed such prestige and fortune in the era he somehow typified. But consider *Danaë and Jupiter*, a painting that is like seeing Titian's description of the same mythological moment in a distorting mirror. Danaë was sequestered behind locked doors by her father, who sought to deflect an evil prophecy: He was to be killed by a grandchild. But Zeus found a way, transforming himself into a cloud, impregnating her in a shower of gold. Titian's Danaë is passion where Tiepolo's is mere flesh, lolling in sleepy amplitude on a chaise, while a *putto* lifts her nightgown to reveal a vast backside, which we but not Zeus can see. Titian's Zeus is gold and power, pouring between Danaë's spread legs. But Tiepolo's Zeus is an old man, wearing an orgasmic expression but capable at best of a very spare discharge of gold coins, which an avaricious crone in a high lace collar captures in a dish. A barking dog knows that something is going on even if the viewer is uncertain whether the horny, ineffectual god is the bad dream of a woman made broad through the backside by too many gnocchi.

Let us now consider *The Finding of Moses*, a horizontal canvas in which Pharaoh's daughter, wearing an opulent garment of yellow satin and holding a tiny dog on her hip, looks distantly down as her handmaidens deal with a squalling infant. The groupment of elegant women at a wooded riverside self-consciously emulates the visual mood of Paolo Veronese—silks and vel-

vets, lace and jewels, water and trees. That applies, as well, to Veronese's brilliance with colors, juxtaposing saturated hues to achieve darks and lights rather than modifying a given hue by adding black or white. But the dignity with which Veronese would have imbued such a scene is broken by the infant screaming, which generates the picture's action. The woman holding the baby on her knees looks up for guidance as to what to do next, the princess looks ineffectually down, an old woman whispers advice in her ear and a remarkably beautiful woman gazes in maternal tenderness at the angry baby. It is characteristic of Tiepolo to shatter luxury with the reality of the belly, rather than to sustain it by means of a baby sleeping in the bulrushes and come upon by court ladies on an outing—that would have been Veronese's way. Rembrandt, an earthier artist, painted a yowling infant as Ganymede, carried off by a pedophile Zeus (that Zeus!) transformed into an eagle. This is a wilder joke than Tiepolo's, who requires a Veronese-like decorum as comic counterfoil to the urgencies of raw life.

Tiepolo executed a series of prints, *capriccios*, but the spirit of caprice gives a human entry into all his work: Venetians as clowns, saints as sexpots, Alexander the Great as thug, Cecilia Guardi as Campaspe, Giambattista Tiepolo—with his long beak and his beady eyes—as the Apelles of modern life, Zeus and Danaë in a bordello fiasco, the anger of Moses inscribed as infantile howls. These suffuse with wit and lightness works that may otherwise seem too distant in their cosmic drama to have much to say to us. So a cloud vested with the properties of a rock is a distinct possibility for calling attention to the line between fantasy and truth. The *capriccio* spirit bubbles over into the lines and washes of the drawings, and is expressed in the brilliance of the brushwork, the sparkle and brightness of the colors, the audacity of invention, the command with which multitudes are summoned out of the artist's limitless imagination to fill vast spaces. How could one not love Tiepolo?

Tiepolo was fundamentally a painter of visions, commanding the illusionist techniques needed to render the visionary as visually convincing as if it were seen. In the self-portrait as Apelles, the painting of Campaspe is shown to be even more compelling than the woman herself (except to the eyes of the artist). In *Danaë and Jupiter*, the King of the Gods is shown as a

figure of female contempt, just possibly masturbating because incapable of taking advantage of her ample flesh. *The Martyrdom of Saint Agatha* is a nightmare vision: Agatha's breasts were cut off. The saint is shown holding her empty hands out in a gesture of sacrifice and faith, as a woman presses a blood-soaked garment against her sheared front. A youth, poised like a waiter or a dancer in a fantastic costume of golden fabric, bears a dish with the severed breasts, and the executioner, wearing a costume no less fantastic, points off-canvas with one arm as he holds his bloody sword with the other. A bystander peers at the breasts from behind a column, and the sky bristles with cruel weapons.

But mainly, with Tiepolo, one thinks of skies less as backgrounds than as sites for the unfurling of visions above the viewer's head, most famously in his masterpiece, the tremendous frescoed ceiling above the grand staircase in the Residenz in Würzburg, where one feels as if one is ascending into the sky as one mounts the wide steps. The scene is of Apollo and the Four Continents (America is emblematized by a Native American wearing a feathered headdress and gold disks on his chest, astride an alligator and surrounded by Caribes—and by a piratelike figure holding a cornucopia filled to the brim with gold coins). The figures are all strenuously foreshortened, a technique of which Tiepolo was a natural and fluent master, and which seems to mark everything he did. The drawings at the Morgan typically imply a perspective *de sotto in su*—"up from below"—which makes it a strenuous experience to look at them, however frothy and swift, as if one feels an anticipatory crick in one's neck and a certain sense of vertigo. In looking at the Sistine Chapel ceiling by Michelangelo, one feels that foreshortening was something he learned to do in the course of executing it: The axis of his great vault is in fact covered with a gallery of paintings of scenes of the Old Testament, and though one does not like to think of Michelangelo cutting corners, this device spared him the problem of putting most of his figures in the same space as that occupied by his intended viewers. One looks and sees not so much Adam and Eve as pictures of them, framed in gold. But Tiepolo creates his immense illusion by making it seem as if the sky were open above our heads, filled with flying creatures—birds, angels, horses, wheels, clouds. The allegorical figures are posed on the cornices of the building we ourselves occupy,

and Apollo, radiating sunbeams, prepares his daily journey across the skies. There is a *modello* of the Würzburg extravaganza at the Metropolitan, a marvelous oil sketch one must rotate in imagination through ninety degrees, and project as if from below, in order to appreciate.

When Tiepolo moved to Spain in 1762, he said, in a kind of press release, that "painters should aim to succeed in great works, the kind that can please noble, rich, people. . . . Therefore the mind of the painter must always be directed toward the Sublime, the Heroic, toward Perfection." Yes, there was something impish in Tiepolo, who planted darts of humor to anchor his vision to reality: There is nothing like an angry baby, however foreshortened, to put things into perspective. Still, the overall modality is the heroic sublime. In 1908, Matisse wrote that he aspired to an art "of purity and serenity, devoid of troubling or depressing subject matter, an art which could be for every mental worker . . . a soothing, calming influence on the mind, something like a good armchair which provides relaxation from physical fatigue." The two statements mark a great transformation in the class structure of society. Five years after Guardi drew his balloon, the French Revolution broke out, after which riches and nobility began to be distributed among different classes. Tiepolo was the end of a line, the last of the old masters, enabled to flourish through commissions rather than having to sell paintings for the living rooms or bedrooms of a middle class that found tranquillity in Matisse. The sense of an ending gives a certain melancholy to his thronged vaults. As Ferdinand murmurs in *The Tempest*, Act IV, "A most majestic vision, and/ Harmonious charmingly. May I be bold/To think these spirits?" "All spirits," Prospero answers a few lines later, "melted into air, into thin air. . . . The cloud-capp'd towers, the gorgeous palaces,/The solemn temples . . . shall dissolve/And, like this insubstantial pageant faded,/Leave not a rack behind."

The introduction to *Tiepolo and His Circle*—the catalogue for the Morgan show—cites a passage from the art historian Svetlana Alpers: "Perhaps . . . we see an affinity between our contemporary, post-modern artists and the eighteenth-century Venetian, who, like today's artists, might have regarded himself as a latecomer who one way or another had to come to grips with a venerable tradition." If there is an affinity, it lies in the fact that, like

Tiepolo, we are at the end of something. Unlike us, I think, Tiepolo had no sense of being the last, but only the latest in a great sweep of history that included the mighty Venetian masters before him. I don't believe, though, that in order to appreciate past artists we need seek a way of seeing them as artistically one of us. The past is the true Other. It is enough that the comedies of food, love, sex, birth, and aging define our common humanity.

—April 21, 1997

The 1997 Whitney Biennial

∎ ∎ ∎

As the elevator doors open onto successive floors of the 1997 Whitney Biennial, visitors will glimpse the following works: a black-on-white silhouette, in the style of Goethe's era but wall-sized and spectacularly indecorous; an assemblage of thirty-odd framed images that look as if they had been culled from the Bettmann Archive; and a modular room, made of 2-by-4s, sheetrock, and glass, suspended by one edge from the ceiling, as if to enable delegates to a builders' convention to examine it from underneath. If these typify the visual art of the late twentieth century, the question becomes one of how to characterize the type itself. In his *Principles of Art History*, Heinrich Wölfflin wrote that not everything is possible at every time. Ours, contrarily, seems a moment in which everything is possible at the same time. If a housing module, a slew of reproductions, and a wall-sized silhouette of prim figures making obscene gestures and visiting violence upon one another are possible as works of art today, what would not be?

Wölfflin had stylistic possibility (and impossibility) in mind, and it was his view that all artists belonging to a given period of art history share certain stylistic attributes, even if they should differ as sharply as the Dutch intimist Gerard Terborch did from his Italian contemporary Gianlorenzo Bernini. And Wölfflin believed it to be the task of art historians to discover the laws of stylistic change, and hence to explain how a period defined by a linear style will be succeeded by one defined by a painterly one. It would, of course, be astonishing if these changes were entirely internal to the history of art, considered in abstraction from the social circumstances in which art is pro-

duced. But if artists like Bernini and Terborch, living under different religious, political, and cultural circumstances, should nevertheless answer to the same stylistic imperatives, it is thinkable that all artists of the present moment might be of a piece, however disjunctive their work may outwardly appear. All the works in the 1997 Whitney Biennial might thus express their (our) period, even if the period's stylistic essence must call upon categories so distant from those known to Wölfflin that they compromise entirely whatever predictive powers he envisioned in a science of art history.

The claim that everything is possible as art today is subject to obvious and irrelevant qualification. A good many of the works in the Biennial call upon electronic technologies once unavailable, and formerly impossible for the same reason that paintings making use of certain techniques of perspective and foreshortening, like Tiepolo's, would have been impossible at the time of Giotto. Since we cannot anticipate the technologies of the future, we cannot imagine the works that will exploit them. What we do know, however, is that since it is possible for anything to be art, the concept of art now in place will accommodate the art of the future. The exclusionary question that shadowed the history of the avant-garde, "But is it Art?", has no application in the present or in any future period. This does not mean that everything is art but that anything *can* be, so that whether something is art is in no sense a matter of what it looks like. Since most of the 1997 Biennial displays could not have been accepted as art when art was a matter of how things looked, the period-defining characteristic of art today, to be consistent with this openness, cannot be defined in visual terms. It *may* be the mark of our period that the visual information provided by the object is insufficient to determine that what one is looking at is art. And this, at the very least, makes art criticism no longer a matter of possessing a fine, discerning eye.

Art today has typically to be addressed from a plane different from the one the object itself occupies, so that even if we know what the object is—a modular room, say—we do not know what the *work* is until we locate the plane from which it is to be interpreted. This is the condition Hegel famously wrote of as the end of art—"What is now aroused in us by works of art is not just immediate enjoyment but our judgment also"—and is very different from those ages in which the art object "yielded full satisfaction." So

when we cannot find the plane, the object creates varying degrees of discomfort—or of irascibility on the part of a visually oriented critic. Consider a work by Charles Long and Stereolab, titled *Bubble Gum Station*. It is a large mound of pink bubblegum simulacrum, mounted on a platform. Suspended from the ceiling are earphones over which (I surmise) we hear the music listened to by the bubblegum crowd. Very few at the press opening could overcome a professional reticence to interact physically with what after all was a mass of undifferentiated stickiness, though some modeling tools were lying about. On a later visit I was amazed at the transformations wrought by a less inhibited, more interactive audience. The mound had become a rich compound of lips, animal heads, body parts, disks, things to eat. I am certain it will be different a week or a month from now, or even by closing time. Perhaps the work is an allegory of transformation, and the immediate interactive relationship between visitors and bubble gum an allegory of what we have left behind in the ascent to the metacritical level from which we must make something of the object in order to experience the art. Visually you would be right to say that it is just a lot of bubble gum. Critically you would be wrong: The work is the object plus the interpretive plane through which it is transformed into art.

Now consider the wall of small framed images as one enters the third floor of the exhibition. The artist, Douglas Blau, selected the images, had them framed, and perhaps determined their arrangement on the wall if he meant them to tell a story. We have little difficulty in recognizing the content of the images, one by one—but what is the content of the work taken as a whole, what is *it* about? Since Blau did not himself make any of the pictures, we can hardly bring to bear critical standards from photography in appraising the work. Are what Clement Greenberg appealed to in his *Nation* reviews of the Whitney Annuals of half a century ago—"the most aesthetically valuable aspects" of work—in any sense applicable to a grouping of thirty or so small pictures, unevenly arranged? Blau's assemblage has the structure of an exhibition-within-an-exhibition, albeit with a unifying determinate theme. It is called *Sacred Allegory*, and typically his pictures show individuals dressed like scientists working with experimental or productive apparatus. The suggestion is that they are transmuting matter from one state to another, like alchemists, in allegorical parallel to the ritual of transubstan-

tiation, which might account for the term "sacred" in the title. Or perhaps it is an allegory for the procedures of art itself, as is suggested by another Blau work, called *The Studio* (included in the catalogue), which again is an assemblage of reproduced images, some of works by Rembrandt, Gerard Dou, and Chardin, together with film stills and some photographs of artists and writers. However little Blau's work resembles the bubblegum piece, the two may exemplify a common theme.

I turn now to the modular room on the fourth floor, *B.D.O.*, by Glen Seator, which in fact is a carpeted replica of the erstwhile office of the Whitney's director, the suspension by one end forming a somewhat dizzying angle with the floor. The replication of rooms has always been possible using the same materials and techniques that making a room requires, but presenting them as art has become a possibility only recently. The room-as-work-of-art was a theme of the recent exhibition of Charles Rennie Mackintosh at the Metropolitan Museum, but there it was fairly clear "work of art" referred to good taste and the integration of space with decorative motifs to produce an aesthetic whole. Seator's is not a room *as* a work of art. It *is* a work of art. Its emptiness does not declare an aesthetic of emptiness, but must have a meaning. Knowing it is art, we know that the tilt is not for purposes of enabling construction specialists to view it from below. So what does the tilt then mean? Since the pitch of its floor might match a deck's pitch in stormy seas, does it allude to a flagship museum tempest-tossed in the seas of artistic change? Or is it a metaphor for upending the bureaucrats and turning power over to the artists? Seator recently tilted in effigy an office (and bathroom) of the New York Kunsthalle in that very institution, so one feels he is embarked on an agenda somewhat parallel to Christo's, who makes statements about institutions by wrapping them. Whatever the case, it is only against the hypothesis that it is art, and then with reference to an interpretation, that one may decide what aspects of the object are pertinent to its identity as art. Is it relevant, for example, that the *exterior* is left unfinished?

Since everything is possible as art if a dislocated room is, it would have been possible to mount a Biennial consisting entirely of small framed paintings of amiable dogs, pretty girls, the sea at sunset, vases of chrysanthemums, the dome of Saint Peter's, comical hobos, fishing boats at Gloucester, some

tasteful abstractions of the kind Greenberg groused about in 1948, together with some sculptured heads, figures, abstractions. But such works, while they conform to the concept of art that visitors feel comfortable with, are not typically part of the present period, even if made this year. One can, on the other hand, imagine someone making a work consisting of just such an array of paintings and sculptures, titled *Art Show*, and even imagine it having a place in the 1997 Biennial. From Blau's example, we know that the hypothetical artist who exhibited a work resembling an exhibition of provincial art need not have painted them herself. There is a work by Wendy Ewald consisting of photographs by children from different cultures, to whom she gave cameras, instructing them to photograph their dreams. The children are not artists, but Ewald is, even if nothing in the assemblage is by her. So a work made up of paintings shown by members of the local Anytown Art Society need include nothing by the artist who made *Art Show*—who merely bought them—and it would be judged by criteria different from those employed by local judges in choosing works for the show!

Even this imaginary example is insufficiently radical. The radical example would be a Biennial entirely made up of works that resemble those to be seen in the Anytown Art Society annual exhibition, and that conform to the narrower concept of art predating the present period. Selecting a Biennial that looked effectively like the Whitney Annual of 1948 would mean that the curators would be claiming for themselves the prerogative of the assemblage artist, and even if everything in such a show were to be familiar, and hence a priori likable, such an exhibition, while possible in 1997, would be shocking now for its lack of objects unlikable on grounds of unfamiliarity. So even if we don't know what we are looking at, we know that these are the kinds of objects that must constitute a Biennial of today if it is to be true to the times. Of course, there would be a profound difference between a 1997 Biennial that looked very much like the Annual of 1948 and the historical original. All the paintings and sculptures would have been made since 1995, and hence be part of a stylistic period whose characteristic objects are such that we don't know what we are looking at when we see them. So probably we would not know what we were looking at when we thought we were looking at paintings and sculptures, either. And anyway, the gigantic silhouette by the im-

mensely talented Kara Walker—who has reinvented the genre in order to convey a content we can deduce from the work's title, *Presenting Negro Scenes Drawn upon My Passage through the South and Reconfigured for the Benefit of Enlightened Audiences Wherever Such May be Found, by Myself, Missus K.E.B. Walker, Colored*—would hardly have been thinkable in Whitney precincts fifty years ago.

Even the photographs and paintings we might like as objects probably have something else in mind for us as art. Matthew Ritchie's *Seven Earths* is a painting handsome enough in terms with which Greenberg would have been comfortable—"sensuousness, learning, and intelligence"—but one that seems resolutely hermetic, implying a code of interpretation we can merely guess at from such inscriptions as "limbic system" and from images of schematic limbs scattered about (is "limbic" a pun on "limbs"?). It is in any case only a fragment of a much larger work, which includes a Web site and implies a cosmology possibly in the same genre as that subscribed to by the members of Heaven's Gate. A strewn assemblage by Jason Rhoades of television cables, monitors, five-gallon containers, typewriters, and much, much more, united by one of those rollered tracks on which goods are transferred from trucks to storerooms, bears the title (itself a kind of verbal assemblage) *Uno Momento/the theater in my dick/a look to the physical/ephemeral (DOS version)*. It left me somehow grateful that I did not have to know what I was looking at as I poked my way, with others, around its perimeter. Sometimes the object and the plane of meaning are sufficiently close that we can tell almost immediately what we are seeing. There is a marvelous piece by Louise Bourgeois—"Best in Show" if I were handing out prizes—that most saliently consists of stiff, worn female garments, some presumably intimate, said to have belonged to the artist herself, hung on a rack. It is a work suffused with some deep human meaning, as is the fabricated clinic by Ilya Kabakov, in which hospital beds, with curtains, occupy small cell-like rooms on the walls of which images of a certain vintage are projected. The power evoked by these works derives in part from the fact that we are confronted by real garments, or physically enter the still, empty rooms. The widening of the class of objects in which works of art consist enables artists like Bourgeois and Kabakov to convey meanings it is hard to suppose painting or conventional sculpture could have aspired to—though Bernini's Cornaro Chapel might be

said to have achieved the kind of effect that Kabakov's clinic does. Work like Rhoades's is the price we have to pay for work like that of Bourgeois and Kabakov, which may have certain affinities with the Baroque, because of the feelings they elicit, but which would have been impossible in most stylistic periods between then and now.

I have heard the objection that the art selected for this Biennial by Lisa Phillips and Louise Neri was "made for museums." This is a criticism that takes the art of the 1948 Biennial as canonical, since it was made for the artists themselves and for their friends, and for patrons to carry home. Institutionally speaking, it is true that artists today will be successful to the degree that they have internalized the agenda of the curatoriate, which plays the role that cardinals or cavaliers did with the Italian and the Dutch Baroque artists, buying or commissioning their works. In the case of the Italian Baroque, the agenda was manipulative and paternalistic: to transform, confirm, or heighten faith by engaging ordinary individuals through art in complex interactive ways. The curatorial agenda is not that different today. Viewers are prompted to ascend to interpretive planes from which they may then find their way back to objects otherwise baffling or disturbing. In the 1993 Biennial, the plane was usually pretty obvious, and the intended transformations didactic and political, and in consequence the exhibition was resented, since no one appreciates being yammered at by moralizers. In 1995, the art was generally too quirky and too specific to what one felt was the individual consciousness of the single curator who organized that show. The 1997 Biennial has a seriousness and a responsibility appropriate to the omnipossibility of where we are in art today. You may not like the art, but it is probably closer to the heart of our period than other art we might prefer. Not knowing what we are looking at is the artistic counterpart of not altogether knowing who we are.

—*June 2, 1997*

ARAKAWA-GINS

■ ■ ■

THE EXTRAORDINARY EXHIBITION AT THE GUGGENHEIM MUSEUM IN SoHo dedicated to the collaborative work of Arakawa and Madeline Gins exists literally on two levels, as if the museum were itself an architectural model of the human person—mind upstairs, body downstairs. Upstairs, there are eighty-three panels of a work titled *The Mechanism of Meaning*, which has never, to my knowledge, been exhibited in its entirety in the United States. In 1971, the Arakawas did publish a work, *Mechanismus der Bedeutung*, in connection with an exhibition in Germany: Ninety-odd panels were reproduced, chiefly in black and white. It is interesting to speculate on what the component paintings could have meant to German viewers, inasmuch as each panel contains written instructions for interacting with it in rather playful English—and even English readers are hard-pressed at times to make out what they are being asked to do. The book in any case quickly obtained a devoted audience, especially among those concerned with logical recreations, conceptual puzzles, and, well, the mechanisms of meaning. Arakawa and Gins were avid readers of philosophy, then as now, and their work of the early 1970s reflected and extended the linguistic preoccupations of the analytical philosophy of that time and the view that, broadly speaking, the world as we conceive and live in it is deeply determined by grammar. The concept of nonsense was much in the philosophical air when the main panels of *The Mechanism of Meaning* were first made, and it was inevitable, given their agenda, that the artists should attempt to map the boundary between mean-

ing and nonsense (one slips easily into absurdity when endeavoring to follow what appear to be clear instructions in the work).

Downstairs, the exhibition consists of models and photographs of Arakawa and Gins's architectural work, all of it visionary and some of it actually built. As the panels of *The Mechanism of Meaning* address the faculty of understanding, the architecture implies interaction through and with the body—or with what certain philosophers refer to as the "lived body," understood as the ways in which the body fits into forms of life. The *physical* body, by contrast, is the body understood as a complex electrochemical system, everywhere and always the same: No body can live—in the physical sense of the term—without constant metabolic exchanges with the world. So the physical body degrades protein molecules, whereas the living body keeps kosher or fasts during Ramadan or can't drink milk because of childhood traumas. The lived body may in large measure be a social construct, as gender is thought of today. But the chromosomal basis of sexual bimorphism is a matter of how we are built. In a way, one might say that the relationship between the lived body and its world is similar to the relationship between a particular grammar and its correlative world: They are made for each other. The interface between the two bodies—the Body/Body Problem, as I term it—is not at all well understood at this point.

The Arakawas refer to the lived body as "the architectural body" on the grounds that "human beings are born into architecture and from then on are conditioned by it." And their thought is that architecture defines the lived body of those who live in it. Hence it is with reference to the shaping influence of architecture that we understand the system of meanings that define the world in which we are embodied. Architecture thus plays the role in their recent work that language did when they were making *The Mechanism of Meaning*. And in truth, the strategies of the two bodies of their work are in many ways parallel, so that to work through *The Mechanism of Meaning* provides as good an introduction as can be had to what the artists' architecture is all about. I would head for the second floor of the museum first, then, and engage with some of the language games in which the panels of the earlier work provoke their viewers to interaction, and then move downstairs, to the

domain of the body and the system of meanings with which architecture vests it.

Arakawa is a painter and Gins a poet, but their images, their words, their evolving agendas, are entirely collaborative. Like many artists today—and especially some exceedingly successful ones—the Arakawas have in recent years turned away from painting to achieve works that transcend painting's limits, even when augmented by writing. The obvious move, for painters restless with these limits, has been filmmaking, which opens up perceptually and narratively widened fields. Robert Longo, Julian Schnabel, David Salle, and Cindy Sherman have made commercially ambitious films, to varying degrees of critical success. But I know of no artists other than the Arakawas who have moved from painting into architecture. And this is because they are not interested in showing the world but in actually changing it—in "reversing destiny," to use their idiom—and in particular changing what we may term *the* Limit, the limit death imposes upon human life. It is their view that "death is old-fashioned," and that, if we get the architecture right, we can, as we should, live forever. Ordinarily, I suppose, we think of death as taking place when something goes wrong with the physical body: when vessel walls collapse or cells miscluster or the immune system crashes. The lived body copes with death by giving it this or that meaning—religious, sentimental, political. To think, as the Arakawas do, that death is a function of the "architectural body"—the body as shaped by the structures that stand to it as the shell stands to the snail—means that they may be no more willing to accept the distinction between the physical and the lived body than the distinction between sense and nonsense. If a change in architecture can change not the meaning of death but death itself through erasure, then the architectural body is a very bold concept indeed. It addresses death as a physical condition through the mechanism of architectural meaning.

In both phases of their evolving work, the Arakawas have been driven by a body of philosophical thought. Their writing is searching and comic at once, filled with sly jokes and a vivid working vocabulary. They use, for example, the picturesque term "landing site" where other philosophers might refer to perceptual or imagined objects, to sense data or to stimuli. It is with

reference to the body, as actual and imagined, that they speak in particular of architectural landing sites, and they challenge professional philosophers to follow them into architecture. "Philosophers considering persons as sites would be obligated to develop a personal architecture. They would have to turn themselves into architecture of sorts." This is what Arakawa-Gins have themselves done, and the result, in the downstairs gallery of the Guggenheim, is a set of architectural structures unlike any other in the world. As is to be expected, given that these are dwelling places designed to reverse the destiny of destiny.

In a famous proposition, Wittgenstein wrote: "To imagine a language is to imagine a form of life." There is a moving proposition in his early work to the effect that death is not an event in life, since it is not something we live through. He was referring, of course, to one's own death. The death of others is very much something we live through, and have to deal with. This accounts for some of the differences in forms of life, since how we handle death varies with the meaning death has from one form of life to another. (Vico had the quirky thought that the word "human" derives from *inhumare*: We are beings who bury our dead.) The Arakawas, so far as I can tell, would not accept this distinction. Their ambition is precisely to falsify, by means of architecture, the "All men are mortal" premise of a famous syllogism. They have even provided a model for what they term *City Without Graveyards*—a city, someone following Vico might say, without humans. "Even longevity— as the postponement of the inevitable—is not enough. The stake must be changed entirely." Making humans immortal has never been an architectural specification. It is, for the Arakawas, the landing site of architecture as they understand it. "All consciousness involves, for the forming of the world, some degree of mastery over landing-site dispersal. But the seeker after reversible destiny must master the landing-site configuring process itself."

The lived body may have a high degree of plasticity, just as any child can learn any natural language. But one would think this less true, if at all, for the physical body, which is vulnerable in so many ways to changes in the physical rather than the semiotic environment, granting that dark damp cellars are less salubrious than bright warm rooms. Can "the landing-site con-

figuring process" override the distinction between the lived and the physical body—eliminating death as a physical state through architectural strategy? The Arakawas insist, as firmly as politicians promising that cancer will be cured, that death really can be abolished. "A vigorous life without end is the highest value of all," they write. And: "Only those schemes for public housing that directly address the problem of mortality can be viewed as cost-effective."

How is this to be achieved? There are two methods, according to Arakawa-Gins. One is "to cause an overload of the familiar by putting surroundings forward in a manner so concentrated that they wax unfamiliar." The other is "to have the body be so greatly and so persistently thrown off balance that the majority of its efforts have to go entirely toward righting itself, leaving no energy for the routine assembling of the sociohistorical matrix of the familiar or, for that matter, for the 'being of a person.'" I think these two methods more or less apply to architecture the kinds of principle on which *The Mechanism of Meaning* is based: to defamiliarize understanding through language games, and to throw the mind sufficiently off balance that room is opened for an understanding that transcends the categories that held it captive.

Each panel of *The Mechanism of Meaning* contains some diagrammatic drawings, together with some words, either printed in roman capitals or written in loose script. At times an object or an appropriated picture is affixed to the surface. Consider panel 4 from a section of the work titled PRESENTATION OF AMBIGUOUS ZONES. It is divided into three horizontal spaces. The upper space contains three figures—a cross, a scribble, and a circle. Beneath them it says EACH OF THESE IS UPSIDE DOWN. If one responds by mental rotation one discovers that these figures have no way of being upside down or right side up. The second area displays a white square, superimposed above the question ONE WHITE? One's impulse to say "Yes" is tempered by a concern with why the question was asked, and whether there is something we have overlooked. In the lower area, a men's shirt is attached with S.H.I.R.T. printed beneath it. Why the initials? Everyone is familiar with the initials Marcel Duchamp put under the picture of Mona Lisa: L.H.O.O.Q. =

Elle a chaud au cul. Does s.h.i.r.t. constitute a rebus, with a salacious translit-
eration? That reading is suppressed when one notices that the shirt is
surrounded with handwritten words in a variety of colors, each saying
shirt. Lines connect words with shirt, as if to emphasize that it is just a
shirt, but that the lesson is evidently sufficiently difficult to teach that it
has to be repeated and repeated, as if we are children being instructed in the
obvious.

Sometimes the inscriptions have the obscurity we by now are well-
acquainted with from computer manuals. In panel 3 of THE ENERGY OF MEAN-
ING (BIOCHEMICAL, PHYSICAL, AND PSYCHOPHYSICAL ASPECTS), there are, in the
upper zone, two triangles of cloth, one red, one blue, whose vertexes are
connected by means of a knotted cord, also red and blue. Below is printed
WELCOME TO THE POTENTIAL ENERGY PATHS—the kind of jovial greeting that
appears on the monitor when we have booted up. Our instruction is: TAKE
(MAKE) AS MUCH ENERGY AS POSSIBLE. How are we to comply? By pulling the
strings? Connecting the loose ends? If we look in the lower panel for an-
swers, we encounter four "windows" above the word STARE, with instructions
to stare at the windows until some specified state is reached. Will this hap-
pen? Does it help with the problem of taking (making) energy? LOOK AT THIS
FOR MORE THAN ONE MINUTE TO KEEP YOUR OWN NAME is printed on another
panel. How much more than one minute? And will I lose my name if I look
at the displayed object for less than a minute? We understand what is meant
and that it is nonsense.

Arakawa is one of the great designers, and the panels of *The Mechanism
of Meaning* have a certain clarity, simplicity, and neatness that make them
pleasant to look at. But looking (except where explicitly instructed to) defeats
the purpose of the work. That is not to present an object for aesthetic appre-
ciation but to be a landing site for perception, only to be sent, within the
panel, to other sites. Something like this is true for the architectural works as
well, which are as beautiful as they are eccentric. Looking down onto one of
the models, in which curved and angled walls intersect to form spaces, it
seemed to me that the whole complex had the form of a kind of labyrinth,
made up of extruded calligraphy in pastel colors. My sense is that aesthetics
is no more the goal of the architectural experiments than of the language
games. Beauty is incidental to their art, or a byproduct of their designs. It is

as if one can make aesthetics irrelevant by creating beauty that has nothing to do with the art.

The first Arakawan structure to be built in Japan is called *Ubiquitous Site. Nagi's Ryoanji. Architectural Body*, commissioned as a permanent installation for the Nagi Museum of Contemporary Art. "Ryoanji" is the name of the Great Stone Garden in Kyoto, laid out about five hundred years ago in conformity with principles of Zen Buddhism. It is a composition of large stones and white sand, and it is a (landing) site for meditation. One does not enter Ryoanji but gazes at it from the terrace of a temple built along one of its sides. The sand, in a certain sense, corresponds to what the Arakawas designate as "blank"—one of their favorite concepts. The stones are interesting only against the blank surface of the sand, which has no interest of its own, save for the pattern of lines raked onto it by monks. Blankness expresses a very Oriental idea, but the adaptation of Ryoanji for the Nagi Museum is far more in the spirit of *The Mechanism of Meaning* than in that of the classics of Taoism. The artists placed on facing sides of a cylindrical space two stone gardens, like mirror images. Imagine entering a tunnel, a bit like Alice's rabbit hole, and seeing the same thing, artistically dense and spiritually profound, right and left. What happens to meditation now? There is also a vertical symmetry: The "ceiling" and the "floor" mirror each other, each furnished with a seesaw and curved wooden benches. Is the room right side up or upside down? Are we to believe the eyes or the body, when there is conflict between the two?

The most developed architecture by the Arakawas is a park in Gifu Prefecture: *Site of Reversible Destiny—Yoro*. I have been told that it has become a favorite destination for Japanese tourists and that navigating it has a kind of funhouse quality, unbalancing the familiar by means of unexpected slopes and drops. It has a number of amazing buildings, including *Reversible Destiny Office*, a complex of curves and planes, of interlocking spaces iterated on floor and ceiling—so that one might have to look up to find one's way through the maze. The outer walls are brilliantly colored, and must look wonderful against the distant mountains. I won't even try to describe another of the buildings, *Critical Resemblances House*. Nor the whole city, adjacent to Tokyo, they hope to build.

Sappho once said that if death were a good thing, the gods would die. Immortality is fine when you are as beautiful as Aphrodite or as powerful as Zeus. But the Sibyl of Cumae, in requesting it, neglected to ask for unending youth. Left a shriveled mass of tissue in a bottle, she wants only to die. Should we want "to not to die," as the Arakawas like to say? In architectural terminology, I think of death as a window through which to crawl out of the world, and a gift from the gods, who have no need of it. Evidently such ideas do not faze the Arakawas. So how are we to criticize their work effectively? Would it fail as art if people in their magnificent buildings died anyway? The great cathedrals, symbolizing eternal life, outlasted the meaning this gave death, but astound us even if the faith that erected them has gone. Thus one can admire the Arakawas' architecture without sharing the belief that explains it.

—August 11, 1997

ROBERT RAUSCHENBERG

■ ■ ■

BERTRAND RUSSELL ONCE DEFINED THE IDEAL FORM OF A WORK IN philosophy: It should begin with propositions no one would question and conclude with propositions no one could accept. There is a certain parallel with the art of Robert Rauschenberg, especially in the period of his greatest inventiveness. In the 1950s, Rauschenberg would begin with objects everyone would recognize and end with objects unlike any encountered. Russell's work was held together by sheer logic, which guaranteed that the paradoxical consequences of commonplace assumptions were irresistible. It is more difficult to identify what held Rauschenberg's so-called "Combines" together as works of art, except a certain associative genius uniquely his. Readers of Russell could follow the steps of his reasoning to see where, if anywhere, he went wrong. One major difference between philosophy and art lies in the fact that there is no comparable way in which one can, objectively, check the results of Rauschenberg's combinatorial intuition—no "decision procedure" of logicians' dreams. Rauschenberg's procedures, as Walter Hopps expresses it, were "improvisational rather than formulaic." His greatness is made evident when one considers that he has countless followers—indeed, the artistic mainstream today is very largely Rauschenbergian—but scarcely any peers.

Jasper Johns, whose relationship with Rauschenberg was deep and transcended mere artistic collaboration, once formulated his creative agenda: "Take an object. Do something to it. Do something else to it." In that period, Johns was making flags and targets. An example of his agenda at work

would perhaps be: "Take a target. Paint it green. Place above it a series of compartments with effigies of different facial and/or bodily parts, functionally like clay pigeons." Rauschenberg's corollary to Johns's laconic recipe might have been: "Take an object. Add something to it. Add something else to it." The genius of each artist lay in going from step to step of these recipes. What do I do to a target, to move to the next stage? What do I add to an automobile tire, and if, in a blaze of intuition, I decide to add a stuffed goat, ringing its neck with the tire, what do I adjoin to this combination to advance the work? In any case, utterly familiar as tires and goats are—so familiar that they could be images in an alphabet book for children (T is for tire, G is for goat)—no one had ever seen a goat wreathed with a tire before, as in Rauschenberg's signature work, *Monogram* (1955–59). Who could say what it meant? The goat is, to be sure, a sacrificial animal, so it is entirely thinkable that it would be wreathed with laurel when led to the altar. *Monogram* is an exceedingly evocative and at the same time a very funny work. Who knows what Rauschenberg was thinking? All one knows is that nothing like it had been seen in the entire history of art, and that goat and tire had identities so strong as to counteract any tendency to think of them as other than what they were. The combination reminded the artist of a monogram, with the tire as O. Hence the title. But the power and absurdity of the combination suggest that his gifts of adjunction surpassed entirely his— our—capacity to interpret.

The idea of expanding the vocabulary of art, especially sculpture, to include the most vernacular of materials was much in the air in the era of Combines. Richard Stankiewicz, for example, built sculptures out of fragments from the junkyard—gears, screws, rods, and other objects, whose original functions in pieces of forgotten machinery could mainly only be guessed at. John Chamberlain compounded objects out of crushed automobile bodies. Part of the pleasure of Stankiewicz's assemblages lay in the recognition of junk redeemed, given new life in a work of art. One could enumerate the parts and admire the artist's formal intuition in welding them into a coherent whole. But none of Stankiewicz's works transcended their materials and facture, and they were in essential respects much alike. The artist was able to follow the first step in the agenda—doing something, or adding something, to an object. But the crucial second step, which would

produce something astonishing—a prod to the interpretive imagination—escaped him almost entirely. And much the same can be said of Chamberlain's heaped, crushed automobile bodies. There were doubtless ways of thinking of them that rose above the perception of their chance crumpledness. One could think of the tragedy of crashes or the obsolescence of vehicular dreams. But such reflections would have been aroused by any of Chamberlain's works, leaving only their formal differences as a basis of appreciation. Rauschenberg nearly always intuited the second step, with the consequence that his works are individually memorable, and like *Monogram*, abidingly astonishing.

Stankiewicz and Chamberlain, it seems to me, were in hostage to their chosen materials and could not escape the constraints of assembling mechanical parts or smashed fenders. Rauschenberg's materials, while they must have a certain antecedent identity through their commonplaceness, are not restricted (with one qualification) to any one domain. The qualification is that the objects should be used, worn, and probably discarded—like certain of Rembrandt's women, bent by care and sorrow. Both Rauschenberg and Rembrandt gave defeated beings a new dignity by translating them into art. I imagine that anything in one of Rauschenberg's Combines, with the likely exception of *Monogram*'s insufficiently banal angora goat, might be found in the family garage. The garage is the site of objects thrown out but not (as yet) away, not fit for the garage sale but still possessing enough of their original integrity that—who knows?—they might come in handy. Old tires; fractionally filled cans of oil; mostly empty pails of paint with dripped-over rims; cracked plates; stacks of yellowing newspapers; bent license plates, nailed year by year to the wall; lengths of wood, splintered at the ends; worn brooms; rusting funnels; curling snapshots, pinups, calendars that survived their dedicated year—or the Plymouth Rock chicken that cousin Edward stuffed for his correspondence course in taxidermy. There are other visible features of garage interiors that are aesthetically suggestive of Rauschenberg's sensibility without being removable: tire tracks and grease spots on the floor, and perhaps the kinds of paint marks enfranchised for art by Abstract Expressionism, but *in situ* serving only as evidence that someone was testing a color or wiping the brush against the wall. And of course drips and lashings of enamel here and there, resembling by accident the kind of splat-

ters one can still see on the floor in Jackson Pollock's barn-studio on Long Island. The garage is a singularly American interior, and the garage sale the American soul objectified. So references to garages is what seems to me to make Rauschenberg's art distinctively American. The Combines enshrine the American propensity to throw things out without wasting anything—consumption tempered by thriftiness—which confers a certain poetry on objects consigned to domestic limbo. This poetry transradiates the work into which these dull and damaged entities are transfigured into something absurd and glorious, like a winged box of Coke bottles too covered with paint to be cashed in for nickels. The Combines fit into no possible form of usefulness because they are so intransigently outsiders, once useful objects given a second chance as art. (This testifies to a deep generosity on Rauschenberg's part, which finds further expression in his exemplary philanthropic and political endeavors.)

Rauschenberg's taste for what aesthetic utopians would dismiss as aesthetic squalor—the cracked, the split, the torn, the mildewed, the shattered—are, I have always felt, the industrial era's equivalent to the dappled things for which Gerard Manley Hopkins gave glory to God. Hopkins saw them as evidence for God in the sense that human imagination is too limited to have conceived them. In Rauschenberg's case, they are always secondary effects of productive activities, marks and traces of practical endeavors, with an inadvertent beauty. So he appropriated and transfigured ready-made textures that no one before him could have regarded as fit for art. There exist certain works, entirely in the Rauschenbergian spirit but by European artists, consisting of posters that had been pasted one over the other down the years but were now worn and peeling, with the underlayered images revealed in parts by opportune rips. Like the abject surfaces of the worn and the wasted, it seems central to the palimpsest of layered posters that they be ready-made and purposeless, even if each layer has its own message to promote (they would have an entirely different meaning had they been composed, rather than found, by the *affichistes*). It is the chance emergence of unintended meaning that gives such works their depth and their ragged beauty.

In a widely quoted statement from 1959, Rauschenberg said, "Painting relates to both art and life. Neither can be made. I try to act in that gap be-

tween the two." When I first read this, I was dazzled by the idea of the "gap between art and life" as a possible site for artistic activity, and indeed it seemed to me that the philosophy that interested me also takes place in a "gap"—in what I termed the space between language and the world. Philosophers did not "make" language any more than they made the world, but taking both as they found them, undertook to explain how the one can represent the other. The analytical philosophy that evolved from critiques of Russell is almost entirely taken up with naming, reference, denotation, description, and truth. The gap between art and life is less easily defined, but one gets the sense that the Combines touch both these domains as boundaries, with art symbolized by raw paint, and life by odds and ends of real things with antecedent identities. The cans and the Coke bottles pull the work down to earth, while the paint pulls it toward the plane of art, with the work itself the tension between them. In that same statement, Rauschenberg went on to say, "A pair of socks is no less suitable to make a painting with than wood, nails, turpentine, oil, and fabric." And he added: "A canvas is never empty."

The inescapable nonemptiness of canvas is doubtless a reference to Rauschenberg's own all-white canvases, which he painted when a student at Black Mountain College in Asheville, North Carolina. The monochrome white canvas had before then been merely a kind of pictorial joke (showing pale girls wearing communion frocks in the snow, which a French magazine published in 1879); an emblem of failure, as in Henry James's story "The Madonna of the Future," where an artist is unable to mark the canvas on which he meant to transcribe his masterpiece; or as an embodiment of purity—the white radiance of eternity—as in Malevich's *White on White*. (Malevich did not go quite so far as to make a monochrome white canvas, but his *Black Square* shows that he understood the impulse.) Art historians, with their obsession over who did what first, treat Rauschenberg's white canvases as anticipatory Minimalism. But what Rauschenberg intended was that the canvas would reflect, from moment to moment, the transient effects of light and shade. And since, except under severely controlled conditions, as in the visual equivalent of an anechoic chamber, there will always be these effects, the painted canvas, as art, displays the shifting lights and shadows of real life. The whiteness was a kind of visible silence that allowed life to reg-

ister against it: The canvases were, John Cage said, "airports for lights, shadows, and particles." Cage's famous 4'33"—in which a professional pianist sits down to the instrument, refrains from touching it for just that interval and allows the noises of the world (the coughs, the whispers, the shuffling feet, and distant traffic) to be heard as the substance of the composition—inevitably differs on each performed occasion. It must be emphasized that only a serious pianist can *perform* silence, so 4'33" transcends, say, my capabilities, since everything in music transcends them: *Not* playing the piano is not something I can *do*. For parallel reasons, it was mandatory that one of Rauschenberg's most famous pieces, his *Erased de Kooning Drawing* (1953), in fact be a good drawing by a great artist. If Rauschenberg was interested chiefly in the aesthetics of erasure, he could have rubbed out anything.

Bed (1955) is perhaps my favorite among the works that bridge the gap between art and life. It is, literally, a bed, hung like a trophy on the wall, consisting of a folded quilt over a sheet and pillow, mounted on a wooden bedframe. The top half is densely painted, about halfway down, with thick swags of dripping pigment (the direction of the drips implies that it was painted in a vertical position rather than flat on a floor or table, which has some critical significance, since an implied flatness has been deemed central to appreciating the artist's work). The bottom half simply shows the quilt, on which a few especially long drips course nearly to *Bed*'s bottom edge. The work is pivotal, it seems to me, pointing in one direction back to the metaphysics of paint, which defined Abstract Expressionism (and hence art, in Rauschenberg's vocabulary), and, in the other, to the uninflected display of commonplace objects, which in various ways was to define Pop. The awe with which paint was regarded under Abstract Expressionism—and, collaterally, the celebration of the drip, which Pollock was credited with having discovered—meant that any work intended to be taken seriously had to pay its respect to paint. It was the emblem of citizenship in the art world. But paint does not cover the entire bed, and since the quilt belongs to life, *Bed* incorporates the boundaries between which Rauschenberg had tried to work. When I first saw it, I thought of Plato's discussion of the bed in his indictment of the arts. In his view, artists could at best achieve imitations of imitations and were accordingly capable only of the lowest degree of reality and knowledge. It seemed to me that finding ways of making art out of real beds was a way of

closing Plato's gap and that *Bed* somehow stretches upward to a higher level of reality.

Rauschenberg recognized that life, especially in the era of mechanical reproduction, includes pictures in its inventory—snapshots, posters, road maps, magazine illustrations, news photographs, fine art reproductions, baseball cards, "Wanted" posters. One's bedroom could have, in addition to beds, quilts, and linens, pictures of various sorts. Hence it was possible to incorporate pictures into one work exactly as one incorporated quilts into it, or pairs of socks. *Levee* has a postcard of what looks like a Clouet. *Factum I* has a calendar picture of some trees by a lake, as well as paired pictures of Dwight D. Eisenhower and of a New York City building. *Currency* shows *Mona Lisa* at least seven times. John F. Kennedy, an astronaut, and Rubens's *Venus* appear in different Rauschenberg paintings. The pictures were transferred onto the work's surface by soaking them with solvents, such as lighter fluid, and rubbing them from behind. They have a somewhat ghostly feel, which makes sense if we think of them as separated, like souls from bodies, from the paper on which they were originally printed. Almost certainly the greatest of Rauschenberg's achievements in the genre of transfer drawing are his thirty-four illustrations for Dante's *Inferno*, in which the ghostliness seems entirely suitable to the depiction of descent from circle to circle of Hell.

The Dante illustrations bring us only to 1960, when Rauschenberg was thirty-five and hence, suitably, at the conventionally recognized midpoint of his life. The sprawling exhibition devoted to his work at both Guggenheim venues in New York shows what Rauschenberg achieved as an artist in the second half of his life. He is seventy-two and unremittingly productive. I have found it difficult to be as responsive to his later production as to the early breakthrough work, but that may in part be due to the show's embracing far more work than one can easily think through in response. I did not find compelling such works as the interactive *Revolver*—in which five large plastic disks can be turned to combine the signs and emblems on each in new constellations. *Revolver* perhaps lacks the presence of the life boundary of Rauschenberg's activity—it belongs instead to the gap between art and *technology*, in which the artist has spent more and more of his time—and the results largely lack the human investitures that come from the other and richer

gap between art and life. Perhaps in the latter half of his creative life Rauschenberg has lacked the kind of creative friction spontaneously provided in his earlier period by Cage, Merce Cunningham, Johns, Cy Twombly, or the Judson dancers, and his work has spun off on a tangent to the direction of the art world, even if the latter would have been unthinkable without his earlier discoveries, his experiments, his conceptual daring. In some ways he has retained the impudence of intractable youth, of a perpetually insubordinate art student animated by the spirit of "Why not?" But in his most recent work the detritus of the garage has finally been thrown away, making room for intricate mechanisms lacking function and humanity. They remain objects of a kind never encountered, but they have lost the touch that connected us to them through the commonplaceness of their materials.

—November 17, 1997

RICHARD DIEBENKORN

▪ ▪ ▪

THERE IS A CHARACTERISTICALLY BEAUTIFUL PAINTING BY RICHARD Diebenkorn in the Neuberger Museum of Art in Purchase, New York, titled *Girl on a Terrace*, done in 1956. The girl is standing with her back to us, her left hand reaching across her back to grasp her right arm, which hangs nearly straight down. She appears to be looking at the landscape beyond the terrace's edge, though of course it would be possible to see her as lost in thought, in which case the landscape is merely background. There is an empty road, brownish in the near distance and then abruptly white, where it makes a sharp ascent to the horizon: It is as if a dirt road turns into a paved one, or one section of the road is in sunlight. In any case, the lighter segment appears to have been painted with a single, masterful stroke of white, which the eye sees as going up and back, hence in the illusional space peculiar to pictures. Were that very stroke to occur in an abstract painting, it would be on the surface rather than in pictorial space. And this ambiguity, between depicted entities and strokes of paint—between meadows and green patches, the sea and areas of blue—belongs to nearly every one of Diebenkorn's works. So his paintings hover between abstraction and depiction.

This indeterminacy affects our experience of even the most abstract of Diebenkorn's paintings, which always feel somehow referential and pictorial, filled with horizon lines and diagonals that could be the edges of roofs or black triangles that feel like shadows. The shapes refuse merely to belong to the surface; they slip, like illusions, into forms in real space. Since there is a girl in *Terrace*, as in so many of Diebenkorn's works from the 1950s, the am-

biguity is somewhat dampened. She is unmistakably a real person, so the white stroke is read as a road. The relationship between girl and landscape is undisclosed. The landscape could be the object of a contemplative gaze. Or the girl is waiting for something to happen and her look in consequence, engaged, expectant, or hopeful (fearful is incompatible with the mood of the painting). In any case, the sky is scrubbed on with a blue seen only in Matisse and certainly never in nature, and in truth one could see the girl standing not in front of nature but of a painting of nature, in an expressionist manner or even an abstraction, with three irregular horizontal zones—blue, green, and terra cotta, separated by two zones, one of ocher and the other gray-blue on one side of the "road" and of ocher again on its other (which would perhaps represent dunes if this were a landscape). I see the girl as in a mood of disinterested contemplation appropriate to looking at a painting of a certain sort, when we are, like her, not looking *for* anything but allowing ourselves to be engulfed by the mood the picture creates. Certain paintings are suffused with moods the way others—Vermeer's, for example—are suffused with light. One feels that the girl is in the painting in order that someone be there to feel the mood the landscape evokes. A mood, Heidegger writes, "comes neither from 'outside' nor from 'inside,' but arises out of Being-in-the-world." The mood of the landscape feels as if it objectifies the mood of the girl—it *shows* what she *feels*. Were the girl in fact subtracted, one is certain that the mood that implies her presence would remain, diffused throughout meadows, dunes, and sky as if the work were a landscape, or the greens and blues and duns as if it were an abstraction.

In the 1950s Diebenkorn moved from abstraction to the form of figuration *Girl on a Terrace* exemplifies. Others shifted to the figure at the same time, most famously de Kooning, who exhibited his *Women* at the Janis Gallery in 1953, to the acute consternation of abstractionism's ideologues. And so many artists of the Bay Area in California, which was Diebenkorn's milieu, had adopted an expressionist kind of figuration that it was spoken of as a movement. But Diebenkorn had already known a certain success with his prefigurative abstractions, so doing the figure meant a certain sacrifice, financial as well as critical, in view of the larger belief that abstraction defined the historical moment. It is characteristic of the artist's extreme indepen-

dence that he explained the change with reference to factors internal to his own project of painting, as if it had nothing to do with events outside the studio. With figuration, he said, "a kind of constraint came in that was welcomed because I had felt that in the last of the abstract paintings around '55, it was almost as though I could do too much, too easily. There was nothing hard to come up against. And suddenly the figure painting furnished a lot of this." On another occasion, he said, in regard to this specific constraint, "The figure . . . takes over and rules the canvas." But why the human figure specifically—why the girl and not the inkwell, milk bottle, coffee cup—all of which appeared in his still lifes of the time? The girl is needed to transform the irregular but scarcely inflected shapes into a landscape with meadows, sky, and dunes instead of areas of green, blue, or beige. She illustrates another Heideggerian concept, that of "Being there"—*Dasein*—which is the kind of being humans have in contrast to milk bottles or inkwells. It is characteristic of Diebenkorn to speak of the figure as a problem in painting ("You can't float around in space") when in fact it meets a metaphysical need. As he said, speaking on another occasion about his turn to figuration, "A delusion appeared, but only momentarily, which was that I knew what I was doing." Who does not suffer from that "delusion"? Artists make their decisions, as we all do, and afterward try to make sense of what they did. That is what makes criticism possible, and at the same time delineates the authority of the artist. The question for critic and artist alike is why the girl (or girls, since there were so many of them in Diebenkorn), and how does she control the canvas?

Diebenkorn's girls are modern spiritual sisters to the women who so enchanted visitors to the National Gallery exhibition of Vermeer two years ago. One can confirm their affinity by considering the quite different kind of woman who stands by the canal in Vermeer's *View of Delft*. She is in the painting in the same way the objects are—the boats, the houses, the towers. She is a further object, which happens to be human. She is in the scene the way a penny is in a box, as part of its content. That is not the "in" of Being-in-the-world, which is after all like the "in" of being in a mood, with outer and inner reality united. There is no temptation to ascribe any inner state to the woman, with her prim bonnet and heavy black skirts. But there is with Vermeer's other women, who look out windows or read letters or pour milk

or weigh gold or play instruments. The light-filled rooms make objective the women's inner states. (Whatever mood is expressed in *View of Delft* has no special connection with the woman on the quay; her relationship to the space is entirely external.) And that is the way it is with Diebenkorn's girls, who are internally related to their surroundings. They are in the paintings, so to speak, to bring the rest of the painting to life within them. Like Vermeer's women, they gaze, read, pour coffee, or write letters, or they sleep. And, being contemporary women, they smoke. And they are almost always by themselves (there would have been no handmaids in Ocean Park, California, to confide in).

Girl on a Terrace is not included in the retrospective exhibition of Diebenkorn's work at New York's Whitney Museum. But there is a generous array of paintings from the 1950s, any one of which might demonstrate the moods that inflect the landscapes like a spiritual presence, explained by the interiority of a woman who is there. Then, as abruptly as he resumed figuration, Diebenkorn took up abstraction again, embarking on his remarkable *Ocean Park* series of paintings, the last of which is *No. 140*, painted in 1985, the year before Diebenkorn and his wife decided to return to northern California, leaving Ocean Park—a somewhat nondescript area in Santa Monica where he had his studio—behind. It was almost as if he could not end the series without moving to a different landscape altogether, but knew it had to stop, for the same reason as thirty years before—that he could "do too much, too easily."

Except for the figurative paintings, Diebenkorn appears to have referred in the titles of his works to the places where they were painted—Sausalito, Albuquerque, Urbana, Berkeley, Ocean Park. Bodies of work indexed to places where he lived, taught, and painted differ from one another sufficiently to suggest a more internal relationship between paintings and place than the convention of the title suggests, although the paintings, especially when abstract, were never about the site of their execution. "Each time Diebenkorn relocated, his work changed drastically to reflect his new environment," Jane Livingston, who curated the show, writes in the catalogue. Perhaps because the decision to paint abstractly was at a certain time almost a conversion experience for artists, Diebenkorn was defensive about his paintings' having

any literal reference, despite the geographical specificity of their titles. "What I paint often seems to pertain to landscape," he said, adding, "I'm not a landscape painter (at this time, at any rate) or I would paint landscape directly." There are difficult questions about why Diebenkorn persisted in painting Ocean Park, and why he stopped when he did. I incline to the view that he had to move to another landscape in order to go on as a painter. The evidence, such as it is, is the last of the series, especially *No. 140* (not in the show but reproduced in the catalogue). There is a diagonal from upper left to lower right in *No. 140*, dividing the space between a blue expanse and a green expanse, hence, roughly, water from land. The diagonal is like a line of vision, at the end of which, in the extreme left-hand corner, is a dense arrangement of trapezoids. What is startling is that *No. 140* is like a mirror image of a brooding painting, *View of Notre Dame*, done by Matisse in 1914. It is one of the rare paintings by Matisse to express some response to political events, in this case the war to come. But it has a diagonal like *No. 140*'s, only reversed; its trapezoids verge on the already abstracted depiction of Notre Dame. Diebenkorn knew the painting, and the fact that it reappears in a body of work with so different a mood and feeling—transformed, to be sure, the way dream images are from the events that caused them—must have communicated to Diebenkorn the thought that he was finished, at last, with Ocean Park as motif.

From this perspective, it is interesting to think of the *Ocean Park* paintings in tandem with the other great series by an American, the *Spanish Elegies* by Diebenkorn's contemporary and fellow Californian, Robert Motherwell, which numbered over one hundred seventy in all. Like the *Ocean Park* paintings, the *Spanish Elegies* resemble one another, more or less: They show black forms in white space, suggestive of shawled women standing among ruins, and they are invariably moving because of the sense of sorrow conveyed. Sometimes Motherwell added a color—an orangy-brown, as if for sand, cadmium red as if for blood. But the moral mood is one that goes with the elegy as a literary form. I once asked Motherwell how long he thought he would paint the *Elegies*, and he said he thought that if he ever did one that was *right*, that captured the idea the paintings as a series expressed, he would stop. I don't think there is an *Ocean Park* painting that does not express, as fully as any other, the idea that unifies the series. In that sense Diebenkorn

could have stopped at any point. So I think it a puzzle that he did painting after painting in the *Ocean Park* mode, not to mention the subsidiary untitled works clearly in the same spirit.

The California art world is restless when one of its number is referred to as a California painter, regarding that as a putdown by the Eastern, especially the New York, elite, whereas it is entirely descriptive of paintings that reflect what Heidegger might call Being-in-California. Motherwell, who invented the name "the New York School," regarded himself as a Californian in this sense. In an interview he explained "how crucial was the fact that I grew up mainly in prewar California. . . . The hills of California are ocher half the year." There really are no colors specific to New York other than black, white, and gray. So a New York painter is not one responsive to her site, but a California painter is, as Diebenkorn certainly was, whether engaged in abstraction or figuration.

Livingston writes: "To the artist's puzzlement, [the *Ocean Park*] paintings seemed to be read by many as literally depicting the actual landscape of Ocean Park, apparently in reference to the ocean itself and the sky, although Ocean Park was a half-residential, half-industrial, slightly scruffy urban area rather more than an idyllic seascape." No one, I think, would regard Ocean Park—whose name is of the kind bestowed by hopeful real estate developers—as in any sense idyllic, at least as it is responded to in the *Ocean Park* paintings. They are not postcards, but they convey the same specificity of mood the other place-named bodies of work do, infused as they are with an acute emptiness or even loneliness. Consider *No. 67*, done in 1973. It is divided into two main horizontal zones, the top one about a fifth the height of the bottom one. The top zone is divided into bands, which run from edge to edge, and three diagonals. There is a side bar on the left edge of the painting, in a faded blue. The side bar, if the ocean, would require us to see the larger area, in California ocher streaked with yellow and pinkish bars, as beach. The bands and angles in the upper area could be roads and bridges. The proportion of freeway to nature, one to five, is about right for California at that site: We are just north of Los Angeles, after all. The abstractness could be read as landscape only if we suppose we are looking down from helicopter height, distant enough that the emptiness takes over. I stress that the

work looks flat and seen from above, rather than vertical and seen from in front. And this is true for nearly all the *Ocean Park* paintings. In *Ocean Park No. 79*, painted two years later, the large oblong that corresponds to the ocher area in *No. 67* is the blue-gray of what could be an empty parking lot, with all the man-made structures again crowded into a narrow upper band. The implicit perspective conduces to a sense of isolation, as if the artist were putting the world at a certain distance. What this leaves out is the rich beauty of the paintings as against the scruffiness of Ocean Park itself. Whatever the landscape, the paintings, as paintings, are idyllic. I find in this an optimism, paralleled in certain ways by that of Pop Art, which celebrated the beauty of the found world, the labels and boxes, the hamburgers and pies, the flags and logos. The difference is that Pop painted the world precisely as it looked. Diebenkorn painted it precisely as it felt to a certain sensibility to place. No one in the history of American art put paint on as meditatively, with as much control as subtlety, and in the end one feels that however much Diebenkorn needed the prompting of objective reality, it was by way of occasioning the moods that became the paintings. That he was not inclined to go further in Ocean Park tells us how powerful the mood must have been for there to have been, after all, one hundred forty *Ocean Parks*. The Diebenkorn touch was always there, in the less-than-satisfactory paintings after the spell was broken, but he never, on the evidence of what he did afterward, connected as intensely with locale again. His relationship with Ocean Park must have been like a passionate marriage about which everyone wonders what the two see in each other. After the separation, he turned to private, personal symbols, and did not live long enough to find another landscape.

—January 5, 1998

MUGHAL PAINTING

. . .

THE PAINTINGS OF MUGHAL INDIA, PARTICULARLY UNDER THE
patronage of its greatest ruler, Shah Jahan (1592–1666), were reportorial in
ambition but ornamental in presentation. So in one direction they have an
affinity with photographs, while in the other they have the intricacy of jew-
els. These aspects are related. Because imperial patrons wanted visual
records of their deeds as hunters and conquerors, their artists accompanied
them on military expeditions or missions of state, or recorded their prowess
as animal slayers, or depicted them in the great dynastic ceremonies of mar-
riages and alliances. The Mughal emperors were connoisseurs of visual truth,
and looked upon paintings as objective memories, which all could share, of
great occasions. And that was one basis for Mughal connoisseurship—that
one should be able to tell from a given painting what it was like to have been
there. But the pictures were required to do more than that; they were also
meant to celebrate the occasions they depicted. Hence the intricacy of design
and the luminosity of their colors: One would want to look at them as at
great jewels, with the result that their truth was reinforced by their beauty.
They have, accordingly, some of the qualities of epic poems: memorializing
high deeds in language so vivid that repeated recitation was irresistible, so
that the events would be remembered forever.

In terms of presentation, the Mughal artists were in debt to the visual strate-
gies of Persian illuminations. In terms of historical fidelity, they borrowed
what they could from the representational strategies of the West, using shad-

ows for solidity and linear perspective for depth. East and West intersect in the court paintings of the era, but only because of the double demand imposed on Mughal painters that their works should be true and beautiful at once, that they instruct the mind and delight the eye.

History is best remembered when condensed into myth. Washington's character is indelibly enshrined in the cherry tree episode. Shah Jahan is mostly remembered for the legendary dimension of his devotion to his wife, for his grief and loss when she died, and for embodying her qualities as a person in a transcendentally beautiful piece of memorial architecture, the Taj Mahal. Mumtaz Mahal was but one of Shah Jahan's wives, and she died giving birth to their fourteenth child. So one feels theirs was a love that presupposes marriage, as with Odysseus and Penelope, or Hector and Andromache, but unlike that of Tristan and Isolde or Romeo and Juliet. It is a love taken beyond itself into something abiding and deep. Shah Jahan led an active life, administering an empire, commanding armies, strengthening ties, building fortifications and mosques as well as that one visionarily jewellike mausoleum. It was the task of his artists to represent these aspects of the imperial persona in images that stood to truth in something like the way the Taj Mahal stands to the felt truth of Mumtaz Mahal as a woman. The paintings glorified him through their own visual glory, giving the truth a mythic aura. They were like the name he took for himself when he ascended the throne. "Shah Jahan" means "King of the World." His father was merely called Jahangir, or "World Grasper"; and the difference between grasping and ruling defines their respective administrations. In a way it defines as well the demands they put on their artists.

In the Brooklyn Museum of Art there is a magnificent portrait of Jahangir from around 1610 that illustrates to perfection the aesthetics of his court. The emperor is shown with the attributes of his power, the way Western saints are shown with the attributes of their martyrdom. A white falcon is on his gloved right hand; his left hand appears to be grasping the handle of a tiger-killer's dagger, thrust into his sash. He wears a double strand of pearls, while a lesser strand is twined into his turban. He stands alone in an undifferentiated and abstract space of celadon green, his face and legs in profile, his body in three-quarter view. The picture shows the way he *appeared* but, more important, it presents him as he *was*. You can glean from the picture

information that poetry would rarely disclose, like what he wore on his feet, and the cut of his coat and the pattern of his pants and the form of his headgear. But reality is transfigured into what is indispensably called a *presence*, since we have no better word. The portrait of Jahangir is at once hieratic and documentary. It belongs to that genre of representation in which a single figure is shown monumentally, like the Buddha, or the bodhisattva Guanyin, or for that matter Jesus or Napoleon.

But Shah Jahan is shown in action, in the midst of institutional structures he dominates and defines, accepting or bestowing gifts, welcoming ambassadors, slaying lions or antelopes. There is one aspect of his representations that sets him apart from other individuals in the same picture with him and that confers on him that status Jahangir claims through being shown in absolute aloneness: He is always shown in profile, and his head is surrounded by a nimbus. The preference for the profile may derive from a European form he especially admired, the cameo, so that showing himself as if carved in a hard medium could have been emblematic of the durability of his reputation. The nimbus, though it has ancient Indic prototypes, must again be a European borrowing, derived from devotional images brought by missionaries and other travelers. It of course exemplifies luminosity, but it also asserts that the person within it belongs on two planes of being at once—a superior human divinely chosen for kinghood. It makes the only supernatural reference I have been able to identify in the paintings from Shah Jahan's regime.

There are forty-four of these paintings on view at the Metropolitan Museum of Art. They come from one of the most magnificently splendid books ever assembled, the *Padshahnama*, which, according to Milo Beach in his introduction to the catalogue, "is both an extraordinary artistic achievement and a major historical chronicle." This exactly specifies the Mughal painters' brief. It shows and narrates major events in Shah Jahan's official life as prince and king, as administrator and warrior, and it finds ways of implying his generosity, his justice, and his might. In many cases the pictures are antedated by the events they record, to which the artists were not true witnesses. But they convey the sense of having witnessed, and the pictures have in consequence

the feeling of resplendent truth. Whether or not the artists attended the events, they were of the period, and their work had to meet the criteria of actuality applied by critics who may have been there and who would recognize errors. In any given *Padshahnama* painting, fifty or so figures will be shown, and one is convinced that these represent specific people rather than constitute the kinds of generalized figures used often by Western artists to imply an audience or a crowd. In some cases there are the animals we expect in imperial precincts—horses and elephants—or animals as prey, such as lions or gazelles. The animals are again so minutely observed that they verge on portraiture, or in any case are deeply informed by naturalistic observation. In *Shah Jahan Hunting Lions at Burhanpur*, the animals are realistic and emblematic at once, like the fierce and elegant unicorn in the tapestries at Cluny, but shown together with their cubs in an enclosure that instructs us encyclopedically in the methodology of lion hunting.

The *Padshahnama* contains a calligraphic text describing what the illustrations display—the pictures *present* the reality the text describes. The book itself was given as a spectacular gift to George III in 1797, and afterward it was placed in the Royal Library at Windsor Castle. This meant that the pictures have been all but invisible to the world at large, or at best seen one sheet at a time, as with the *Book of Hours* at Chantilly. Because conservation required unbinding the book, it was decided to make an exhibition of the works, to coincide with the fiftieth anniversary of the independence of India and Pakistan—so the paintings continue to serve a celebratory function into the present era. There is, of course, a profound difference between seeing an image upon turning a page and moving from picture to picture along a gallery wall. Most of us will never experience the book as a book, in which the pictures are like treasures revealed one at a time. But there is something marvelous in the linear array their unbinding makes possible: The forty-four paintings are like as many windows into another time and place—as if we see *through* them into the world of Shah Jahan, shown as he and his courtiers would have seen it. The order in which they are presented is the presumed order of the narrative itself: They are not, so to speak, "stills," like Brooklyn's Jahangir. So there is a certain cinematic unity in viewing them successively.

The compositions, especially those in which Shah Jahan sits in state, transmit an almost political sense of order and hierarchy. They are divided into three registers, with the official space of the King of the World appropriately at the top, on a sort of balcony. He is generally seated on a throne, under a sort of baldachin, which ritualizes the space beneath it, the way a *chuppah* does or a canopy placed over an altar. In most of the images of him, Shah Jahan looks to the left, at an approaching figure, incredibly privileged to be able to share, or partially share, the ritual space with its ordained occupant. In one painting, Shah Jahan is receiving his three sons in a ceremony connected with his accession. One of the sons, presumably the eldest, is bent down in acknowledgment of his subordination, but at least his head and upper body are in the same space with Shah Jahan, forecasting, so to speak, the office to which he will ascend. The other sons are standing at the left, their hands in a gesture of respect, wearing opulent garments, waiting for their father's blessing, shepherded by an imposing attendant. In the middle register, there is an enclosed space below and in front of the Emperor's balcony. This space is occupied by figures from the court, handsomely rather than opulently dressed. And in the lowest register, a crowd of figures is shown who are, one supposes, "beyond the pale" of privilege and authority but still subjects of the king and permitted to stand as spectators to the great event above them. The organization of the space, as I see it, conforms to the same hierarchical structure as that of the ideal society, and an analogy points irresistibly to the tripartite division of society as articulated in Plato's *Republic*, with the philosopher-king at the lonely top, the guardians in the middle register, and the ordinary people at the base.

Realism demands that the figures, whatever their rank, should all be, like human beings in general, more or less the same size. Given the awesome difference between the king and even those closest to him in rank, there are traditions that present this as a difference in size, with monarchs shown as giants and their subjects as near-dwarfs. One feels that Jahangir would have liked to have been shown physically larger than others, but his realist attitude was inconsistent with that and so he had himself shown alone. The same symbolic effect is achieved in the *Padshahnama* through the placement of the figures in the architecture—on the balcony, behind the rail, beyond the pale.

The sons in the picture just described really *look* like sons—youthful and respectful of their haloed father. The scene on the balcony is a family picture, and merits comparison with the Gonzaga family in Mantegna's great *Camera degli Sposi* in Mantua. But the audience transforms it into a public event of immense moment. The scene is very specific. It took place on March 8, 1628. The relationship of picture to text teaches a deep lesson. "The princes . . . were allowed to pay homage" does not tell us, as the picture does, what they wore and who else was there, and whether or not there were elephants—or how the walls were decorated and what kinds of pictures the king liked to have on his walls. On the other hand (and this is why we need words as well as pictures) a picture of someone with a halo is a pretty thin way of showing what the text describes as the "Hall of Public and Private Audience . . . illuminated by the rays of the Emperor's enthronement." It would have required the mystical vocabulary of the Baroque, entirely distant from the uniform clarity that Mughal realism required, to describe Shah Jahan as *transfigured*.

The nimbus, in *Shah Jahan Hunting*, has acquired rays, as if, like his younger contemporary, Louis XIV, Shah Jahan were the sun. The text tells us that "in one day he himself shot forty black antelope with the royal gun called Khassban, and not a one needed a second shot. This of course occasioned astonishment in all." Killing forty antelope with one shot each bespeaks a level of marksmanship well out of the ordinary. But the language implies limits to pictorial representation, and in truth there is not a single dead antelope in the picture—though I counted enough live ones for there to be at least forty. They are grazing, leaping, drinking from a pond, reposing. Due to the realist imperative of Mughal art, counting is problematic— figures get appropriately smaller as we look into the distance. The foreground foliage is botanically exact. There is a rolling perspective in the scene, of the sort we see in the Flemish masters, which shows how things look from each successive position between foreground and horizon. The horizon rises as the eye approaches it, creating a large area beneath it to crowd with incident. This permits the artist to fuse depth with flatness, the one associated with looking through windows, the other with seeing an image in a book. The figures are so grouped that they at once appear behind

one another and above one another: They go back in space and at the same time form a flat design. Symbolically, the whole landscape appears illuminated with an internal light, as if hunter and hunted were participating in a ritual enactment of cosmic significance. It is as if falling under the king's single bullet were as much a privilege as sharing his space beneath the roof of the baldachin.

Mumtaz is present by her absence, especially in the magnificent painting of the delivery of wedding gifts to Dara-Shikoh, Shah Jahan's designated heir. Mumtaz had planned the wedding but died before it could take place, so the immense procession of gift-bearers and their consorts celebrates her memory as well as expresses the momentousness of the new union. The text tells us how much the gifts were worth, but the picture shows a large company of porters carrying, on trays covered with ornamental cloths, whatever was thought fit for a king. (We see the presents themselves, in jewel-encrusted gold, in *The Presentation of Prince Dara-Shikoh's Wedding Gifts*.) The porters are preceded by a row of elephants carrying groups of female singers, and followed by a magnificent crescent of mounted men. In this picture, I noticed that the mounted figures were in profile while the bearers are shown full face, and I could not help wondering if this were a way of representing differences in class. If so, the difference is not entirely formulaic: Occasionally a mounted figure looks toward the viewer, as if to break expectations, the way reality does, and to humanize the scene. Still, the gift-bearers look in all possible directions, as if taking in everything there is to see in the great spectacle. So I infer that this is a lower-class attribute, the upper classes disciplining themselves by controlling the propensity to gaze and gape. The procession stretches across two sheets, and it is astonishing to see how the whole scene—pennants, animals, soldiers, musicians—is pictorially as regimented as the procession itself aspired to be.

The world of Shah Jahan was not all ceremony and priceless stones and golden ewers and royal protocol. Its obverse was warfare, and Mughal realism is particularly lucid in battle scenes, where two conflicting attitudes have to be reconciled: war as glory and war as hell. In *The Siege of Qandahar*, glory is concentrated in the lower right corner, with white horses and brilliantly armored horsemen, and a commander pointing to a hell of smoke and

flames, breached walls and slain soldiers, in the upper left. As a commentary, the artist has placed two rabbits in the nearest foreground, nibbling grass, one of them reflected in a shallow pool. This puts the scene of strife in a certain moral perspective. The life of Mughal art is in the details. You have to address them as reader. For most of us, this is the one chance we will ever have of seeing them all together.

—February 2, 1998

FERNAND LÉGER

∎ ∎ ∎

Braque and picasso are widely considered the inventors of Cubism—but did they especially know it was *Cubism* they were inventing? "We had no intention whatever of inventing Cubism," Picasso said long after the event, leaving the question open of what their intentions in fact were. I would argue that Cubism was a concept others found to represent what Picasso and Braque had invented but that had scant reference to what the artists actually believed they were doing. "We simply wanted to express what was in us," Picasso said, implying that their extraordinary creativity of those years, 1907–08, was a way of giving objective form to certain attitudes and feelings—toward women, for example. *Les Demoiselles d'Avignon* is often cited as an early Cubist masterpiece, even though in 1907, when it was painted, the concept of Cubism did not yet exist. It seems, as a painting, to have very little to do with cubes, or, for that matter, with geometry—though until Leo Steinberg published *Other Criteria*, the acknowledged experts treated the work as if it were a diagram for an elaborate geometrical theorem. "Can we be looking at the same picture?" Steinberg asks in mock credulity. The scary female sexuality he saw had nothing to do with the laws connecting the faces, edges, and vertexes of regular Euclidean solids. So Cubism blinded critics to what the pictures that led up to it, *Demoiselles* included, were really all about.

The idea of the cube first entered the discussion when Matisse observed that Braque had submitted, to the Salon d'Automne of 1908, "a painting made of small cubes." The "small cubes" were in fact houses in a painting Braque made of a village in southern France; and though it scarcely seems an

act of geometrizing will to represent a village as an aggregation of loosely cubic forms like blocks spilling down a slope, the effect was unusual enough to impress Matisse. When Braque exhibited at Kahnweiler's later that year, the critic Louis Vauxcelles wrote that "Braque despises form, reduces everything, places, figures and houses, to geometrical schemes, to cubes." Cubism was really invented with these words. The suffix transforms the act of painting cubes into the enactment of a geometrical ideology that the expression "Cubism" serves to disparage.

The power to define is the power to deform. In no work from those years did Braque—or Picasso—achieve a reduction comparable to that achieved by Vauxcelles in this fateful paragraph in the November 14, 1908, issue of *Gil Blas*. The critic painted a portrait of the artist as engaged in a *simplification terrible*, turning everything—and not just a sleepy village—into so many cubes. And if it failed to capture the openness, the tentativeness, the nuance of Braque's efforts as an artist, it projected an image Vauxcelles's readers, if artists, must have found irresistible. What a joy to despise form, to simplify terribly, to dissolve, to reduce—to cubify the world! Cubism as a movement owes as much to the will to power of a critic attempting to be clever as it does to anything actually painted by the founding masters. Like the term "deconstruction" sixty years later, Cubism evoked a set of giddy opportunities more than it conveyed a doctrinal truth. Such lesser figures as Albert Gleizes and Jean Metzinger—whom Gertrude Stein dismissed as "little Cubists"—were not entirely wrong in holding that it was they, far more than Braque and Picasso, who had really invented Cubism. For it was they, together with Marcel Duchamp and his brothers and other members of the so-called Puteaux group of Cubist theoreticians, who connected Cubism to science through the fourth dimension, non-Euclidean geometry, and the theory of relativity; and to art through the neo-Pythagoreanism of Cézanne, who had urged painters to "treat nature by means of the cylinder, the sphere, and the cone." Braque could have said sincerely, "*Je ne suis pas Cubiste!*" But neither he nor Picasso made the vaguest attempt to formulate what they were instead.

These questions came home to me in thinking about the earliest painting by Fernand Léger in the exhibition devoted to his work at the Museum of Modern Art. It is a resolutely Cubist treatment of a woman sewing,

painted in the drab colors early Cubism favored. She is seated in a room whose source of illumination is as clearly indicated as in a painting by Vermeer of the same subject, creating planes of light and shade. The woman herself is all slabs, with hands like prosthetic devices, but there is no sense that Léger was envisioning a mechanical seamstress, like the robotic domestic in *The Jetsons*. He was instead depicting, in a mechanistic way, a flesh-and-blood seamstress; there is a plane that defines the shelf of her upper bosom. What did the fact that she had been translated into the idiom of Cubism add to the fact that she was a matronly woman, sewing the afternoon away in her parlor?

My sense is that Cubism, in the minds of its first users, was perceived as a universal style of pictorial representation through which whatever had been shown in traditional modes could now be shown in modern ones. It may indeed have been the first known notational system alternative to the traditional one that largely governed pictorial representation from the early Renaissance onward. So it had to have been exciting in the extreme to see a motif as ordinary as a sewing woman rendered in the new way—and sheer bliss, as an artist, to be among the first to apply the novel notation. Cubism retained its edge of visual excitement and empowerment well after it had subsided as a movement. In the art schools of my youth, it was still felt audacious to be able to resolve a face or figure into facets like a cut gem, dismissing entirely the traditional academic strategies for rendering volumes, lights, and shadows.

Cubist retranscription was so heady an undertaking that practitioners may have felt it important to retain all the familiar studio genres—landscapes, still lifes, figure studies, portraits—but to address them in an unmistakably twentieth-century way. The traditionalist notation (which could be thought of as a notation only once there was an alternative) was indexed to visual appearances—to the way things looked. It is far less clear to what Cubist notation was indexed, or what, other than achieving a Modernist tone of address, would be achieved in using it. But there is, in Léger's early Cubist works—*La Noce* (The Wedding) of 1911, or the slightly later *Les Fumeurs* (The Smokers)—almost always enough identifiable reality glimpsed through the refractions of its planes, its simplifications and dissolutions of forms, to

reassure the viewer that the ordered world of what Matisse once referred to as "country aunts" was still intact. Thus we see the roofs of villages, rows of simplified trees, the hands and faces of the wedding guests, distributed arbitrarily among other forms to which it was not necessary to assign a referential function. A highly inflected grammar gives writers great freedom in juxtaposing words, knowing in advance that readers will achieve a correct understanding. So, guided by the title, one finds a fragment here, a fragment there, which belong to the subject with which the artist has taken notational liberties. I once saw some Cubist costumes, designed by Sonia Delaunay-Terk, and so I can imagine a Cubist wedding in which the bride wore a frock of squares, with the matron of honor done up in triangles. But Léger's wedding was not an incursion of Cubism into life. His wedding was the familiar country ritual, but depicted discontinuously, with fragments of itself arranged this way or that over the surface of the work. It was as if notation and reality were entirely external to each other—as if the notation were ultramodern though the reality were the timelessly traditional life of *La Vieille France*.

It is difficult to believe that Cubist notation, as increasingly employed by Léger in the years between his *La Couseuse* (Woman Sewing) of 1909–10, with her slablike limbs and awkwardly hewn features, and his *Femme cousant* (Woman Sewing) of 1914, in which the seamstress is resolved into an abstract notation of half-cylinders, conic sections, and cubes, has anything to do with changed feelings toward the putative subject. In these years Léger had evolved a handsome notation of loosely striped drumlike forms, which, when he furnishes a title (like Woman Sewing), allows us to pick out cadences of planes and angles, arrangements of truncated cones and open cylinders. But his new notation has as little to do with the subject, when one can be identified, as Cubist notation ever did. Vauxcelles, pressing his luck, decided to call Léger a *tubiste* in 1911, more, one supposes, because of the pun on *Cubiste* than because Léger's forms were especially tubular. No doubt it was an honor to be disparaged by the critic who conferred fame on the Fauves and the Cubists by giving them these names—but tubes must have seemed too far from a world of pure geometry to attract theoretical speculation, and the term leaves obscure why anyone would want to resolve forms

into tubes. Whatever *Femme cousant* were called, anyone would be able to pick out a pair of hands. The cylinder then must be an arm, the broken circle the head, the red triangle a nose, the curve an ear. There is a lot happening that communicates activity, as with the whiz-lines of the cartoonist (or more pretentiously, the force-lines of Futurism). But does this notation imply that the seamstress was sewing with a particular dynamic energy? At what point if any do reality and notation meet?

The titles remain indispensable. In *La Sortie des Ballets Russes* (1914), one cannot repress an "I get it!" when one recognizes that ballerinas, in blue and in red costumes, their conical torsos disappearing into their hemispheric skirts, are swarming up an exit stairwell in bobbing tutus, like spindled shapes spilling off an assembly line. Léger made a film, *Ballet mécanique* (1924), and the term "mechanical" seems fitter than "cubist" to represent his dancers, whatever may justify thinking of dancing as any more a mechanical activity than sewing or smoking. In any case, once we see how to read the dancers in the assemblages of cones—where the waists are, the shoulders, the faces—we can edge our way into the more abstract arrays in other paintings of the period without entirely appreciating why it is important that we be able to do this. These paintings, nevertheless, are probably the best Léger was to do. His *Contraste de formes* of 1913 is almost a precise contemporary of Duchamp's notorious *Nude Descending a Staircase*, but it is more cheerful and less threatening. It feels like a drum bumping stair by stair to the bottom of the stairwell, and then rolling out the door. There is a sketchiness to the paint, a lightness to the drawing, and a spirit of play in the rolls and rhythms, that convey a kind of gaiety not commonly associated with Cubism's claims of a higher knowledge. Admittedly, the interest in these visual drumrolls diminishes when the title of a painting refers us to a woman sewing. It is as though notation and subject matter, save for rare moments, go their separate ways. But that leaves open the question of what the notation was meant to do beyond expressing an ingratiating kind of syncopation. It perhaps helps that among the drums and cones there are some forms suspiciously like champagne corks, as in the lower left of *Contraste de formes*.

Sometime after World War I, Léger put aside the rich new notational vocabulary of the works of 1914 and evoked, in response to his own *rappel à*

l'ordre ("call to order"), the distinctively stylized version of traditional notation he came to be associated with. His heavily outlined forms have a poster-like clarity and legibility, and an affecting innocence. There was, in the 1920s in France, a certain conservative cultural agenda, deeply felt by avant-garde artists, who were urged to forgo their formal experiments in favor of overcoming the trauma of the war. So the caesura one feels in Léger's work between 1914 and the 1920s is less an internal evolution than an attempt to comply with an external injunction.

Such *rappels à l'ordre* are not uncommon in the history of art. Millard Meiss, in his classical text *Painting in Florence and Siena after the Black Death*, describes how artists retreated from the rational pictorial strategies derived from Giotto to a hieratic mode of painting that belonged to a much earlier era. Many who heeded the *rappel à l'ordre* of the 1920s composed pictorial celebrations of a rural and traditionalist France, brilliantly discussed by Romy Golan in her *Modernity and Nostalgia*. That vision of a poky, charming *France de terroirs* still forms part of French patriotic rhetoric, which, because it is also believed in, makes France so marvelous a country to visit. But Léger's vision was less Gallic and retrospective. He created, rather, a world charming in its spotless modernity. It was a landscape of mechanical order, in which objects looked like Art Deco representations of themselves. It was a world in which, for example, the ocean liner *Normandie* would entirely resemble its airbrushed posters. Léger's world is one in which everything is sleek and polished the way machines have to be to work, as frictionlessly as possible.

In a way Léger created a world in which his own paintings would fit perfectly, and would be taken, by the men and women of that world, to be precise representations of the way things looked, themselves included. To see the paintings in this way was in effect already to be part of the reality they displayed. So Léger created a France, at once machine-age and eternal, in which boneless men and women went imperturbably about the basic tasks of life, as in a kind of ballet. Even his cityscapes, with their industrial structures, their bright walls, gay posters, and urban billboards, have the ingratiating innocence of illustrations for children's books. They belong to the same genre of imaginary places as Toontown in *Who Framed Roger Rabbit?* The pictures make you feel good just to look at them. Collectively, they compose the landscape of life as good to live.

Consider *Three Women* (*Le Grand Déjeuner*), of 1921. The women are lolling about like machine-age odalisques, with bland features and modernesque pneumatic bodies, basketball-sized breasts without nipples, and cascades of black hair undulating to their shoulders. The room could be the stateroom of an up-to-the-minute luxury liner, with striped carpets and sofas with cylindrical arms. The women are arranged as if posing for a photograph, displaying the attributes of their leisure—books, dishes of food—and their sense of comfort in what they are. It is an image of total dedication to *luxe, calme, et volupté*.

Even when doing physical labor, as in the marvelous *Les Constructeurs* of 1951, where workmen are shown among the riveted beams and pillars of a skyscraper under construction, with ropes and ladders and heavy cranes, the figures strike poses as if they form part of a chorus. A quartet of burly men hold an I-beam as if dancers about to break into song. The sky is the blue that blue skies should be, and the clouds are like a passing show of contemporary sculptures. One can virtually hear the scratchy soundtrack of one of René Clair's films—*A Nous la liberté*, for example—celebrating the overcoming of the line between work and play, or alienation and fiction.

We must be grateful to Carolyn Lanchner, who curated this show, for enabling us to readdress an artist who has for too long a time been a Modernist fixture, whose paintings we register as Légers without responding to them in any further way. One has to work a bit to overcome the kind of glaze that notions like Cubism interpose between artworks and ourselves. Léger was trying to make us feel good—and of which artists today is anything like this true? Indeed, that was by and large the effort the artists of Paris made in the period between the wars; think of Dufy, Chagall, Calder, even Picasso, and (with qualifications) Matisse. Léger was playing the role of the clown, sacrificing his dignity in order to enhance the well-being of others. There is something wonderful in an artist whose concluding work is *La Grande Parade*, of 1954. It is like a ship of fools—or the hayrick in Bosch's great painting—filled with clowns, acrobats, dancers, bareback riders, ringmasters, waving as they pass, enjoining us to see the show and join the parade. It belongs with those forms of comedy with which great artists conclude a career—*Falstaff* in the case of Verdi, *The Tempest* in the case of Shakespeare.

Léger knew what there was to know about terror and destruction: He spent four years in the front lines as a sapper. Like many in his generation he saw art as a way of healing and a means to happiness and a source of pleasure. Lightness has its own depth.

—April 20, 1998

YASMINA REZA'S *ART*

▪ ▪ ▪

L'ART CONTEMPORAIN HAS BECOME AN INCENDIARY EXPRESSION IN French discourse today, arousing anger and partisanship of a kind largely unknown in the United States, where "contemporary art" merely denotes the art being made these days. In April 1997, what had been a series of heated exchanges in various newspapers and journals spilled over into a public disputation at Ecole des Beaux-Arts in Paris, where advocates of various positions sought to defend them before an exceedingly unruly crowd of about a thousand people, who drowned them out with shouts of "Nazi!" "Fascist!" and the like. It is not that contemporary art in France is especially more audacious or challenging than it is here. Nor are the French necessarily more passionate than Americans on matters of aesthetics. The difference, rather, is a bread-and-butter issue in France, where anything disparaging said about *l'art contemporain* might be heeded by politicians seeking ways of slashing budgets and wondering how France's heavy financial commitment to *l'art contemporain* can be defended in the face of high unemployment and a burdensome tax structure. *L'art contemporain* is subsidized in France to a degree undreamt of in America. The FNAC (Fondation Nationale d'Art Contemporain) is charged with a triple mandate: identifying new talent, enriching the national patrimony by purchasing meritorious work for public collections, and bringing aesthetic enhancement to public spaces. Very little of *l'art contemporain* is received with gratitude by its intended beneficiaries, though the assumption would be that experts on matters of art would be able

to explain its virtues. But when the experts themselves turn against it, joining, so to speak, the hostile or indifferent public, politicians see a way of cutting costs without losing electoral support. And contemporary artists, facing the loss of subsidy, find themselves defending *l'art contemporain* against the public, the politicians, and such renegade experts as Jean Clair, the director of the Picasso Museum, who expresses an exceedingly sour view of the direction art has taken.

Clair's intelligent and ironic arguments, were they published in an Op-Ed piece here, would at best generate a few carefully balanced letters to the editor. They would hardly detonate a near riot. In the United States, where government support for the arts is marginal to the point of nonexistence, nobody much cares what contemporary artists do unless it appears to violate some alleged standard of decency. It would be brash but doubtless true to say that none of our representatives ever read into the Congressional Record an indictment of monochrome painting, asking whether our taxes should go for *this*. Since the Armory Show of 1913, Americans have formed a stereotype of nutty artists making nutty but harmless art. In what country other than France, on the other hand, could its best-known contemporary artist (Daniel Buren) consider painting stripes an act of political subversion? In any case, the question of what is art, instead of something mooted in the dispassionate pages of philosophical journals, has taken on the stridency of street politics in France, where *l'art contemporain* is condemned for not being art—for being instead so much *merde*.

The widely appreciated play *ART* (just awarded a Tony as best of the season), by the Parisian playwright Yasmina Reza, is in part an allegory of the politics of aesthetics in France today. The action takes place in three apartments entirely alike except for three paintings, which express the philosophies of art of the play's three characters. The characters are *copains*—a word not entirely translatable into English since we do not quite have the relevant form of life: "Pal" is too casual and "friend" too close to mere acquaintanceship to convey not only the warmth and intimacy *copains* enjoy but the price one has to pay for these undeniable advantages. One can have friends in high places and pals from across the tracks, but *copains* cannot be separated by great social distances. Perhaps for that reason, *copains* tend to

hold one another in behavioral orbit, in the respect that if one member of the group begins to give himself what the others perceive as airs, the relationship is put at risk, and must be defended. If a *copain* buys a new suit, the others will mark the purchase with a certain jocular equanimity. But if all at once he goes off on a tangent and buys a silk suit by Armani, the response will be: Who the hell does he think he is? Certain behavior is too wildly off the scale not to be regarded as a threat.

This is the case in *ART* when Serge, a fairly successful professional, purchases a painting for two hundred thousand francs (about forty thousand dollars) by an artist named Antrios, two of whose paintings—neither of which, Serge claims, are as good as his—are in the collection of the Centre Pompidou. Yvan and Marc—the other two characters—live with radically undistinguished paintings. Yvan's was painted by his father. Marc's is the kind only someone with the most conventional views of pictorial art would choose as decoration. But the news that a *copain* has bought an Antrios transcends the usual indulgent chafing *copains* let themselves in for. "Suddenly, in some grotesque way," Marc tells Yvan, "Serge fancies himself as a collector. . . . From now on, our friend Serge is one of the great connoisseurs." Hence, Serge acts as if he is no longer "one of us." The play is a series of confrontations in which, finally, a way is found to assimilate the threatening Antrios to the conception of art that Marc understands. Thus the allegory of *l'art contemporain* is played out against the *copain* relationship as an allegory of French society.

It is remarkable that a play so steeped in French sociology should export as easily as *ART*, first to England, where the play was a great hit, and now to New York, where it is likely to be in place for a long time. Part of the reason for its popularity is the comedy of its conflicts, and the aesthetic bafflement generated by Serge's acquisition—an all-white painting, spontaneously characterized by Marc, and at a certain moment by the conciliatory Yvan, as "a piece of shit." One could (just) forgive a pal who spent forty thousand dollars on an Old Master. An Old Master would recognizably belong to the same overall genre of pictorial representation as Yvan's and Marc's paintings. Marc adopts the indignant voice of a letter writer to the provincial newspa-

per when FNAC has imposed an all-white painting on the local museum. The comedy of Marc's ultimate conversion lies in the fact that the clever playwright finds a way of getting him to view the painting *as a picture*—as, so to speak, an imitation of an all-white reality.

The ancient theory that art is imitation can accommodate a monochrome painting providing it mimics a monochrome reality, which means that the very idea of the monochrome picture gives rise to various jokes. (Early in the action, Marc asks Serge, "Where's your sense of humor? Why aren't you laughing?")

In 1897, Alphonse Allais published a portfolio of seven monochromatic images under the title *Album primo-avrilesque* (April Foolish Album). Each of the differently colored images is displayed in an engraved ornamental frame, without which they would look more or less the way color chips do in the sample charts that paint stores give out. Allais's humor consists in finding a title that describes a monochrome reality of which the chips can be understood as representative. Thus the all-white painting is *First Communion of Chlorotic Young Girls in Snowy Weather*, a reading quite close, as it turns out, to the one Marc arrives at of Serge's painting. The all-red painting is *Harvesting Tomatoes by Apoplectic Cardinals on the Edge of the Red Sea*. The all-blue painting is *Astonishment of Young Recruits Upon First Perceiving Thy Azure Expanse, O Mediterranean!* And so on. Allais's album implies a parlor game in which participants imagine chromatically indiscernible images that imitate, hence are "of," different realities. *Albino Mountain Troops Crossing the Rhone Glacier* would look just like the painting of the snowed-upon girls in communion frocks. But it is difficult to imagine that Allais could have had a real art-world target in mind. Monochromy had been available for literary exploitation since at least 1760, when Laurence Sterne displayed a black square as an emblem of death in Chapter 12 of *Tristram Shandy*. But it could not represent a serious option for the visual arts at that time. In a 1912 parody of the austere philosophical journal *Mind* a blank page was titled "The Absolute," doubtless in reference to the philosophy of F. H. Bradley. But even at this late date, art history had not quite evolved to a point where monochrome painting could actually be made without it being a joke.

My favorite monochrome joke comes from Kierkegaard's *Either/Or*, published in 1848, when monochrome painting could not have been nonhumorously considered as possible. Kierkegaard invented an aphorist, who writes:

> The result of my life is simply nothing, a mood, a single color. My
> result is like the painting of the artist who was to paint a picture of the
> Israelites crossing the Red Sea. To this end, he painted the whole wall
> red, explaining that the Israelites had already crossed over, and that the
> Egyptians were drowned.

This suggested to me the possibility of two paintings, entirely alike, one of which was a psychological portrait of a monochrome mind and the other a seascape in the same genre as Allais's azure Mediterranean. I went on to imagine an exhibition consisting of about eight all-red canvases, each a picture of a different reality but looking entirely the same. It was essential to include an all-red canvas that was simply a canvas painted red, with no more claim to be a painting than a painted wall has, and ipso facto no claim to picture anything. The difference between this painted square and the remaining square paintings was a different kind of difference from whatever distinguished one from another of them. And I wanted to understand this difference, since the art world had begun to fill up with works of art that could not be told apart from what I termed "mere real things." In the 1970s, when I began to think about these matters, it all at once seemed possible that anything could be a work of art. My problem was (and is): What makes this possible when there need be no *visual* difference between what is art and what is not?

Let us now return to *ART*, and the all-white painting, which, so far as I can make out, has no title (if it had one, it would probably be *Untitled*, perhaps with a number indicating the order in which it was painted relative to Antrios's others). It turns out that Marc has taken in a great deal of visual information when he stood scoffing in front of the work. It is not quite an undifferentiated white expanse. He describes it to Yvan:

MARC: Imagine a canvas about five foot by four . . . with a white
background . . . completely white in fact . . . with fine white diagonal
stripes . . . you know . . . and maybe another horizontal white line,
towards the bottom. . . .
YVAN: How can you see them?
MARC: What?
YVAN: These white lines. If the background's white, how can you see
the lines?
MARC: You just do. Because I suppose the lines are slightly gray, or vice
versa, or anyway there are degrees of white! There's more than one
kind of white!

Those just-discernible white-on-white lines serve, in the course of the play,
as a means by which Marc can pictorialize the painting, and so accept it as
not all that different from his own painting. He finds a way of preserving the
theory that art is imitation.

At a climactic moment, Marc and Serge come to blows, unintentionally hurt-
ing Yvan, who consistently illustrates the cynical thesis about no good deed
going unpunished—he tried to come between them. At this point the adver-
saries are in a bind. Serge can go with his painting, leaving his *copains* behind.
Marc can remain Serge's *copain* only by accepting the painting as legitimate.
As if to show that friendship is finally more important to him than art, Serge
hands Marc a blue felt-tip pen (borrowed from Yvan, who has just gone into
the stationery business) and Marc, after a dramatic pause, all at once defaces
the Antrios. He draws a line deliberately from the upper left to the bottom
right of the canvas—and then, facing the work, he scribbles something we
cannot see until he moves. What he has drawn is a rather crude skier, as it
were gliding down the hill. The audience reaction is fascinating. When Marc
draws his first iconoclastic line, the audience draws in its breath the way it
would were someone's throat slashed on stage. I found this exceedingly reas-
suring. It showed that a New York audience still attaches a certain value to
art that it is not entirely certain is not a joke. By contrast, the recent slashing

of a second Barnett Newman in the Netherlands has not, like the first, evoked expressions of shock in the Dutch art world. The attitude, even—or perhaps especially—among Dutch intellectuals, has been that the Newman, which is close to a monochrome blue painting, "had it coming": that a painting like that is merely elitist. That is what gets said about *l'art contemporain* in Paris. That's the kind of thing Patrick Buchanan tried to say in the 1992 presidential primaries, when he attacked the NEA. It is clearly not the view of those who have been attending *ART*. I felt that if the NEA were put to a referendum, its enemies would be routed.

Clearly, the diagonal had been obsessing Marc from the beginning, and he saw a way to pictorialize the painting by tracing it in blue. It gave him a way of claiming the painting for his own. The skier was an afterthought—a way of nailing his interpretation down. In a rather poetic soliloquy, which ends the play, Marc says:

Under the white clouds, the snow is falling.
You can't see the white clouds, or the snow.
Or the cold, or the white glow of the earth.
A solitary man glides downhill on his skis.
The snow is falling.
It falls until the man disappears back into the landscape.
My friend Serge, who's one of my oldest friends, has bought a painting.
It's a canvas about five foot by four.
It represents a man who moves across a space and disappears.

It is, according to Marc, like the Jews and the Egyptians in the painting of the Red Sea. The former have left the space and gotten to the other side, the latter have entered the space and drowned. Tranquillity reigns, as before the Exodus. Pictorialization decontemporizes *l'art contemporain*. We all know how to deal with pictures, once we know what they resemble.

Critics have questioned one of the premises of the play. The idea of the monochrome painting belongs to the classical phase of advanced art in this century. It made its appearance in the Suprematist movement of Malevich,

around 1915. The implication is that Serge's painting is out of date, and that Marc is out of date and out of touch as well. The cover of the British translation of *ART*'s script shows a canvas with three parallel slashes. It looks like a work by Lucio Fontana, who attacked the surfaces of his canvas in a physical way, perhaps in order to draw attention to the fact that they were physical rather than illusional: Those were real slashes rather than *trompe l'oeil* depictions of real slashes. Fontana thus rendered any impulse to pictorialize his canvas unfulfillable. Without the possibility of pictorialization, *ART* could not end. I am not certain one could touch a Fontana today for a mere forty thousand dollars. Marc would have found Serge's slashed canvas, had he found one, "a piece of shit." And the return to friendship would have been out of the question.

Meanwhile, monochrome painting has never been more alive than it is today. Robert Ryman, one of our major painters, scarcely paints anything else. I just got a notice of a show of reddish squares by the artist Marcia Hafif, which I look forward to seeing, having followed her work for years. How are we to appreciate their works, and others like them? There is no single right answer; we have to take them one at a time. The only wrong answer, at least since 1915, is pictorialization. I don't know if Yasmina Reza knows this, but that is of no importance. Her contribution, aside from having composed an amusing play, is to have caused her audience to draw its breath when a work of art is attacked. I wonder what the reaction was in France?

—*June 29, 1998*

ABSTRACTING SOUTINE

■ ■ ■

*I*N HIS CATALOGUE ESSAY FOR THE 1950 EXHIBITION OF CHAIM
Soutine's paintings at the Museum of Modern Art, Monroe Wheeler asked
whether the artist "might be called an abstract expressionist?" The question
was in part rhetorical: There had to have been enough apparent similarity—
what art historians like to call "affinity"—between Soutine and the Abstract
Expressionists to have made it seem natural to ask if he was a predecessor.
No other painter, contemporary with or earlier than Soutine, could have
provoked Wheeler's question: It would have been puzzling to ask whether
Picasso was an Abstract Expressionist, or Matisse, or Modigliani, or Pascin,
or Derain. The intensity of Soutine's brushwork combined with fierce dis-
tortions in his images made it irresistible, in 1950 terms, to see both as the
expression of proportionately intense feelings. So apart from the inconve-
nience that he was in no sense abstract, there were enough surface affinities
for the Abstract Expressionists—the term came into common use in 1950—
to embrace him as one of their own.

That by itself underscores Soutine's astonishing originality. Until the
Abstract Expressionists, no one except Soutine really handled paint the way
they did. Soutine was not among the sources of their extraordinary style, but
they saluted him as someone who had arrived at attitudes toward the physi-
cality and the expressivity of paint that ran parallel to theirs. That might
seem to have given the New York painters ways of understanding Soutine
that were unavailable to his contemporaries. Since Soutine was greatly ad-

mired in his lifetime—he died in 1943—this raises questions of what his contemporaries admired him for.

To today's critics, the question of whether Soutine is interestingly to be thought of as a precocious Abstract Expressionist is of no particular moment. The question singles out a subset of properties as central—the impulsive gesturality of the painting act—leaving the larger relationship of the paintings to Soutine's life unacknowledged. For them, the question itself is a 1950s question—an effort to explain the artist formalistically, and is of interest mainly because he seemed a harbinger of painting that owed nothing to his precedence. Moreover, the atmosphere of critical practice today is dense with attitudes that would have had no pertinence in 1950, when questions of gender or ethnic identity would have seemed entirely beside the point of art. Soutine was a Lithuanian Jew with a strictly Orthodox upbringing, and under multiculturalist auspices, it seems natural to appeal to his *shtetl* youth, with the entirely non-Jewish ambition to be a painter. That he got beaten for wanting to paint portraits, that there is no obvious Jewish content in his work, and that he later converted to Roman Catholicism may be neither here nor there. For it is always possible to argue that, however suppressed or denied, Soutine's Jewishness might account for what made him so unique: You cannot take the *shtetl* out of the boy, though the boy leaves the *shtetl* to create graven images in Vilna and Paris.

In 1950, ethnic explanations would have been vehemently rejected by those for whom "Jewish art"—like "Jewish science"—conveyed the chill cruelty of Nazi slogans. Half the first generation of Abstract Expressionists were Jewish, and one of them—Mark Rothko—came from an Eastern European background not dissimilar to Soutine's. But their art would not have been presented as Jewish when shown, in the 1960s, at the Jewish Museum in New York, which was *the* showcase for the most advanced art of its time. It is mistaken to say that the artists of 1950 were really only formalists. They thought of their art in terms of what Hegel spoke of as art's "highest vocation"—as giving sensuous embodiment to the highest realities. Art, and philosophy and religion, were for Hegel "moments" of Absolute Spirit—a concept the 1950s painters would have endorsed. So they would have supposed Soutine, who resembled them, to be aspiring to the same heights. But

in an art world in which cultural differences were taken seriously, Jewishness, whether acknowledged or not by Jewish painters, suggests patterns of interpretation that make the distinction between anthropological museums and museums of fine art increasingly weak. It is one thing to say that artists should not be excluded from the latter because they are women or blacks— or Jews—and quite another to say they have a *right* to be there because they are women or blacks or Jews. But everyone has a rightful place in museums of anthropology.

The critical question an ethnic explanation of Soutine's work raises is, What is in the paintings that Jewishness explains? By what criterion can we redescribe its features as in any way Jewish? The claim that he was an Abstract Expressionist in advance of that movement rests on palpable features of his paintings. One can hardly credit Jewishness as accounting for his style, since it would have no explanatory relevance to the Abstract Expressionists who were not Jewish. Moreover, since there is no obvious content in Soutine's work that can be described as Jewish, those who wish to interpret him ethnically must treat his content as in some way coded—as making subterranean reference to his experience as a Jew. This generates a methodology rather similar to the interpretation of dreams, moving from manifest to latent dream content, the latter housed in the artist's perhaps repressed Jewish unconscious. Thus the fact that Soutine paints a chicken is referred to the ritual practice of sacrificing chickens in the *shtetl*. But what, then, do his dead rabbits refer to, since rabbit meat was forbidden in the *shtetl*? The apparatus of interpretation tends to make Soutine as painter a crypto-Jew, unable to conceal his identity from those equipped with the right theory. But how is that theory to be confirmed, since no one else had painted like him before the Abstract Expressionists, least of all Soutine's Jewish contemporaries— Modigliani, Pascin, Chagall, and others? The danger is that we shall find ourselves explaining Soutine through the fact that he was Soutine.

We can do better than that. Soutine identified himself with a history not his own, but to which he felt he belonged by right of his gifts. His chosen history was that of the tradition of Great Masters—Rembrandt, Chardin, and Courbet, among others. The vehemence of his denial that he may have been influenced by van Gogh, between whose work and his there is a distant affin-

ity, is probably evidence that he did not regard van Gogh as a Master. Would he have thought this true of the Abstract Expressionists had he survived the war and come to know them? Could he have thought himself one with them because of the way they handled paint? I think not. He would have found missing from their work what was central to the Old Masters— pictorial content. Soutine left very little, other than his paintings, from which we might answer the questions they raise. His correspondence is sparse and chiefly practical. There is no "artist's statement" we know of. But we can eke out a few hypotheses on the basis of his artistic situation. He explicitly scorned the Parisian avant-garde. He had no use for Cubist experiment. Abstraction was an artistic option in 1913, when he came to Paris at the age of twenty. But it could not have been an option for him for the same reason he could not accept van Gogh as a peer: The Masters were not abstractionists. His school was not the School of Paris. It was the walls of the Louvre, and enough of his paintings appropriate what he saw there for us to imagine that what he sought was what the Old Masters had found.

My sense is that the only Abstract Expressionist with whom Soutine could possibly have identified was Willem de Kooning, who was to betray the abstractionist revolution by introducing the figure in his tremendous *Woman* paintings, shown in 1953. But Soutine would have found de Kooning's explanations of why he painted women repugnant. In an interview with David Sylvester, de Kooning said, "In a way, if you pick up some paint with your brush and make somebody's nose with it, this is rather ridiculous, when you think of it, theoretically or philosophically. It's really absurd to make an image, like a human image, with paint . . . since we have this problem of doing or not doing it. But then all of a sudden it was even more absurd not to do it." I think we can confidently say that Soutine did not paint images because he thought it was silly not to. It was imperative to paint them because the Masters did. He did not have the problem of "doing or not doing." So if abstraction is central to Abstract Expressionism, we can answer Wheeler's question negatively, however thick and agitated the surfaces. In Soutine the surfaces must somehow relate to subject matter.

So internal was the relationship between Soutine and the Masters that we must wonder whether he painted the things he painted—butchered animals, hung poultry, gutted fish, twisted trees, solitary individuals from the

serving classes—because of some feeling he had toward them or because he had a feeling for the painters whose motifs these had also been. Beyond question, he painted a carcass of beef because Rembrandt had painted one. He painted a stingray, with its almost foolishly human face, because Chardin had painted one. The French term for still life is *nature morte*—"dead nature"—which scarcely fits most still lifes at all: A pitcher and a glass, for example, are neither natural nor dead. But whole menageries of dead animals can be found on the walls of the Louvre. It is true that an antecedent interest in the metaphoric possibility of dead or flayed animals may have explained Soutine's choice among the masterpieces he appropriated. He did not choose for emulation any of the female nudes in which the Louvre abounds: So far as anyone seems to know, he painted only one diffident female nude in the thirty years of his artistic life. Perhaps a strain of Jewish *pudeur* explains this forbearance, but that would at best account only for something absent from his work, not present in the canvases. It is my sense that the Masters interposed themselves between Soutine and reality to so great a degree that it is difficult to say what his attitude toward reality itself was. The art of the usable past was like a pair of spectacles he never took off. Hence it is difficult to infer anything about him from the subjects he chose—or vice versa.

What de Kooning might have seen in Soutine was how it was possible to paint like a New York artist—with gestural slabs and strokes of thick paint—*and* do the figure: to be abstract and referential at once. So for what it is worth, it is thinkable that the 1950 show enters into the explanation of de Kooning's *Women*. But de Kooning's own description of what he found in Soutine rests only partly on such reasons:

> I've always been crazy about Soutine—all of his paintings. Maybe it's the lushness of the paint. He builds up a surface that looks like a material, like a substance. There's a kind of transfiguration, a certain fleshiness, in his work. . . . The Soutines had a glow that came from within the paintings—it was another kind of light.

Transfiguration is the transformation of flesh into light, as with Christ's transfiguration as described in Matthew 17: "His face did shine as the

sun, and his raiment was white as the light." I don't know whether trans-figuration in this sense was something sought, or merely (merely!) some-thing that happened in Soutine's case. But I would say that light is, as de Kooning astutely discerned, the principal feature of his work. It is what (unconsciously?) suggests to his admirers that he is in some deep way a religious artist. This may lead them down various blind alleys—seeing his trussed animals as metaphors for martyrs, for example. But Soutine's light is effulgent whatever the subject, and whatever the actual light in the depicted scene. It is a magical artifact of the paint as he handled it, and it explains his greatness as a painter. That light would be like the inimit-able tone of a great pianist. Others could play the same pieces—but the tone would be beyond their reach. It is the light—not the light they show but the light they possess—that draws us to the Old Masters, the way we are drawn by "all things bright and beautiful." The style was invented to create light.

There are two modes of abstract painting. The first is painting without any recognizable subject, as in the case of Abstract Expressionism circa 1950. The second is to paint recognizable subjects abstractly, that is to say, without the isomorphism between the image and the subject's visual form as tradi-tionally sought. If we subtract from de Kooning's *Women* the fact that they are women, a lot will be left over that we have no better term to refer to than "expression." I think the fit between Soutine's paintings and their subjects is a lot closer than that—but there are sufficient discrepancies that we can say Soutine also painted abstractly. A difference lies in the fact that de Kooning painted an idea of women, whereas Soutine confronted reality, like a plein-air painter peering around his easel at the landscape before him. He con-fronted in this respect an actual carcass of beef—an episode that gave rise to a cluster of anecdotes in Soutine's mythology: how he took so long to paint the meat that it stank; how he successfully lectured the sanitation inspectors on the supremacy of art over health; how they taught him to use formalde-hyde; how he sloshed blood from a bucket to bring back the reds; how he stationed an assistant next to the beef to sweep away the flies, etc., etc. This is not explained through some symbolic concern with beef itself but through Rembrandt. Soutine did not, as a famous Japanese poet said, "follow in the footsteps of the masters. He sought what they sought." And he felt he

needed reality for purposes of transfiguration. He never, so far as I can tell, painted the mere idea of anything.

It was certainly because of his being Jewish that Soutine was obliged to display the yellow star in the last year of his life in France, under the Occupation. But I have no idea how internally meaningful, on any stratum of his spirit, his Jewishness was. He is said to have gone to Amsterdam to see Rembrandt's *The Jewish Bride*. But he never sought to appropriate *The Jewish Bride*—perhaps because he almost never painted two figures together in any one canvas. It is true that, looking at his paintings, with their twisted forms and the unmistakable presence in some of them of death, they might connote suffering—and suffering has been deeply associated with Jewish history. An interviewer once asked, on the evident feeling of his works, whether Soutine had not had great unhappiness in his life. Soutine responded with astonishment. "What makes you think that? I have always been a happy man." Either this is disingenuous to a degree hardly consistent with Soutine's personality as it has been described to us, or it means that he really did not see the art as having anything to do with suffering or unhappiness. Whatever the paintings show, everything one reads about Soutine suggests that he really was a happy man.

True, Soutine had a rough time making ends meet in Paris before he became famous, but that was something an artist would have expected, then as now. He situated himself through his paintings in the tradition in which he believed. He became well-off. He had patrons. He had dealers whom he terrorized by slashing or burning his canvases when he thought them weak. He had friends and adoring lovers. It is undeniable that there was suffering in the last phase of his life, partly from medical but mainly from political causes, and those of course do connect with his Jewishness. But this was the end of his life, and the entire bulk of his work, on the basis of which one would mistakenly have identified him as tragic, was behind him.

In 1986 the poet John Ashbery, in an essay on the painter Jane Freilicher, wrote of Soutine that he "seems to have gone back to being a secondary modern master after the heady revelation of his Museum of Modern Art show in 1950." But he adds, prophetically, that his "time will undoubtedly come again." Ashbery was right. The magnificent show at the Jewish

Museum—"An Expressionist in Paris"—fulfills his forecast. Reference neither to Abstract Expressionism nor to *Yiddishkeit* will greatly color your experience of Soutine's astonishing works, so many of the best of which are on view there. Entering the galleries one is bowled over by a painterly greatness that has nothing to do with what critics have used to explain it. The power of the work is such that it erases everything we have been told about the artist, leaving us to begin all over again. Art sometimes addresses us so directly and completely that it leaves us with nothing beyond that to say.

—August 24, 1998

"ART INTO LIFE"
RODCHENKO

■ ■ ■

I HAVE SPENT A FAIR AMOUNT OF PHILOSOPHICAL TIME THE PAST many years pondering the difference between Andy Warhol's *Brillo Box* and the actual cardboard boxes in which Brillo was shipped from factories to warehouses to the stockrooms of supermarkets, to be discarded when unpacked, or recycled, or given away to those in need of a carton to ship books or house kittens or store documents. The ordinary shipping carton exemplifies, if anything does, a slogan of the Russian artist Aleksandr Rodchenko: "Art Into Life!" Or it would do so if it were art in the first place, the way Warhol's facsimile of it is. The question that obsessed me was how this distinction could be made, since the *Brillo Box* that was art and the Brillo box that was merely a corrugated paper carton looked exactly alike. Or at least, the differences between them were not of a kind one could appeal to in explaining why one was art and the other not. Warhol's boxes, in any case, sell today for about forty-five thousand dollars—and though they could be used for the same purposes as the manufacturer's paper cartons, it would be a very privileged litter that tumbled and mewed in them. It is extremely unlikely that a *Brillo Box* would be permitted to divest itself of whatever aura it may possess and be put into the service of life. Sooner or later, each *Brillo Box* will find its way into one museum or another. This is not a destiny that Brillo cartons are likely to have, unless for a museum of commercial design.

In 1961 the Pop sculptor Claes Oldenburg opened a storefront on East 2nd Street in New York—called The Store—and stocked it with objects that (roughly) replicated items of common use: frocks, gym shoes, automobile

tires, underpants. He handed visitors a spirited manifesto that defended turning the most commonplace objects into art, and placing them for sale in a space that far more resembled a mom-and-pop store than one of the standard art galleries of the time. And consistently, he sold his art the way a storekeeper sells canned goods—over the counter, with sales slips and the like. It was, in a way, an effort to bring art out of the institutions in which it grew auras and re-situate it in life. "I am for an art," Oldenburg's manifesto asserted, "that does something other than sit on its ass in a museum." He continued: "I am for an art that is put on and taken off, like pants, which develops holes, like socks, which is eaten, like a piece of pie, or abandoned with great contempt, like a piece of shit." The art shown in Oldenburg's Store did not quite satisfy these specifications. No one could slip into the blue or pink underpants of his 1961 *Blue and Pink Panties* or eat *Ice Cream Sandwich* of the same year, both of which were made of muslin soaked in plaster over wire frames and painted with enamel. So what Oldenburg had to mean was that he was for an art that depicted the most ordinary objects of daily consumption—objects that would not commonly have provided the motifs of fine art. His work perhaps celebrated their ordinariness, but it was the ironic destiny of his art to sit on its ass in the museum.

It would be difficult for anyone to mistake *Blue and Pink Panties* for actual lingerie: The paint drips, almost as if the work were driven by the imperatives of Abstract Expressionism—and it shines the way enamel shines, not the way nylon or silk shines. This is not the case with *Brillo Box*, which forces us to recognize that what makes the difference between art and nonart cannot be something that meets the eye.

Warhol was one of New York's most successful commercial artists before it occurred to him that, without changing a thing, he could be a fine artist instead. Or, as the art world patois would have it, a *real* artist. This would not have occurred to Steve Harvey, the actual designer of Brillo's shipping cartons, who took up commercial art when it was no longer possible for a "real" artist—by which Harvey would have meant an Abstract Expressionist—to make a living by means of real art. The thought that must have gone into his design for Brillo was almost certainly closer to real artistic thought than whatever went through Warhol's mind in inventing *Brillo Box* as sculpture—

Warhol merely selected what Harvey had wrought, and turned it into art without changing anything, the way he shifted from one career to another making the same kinds of things.

Still, there is the problem of what makes commercial art different from fine art when the products of either can look as much alike as anyone cares to make them. It seems to me that part of the difference can be identified if we consider the art criticism appropriate to the two kinds of objects. Harvey had the task of celebrating what his boxes were to contain—scouring pads. From this perspective, the shapes on his carton are emblems of sanitation and of patriotism (the wavy shapes of white and red, together with the blue letters, are like a flag)—and they have art-historical references to Hard-Edged Abstraction. The cartons shriek NEW! GIANT! FAST! The words Harvey has chosen belong to the ecstatic hypervocabulary of the used car lot, and his work is a remarkable piece of visual rhetoric. Warhol's by contrast is laconic. It is *of* a piece of rhetoric without *being* one in its own right. The art history of his box takes us back not to Hard-Edged Abstraction but to Duchamp. His box raises deep philosophical questions on which Harvey's text is mute.

Steve Harvey's box is a piece of visual rhetoric, proclaiming joy and even ecstasy that something is able to make the surfaces of the world shine and glisten. But Warhol's box is laconic and detached, though visually of a piece with Harvey's. Without appropriate background assumptions, the unaided eye tells us nothing about why one is fine and the other commercial art.

A lot of the world's great art is rhetorical and celebratory, aiming to move viewers to hold certain prescribed feelings toward what the art shows. The martyrs are shown in torment, to move us to empathize with their sufferings. The Madonna is beautifully if simply dressed, the Son is luminous and handsome. The *Grands Boulevards* shown from a balcony on the *sixième étage* are celebrations of Paris. *The Death of Montcalm* celebrates heroism and victory. So being rhetorical cannot disqualify Harvey's boxes as (fine) art. Perhaps what does is the fact that he uses his rhetorical skills to recommend something unworthy of it. But that may be a prejudiced view, as we might recognize if one of our best painters were to portray a pad of Brillo. I recently visited the Munch Museum in Oslo and was thrilled to find that when he was a child Munch painted the most commonplace of objects—such as his toothbrush.

I am not certain I know the rhetoric of Warhol's *Brillo Box*, unless it is a celebration of commercial art. But I know that if Steve Harvey's box should find its way into the museum, it would be as a collectible rather than a work of fine art, or as a superlative example of graphic design circa 1960. We can imagine an exhibition of Harvey's work consisting of his perhaps derivative Abstract Expressionist canvases, his drawings—and his commercial art. Perhaps the paintings would help us understand how he arrived at his beautiful graphic solutions, perhaps not. But the question of whether we are to look at that work in the same way in which we look at the paintings will not entirely go away. Nor will it when we work our way through the retrospective exhibition of the work of Aleksandr Rodchenko (1891–1956) on view at the Museum of Modern Art. Like Warhol and Harvey, Rodchenko was a commercial as well as a fine artist. Unlike Warhol, he began as fine, but unlike Harvey, his downshift into visual rhetoric was not a *pis aller*—a matter of having to make a living. It was, rather, an act of political sacrifice and a gesture of political commitment. The place of art after the Russian Revolution was in the life for which the Revolution had ostensibly been fought. In the new communist society, there could be no place for fine art. The comedy is that Rodchenko's commercial art now sits on its ass in the museum. The tragedy is that the form of life the art was to enhance was betrayed by its leaders.

"Art Into Life" was formulated in a plenary session of the Institute of Artistic Culture (Inkhuk) on November 24, 1921. Inkhuk, established a year earlier, had been charged with formulating the role art was to play in a true communist society. A majority of the members present condemned easel painting as outmoded and irrelevant to communism's cultural needs: It emblematized the society whose demise the Revolution was believed to entail. Incidentally, there was no call for a Bonfire of the Vanities. Paintings, confiscated by the Revolution, were recognized by the Soviet as a form of currency bourgeois society would honor, and were sold to the West in exchange for industrial equipment. Our own National Gallery is the immense beneficiary of just such an astute negotiation with Stalin by Andrew Mellon.

Rodchenko and Lyubov Popova resigned from Inkhuk to go into industry as applied artists. The shift released immense energies in both. Popova

designed fabrics, and said that whenever she saw a peasant woman wearing one of her patterns she felt a greater joy than easel painting had ever given her. I think she found herself as an artist in the process: The set she designed for Meyerhold's production of *The Magnanimous Cuckold* is in every sense a masterpiece of sculptural architecture. The actors wore "production clothing," which she (and, judging by one of the drawings in this show, Rodchenko) designed—jumpsuits with several pockets and snappy Russian collars. Rodchenko's great work, whatever its genre, was his graphic design and especially his book covers. The abandonment of easel painting by Rodchenko and Popova was an artistic deliverance and a dedication to a new form of social life: "Bliss was it in that dawn to be alive."

Rodchenko painted a farewell to painting in 1921, in the sense that his *Pure Red Color, Pure Yellow Color, and Pure Blue Color* was recognized, in his circle, as the Last Painting. The Last Painting consists of three monochrome panels, in red, in yellow, and in blue—though whether there is some meaning in their order I do not know. My sense is that the idea of this being the Last Painting has to do with the thought that each of the panels has the *shape* of an easel painting, into which any subject can be fitted. And the colors are the basic colors every painting will combine. These being the ultimate colors and the shape being the ultimate shape, painting has been resolved into its ultimate components. We now, analytically, know what painting is. And having broken through to this level of self-consciousness, we are liberated to put art to work in the service of the proletariat. With the whole of painting behind him, Rodchenko left the artistic life of bourgeois culture and, like a butterfly leaving a cocoon, he emerged as—well—an advertising artist. What would our leftist denouncers of advertising as crass say to that?

Advertising was not regarded as in any sense a sellout in the new society. Rodchenko, with inventiveness and damped gaiety, flourished. He designed advertisements for the Red October Cookie Factory, for example, in which a row of cookies disappears into the mouth of a young girl, pretty and smiling, who manages to say: "I eat cookies/from the Krasni Oktiabr' factory/formerly Einem./I don't buy anywhere except at/Mossel'prom [the state grocery store]." The girl's head is set in a hexagonal frame, superimposed on a blue grid. The row of cookies breaks the frame, as if to say, "From the oven's shelf to your mouth." Rodchenko's advertisement for vegetable oil is equally

ingenious. The grid this time is red and vertical, and the bottle is portrayed as having the grid as part of its label. I cannot forbear reproducing the message: "Cooking oil/Attention working masses/Three times cheaper than butter!/More nutritious than other oils! Nowhere else as at Mossel'prom." We forget, I think, that advertising was an expression of Modernism. In *The Ambassadors*, Henry James redeems a wayward young man by giving him a career in advertising: "Advertising scientifically worked presented itself thus as the great new force," he has the young man say. "It really does the thing, you know"—advertising advertising by way of a slogan Rodchenko would have admired.

I draw attention to Rodchenko's exclamation points, to which the corresponding ones on my keyboard do not do justice. Exclamation points belong to verbal moods in two ways: to mark imperatives and to convey excitement. Rodchenko's exclamation points are in red, in the upper right corner of the vegetable oil poster, and they are respectively two and three lines high—higher, that is, than the words they punctuate. They are ancestors of Steve Harvey's exclamation points and MUCH MUCH MORE!!! They are marvels of graphic design. I would venture, even, that Rodchenko made the exclamation point his own.

When the widely controversial exhibition "High & Low" (note the ampersand!) was held at MoMA in 1990–91, the press was issued, in the spirit of frolic, a plastic badge with a large red exclamation point on an ivory background. The dot was a perfect circle. The vertical stroke was sharply cropped across its top (upside down, it looked like an abstract figure, with a round head atop a trapezoidal body). It conveyed the excitement the show was intended to create, and I have kept my exclamation point to this day as a memento of a show I—but scarcely the critical community—admired greatly. It was, of course, appropriated from Rodchenko.

In several advertisements for cigarettes, the exclamation points are nearly as high as the page, and stand, like pillars, on either side of the text ("No story can tell/no pen can describe/Mossel'prom cigarettes./Nowhere else as at Mossel'prom"). But the mother of all exclamation points is placed on the right side of a jacket Rodchenko designed in 1923 for a book on the poet Mayakovsky. It is black on cream (with red letters) and is nearly nine inches high. The catalogue for "High & Low" was a celebration of Rod-

chenko. The exclamation point was in red, and eleven (!) inches high. The ampersand replaced Rodchenko's squared-off O, below which the subtitle of the show was presented through a cross made of words, just the way Mayakovsky's name was in Rodchenko's design.

I think nothing could more graphically present Rodchenko's achievement than juxtaposing the "High & Low" catalogue cover and the book jacket Rodchenko designed. It proclaims that high and low are not artistic antinomies—Rodchenko, in his advertisements, was at once high and low. There was nothing anywhere in the 1920s to match them. They are as brilliant today as they were when freshly painted. They exhibit what it means for art to go into life.

Hegel writes: "Beauty and art does indeed pervade all the business of life like a friendly genius and brightly adorns all our surroundings whether inner or outer, mitigating the seriousness of our circumstances and the complexities of the actual world." He contrasts this with what he speaks of as "art in its highest vocation," which he thought of as no longer possible. I am reasonably sure that our own distinction between fine and commercial art makes a tacit reference to Hegel, but with artists like Rodchenko and Warhol, I think we find that "high" and "low" fuse. Warhol expressed the defining ideals of American life as Rodchenko did the defining ideals of communist life—and this is precisely the office of art in its highest vocation.

And now for the tragedy. The bright promise of the world Inkhuk was to enhance was stifled under Stalinism, and the marvelous designs Popova and Rodchenko created gave way to heroic depictions of Lenin and Stalin and of working-class heroes, in a retrograde academic style known, after 1934, as Socialist Realism. The great purges began in 1936. Miraculously, given his politics, Rodchenko died a natural death. He made some wonderful photographs, showing the streets from a perspective high above the action and symbolizing the distance between the artist and the society he had hoped to enhance. From 1935 on, he rededicated himself to painting.

In a photograph of 1947 we see Rodchenko seated beneath a painting, titled *Clown With Saxophone*, that must have meant a great deal to him, since he shows himself together with it. Given what painting meant to him under Marxist analysis, this was a sad effort to turn back history. His late paintings

are not in the Modern's show, alas, evidently failing to fulfill the aim of the exhibition, "to grasp Rodchenko's best work, in all of its varieties, as a whole." I think "best work" and "as a whole" impose conflicting imperatives, above all in respect to an artist bent on entwining art and life. The life, as a whole, requires these final paintings, even if they are not among the "best work." From a human point of view, they are testimony to the kinds of straws this master grasped as his world disintegrated into terror and his life into neglect.

—September 21, 1998

THE LATE WORKS OF DELACROIX

◾ ◾ ◾

AT THE PRESS OPENING OF THE FASCINATING EXHIBITION OF EUGÈNE Delacroix's late work at the Philadelphia Museum of Art, a colleague and I paused before a luminous painting of a puma next to a tree. Neither of us, not surprisingly, happened to know much about pumas, let alone their habitat, but even so we felt that the puma and that particular tree would not normally share an environment. In fact, there is uncertainty as to whether the magnificent feline is a puma at all—it has also been identified as a lioness or a lynx. Scholars have noted that the animal is too stocky and its coat too long for a lioness, while the lower jaw is too heavy for a puma. The tree, too, has a botanical indeterminacy: It may be an oak, or may not—but in any case it is "reminiscent of the forests of the Ile-de-France," as the catalogue observes. Discounting auxiliary hypotheses to the effect that a lioness (or puma or lynx) had escaped from a zoo or a circus to the Forêt de Fontainebleau, the proposition of the painting is deeply baffling: Why is the great cat, depicted mid-roar, situated beneath a tree that belongs to a landscape not its own?

Formalistically, of course, one can see why Delacroix was taken with the juxtaposition. The energetic brushiness with which the leaves are painted in seems a translation into a different visual language of the brushiness with which the animal's coat is painted: Both are in burnt sienna and gold. The branch and the animal seem in this sense reflections of one another. The leaves screen what appears to be a diffuse light, as of the rising—or setting—sun. But that would leave mysteriously unaccounted for the source of light

by which the animal's bristling ruff and heavy jaw are picked out as by a searchlight. The painting is a luminous whole, which explains why my colleague and I were arrested by it. "The first merit of a picture," Delacroix wrote in his notebook near the end of his life, "is to be a feast for the eye." He then added, "That is not to say that reason is not needed in it." It was the reason that escaped our futile efforts to bring tree and puma together other than through the parallels of brushwork and coloration.

Of course, the disparities could be merely artistic license. Delacroix almost certainly studied the great cat in the Jardin des Plantes in Paris, and it was once conjectured that the tree was an oak near Delacroix's house in Champrosay, famous even in his own time. The same order of disparity is found throughout his work. Roughly at the same time he painted the puma—1854—Delacroix executed the somewhat larger *Arabs Stalking a Lion*. The Arabs, following their prey, have wandered into the Ile-de-France, as has the unsuspecting lion, concentrating on eating. An Arab in red breeches tensely grips his awkward musket, the light falls on the curved sword he has laid on the ground in anticipation of furious conflict between animal and hunter. Still, there would have been no rational space in which Arabs could have hunted lions in the woods south of Paris, any more than for a puma to stand or stalk beneath a feathery northern tree. "Studying the trees by the roadside has helped me to tone up the picture of the *Lion Killers*," Delacroix noted in his journal. It is as if he took what he needed to bring his paintings to life, geographical reason be damned. He was not painting dioramas for the American Museum of Natural History or painstaking reconstructions of habitats for *National Geographic*. So he posed his Arabs beneath a tree he could study without leaving home.

It is difficult to suppose that Delacroix's viewers knew much more about pumas than my colleague and I, and very few among them would have had firsthand knowledge of what the landscapes in which Arabs hunted lions looked like. That makes it problematic if they noticed the contradictions that Delacroix specialists seek to rationalize (the "famous" oak tree was "larger than this tree by the 1850s"). And there is a question of whether the irrationalities, if that is what they are, were even meant to be taken account of. But somehow, I am unable to let them pass, or to be explained away as over-

sight or license. They seem to express something profound about Delacroix's artistic mission, difficult enough for a Modernist temper to get a grip on. The magnificent puma embodies a vision of exotic wildness, the kind of strength, beauty, and savagery with which Blake infused the "fearful symmetry" of his tiger—"burning bright/In the forests of the night" (by contrast with the leopards in Connecticut in the screwball comedy *Bringing Up Baby*). It is as if the Arabs and the fierce animals, which Delacroix loved to show in combat with one another, were a hallucinatory vision set in the familiar landscape, pointing to a life more urgent and primitive, and one more consistent with the dignity of men and animals than the domestic life available to those who walked the woods or entered art galleries wearing stiff hats. In a way, Delacroix's own paintings stand to the surrounding art world in precisely that sort of relationship. They are tacit critiques of the civilization that appreciated them, at right angles to the reality of daily life, illuminating it like dreams. I suppose, if this is right, Delacroix's intentions intimate the later spirit of Surrealism.

But it is difficult to situate Delacroix in any of the available narratives of nineteenth-century European art. The quarrel between him and Ingres, hence between color and line, is of course one of the set pieces in standard art history courses. Ingres had his own disparities, which Richard Wollheim has discussed with considerable acuity in his book *Painting as an Art* as recurrent "spatial anomalies," which are all the more difficult to rationalize since Ingres worked in a highly linear neoclassical style, inherently conducive to the most straightforward placement of persons and objects in space. Wollheim sees these anomalies "as though they had been brought about by someone strenuously trying to wrench apart the scene, to dislocate objects, to open up gaps, so as to accomplish changes upon which he has set his heart." It is as though Ingres's style of drawing was selected in order to *mis*draw, and hence to express feelings that must require a psychological explanation, since there could be no possibility of ineptitude. But then a parallel account might be given of Delacroix's use of color: The color gives intensity to the hallucinated cats and Arabs in one's own bland backyard. It belongs to the mode of presentation of dreams and visions. The conflict between the two masters was not—or not merely—a style war. It would have

been connected with the deepest dimensions of their respective modes of "being-in-the-world," to use Martin Heidegger's unavoidable phrase.

What we do know is that Delacroix was the greatest colorist of the nineteenth century and was esteemed as such by the great artists who came under his influence. In an 1888 letter to Emile Bernard, van Gogh exclaimed over Delacroix's *Christ on the Sea of Galilee*: Christ—"with his pale lemon-yellow aureole, sleeping, luminous in the dramatic purple, dark-blue, blood-red patch of the group of bewildered disciples—on that terrible emerald-green sea, rising, rising, right to the top of the frame." In a later letter, he describes a Christ painted by Delacroix as marked by "the unexpected note of bright lemon yellow in such a way that the colourful and radiant note in the picture assumes the inexpressible strangeness and charm of a star in a corner of the firmament." There are five versions of *Christ on the Sea of Galilee* in the Philadelphia show, in two of which Christ's sleeping head is surrounded by an aureole. That he is asleep while everyone else is agitated and uncertain is enough to set Christ apart from and above the disciples, whose animated limbs seem borrowed from Géricault's *Raft of the Medusa* (for which Delacroix served as one of the models). But it is very difficult to see "blood-red" and "emerald-green." Van Gogh wrote: "Only Delacroix and Rembrandt have painted the face of Christ in such a way that I can feel him." And the question is whether any difficulty we may have in "feeling" Christ in these paintings is due to the way in which colors visible to van Gogh are lost to us through deterioration. It does not appear that Delacroix was deeply concerned to make works that would last forever. He was reckless with his materials, the way Rothko was, and his late masterpieces in Paris, like the mural in the Church of Saint-Sulpice, are blackened almost to the point of illegibility—like the panels Rothko did for Harvard. Or if not reckless, he was prepared to make certain sacrifices for the sake of apparitional luminosity.

The relationship of color to form was a topic of profound investigation by nineteenth-century French artists, and it is worth considering for a moment what being a great colorist meant to them. It meant using colors to enhance luminosity, itself perhaps a response to a change in taste. It did not begin with painters so much as with dyers, who wished to intensify the

brightness of tapestries woven at Gobelins, which were perceived as somehow duller than the colors of the threads themselves, and the question was whether different dyes were needed. It was discovered by the chemist Michel Chevreul that the dyes were not the problem, which arose instead from the way the *eye* mixed colors (Ingres's paintings look so chill in part because he mixed colors on the palette, gradating them by adding concentrations of black). Chevreul explained the dullness as due to the way adjacent hues fuse in the eye to create an impression of neutral gray. The practical problem was thus how to adjoin hues in such a way as to exploit optical mixture. Impressionism was a precise exemplification of Chevreul's system. The eye does not see the world as so many dabs of color, but an educated distribution of such dabs on canvas will create an impression at least as vivid as that caused by the scene itself, and probably more vivid. The eye of the viewer was co-opted to create the art. The eye was in effect enlisted not merely to gaze at but to generate the colors on which it feasted.

We might think of Manet's innovations from this perspective. Manet's agenda was to liberate painting from the "stews and gravies" of official salon *tableaux*. This meant that he rejected traditional shading, from light to dark through immediate gradations. Instead, Manet pushed shadow to the boundaries of his forms, in order to allow a maximum area for brightness. This tended to flatten his forms and to minimize illusion, the way it happens with frontally illuminated photographs, from which Clement Greenberg speculated that the artist derived his manner: "For the sake of luminousness Manet was willing to accept this flatness." Greenberg insisted that the history of Modernist painting lay in the discovery of flatness, which is why he regarded Manet as the first Modernist—even if he stumbled unawares into Modernism, flatness being a consequence of the way he used colors.

Manet quickly discovered how shocking his flattened, almost posterish forms were to viewers used to "stews and gravies." When he attempted to exhibit *Déjeuner sur l'herbe* in the Salon of 1863, a special annex was invented—the Salon des Refusés—that enabled the Parisian public to view the painting without the implication that those in charge of the official Salon endorsed the work. The extreme vilification to which Manet was thus exposed was the first in the history of violent aesthetic clashes between avant-garde

artists and those outraged by what they produced. But the avant-garde had not been invented as an artistic concept in 1863, so Manet had to be regarded as either having lost his powers or engaging in some colossal hoax. Yet he saw himself merely as having found one solution to the problem of maximizing brightness. It is not difficult to understand why he would see himself as Delacroix's peer, though Delacroix's means did not jar visual expectations the way Manet's did. When Fantin-Latour painted his *Homage to Delacroix* in 1864, Manet is shown standing alongside a portrait of Delacroix around which various artists who venerated the master are gathered.

It is, I think, striking that Delacroix died in the same year in which Manet's debacle in the Salon des Refusés took place. If indeed Manet's painting was the first Modernist work, the two events define a beginning and an ending that we are able to see only in hindsight. The border between traditionalism and Modernism had been crossed in 1863. But no one would have been aware of anything that dramatic taking place. Delacroix could have been viewed as belonging to the same narrative of color investigation as Manet and the Impressionists—or even as inaugurating an approach to color that would finally be taken by Cézanne, Signac, and Matisse.

Delacroix appears to have discovered independently, from Oriental artifacts, how to juxtapose areas of complementary colors, counting on the eye to fuse them to an intensity beyond the intensities of the component hues. He derived his color practice from Persian carpets, according to John Gage's great book *Color and Culture*, which further tells us how Delacroix hatched red against green to achieve chromatic brilliance the way it is produced by cashmere shawls. One might in this regard compare his *Women of Algiers* (done in 1834, and hence too early for inclusion in this show), which has the brilliance of Oriental jewels and textiles, with Ingres's almost incomprehensibly inanimate painting *The Turkish Bath* (1859–62), in which nude women are arrayed like classical statuary in a gallery of antiquities. Ingres drew them in such a way as to exclude himself, as if he were obeying the sanctions of the harem. By contrast, Delacroix gained entry to the women's quarters in Algiers. Delacroix's Orientalism, one might say, gives his work, even when we view it through the whole history of Modernism by which we are separated from him, an unmatched visual excitement.

Baudelaire wrote a remarkable essay that was not, but many think should have been, about Manet. It is called "The Painter of Modern Life." The poet knew Delacroix, and wrote an important essay on him as well. But Delacroix could never have been the Painter of Modern Life. "Delacroix was passionately in love with passion," Baudelaire wrote, "and coldly determined to discover the means to express passion in the most visual way." On the occasion of Delacroix's death, one critic concluded that "over the course of forty years, he touched the entire range of human passions with his magnificent brush, sometimes fearsome and sometimes tender, going from saints to warriors, from warriors to lovers, from lovers to tigers, and from tigers to flowers." One cannot say anything like this about Manet, or about most of the masters of Modernism. It is something that lies outside Impressionism, and beyond the ambit of Cézanne (though in his youth he seems to have been affected by the violence of Delacroix's images). It suggests that Modernism was corollary with a resolution to rely on observing modern life—the railroads, the boulevards, the café concerts, the bordellos, the gardens, the lanes, boats on the river, couples promenading—and hence the way the world is lived. I think that is what endears the Impressionists to us: The world as they showed it lightens the soul. What Delacroix painted was not modern life, or, for that matter, the dear world of daily life, sufficiently threatened as it is.

His images—the pumas in Fontainebleau, the Arabs in Barbizon—lie outside the range of common life. For all that his color theories influenced the subsequent history of art, his images do not belong to the narrative of Modernism. He stands entirely on his own. Where in modern life is there room for a stupendous painting like *Lion Hunt*, which Gautier described as "the most frightening pêle-mêle of lions, men and horses; a chaos of claws, of teeth, of cutlasses, of lances, of bodies, of rumps, such as Rubens loved, all glowing in red color and so full of sunshine that it almost makes you lower your eyes"? The major work in the show, this painting was badly damaged by fire, which burned away its entire top half. So no sunshine, and none of the background clues to tell us whether that vortex of savagery takes place— who knows?—in the Bois de Boulogne, under northern skies.

—November 9, 1998

ROTHKO AND BEAUTY

∎ ∎ ∎

*W*HEN ABSTRACT EXPRESSIONISM BEGAN TO ENTER AMERICAN CON-
sciousness, it was not uncommon for magazines to publish photo essays in
which a painting would be juxtaposed with a piece of the real world to which
it somehow seemed to correspond. A great deal of ingenious matching went
into these essays, which instructed viewers in one way to "read" abstract
painting: Treat it as if it were a picture, then try to find a piece of reality it
might match. Thus a painting by Franz Kline, using his characteristic black
forms, starkly composed against a white background, might be placed along-
side a photograph of some industrial scaffolding, shown silhouetted against a
light sky. A canvas of Jackson Pollock's might be placed next to a photograph
of tangled water weeds. Divergences between real motifs and pictorial repre-
sentations could then be explained as due to "expression": The artist was
showing how he felt about the world the photographs showed. This art
could be mimetic after all! It was only, for example, when he could find
something in reality that abstract paintings resembled that an art historian
like Ernst Gombrich was able to accept abstract painting as art.

Pictorial mimesis, however, requires two relationships between painting
and motif beyond the requirement of looking more or less alike: The paint-
ing has to be *about* the motif, and the motif must *cause*—must enter into the
explanation of—the painting's form. There would have been little reason to
suppose that Kline's painting was about scaffolding, or that the latter in-
spired him to paint as he did. And it would be startling to discover that Pol-
lock, who stumbled into throwing and dripping paint, was somehow driven

to achieve the effect of tangled water weeds. So identifying correspondences between paintings and objects is cognitively empty, like seeing shapes in clouds: A whale-shaped cloud ("How like a whale!") is not about a whale and certainly not caused by one. The matchup is sheer coincidence.

What is undeniable is that these essays showed that abstractions, not unlike the most scrupulously realistic works, can draw our attention to features in the real world to which we might not otherwise have been sensitive. Standing before a silhouetted scaffolding against the dawn sky, we might exclaim over how much it looks like a Kline, and perhaps realize that we would have been indifferent to the aesthetics of the situation had Kline not given us a way to respond to it. The scaffolding has become, so to say, a readymade Kline, something we would not have been able to see as such had we never seen Kline's work. Still, there may be no great cognitive gain. Proust's character Swann falls hopelessly in love with a woman who happens to resemble Zipporah, the daughter of Jethro, in a Vatican fresco by Botticelli: He sees her as a Botticelli. The picture, as he discovers to his agony, is no guide whatever to the woman's furtive personality. The benefit is entirely aesthetic, a way of experiencing the world as if it were art. It is a key to Swann's character that he experiences life as so many *tableaux vivants*.

Not long ago I saw a readymade Rothko. I was flying to Iceland at that time of year when the sun scarcely sets, and through the window saw the sky divided into horizontal bands—a heavy purple at the bottom, separated from the upper band of light blue by a band of rose and orange. Even the darkest band was translucent. It was a spectacular sky, and it accompanied us until the plane made its descent into Keflavik. It was *so* spectacular that we would have been struck by its beauty irrespective of the way it evoked Rothko's great works. The sunset had the type of beauty in which Kant would have seen a kind of purposiveness, even if we might be unable to assign it any specific purpose. Natural beauty somehow assures us, Kant felt, that life has a meaning and the world is not indifferent to our purposes. Kant never especially distinguished artistic from natural beauty, and perhaps he thought them sufficiently parallel that just as the beauty of a painting is connected with artistic purpose, natural beauty is connected with divine purpose—as if God were a kind of artist, revealing meanings through sunsets and the like.

That would more or less have been the philosophy of beauty subscribed to by the painters of the Hudson River School. They saw radiant assurances of divinity in the grander aspects of nature, which they then sought to transcribe into paint. Their paintings were not, as it were, postcards of waterfalls, mountain peaks, dense forests, and precipitous ravines. They attempted rather to depict nature in such a way that the viewer would be enough stirred by the beauty of the scene to feel it a medium for divine communications. They were religious painters, not reluctant to depict natural crosses on the mountainsides, as if there were messages even in the way snow fell in the Andes.

Few advanced painters today—except Komar and Melamid in a spirit of frolic—would dare to paint a northern sunset, or worry how the translucency of clouds could be rendered. It would somehow diminish a Rothko were we to imagine it to be about a sunset sky it happens to resemble; he was not painting sunsets in abstract ways. It enlarges our appreciation of Rothko, however, to see his paintings as having the kind of meaning the Hudson River painters believed they sensed in nature—as if the shapes, colors, and translucencies he composed and recomposed, in painting after painting, served to intimate meanings of a spiritual order no longer to be found in nature. It was as if art had taken over a task we no longer looked to nature to perform.

Under Hudson River School metaphysics, natural and artistic beauty were entirely of a piece, as Kant had believed. Their landscapes delivered the kinds of meanings nature itself did when it was beautiful. One main difference between those painters and ourselves is that we cannot believe in transcendent beings who address humanity through the media of volcanoes and cascades. So for just that reason, a painting today, done as realistically as a Hudson River School landscape, could not convey to us the meanings Kant believed natural beauty was designed to transmit. Rather, if that is what an artist with a religious calling were concerned to do, it would almost of necessity have to be *abstract*. That is why the resemblances between a Rothko and the midsummer night sky are neither here nor there.

Whatever the outward similarity between a given Rothko and such a sky, there have to be crucial differences that do not meet the eye. One difference is that it is legitimate to ask what a painting by Rothko means,

whereas sunset skies have no meaning at all, or at least no supernatural meanings. In naturalistic terms, of course, such a sky might mean rain to-morrow: One bit of nature is a sign for another bit. The meaning of a work of art is its content—what it is about—even if it is merely about its own material constitution, its brushed pigment, its colors, its internal and external shapes. Rothko sometimes spoke this way himself. He said, contrasting his canvases with the black paintings of Ad Reinhardt (with whose widow Rothko was to have a relationship near the end of his own life), "His paintings are immaterial. Mine are *here*. Materially. The surfaces, the work of the brush and so on. His are untouchable." There is no question that Reinhardt turned his back on the identifying features of Abstract Expressionist paint-ing, which so greatly celebrated the materiality of pigment and the expressiv-ity of painterly gestures. It was as if his paintings were meant to disappear once his viewers were put in touch with the ulterior realities alleged to be conveyed as through a glass darkly. This, I think, was precisely *not* what Rothko wanted. His meanings were connected to, but not entirely identical with, the materials of his paintings and the material evidence of his touch. It was rather that one could experience those meanings only through keeping in view what one saw when one looked at the paintings closely. In some way, the paintings relate to his meanings the way a sentence relates to the propo-sition it conveys. We can grasp the proposition only through understanding the sentence. To experience a Rothko is to wonder what it is trying to reveal. It is like experiencing spectacular sunsets if you share the metaphysics of the Hudson River School painters. Of course they knew about the refractions and reflections—and dust particles—that explain the materiality of the sun-set and even, in a sense, how sunsets can be beautiful. But it seemed to them that God would not tolerate a throwaway beauty of that dimension. It *had* to have a meaning. And that is the way it is with the beauty of Rothko's paint-ings. To experience it is not merely to see the forms and colors and brush-work.

It is as if Rothko had found a way of presenting a high truth of meta-physics or theology in entirely sensuous terms. And that is what painting, in what Hegel calls art's "highest vocation," is supposed to do. Whatever expe-rience it is to which Rothko's paintings refer us, it cannot be an ordinary ex-

perience, like that of witnessing a scaffolding against the sky or a spectacular sunset on the night flight to Iceland. What his paintings make present is something that has vanished from the visual world, in which burning bushes are, well, just burning bushes. Artistic beauty, Hegel said, is beauty born of the spirit and born again.

In 1951 Rothko declared, "I paint very large pictures . . . the reason I paint them, however—I think it applies to other painters I know—is precisely because I want to be very intimate and human." I take this to mean that each painting dictates where the viewer should stand in relation to it. If we should happen to see one of his paintings from a different position, we would feel nothing of the way its content reaches out to touch us. Some years back there was an exhibition of his work at the Guggenheim Museum in New York, in which, ideally, the narrow dimensions of the Guggenheim walled ramp keep us from stepping too far back from the surfaces of the paintings we stand in front of. We are not at the viewing distance of eighteen inches he once recommended. But we are close enough to register the paintings' materialities. Unfortunately, one could also see, over the wall and across the space of the atrium, rows of Rothkos that looked like Indian blankets, striped or banded, as if displayed for tourists. Viewer and painting must stand in the right spatial relationship to each other, as if spatial closeness is a condition for the bond between painting and viewer to arise. I would propose that there should be only as much space between viewer and painting as allows for the possibility of touch. That is what makes describing Reinhardt's painting as "untouchable" a deep criticism.

The installation of Rothko's work recently taken down at the Whitney Museum of American Art emphasized this closeness through placing the paintings in small, intimate, and suitably darkened galleries, in which the works nearly glowed with a light of their own. None of the gallery spaces were so large that paintings were separated from viewers by the kind of neutralizing distances the space of the Guggenheim exemplifies. The intimacy of the space assured us that the other paintings in the room were not so far away that closeness was ruled out. Rothko, who was somewhat exigent in how his

work was to be viewed, wanted his paintings hung quite low to the floor. That demanded an appropriate size, since it would be inconsistent with his intentions were we to have to bend over to look at small paintings, hung near our feet. Ideally, the paintings should be about our height, as if one person were facing another. Rothko did make a number of paintings much wider than the person who confronted them. I feel this extra expanse somewhat dilutes the intensity of these works. The optimal proportions would be defined by the human body—wide enough that we could touch the edges were we to stretch out our arms, high enough that we do not see over the top of the painting. It would defeat the purpose of the work if we felt ourselves to be disproportionately small in front of it, the way, say, Faust felt when towered over by the *Erdgeist*. The beauty is, as Kant believed it to be in nature, somehow reassuring. This raises a question about the quite vast panels Rothko painted for the chapel at St. Thomas University in Houston, which are disproportionately large in regard to humans standing in front of them. They are, moreover, black—a fact that has been the basis of a number of speculations about the artist's mood when he painted them, since he committed suicide some months before they were finally installed. But these last vast paintings were originally red—indeed, red on red—and hopeful rather than tragic. It was just that the artist was reckless with the pigments he used, though I don't think ephemerality could have been part of their meaning. Abstract Expressionists would have mixed pigment with mayonnaise or molasses if they thought an effect could be achieved no other way.

At this point it becomes important to consider the visual detail so lacking when we see the work from an inappropriate distance. *Untitled* (1960) has the advantage of resembling the "Rothko sky" I encountered at 33,000 feet above the North Atlantic near midnight. On a field of twilight purple, three colored rectangles are arrayed, one above the other. They appear to hover, like disembodied glows—an effect facilitated by the fact that they touch the edges of neither the painting nor one another. The very last paintings in the Whitney installation were those in which the colored rectangles are bounded by the edges of the painting on three sides, leaving it to the viewer to decide whether the painting functions to crop the rectangles, the way a window frame would a sunset, or consists of two rectangles, three of whose edges co-

incide with the physical edges of the canvas. If the latter, then there is an illusory painted edge at which the two rectangles meet. I cannot but feel that when the rectangles stopped hovering and became, as it were, nearly one with the physical shape of the canvas, this reflected some deep change in the artist's outlook.

In any case, the rectangles in *Untitled* share no boundaries. They hover autonomously, and yet they constitute an ascending formation in which their contrasting colors and sizes play a role. Both bottom and top rectangles are, crudely speaking, black, but the top one is about a quarter the height of the one on the bottom. The middle rectangle—half as high as the bottom rectangle, twice as high as the upper one—is predominantly a cadmium red. All are of the same width, arranged one above the other. Each seems to vibrate, independently of the others. From a great distance (as across the Guggenheim's atrium), one could identify most of the properties I have just described, so what does being close to them reveal? The amazing edges of the rectangles, and the way underlayers of paint reach through the rectangles to give a sense of translucency. These forms are not pure red and pure black, as they appear from afar. The extraordinary beauty is due to the way the edges of the forms appear to penetrate and to be penetrated by the ground color of the painting; and to the way the undercolors flicker through the surface colors. These animate the forms as well as the colors through irregular pulsations of light. Back away from the surface, and the light disappears. And when the light disappears the paintings go dead and formal.

I was tempted to consider *No. 16 (Two Whites, Two Reds)* (1957), which, when it was acquired by the National Gallery of Canada in Ottawa, created so philistine an outcry from Canada's Parliament and tabloid press that a bit of remedial art criticism might be of some value. I wondered whether there would have been the same sense of outrage had the museum acquired *Untitled* (1960) instead. The truth is that *No. 16* is merely the promise of a painting. It seems somehow raw, as if abandoned by the artist. We can see how he has brushed white over the red to begin to form the edges that are his signature. But white and red do not have here the interpenetration that locks them together. The white is more transparent than translucent. So nothing is fully realized. In the end, the painting shows what materiality comes to

when it does not evoke something deeper than itself, for which its beauty is an emblem. The philistines were boorish but not entirely wrong.

The concept of beauty plays a very small role in my *Nation* columns, and for good reason: It plays no large role in much of the contemporary art that interests me. It is, however, the meaning of Rothko's works.

—*December 21, 1998*

POLLOCK AND THE DRIP

▪ ▪ ▪

A CHARACTERISTICALLY HANDSOME PAINTING BY JOAN MITCHELL IS on view at the Museum of Modern Art in the exhibition *American Art: 1940–1970*. I think of it as a kind of footnote to the retrospective exhibition of Jackson Pollock on the museum's third floor. Mitchell was one of the strongest painters in the so-called second generation of Abstract Expressionists, and she painted *Ladybug*, as it is titled, in 1957—the year after Pollock was killed. There was not to be a third generation, as things turned out: The movement came to an end in 1962, giving way to forms of art, like Pop Art and Minimalism, that could not have been more alien to Abstract Expressionism's founding vision. *Ladybug* is a little lexicon of Abstract Expressionist devices: the smear, the swipe, the drop, the drip. It is the drip, however, to which I mean to call attention, since it played so great a role in the artistic metaphysics of the movement and in the perception of Jackson Pollock as the master of the drip: Whole cascades of them course down Mitchell's canvas. Whatever else she was bent on achieving in *Ladybug*, it seems clear that Mitchell was laying on paint for the sake of the drips and going on from there.

Drips are generally a kind of incontinence, a mark of control betrayed by the treacheries of fluid, whether allowed to happen by house painters or by artists. The masters of subway graffiti recruited apprentices to wipe away the drips, regarded by them as inconsistent with their claim to mastery. Abstract Expressionism made wiping drips away obsolete. The drips affirmed

that paint has an expressive life of its own, that it is not a passive paste to be moved where the artist wants it to be moved but possesses a fluid energy over which the painter endeavors to exercise control. The act of painting then is like a match between two opposed wills, like the act of taming tigers. The internal drama of Mitchell's painting derives from the way she uses paint's propensity to drip to her own advantage by taming it with over-strokes of pigment through which she displays her own discipline and power. It was in just these terms that Harold Rosenberg, with Pollock especially in mind, wrote of the artist as agon and coined the expression "Action Painting." In any case, *Ladybug* shows how the drip had become so theatricalized in late Abstract Expressionism that paintings could consist almost entirely of them.

Against both the mythology of his having discovered the drip and the way dripping had become a mark of Abstract Expressionist identity, it is somewhat remarkable that there are very few drips to be encountered in Pollock's show upstairs, at least of the kind Mitchell made her own. The first paint drips I encountered were in the lower right corner of his *Mural*, commissioned in 1943 by Peggy Guggenheim for her East Side town house. For several years thereafter there are no drips at all, most particularly not in the sublime canvases of 1950. It might even be said that Pollock's project was to *keep drips from happening*! Placing the canvas on the floor would be a means to thwart paint's disposition to dribble. The species of drip so central to *Ladybug*'s structure is mostly seen on the sides of gallon paint cans, after the painter has wiped excess fluid from the brush. After the marginal drips in *Mural*, ones like those used by Mitchell appear in Pollock's work for the first time in his 1952 *Blue Poles*. In my view, this represents a fundamental change in direction, however that is to be accounted for.

A film of Pollock painting, made by Hans Namuth in 1950, begins with the artist describing his approach to painting, emphasizing his complete control, which he goes on to demonstrate by putting paint on a canvas on the ground. That was doubtless intended as a riposte to criticisms that his work was chaotic, lacking structure and organization, and that it exhibited a total absence of technique, that he was what *Time* once called—and *The New Yorker*

still does—"Jack the Dripper." Against the evidence of Pollock's surfaces—clotted, curdled, and whipped in ways that could not have been planned—this must have seemed an empty boast by the artist. But when Pollock demonstrates the way he paints, we see that he has discovered how to draw with streams of enamel, which he whips off the end of a stick to create spontaneous calligraphic forms—pearlike, leaf-shaped, organic, lobed. These look almost Japanese. The paint does not *drip* off the end of the stick—it is like a liquid lash the artist snaps with the exactitude of a circus performer taking the cigarette out of a partner's mouth with a bullwhip. It is breathlessly fascinating to see how an abrupt turn of the wrist alters a line's direction and thickness, virtually the way a fine brush in the hand of a master would do.

On the other hand, the forms themselves seem made for the technique: It would be monstrous were Pollock to attempt something like the *Mona Lisa* by manipulating swift streams of liquid paint! His are the kinds of forms paint used this way would spontaneously achieve, once one had learned how to do it. They look, in fact, like brilliant doodles, to borrow from Robert Motherwell the expression he liked to use in describing the initial address to the blank canvas or empty sheet of paper. When one studies the hundreds of small spontaneous drawings Motherwell made in 1965, to which he gave the name *Lyric Suite*, one cannot but notice that his and Pollock's forms are entirely cognate. Both subscribed to the Surrealist concept of "psychic automatism," which they had learned from Matta and which Motherwell often spoke of as "the original creative principle." The problem for the artist was to find a technique that enabled the creative unconscious to express itself on a surface. But for just this reason the paint had to be disciplined. A drip refers to a disposition of undisciplined paint rather than an active artistic power. That is why controlling paint was a defining value for Pollock: It enabled him to yield to the unconscious and to bring up from its depth the forms that were its gift to consciousness.

Let us return to *Ladybug*: Two truths can be inferred from the density of its drips, apart from the symbolism the drip had acquired in Abstract Expressionist discourse. First, since the existence of drips entails verticality, the painting had to have been executed in a vertical position, on an easel or

[345]

against a wall. (That would have been simply taken for granted before Pollock's decision to paint on unstretched pieces of canvases laid flat on the floor.) Second, the drip is the product of gravity overcoming surface tension. So the drip defines the bottom and top of a painting by its direction. But top and bottom imply verticality as well—a canvas on a floor will yield no physical clue as to what is "up" and what is "down." In fact, I think that Pollock's paintings do have tops and bottoms, which means that they were ultimately to be seen as vertical. This came to me when I noticed the reproduction of *Number 32, 1950*, on the back cover of the catalogue MoMA has produced for the show. The image seemed upside down, and though there were any number of visual clues as to which way was right-side-up, based on the way books are put together—in our culture, always opening from the right rather than the left, for instance—the painting looks wrong seen in any way other than the one Pollock himself intended, obvious from the placement of his signature in the lower right corner. The painting, then, internally determines which edge is top and which is bottom. (Try rotating it, and see if you agree.) Allowing paint to drip removes that ambiguity. To be sure, Mitchell could have mocked gravity by so hanging her painting that the drips went up! But that would be an impudence entirely inconsistent with the seriousness with which she took the act of painting and the importance she so clearly attached to the physics of dripping paint.

Mural, as its name implies, refers to a wall. Guggenheim originally wanted it painted on her wall, like a proper mural, but instead it was painted on canvas mounted on a wall in Pollock's studio: He even broke down a dividing wall so that he would have an uninterrupted vertical expanse on which to execute a painting nineteen feet long. *Mural* is exceedingly rhythmic, but it is a rhythm of forms with a definite upward vector, like that which flowers or trees possess. I once saw a photograph someone compared to *Mural*, in which a row of leather straps hangs from nails along a wall. Yet the forms in *Mural* cannot be thought of as hanging down. *Mural* is about growth, and it marks where the sky should be as definitively as clouds do in conventional landscapes. The presence of the drips in the lower right corner serves as external evidence of the painting's vertical orientation, but someone with the kind of control Pollock insisted he possessed would want the orientation of the painting to come entirely from within. Namuth's film does not show

how the doodles were connected up and overlaid by lashes of spun paint, but to judge from the paintings from that period that are on view, one imagines that each move suggested the next, and bit by bit some form began to emerge, perhaps evoked by the doodles, perhaps not. It would have been inconsistent with the methodology of creative automatism to prepare sketches or studies, as Pollock acknowledges in his speech at the beginning of the film.

It is unrealistic to suppose, in a work so driven by energy and passion as *Mural*, that Pollock should have noticed the drips in the lower right corner. They would, if anything, have been beneath notice, but in no sense out of place given the changes that were taking place in the concept of painting in those years (think of what drips would mean in one of Mondrian's severely rectitudinal masterpieces). But it is not unrealistic to suppose that however it occurred to him, Pollock recognized that laying the canvas flat would enhance his control over the paint. He was still thinking in vertical terms when he painted *The Key* in 1946: The canvas, which he laid on a bedroom floor, was fastened to a curtain stretcher. The stretcher implies an up, a down, a right and a left, and a face. But so does the painting's image, which is like that of an abstractly rendered landscape, with mountainy forms at the horizon. I mean that it was conceived as vertical from the beginning. When Pollock moved his studio to the barn made legendary by Namuth's films, by contrast, verticality was something that had to be allowed to emerge in the course of painting. Pollock did not begin with anything in mind. In principle, any edge could become top or bottom, depending on the way the painting went. He controlled the paint but in some way the painting controlled him.

The floor enabled Pollock to control paint as fluid—imagine what a mess it would be were he to have attempted to paint a vertical canvas in the same way he did a horizontal one! What is impressive about the paint is its velocity, as if it left the brush at the speed of sound and lay on the canvas in slender threads of pure directedness. Painting on a wall would have excluded walking around the canvas as well, seeking an entrance with no idea which edge was to be up and which down, the doodles serving as forays into the blankness, Pollock, at least in the film, working from the outside in. Critics—beginning with Clement Greenberg, who so championed the artist—

have described the paintings as "all-over," which seems to me to imply the absence of direction, like a scribble or a grid, and suggests a kind of pattern rather than a reality constituted out of paint jet-streamed across space. A square sheet divided into even squares cannot have a top or a bottom—it is the same whichever way it is rotated. I surmise that the sense of all-overness was prompted by the fact that so many of the photographs we have of Pollock show him hovering over works in progress that have not yet found their direction. The critics did not think of the finished painting, viewed vertically, with a clear and vivid sense of balance and even a certain wild symmetry. The paintings relate to the canvas in much the same way that a drawing does to a sheet of paper. It does not claim the corners, it barely touches the edges. The magnificent *Autumn Rhythm* of 1950 has the presence of a great drawing. There is not a drip in it, but dashes and spatters as evidence of the intense energy with which the paint is cast.

The floor, meanwhile, enabled a whole complex of other changes. Paint as paste usually implies the paint tube, to be purchased in the artist's supply store. Paint as fluid implies the quart or gallon can of proletarian enamel, purchased where house painters buy dropcloths, heavy brushes, spackle, rollers, and the like—the kind of supply store that could have existed out on the end of Long Island in Pollock's day, whereas art-supply stores there were probably for amateurs and china painters. Paint as paste implies brushes made of the finest hair. Paint as liquid goes with the coarsest house-painter brushes or, as Pollock's conception of painting evolved, sticks.

I have often appealed to one of Heidegger's most remarkable ideas—that of a system of interrelated tools, which he called a *Zeugganz*. The components of a *Zeugganz* are what they are by virtue of the other elements to which they refer and which in turn refer to them: The head of the nail refers to the hammer, the point to the board, the hammer's claw to the head again, but for pulling out rather than pounding in. In order to paint as he did, Pollock had to create an entirely new *Zeugganz*, in which casting paint was only one component. He re-created the way his body had to act in order to direct the urgent whips of pigment. The hand—which Aristotle designates the tool of tools—was part of the whole. Only with the paint dry could the canvas be lifted into a vertical position—or gravity would work against what Pollock

required of his medium. It would drip or smear, neither of which has anything to do with the Original Creative Principle. A painting is not, after all, a dropcloth—or at least Pollock's paintings are not.

If I am right about the drips in *Blue Poles*, Pollock must have painted it on a vertical canvas, using runny paint, at least in part, the way Mitchell was to do. Why then this return to verticality? On this I have nothing to offer, other than the thought that he must have felt he had gone as far as he could within the *Zeugganz* of the canvas on the floor. There are other regressions evident as well. The figure begins to come back, for example. So it may have been a case of taking a backward step in order to advance. To an artist committed as Pollock was to the Original Creative Principle, the faith would have been that sooner or later a set of forms would well up from the unconscious—and indeed in one case they did. There is a powerful late painting of 1953 called *The Deep*, as vaginal as Courbet's *Origin of the World*, in which the female opening is monumentalized and detached from the woman's body, like something with a life of its own. The orifice—see if *The Deep* means something else to you—is a dark cleft in a field of white paint seemingly scrubbed on. There is a minimal use of interlacing strings of white paint across the orifice, which conveys a kind of wetness. There are no drips, but there are some fierce dashes of yellow in the surrounding white.

Pollock did very little painting after that. Who knows—maybe he had found what the unconscious was trying to tell him. Greenberg meanly said Jackson had lost his stuff, but perhaps instead he had found what he wanted to say. The vocabulary of the unconscious consists in the most primitive of human ideas. What retrospective light does *The Deep* throw on the great climactic works of 1950? Can any meaning justify the intensity of their embodiment in the biomass of whipped lines? Could any motif explain why someone would expend that degree of fury in seeking it? Pollock has suffered through the fact that his life is so much easier to write about than his work, that the work itself has scarcely been addressed. What was it about? How was its meaning embodied in the thickets of spun paint? Every interpretation seems puny alongside the material truth of the art.

Pollock was a great painter before he discovered the drip. *The She-Wolf*

(1943) is as daunting in its wildness as the tremendous dog painted against a Dutch sky by Paulus Potter. That same year he painted *Guardians of the Secret*, with two gnomic figures standing on either side of something cryptic. The great works of 1950 are guardians of their own secret. Better to let it go at that than surrender to glibness.

—January 25, 1999

DEGAS IN VEGAS

· ■ ■

*F*ROM VARIOUS OF THE ITALIANATE TERRACES OF THE BELLAGIO HO-
tel in Las Vegas, looking over an artificial lake, girdled by balustrades no less
Italianate and meant to be emblematic of Como, one may see a half-scale
simulacrum of the Eiffel Tower rapidly rising across the Strip. The tower is
to be one element in a complex of simulative monuments and buildings, to
be called "Paris" when it opens later this year. The Arc de Triomphe is al-
ready in place, as well as a fragment of a sixteenth-century chateau; another
structure—still screened by its scaffolding—may turn out to be the
Madeleine or even the Gare Saint-Lazare. Farther north along the Strip, a
similar complex, this time of Venetian landmarks, is under construction,
with the Ca' d'Oro nearly completed and the tower of San Marco not far be-
hind. To the south, "New York–New York" has been open to the public
since 1997: The Chrysler Building is nearly adjacent to a stunted Empire
State Building; Lady Liberty, with two New York Harbor tugboats at her
feet, looms over the Brooklyn Bridge; steam plumes up from manhole cov-
ers—but one encounters vast ranks of gambling devices upon entering a cav-
ernous Grand Central Station. The sense is irrepressible that before long,
Las Vegas will be an architectural theme park, in which every edifice known
to popular visual culture—Chartres, the Golden Pavilion, the Stone Garden
of Kyoto, the Taj Mahal, the White House, the Houses of Parliament, the
Golden Gate Bridge, the Colosseum—will have its simulacrum. That leaves
the question of whether any of Las Vegas's own buildings would find a place
in that landscape of monumentary knockoffs. Caesars Palace, perhaps, since

it itself replicates no known structure of Imperial Rome but stands as a fantasy, inspired partly by the Vittorio Emanuele monument and partly by *Ben-Hur*. Or perhaps one of the rapidly disappearing "decorated shacks" that so stimulated the architects Robert Venturi and Denise Scott Brown when they wrote the classic of postmodernism, *Learning From Las Vegas*.

It would be reasonable to suppose that were some entrepreneur to undertake an art museum in the Las Vegas spirit, it might be called The Museum of Museums, and feature simulacra of all the world's masterpieces—*Mona Lisa*, *Portrait of the Artist's Mother* (Whistler's Mother), *The Night Watch*, *The Creation of Adam*, *Gold Marilyn*, Piero's *Resurrection*, Raphael's *The Transfiguration*, the Bayeux Tapestry, *Les Demoiselles d'Avignon*. Why chase across continents, from museum to museum, when everything one would have gone to see is here in one place, brush stroke by brush stroke, indistinguishable from the prototypes? What difference does it make, visually speaking? One only expects "Reality–Las Vegas" in Las Vegas—like the artificial volcano that rumbles and erupts every fifteen minutes each evening in front of the Mirage, the concrete Trojan Horse at FAO Schwarz or the golden Sphinx, with laser lights for eyes, beaming toward the fabricated pyramid in front of the Luxor Casino and Hotel—and everything is advertised as Magical, Enchanted, Fantastic, Fabulous, or Incredible. One does not expect to encounter Reality as such, where things are what they are and not something else they merely look like.

In consequence, visitors are not entirely secure in viewing what it is not hype to describe as the world-class paintings hung in the Bellagio Gallery of Fine Art. Steve Wynn, whose conception the gallery is, asks, "Why, of all things to feature in a new resort hotel in Las Vegas (of all places!) would one select an enormously costly and potentially limited-appeal attraction such as a serious fine-art presentation of paintings and sculptures?" Why indeed, when the possibility of simulacra indiscernible from the originals exists in principle, and visitors only expect "Reality–Las Vegas" to begin with? When it first opened some months ago, an interviewer from a Las Vegas newspaper questioned me on whether I thought it entirely suitable that there should be an art gallery in a site given over mainly to gambling. Well, casinos vie with one another to attract patrons: Approaching the Bellagio, one passes a looming sign: NOW APPEARING: VAN GOGH. MONET. CÉZANNE. PICASSO, just the way

other "now appearing" signs announce Cirque du Soleil or Andrew "Dice" Clay. So Wynn has gambled that a significant population would be as attracted by van Gogh, Monet, Cézanne, and Picasso as by the magicians, stand-up comics, feminine extravaganzas, and impersonators that form the city's standard repertoire of distractions and entertainments. For that population, of course, the art included must be as familiar a part of visual culture as the Eiffel Tower or the Chrysler Building. Those who have taken Art History 101 and traveled a bit are able to tell a Monet from a Cézanne, a Modigliani from a Matisse, a Picasso from a Pissarro, a Degas from anyone else—even if the paintings themselves have not attained the canonical status required by my imagined Museum of Museums. My interviewer asked if I thought the paintings were *real*. That, she said, was what "folks out here really want to know."

I thought it strange that people worry about the reality of the art when reality is required of little else in Las Vegas. "The popular question that seems to have overshadowed the lively speculation about the Bellagio Gallery itself," Wynn writes, "seems to be 'Why?' " I don't think the overwhelming question is "Why paintings?" so much as "Why real paintings?" when "Reality–Las Vegas" suffices for Paris and Venice. What business does real art have in Las Vegas when we can imagine the Museum of Museums on an ontological footing with "New York–New York"? It struck me that the anxiety the question of reality implies could almost only have been provoked by Las Vegas: In a lifetime of visiting museums and galleries, I have never once wondered if what I was about to see was real. So what is at stake in the Bellagio? And what does it tell us about viewing art? At the very least, real paintings constitute a critique of Las Vegas through the fact that they *are* real. To have installed a collection of real masters is already to have taken a step toward the transformation of Las Vegas from a theme park to something that addresses the "higher sensibilities" of people "who would not easily be fooled by advertising or hype." One outcome of such a transformation would be that the question of whether what one was looking at was real would be as taken for granted as it is everywhere else.

Wynn is impressed by the fact that "attendance at museums in the past few years has exceeded attendance at professional sporting events throughout the

U.S.A." So presumably there are enough aesthetic pilgrims in the country (and elsewhere in the world—one hears dozens of different languages in Bellagio's lobby) to put Las Vegas on their map if there were a superlative collection of art to draw them there. But would enough of them come to Las Vegas ("of all places!") to justify assembling a collection that cost three hundred million dollars, let alone the expense of presenting and maintaining the art, and turning a profit besides? The question is not without substance. Las Vegas not long ago decided that "family values" pointed the way to profit. Thus the theme-park atmosphere, where factitious monuments can be thought of at once as fun and educational, and the inexpensive buffets—Las Vegas's contribution to dining—that make it possible to bring the kids along. It *is* fun, a kind of toyland full of crazy surprises, a Disneyland with slots. But the family-values crowd is not made up of big spenders or high rollers, and the profits have apparently not materialized. Besides, as Wynn observes, "All the old ideas of resort attractions have become, well, just old." Hence the bold idea of a gallery of fine art as an attraction, and hence the possibility of changing the whole concept of Las Vegas. Suppose that "under the circumstances of today's very competitive world leisure market" other Las Vegas resorts add galleries of their own? Already, the Rio has become a venue for "The Treasures of Russia"—real enough but objects of a kind compatible with the fantasized atmosphere of "Reality–Las Vegas," and hardly the classy drawing card the Bellagio Gallery aspires to be. The more such galleries the better, one might think. But can we imagine Las Vegas as a true art center, even if every casino were to follow suit and build a collection?

In a small way, the city already is an art center, consisting of at least a number of exhibiting artists, initially drawn to the graduate fine-arts program at the University of Nevada, Las Vegas, to work with the legendary art critic and theoretician Dave Hickey. There are no real art galleries to speak of in Las Vegas, other than the somewhat awful emporia one encounters when strolling along the various streets of shops attached to the casinos, which display in their windows objects it would be punishing to have to live with if one thirsted to be in the presence of what Wynn calls "singular creative energy." For various reasons, the artists have remained in Las Vegas, traveling

to the coasts or to Europe, where their work is exhibited and sold. In a "Top Ten" guest column in the January *ARTFORUM*, Las Vegas artist Jeffrey Vallance begins by praising "the fabulous Bellagio casino": "Right on the Strip you can see Cézanne, Degas, Gauguin, Manet, Monet, van Gogh, Picasso, Pollock, Rauschenberg, and Warhol." (It is striking that Vallance mentions painters and not paintings—nothing in the gallery would be in candidacy for simulation in the Museum of Museums, for the same reason that few of us are likely to have waxen effigies of ourselves in Madame Tussaud's museum of world personalities, however exemplary we are as people. The important thing is that the art is by artists who have also produced masterpieces by Museum of Museums criteria.) I decided to devote an afternoon to local studio visits, guided by the Reverend Ethan Acres, an artist whose work is shown in Los Angeles and New York. The Reverend—a real Southern Baptist minister—aims, as an artist, to "put the fun back in fundamentalism," and once a week he walks the Strip to preach the gospel in the good old Southern way he learned in Alabama, which he regards as no less religious for being performance art. I was impressed with the quality and interest of everything he took me to see, but it is safe to say that none of it would claim a place in the Bellagio Gallery of Fine Art, not least of all because, as with contemporary art in general, it affords very little by way of a glimpse of beauty.

But there is an important connection between the Las Vegas art scene and the Bellagio Gallery. The latter's collection is made up of works, many of which it would be worthwhile to travel some distance to see—the Miró *Dialogue of Insects*, for example, or Modigliani's marvelous portrait of his dealer, Paul Guillaume. There is Willem de Kooning's great *Police Gazette* and a luminous painting of a peasant woman by van Gogh. A Degas of a dancer accepting a bouquet has not been on public view for decades. And everything is deeply authenticated, to settle the question of reality certain to arise in the context. But surely the gallery is not primarily in place to attract specialists and connoisseurs, and one cannot help wondering, whatever the quality, whether by itself it could draw the numbers and kinds of visitors it is intended to do. Those with money enough to stay at the Bellagio have their choice of the world's centers of fine art to visit. So why visit Las Vegas? The

answer is obvious. No one, except those professionally involved in the art world, visits distant places for the art alone. They may come for the art primarily, but they are interested in fine restaurants, in shopping, in entertainment. So in an important sense, plain old unreconstructed Las Vegas is in a synergetic relationship with the Gallery of Fine Art, giving tourists the extra incentive to undertake the trip. What I had not figured in until I got there was a phenomenon of contemporary museum culture: the art tour. The mere existence of the Bellagio collection makes Las Vegas a destination for museum tours from Los Angeles, Santa Barbara, and elsewhere—and the mere existence of Las Vegas itself gives the added incentive to subscribe to them. Everybody benefits, and there is even a fallout for the Las Vegas artists. Tour groups really are interested in art, and the curators who lead them will typically be interested in the kinds of contemporary expression produced there. So impromptu exhibitions are arranged and, as often as not, tourists return home with examples of Las Vegas art, as well as with whatever they may have found irresistible in such boutiques as Prada, Chanel, Armani, Gucci, Tiffany & Co., and the other *marchands de luxe* on "Via Bellagio."

In 1963 the world's youngest island erupted into being from the ocean floor in Iceland. It is used as a natural laboratory, enabling scientists to study and observe the stages by which life arrives on a stony tabula rasa of mere rocks. I felt that I was observing something like that in Las Vegas—the formation of an art world. Hickey accepted a job at the university, perhaps to liberate himself from the precariousness of running a gallery of contemporary art and writing freelance criticism. Artists who knew his writing came to work in the graduate program and stayed on, as much perhaps for what Las Vegas offered as for the support they gave one another, and for the kinds of day jobs available to them while making their name: Las Vegas employs as many sculptors as papal Rome. I met one who earns his living executing styrofoam and fiberglass statuary for "The Venetian" hotel. Reverend Acres told me that when he first arrived, at four in the morning, he encountered two Elvis impersonators walking along the Strip holding hands, and he knew immediately that Las Vegas was his kind of city. The January/February *Art issues* shows him on the cover, preaching in a white suit in front of the Bellagio,

uniting the art scene and the gallery of notable paintings in a single vision
that defines Art–Las Vegas. I imagine Wynn would be indifferent to the lo-
cal art, though its unforeseen existence may ultimately contribute to his
gallery's success. So one had better go slow in transforming Las Vegas—man
does not live by higher sensibilities alone. I am still uncertain that art alone,
even when part of a hotel that exemplifies "the world as it might be if every-
thing were just right," would bring the required numbers of art lovers. The
gallery needs Las Vegas–Las Vegas to make a go of it as a high-cultural at-
traction. The question is whether the gallery's presence will transform the
resort into something higher. Las Vegas is a convention city. Perhaps it
should think of hosting an annual art fair!

Wynn himself is about as improbable a compound as Las Vegas with a
serious art collection—a showman and a businessman, but also an aesthete,
passionately responsive to art. (Warhol did a triple portrait of him in 1983,
so he has not just jumped onto the bandwagon of art.) I was able to spend
about two hours with him and his curator, Libby Lumpkin, talking about the
paintings he has acquired and examining transparencies of works Wynn has
his eye on. The gallery has lately added two old masters—a stunning paint-
ing by Rubens of Salome in a silken gown receiving the gory head of John
the Baptist and a Rembrandt portrait of a mustachioed man in a frogged
scarlet tunic. Wynn aims to have exemplary works from each century since
the Renaissance. Only someone of the greatest energy and means would
have been able to put together, in just three years, an art collection of such
quality, given the way the market for Impressionism is. But he is a business-
man to his toes, and I cannot for a moment imagine him doing that if he
could not justify it on the bottom line. He might not have done it except for
the money—but it was not for the money alone that he did it. The gallery is
intended at once to be a benefit and to make money, oddly parallel to the
way Reverend Acres's sermons are meant to be art and to save souls. The art
world is hopeful but cynical, and nothing better testifies to Wynn's status as
an outsider than the degree of his optimism and the absence of cynicism.
Only someone combining a fierce business drive with an extreme passion for
and belief in art would have supposed he could do well by doing good, bring-
ing great art to what Vallance calls "the people."

This combination explains many of the incongruities and anomalies of the Bellagio hotel. A pair of marvelous de Koonings hang on either side of the registration desk, for example. An impressive collection of (real) Picassos—paintings and ceramics—enlivens the walls of Bellagio's flagship restaurant, Picasso. Contrary to the rumor, none of the gallery's works are displayed in gambling precincts, though I was told that before its spaces were ready to receive them, paintings were hung where the high rollers—who are known locally as "whales"—gamble in privacy at the Mirage. But the paintings were there because security is understandably tight, not as a way of enhancing the experience of playing poker or shooting dice. Where better to store paintings worth twenty million dollars each? As if to make the distinction vivid between Bellagio's two functions, one can visit the gallery without even having to pass through the gaming area, whereas in every other casino I visited, the urgent electronic chirping of the slots and the exhilarating crash of silver coins greet you the minute you walk through the door. Instead, you approach the gallery at the far end of the opulently planted conservatory, which varies its floral displays to mark the seasons' changes (there are, of course, no such changes in the surrounding desert). During my stay, the Christmas display gave way to a planting that celebrated the Chinese New Year. The paths to the gallery and to the gaming area are at right angles, as if one must decide which path to follow. The complex connection between money and art, meanwhile, is embodied in the curious fact that everything in the gallery is for sale—though, that this policy can endure for very long, given the inherent scarcity of, well, blue-chip art, is hard to imagine.

Before leaving Las Vegas, I wanted a photograph of the "Now Appearing" sign with van Gogh's name on it. A man rushed out of the shadows, heading toward the Strip, shouting over his shoulder, "He only sold one painting in his *whole life!*" I wondered if he were a painter himself, when it struck me that this *triste* truth of van Gogh's life is a moral legend for us all. However outwardly like frogs we are, there is within us a prince or princess whose golden merit will one day be visible to all. That, I thought, was why it was so important that the art be real. It would not be a redemption for van Gogh that a reproduction of one of his paintings, however exact, should hang in Las Vegas, where the only thing real other than art is money. In the

game of life, any of us can become big winners. I conclude, brethren, with words by the Reverend Ethan Acres, describing an encounter between Steve Wynn and the Devil. The Devil says,

"Hey Steve, hey buddy old pal, c'mon, who's gonna come to this town, *my* town, to look at a bunch of girlie paintings? Listen, my man, what you need in Bellagio is a roller coaster, or better yet, just ditch the whole Italian crap and go with the Titanic as a theme . . ." Yes, the Devil offered him the easy road, but moved by God, Steven A. Wynn made his highway the hard way. . . . Flesh over paper, substance over style. Hallelluiah!

—March 1, 1999

RAY JOHNSON
∎ ∎ ∎

*I*F WE THINK OF A HISTORICAL PERIOD AS DEFINED BY WHAT THE
French have usefully designated a *mentalité*—a shared set of attitudes, prac-
tices, and beliefs—then a period ends when one *mentalité* gives way to an-
other. Something like this happened in 1962, when Abstract Expressionism
came to an end—not necessarily because the movement was internally ex-
hausted but because a new artistic *mentalité* was in place. And these *mentalités*
tend to rewrite the history of art in their own image. So Marcel Duchamp
and John Cage, who would at best have been marginal to the Modernist aes-
thetic to which Abstract Expressionism subscribed, became the generative
figures of the new period. Picasso, who had cast so daunting a shadow over
Modernist artistic practice, was now esteemed primarily for having invented
collage. Not everyone, of course, crossed the boundary into the new *mental-
ité* at once. There were many in the art world—artists as well as critics—who
continued to frame the meaning of art in terms of the *mentalité* in which they
had grown up. They were in, one might say, but not *of* the new period. It is
possible that the new artistic mentality was but part of a larger one—that of
the 1960s. If that is true, then the transforming forces that explain the upris-
ings of 1968 must already have been operative in artistic precincts in the
early years of the decade. Although 1968 is often explained with reference to
a revulsion against the Vietnam War, this reverses the direction of causality:
That revulsion is explained by the new *mentalité*. (What explains the *mental-
ité* itself? I have no idea!)

The new *mentalité* surfaced in 1962, when the artistic practices of a loosely structured group of American, European, and Japanese artists began to be referred to as Fluxus. The name was invented by George Maciunas, the prophet if not the founder of the movement, and it expressed a dissatisfaction with the kind of compartmentalization of artistic endeavors made explicit in the writings of Clement Greenberg. Under Modernist imperatives, Greenberg claimed in a famous essay, each medium must aspire to a pure state of itself, expunging any borrowings from other media. Fluxus works, by exuberant contrast, disregarded the borderlines between music, writing, theater, and the visual arts, so that every work of Fluxus art was in principle a kind of *Gesamtkunstwerk*. And the idea of artistic purity was not the only erstwhile value demoted by Fluxus. Its art was ephemeral and irreverent, often trivial, and typically took the form of a joke.

What Maciunas designated proto-Fluxus works were created in the late 1950s, when Abstract Expressionism was at its peak, so the art existed before its practitioners were conscious of themselves as forming a movement. The two *mentalités* coexisted for some years. The difference in attitude and practice, however, would have made it difficult to imagine that the concept of art was wide and elastic enough to accommodate the characteristic expressions of them both. The paradigmatic Abstract Expressionist work would be a large, heroic canvas affirming the agony of creation and the tragic view of life, such as Barnett Newman's painting *Vir Heroicus Sublimus* (1951). A not untypical Fluxwork would be Robert Watts's *Female Underpants* (circa 1966), displaying a patch of silk-screened pubic hair and worn by performers in a Fluxconcert irrespective of gender. The situation more or less resembled a marvelous scene in Richard Strauss's *Ariadne auf Naxos*, in which the tragic heroine shares an island with commedia dell'arte buffoons who try to snap her out of her grief by making faces and performing cartwheels.

Fluxus objects raised in an acute way what Abstract Expressionism took for granted—the philosophical question of the nature of art. Duchamp had raised this question through his readymades, which is why he was counted a proto-Fluxus master. And Cage brought to Fluxus a certain Zen disregard for sharp boundaries. Ben Vautier, a Swiss who joined the movement in 1962, declared that *everything* is art and began signing whatever came to

hand. (Warhol, too, once said he would sign anything.) Zen, in the form in which the deeply influential Dr. Suzuki expounded it, saw no distinction between sacred objects—like a statue of Buddha—and anything else. The avant-garde of 1962 was accordingly driven by concerns that could not easily be translated back into the problems of Modernism, in part because the formalism that had come to define Modernist aesthetics had no application to, say, *Female Underpants.*

Fluxus was defined less by a style of object than by a sense of performance. Fluxus objects were more or less props for art as a system of performances, rather than focuses of aesthetic contemplation. I was once shown a roomful of Fluxworks, acquired from a collector by the Getty Research Institute in Los Angeles. What they had in common was mainly the fact that they would not have been seen as even in candidacy for the status of art before 1962, and the fact that it was almost impossible to understand what they were about without art-historical reference to the actions to which they testified. One can get a good idea of such an aggregate from an illustration in *Fluxus Codex*—a kind of *catalogue raisonné* of the Gilbert and Lila Silverman Fluxus collection in Detroit—which shows a work of 1965 by Willem de Ridder, called *European Mail-order Warehouse/Fluxshop 1965.* Valises and toyboxes—and a hairbrush—are piled up together with books, journals, and posters, with FLUXUS printed on them. The critic Robert Pincus-Witten writes that while "the lion's share of Fluxus work assumes the form of transient pieces of paper—handbills and broadsides or boxed thematic accumulations,"

> Fluxus is an art jammed chock-a-block with minute containers of all shapes and sizes, little wooden and plastic boxes found in the "for sale" streetside cartons of the Canal Street supply houses—corrugated cardboard, mailing tubes, scraps of paper, plastic indecencies from the local joke or tourist shop, miniaturized Pop gewgaws of prepossessing verisimilitude—cucumbers, fried eggs—ballbearing puzzles that tax manual skill, articulated plastic and wooden take-apart puzzles and games, meaningless gadgets displaced from household and hobbyist needs, the tiny paraphernalia of the home workshop and playroom.

They are the leavings-behind of an art that did not so much make these objects as ends in themselves but use them as a means of communication with other artists who participated in the Fluxus *mentalité*.

Ray Johnson's work, on view at the Whitney Museum of American Art, has somewhat the look of a Fluxshop's inventory, arrayed in display cases and consisting of postcards, letters, collages, drawings, enclosures and attachments, and envelopes, to and from what Johnson described in 1969 as "several hundred New York Correspondance School International artist and writer 'members.' " The deliberate misspelling "correspondance" is characteristic of the ludic spirit of The New York Correspondance School, understood, in Fluxus terms, as a verb rather than a noun—as a way of interacting rather than the means by which interaction is achieved. And the idea of a "New York Correspondance School" may have been a jokey transform of "New York School," the term coined by Robert Motherwell as a label for those who did what Greenberg—hating "action painting" as a term—simply called "New York-style painting." If The New York Correspondance School was not itself a Fluxus work, it expressed the spirit of Fluxus, whose membership, like the network of New York Correspondance, was in constant, well, flux. Johnson may have been a Fluxus alumnus, like so many artists who participated in its eccentric manifestations—Joseph Beuys and Nam June Paik, for example; Yoko Ono (and, through her, John Lennon), Claes Oldenburg, Allen Kaprow (the inventor of Happenings), and Christo, all of whose works are grounded on Fluxus premises. The movement had no pope, the way Surrealism had Breton, empowered to say who was or was not a member. So artists came and went.

Most of the Correspondance School members are fairly obscure (as were, for that matter, most members of Fluxus). The artist John Willenbecher identified for me the exceedingly obscure Jeter Stalcup, "which only a few initiates might know was the name of someone Bill Wilson's mother, May, found in an early computer-generated dating service shortly before she moved to New York in her 70s." The letters, often ornamented by simple drawings or by stick-ons, usually instructed the recipient to perform some fairly simple action. The Correspondance School was a network of individuals who were artists by virtue of playing the game. Some of them were what

Willenbecher terms "initiates" by virtue of sharing—or at least appreciating—Johnson's sense of humor: a readiness to respond to a certain kind of joke or pun, visual or verbal; to take trivial things as monumentally important; and to profess a fan's dedication to certain borderline celebrities like Anna May Wong or Ernie Bushmiller, who drew the comic strip *Nancy*.

One of the activities of the Correspondance School consisted in calling meetings of fan clubs. In one of the display cases there is a flier, on cheap red paper, announcing an Anna May Wong club meeting at the New York Cultural Center, to take place on June 3 of the year it was sent, from 1 to 3 PM. On it Johnson drew a number of cartoon bunny heads, looking much alike but, in deference to Anna May Wong herself, all with slanted eyes. The bunny head was Johnson's logo, and since the bunny heads on the flier all look alike, the implication of a common *mentalité* is graphically conveyed. The heads designated the putative members of the fan club—fifty-two by my count. I think of it as a kind of class picture of the school's more faithful members. I know—or know of—perhaps eighteen. I suppose that what one did at such a club meeting was to compare Anna May Wong's roles with one another. Or is it possible that no one turned up at the center, and the meeting consisted in just its own announcement?

I expect that every letter Johnson ever sent was part of the New York Correspondance School archive, but the characteristic communication would have been addressed—in all senses of the word—to an individual who could be counted on to perform the simple task the letter enjoined (which sometimes consisted in sending the letter on to someone else) or to connect the dots in such a way as to reveal the joke. Sometimes the letter is generic, implying, with qualification, a bulk mailing. In one letter—to someone named "George"—Johnson described spilling boiling water on himself, causing him to take a tetanus shot at the emergency clinic. He asks George to photocopy the page, "sending one copy to Andy Warhol at 33 Union Square, New York City. I could use about forty-four xerox pages for N.Y.C.S. mailing." It is signed with a bunny logo, interestingly rotated, as in Wittgenstein's duck-rabbit puzzle. One can see the quality of Johnson's wit when one considers that the horizontal ears make the logo look like the two-

fingered victory sign turned on its side. Not unexpectedly, he writes "Peace" just above the logo. The letter is dated April 22, 1969, so the rotated bunny is a muted political gesture. Johnson's basic form of perception consisted in seeing what Wittgenstein called "aspects"—the duck in the rabbit (or vice versa), the peace sign in the victory sign rotated, the way "PALS" and "SLAP" are anagrams, as if there were some deep truth about friendship hidden in this fact. To appreciate the disclosure of these meanings qualified one as a member of the NYCS. To continue the play required that one did not suffer, to use an expression Wittgenstein associated with the duck-rabbit, "aspect blindness."

It fits my historical schematism to perfection that Johnson should have begun the Correspondance School in 1962. Others before him had certainly modified postcards and letters in ways that would be appreciated—perhaps uniquely appreciated—by their intended recipients; Mallarmé, for example, found witty ways of addressing envelopes. But such poetic spillovers would not have been seriously considered as art until the concept of art was transformed—by Fluxus, among others. It also fits my sense of Fluxus that The New York Correspondance School belongs only incidentally to what came to be known as "mail art" later on. At one time Ida Applebroog printed up a number of pamphletlike books, which she mailed to various persons in the art world. She called them "performances," and they typically consisted of an image repeated several times, like a comic book in which every panel shows the same thing. In *Now Then* (1979), the same man is shown seated in the same way, frame after frame. After three frames, there is a subtitle: "*Take off your panties.*" There follow four frames exactly like the last one—though the words now enable us to describe the man as looking at someone he humiliates through his gaze. The subtitle transforms the iterated frames into a narrative—it removes our aspect blindness. So they have the structure of NYCS jokes. Applebroog had an address list, but she did not have a network. The booklets were, so to speak, self-advertisements, giving her a way of getting recognition until her work was accepted by a gallery. Though Johnson had gallery shows—and was exhibited at the Whitney in 1970—he would not have regarded the gallery as his destined locus. The New York Correspondance School was not intended as a means to anything beyond its own con-

tinuation—though it was so integrally expressive of Johnson's artistic personality that no one appears to have succeeded him after his death.

The work tends to split the Whitney show's viewers into two classes. One class consists of those "hundreds of artists and writers" who received letters and did whatever they were asked to do, whose lives were infused by the sensibility the letters express. The other class consists of the rest of us, who must take what pleasure we can from what remains public and accessible in the assembled letters and collages. I am impressed that most of the essays intended for the catalogue of the show were written more or less as reminiscences of Ray Johnson by people who were, or might have been, members of the Anna May Wong Fan Club. That means there are not as yet real Johnson specialists, who have done research time in the scrapboxes of Johnson's studio in Locust Valley, New York, and are able to annotate the letters, identify the recipients, tell us from what issue of what magazine a given picture was scissored out, draw to our attention hidden meanings that have inexplicably not been noticed by the learned Professor X in his definitive (ha!) catalogue.

Perhaps because I once held the Johnsonian chair in philosophy at Columbia University, I received a few mailings from The New York Correspondance School, which I dutifully modified and returned—though I have no idea what Johnson would have wanted done with them. I did not especially share the prerequisite sensibility, though when we met we found we had certain things in common. We both grew up in Detroit, where we discovered the Danish Sportsman's Club as a neat place to drink, and we had moved to New York in the same year. I did not hear from him for many years after that, until a piece of mail arrived late in 1994. It was a drawing of a faceless woman. We were (I am certain I was not the only recipient) to answer the question "Who is this curator?"—and were given some of the letters of her name. I quickly saw that it was Donna De Salvo, a curator of the Wexner Center for the Arts in Columbus, Ohio, who in fact curated this fascinating show at the Whitney. The press opening for it took place on January 14, 1999—almost four years to the day after the artist's suicide by drowning in the chill waters off Sag Harbor, Long Island. A suicide note would have been too portentous for The New York Correspondance School.

There are, however, a number of what may be clues if we want to think of the drowning as a last performance—a way of communicating with everyone through the obituary pages of the major newspapers. The Correspondance School is a Fluxus masterpiece, if that makes any sense. But its countless scraps and scribbles merely express its spirit, which can hardly be put on view in a vitrine. Spinoza made a distinction between *natura naturata* and *natura naturans*—between the world as a system of objects and the world as a system of processes. What we see in the display cases is *Johnson johnsonata*. The art was *Johnson johnsonans*.

—*March 29, 1999*

THE AMERICAN CENTURY
▪ ▪ ▪

ONE AFTERNOON IN 1985, I RODE IN A TAXI DOWN BROADWAY WITH the physicist I. I. Rabi, discussing time and age. Rabi told me he was eighty-eight—"as old as the century." "Rabi," I murmured, "your computational powers appear to be waning." He responded sharply: "The twentieth century began with the discovery of the electron by J. J. Thomson, in 1897." In view of Rabi's immense scientific contribution—he won the Nobel Prize for his work on nuclear magnetic resonance in molecular beams and trained far more Nobel laureates in physics than anyone else—it was entirely understandable that he should identify his birthdate with that of modern physics. And Rabi chided me for supposing that centuries begin and end on a midnight's stroke. By the time the twentieth century began, it had, so far as physics is concerned, already begun.

It is irresistible to ask, on parallel grounds, when the twentieth century began in art. Since Modernism is prima facie the defining twentieth-century style, the beginning of twentieth-century art must coincide with the origins of Modernism, however that is to be dated. It had its beginnings in Europe sometime in the nineteenth century, defining itself in opposition to a tradition of pictorial representation dating back to the early Renaissance. According to that tradition, the visual and the picturable must be equivalent—a picture of an object should ideally yield the same experience as the object itself. For that reason, illusion played a central role in theories of visual art almost from the beginning. Modernism, for whatever reason, separated picturability and visuality, so that a picture need no longer look like what it was to represent. There is

no specific event associated with this discovery. It was rather something that slowly dawned over the face of European art, possibly having to do with the growing awareness of different representational systems, coming from other cultures, which were free of the optical constraints of traditional Western painting. That would have meant a crisis of cultural confidence we can appreciate when we consider that such art had often been disparaged as "primitive" in relation to the towering European achievements. Some writers, Clement Greenberg for example, claim that Modernism begins with Manet's *Déjeuner sur l'herbe*, in 1863. The first stage of the massive exhibition to which New York's Museum of Modern Art will dedicate itself over a span of seventeen months—MoMA 2000—will be titled "Modern Starts" and will cover the years 1880 to 1920. Although the beginning of the twentieth century bisects this period perfectly, should we say that our century began in 1880? Or might Modernism itself have been a nineteenth-century phenomenon, which lived on for about two-thirds of the twentieth century? So that, artistically, we have been in the twenty-first century since perhaps 1964?

Gertrude Stein said, wittily but wrongly, that America is the oldest country in the world, since it was the first to enter the twentieth century. From the perspective of art history, the United States was among the last to enter the new century. In 1905 Matisse and his colleagues earned the label of *fauves* (wild beasts) at the Salon d'Automne. In 1907 Picasso painted the *Demoiselles d'Avignon*. A memorial exhibition of Cézanne in that same year sparked a series of radical experiments in modes of representation, which made artistic success increasingly dependent on formal innovation. Futurism began in 1909. Malevich's Suprematism was invented in 1913. Discounting a handful of prophetic figures in the United States, Modernism exploded into American consciousness in the Armory Show of that year, primarily as an occasion for journalistic hilarity. If we follow Rabi's principle, the twentieth century in American art began well after the calendar, which he held in such contempt, showed that it had begun.

Gertrude Vanderbilt Whitney opened her studio in 1907 as an exhibition space for young American artists to whom the commercial galleries of the time were closed. Most of what they showed was twentieth-century art by calendrical default, but almost certainly it was not Modernist. The Whitney

Museum of American Art was founded in 1930 when the Metropolitan Museum of Art turned down Whitney's offered donation of about 500 American works. From its inception the Whitney was obviously an artist-oriented institution, in contrast with the major art museums of the time, which addressed aesthetic consumers athirst for the beauty and spiritual meaning attributed to the fine arts. It is perhaps in the spirit of its continuing championing of American artists that the Whitney has decided to present as its valediction to this century an extraordinarily ambitious exhibition, "The American Century"—as if those who could not find commercial venues in 1907 had taken over the world, artistically speaking, by century's end. The title is perhaps excusably triumphalist, but it is hardly sustained by the chronology of American art through the period 1900–50, which Part 1 of the exhibition covers. (Part II, of course, will cover the rest of the—calendrical—century.) American paintings from the first decade of the 1900s look like society paintings from Paris or London in the 1890s or even earlier. They would make marvelous illustrations for the novels of Henry James. (James, who deeply appreciated painting, extravagantly admired the Pre-Raphaelite Edward Burne-Jones and so had an understandably difficult time learning to accept Impressionism, which marked the cusp between traditional and Modernist painting.) It is true that after 1950 New York replaced Paris as the artistic center and that American art swept the world, first with Abstract Expressionism and then with Pop and Minimalism. But the social politics of art had so changed by the 1960s that successful American artists simply became members of the international art scene, and Americanness as a concept dropped into obscurity. The Whitney itself has sought ways of getting around the restrictions implied by having "American art" as part of its identity—since its rivals in any case now collect American art with impunity—by organizing exhibitions that reflect the internationalist spirit of the age. The exhibition might better have carried the title "A Century of American Art." The period bounded by 1900 and 2000 contains artistic transformations that perhaps parallel the discovery of the electron—a particle that, it was recognized by 1927, is radically unpicturable—but the periods into which the present exhibition is divided correspond less to the internal development of art within the borders of the United States than to the historical events through which the United States lived, the two world wars and the Depression.

[370]

It is a staggeringly rich exhibition that integrates a massive number of objects, selected and organized into a coherent whole by Barbara Haskell. There is, on the other hand, the major question of how so large and diversified an exhibition is to be critically addressed. Critics like to complain that there are few surprises or that certain works from the years the exhibition covers are not included. But even if there were many surprises and all the canonical works were on view, the large question would remain: How are we to address an exhibition on the scale of a century of American art? A few years ago, an important New York museum director declined to put on a proposed show called "The Twentieth Century" on the grounds that we already have, in the permanent collection of the Museum of Modern Art, as full a selection of twentieth-century art as might be wanted. But an exhibition is something more than a collection of objects, however expansive, and it seems to me that critical attention might better focus on the larger exhibitional structure here, rather than attempt the object-by-object scrutiny with which art criticism is most comfortable. How is one to experience the exhibition on its own terms, whatever objects may catch one's aesthetic attention or evoke one's historical memories?

So far as the internal history of art is concerned, 1950 is a good place to pause. Most of the artists who were to define the American presence in the consciousness of the world were already in possession of their signature styles. In 1950 Jackson Pollock painted masterpiece after Modernist masterpiece. Mark Rothko felt that a period in art that might last a thousand years was under way, replacing the period that began with the Renaissance. The future looked reasonably clear. But Abstract Expressionism, for complicated reasons, came to an end a dozen years later—and though art in more or less Modernist styles went on being created after that, as part of the pluralism that has overtaken the art world, that very pluralism makes the future of art after 2000 exceedingly obscure. (These matters will have to be addressed when Part II is installed.) Since both parts of the show use the subtitle "Art & Culture," however, I shall suppose that this conjunction marks the way the organizers of the show intend each part to be experienced and explains why many of its objects have been selected as well as how they have been arranged.

Like the old "theater of memory," which Renaissance speakers used for mnemonic purposes, the Whitney periodizes the twentieth century with reference to its own architecture. The show begins on the fifth floor with "America in the Age of Confidence" (the overall title, "The American Century," itself seems an "Age of Confidence" expression). One descends to "Jazz Age America, 1920–1929" on the fourth floor, and, after "America in Crisis, 1930–1939" and "Wartime America, 1940–1945" on the third; the show ends on the second floor with "Postwar America, 1945–1950." I have no idea how Part II will be structured, but it is reasonable to suppose that it will begin with something like "America in the Cold War"—though it is not easy to think of much American painting done in response to that sullen phase of recent history. The spirit of American art after 1950 might be better expressed through Mark Tansey's allegorical masterpiece of 1984, *Triumph of the New York School*, which depicts the Americans—in World War II uniforms and led by Clement Greenberg—receiving the surrender of the French, dressed in the uniforms of World War I and led by André Breton. In any case, the show divides, under its general subtitle "Art & Culture," each of its periods into objects regarded as Art and objects meant to exemplify Culture. So there is an initial question of which is which and a further question of how they are related to each other, other than belonging to the same historical moment.

Let's begin with "America in the Age of Confidence" and use as our guide the corresponding chapter of the very handsome catalogue Haskell has compiled for this occasion. It shows, as Art, paintings, sculptures, and—what might have been heavily contested at the time—photographs. Whether photography falls within the scope of Art was an internal critical problem then, with one influential answer being that photographs are art when they look like paintings. But even photography's most energetic enthusiasts would have drawn a distinction between artistic photographs and vernacular, utilitarian photographs. The "working photographs" would presumably belong to Culture. Punctuating Haskell's text on the historical development of art from 1900 to 1919 are a number of sidebars that address further aspects of Culture: the decorative arts, illustration, dance, arts and crafts, urbanism, vaudeville, early film, popular music, politics, and theater. With the exception of the work of Louis Comfort Tiffany, who, until Charlie Chaplin, was

the American artist most admired outside the United States, it might be more on the basis of Culture than of Art that the twentieth century can be considered the American Century. American popular culture so infuses the consciousness of the world that everyone, however anti-American in politics or attitude, is more or less deeply American in culture.

Displaying Art, especially from before 1950, is conveniently easy. One hangs the pictures next to one another on the walls and places sculptures where they can participate in "dialogues" with one another and with the pictures. For obvious reasons, displaying Culture is a less settled matter, though the technologies available to contemporary museums allow facilities for showing film clips and playing snatches of music. Beyond that, of course, there are photographs of vaudevillians—actors and actresses and dancers—as well as of important architectural and urban sites. These would be working photographs—they show us things that cannot themselves be shown within standard museum spaces, certainly not in any permanent way. So it is a simple enough matter to distinguish Art from Culture. The paintings are paradigmatically Art. If audiovisual technologies are required to show something, it belongs, roughly, to Culture. So Tiffany lamps might be considered Art, since we can show examples and not just photographic reproductions of them. We can also show handsomely designed coffeepots and vacuum cleaners, as MoMA began to do decades ago. But most of Culture is displayable mainly through secondary means, like photographs of performances, posters, playbills, and the like.

I must admit to a certain paranoia when I encounter the word "Art" in conjunction with "Culture." It echoes those earlier exercises in cultural criticism, epitomized by Greenberg's "Avant-Garde and Kitsch," Dwight Macdonald's parallel division between popular and high art, and comparable exclusionary schematisms that gave such comfort to midcentury American intellectuals. The exclusionary spirit erupts in anger and resentment whenever an inclusionary effort is made—witness the critical frenzy unleashed by the great MoMA exhibition "High & Low" of 1990, in which the effort was made to demonstrate how art and popular culture were connected under Modernism. My overall attitude is: Why not treat all the sidebar material as Art, instead of separating it by virtue of the "Art & Culture" formula? What American intellectuals resented in popular art was that it could be enjoyed by

people who had not undergone a quasi-priestly preparation in learning about history and critical canons. That such art could be so enjoyed was considered a mark against it. But it should not be counted as a mark against popular art that it is popular, as if "popular" were a disabling critical criterion. Chaplin's or Hitchcock's films were both, as were magazine covers in their golden age and much else dismissed as kitsch. The distinction between good and bad art cuts across the distinction between Art and Culture.

Once we reclassify Culture as Art, we are no longer obliged to ask what the relationship is between objects of Art and of Culture or what knowing about Culture helps to explain about Art. If Culture is already Art, then it no more provides a context within which Art is to be understood than painting provides a context within which vaudeville is to be understood. And one of the educational hopes for such exhibitions drops out of the picture. Painting and vaudeville just happened to be going on at the same time, the latter occasionally furnishing content for the former, as in some of the Ashcan School painters or in Reginald Marsh or Edward Hopper. One of my cherished possessions is a theatrical photograph of my uncle Will Aubrey—"The Bard of the Byways" on the Keith-Orpheum circuit. I cannot imagine, however, that it helps one bit in understanding the painting being done in the last years of American vaudeville—though the schematism for showing a singer accompanying himself on the guitar may have been a commonplace since Manet.

There is another way to think of the matter. This is to treat art *as* culture. That means, of course, treating high as well as low art as indexes of and openings into the American *mentalité* at a given moment. Here are their songs, their dances; this is what they wore; these were the pictures they looked at; this is how they lived. From this perspective, there is nothing to choose between paintings and MetroCards or five-dollar bills or IRS 1040 forms or lottery tickets. These all help to open the American spirit up for cultural analysis. Inferring from cultural object to cultural spirit belongs to the methodology of the so-called human sciences, on which so many of the fundamental practices of art history are based. By treating art as culture in this way, the whole exhibition becomes an educational tool. It instructs us about changes in American mentality, 1900 to 1950. The show's billboards around town, reproducing Grant Wood's *American Gothic*, enjoin us to "make some sense of America." Does American art really lend itself to that?

Hegel wrote that in art the spirit appears made sensuous. But he believed that art belongs not only to what he termed "objective spirit"—to the cultural beliefs and attitudes a people more or less shares for a period of time—but also to what he called (forgive me) "Absolute Spirit." It expresses or is capable of expressing, through sensuous means, the highest truths of philosophy or theology. It is not a simple matter to integrate these two dimensions of Art, even when we construe the latter to include so much of what this exhibition defines as Culture. Art criticism belongs to art considered in Absolute terms, in which we seek to determine what it is about and how it transmits its meaning. On the other hand, art criticism has nothing much to do with Art as an expression of objective spirit. But we can instead, through the art, practice a kind of cultural criticism. It will be recognized that much of art scholarship, including much of what is designated as the "New Art History," is cultural criticism in this sense. Choosing how to have themselves portrayed tells us something about Americans, whatever the artistic merits of the portraits themselves.

There is no reason we should not see art in both ways, though the two kinds of criticism usually take us in opposite directions. This is the problem raised by exhibitions of this sort, and it means that experiencing such shows involves what we may call bifocal adjustments at every step. Making sense of America, however, had better be only part of what we emerge with, if there is any point at all in exhibiting American art. But even when restricted to that purpose, I am unsure how far America's art brings American culture within our reach. The huge success of American popular culture, for just the reason that it is so successful globally, tells us only what global culture is like, since everyone listens to the songs and sees the movies and wears the jeans and running shoes. Even when expanded to cover popular art, however, art is too restricted a sector of American culture to make much sense of it. Like the boundaries of a century, the boundaries of a nation serve poorly to exhibit the latter's spirit when that spirit is the result of so much that takes place outside them, as happened with Modernism. Had my ride downtown with Rabi continued, he might have made a parallel point about American science.

—June 7, 1999

WARHOL AND THE
POLITICS OF PRINTS

• • •

For Ron and Frayda Feldman

IN THE YEARS OF REVOLUTIONARY FERVOR—IN 1968 AND '69, AND fitfully and more ritualistically until the mid-1970s—students in American universities felt themselves to be the only agents for moral change in a largely corrupt society. So even when their lives were occupied with demonstrations and occupations, with rallies and picketing and confrontational disruptions, they lost no opportunity to enhance their understanding of things by participating in teach-ins, and by listening to speakers who explained the complicity of their universities in military research, and instructed them about the imperialist backgrounds of political struggle in the Third World. Flyers would appear and disappear, announcing this or that celebrity from the left, and, as a professor at Columbia University, curious to understand the forces which appeared to be shaking the foundations of my institution, if not indeed the world, I tried to attend as many of these events as I could. One day a flyer announced that all were invited to hear Buffalo Bob and Howdy Doody at Ferris Booth Hall. The discourse of indignation and outrage was relieved, from time to time, by programs of folk song and poetry readings, but Howdy Doody seemed an unlikely source of revolutionary inspiration. Doubtless, he and Buffalo Bob had been scheduled by some student activity committee at a time when no one had anticipated the events we were all living through, and they came to put their show on and collect their fee. That night, the zealous agents of moral redemption sat like children on the floor of the student lounge; they happily sang along with Howdy Doody the songs they had sung with him in front of their television sets in secure

family rooms in suburbia only a few years before, with milk and cookies, before going off to bed. Not dance nor drugs nor political victory could have made them as happy as they were on that incongruous evening. On most occasions, the students looked and acted the part of Cuban revolutionaries, fighting alongside Fidel in Oriente province. But tonight they were children again, singing alongside Howdy Doody in snuggies, innocent of the injustices in the dark world around them.

I thought of that disclosing moment when I saw Andy Warhol's print of Howdy Doody in his suite of prints called *Myths*, when it opened at the Ronald Feldman Fine Arts gallery on Mercer Street in the early 1980s. It was a very widely attended opening, with crowds spilling out into the street, and I wondered how many of those present had sung the Howdy Doody songs at Columbia or at some other of the campuses Buffalo Bob and his wooden consort must have toured, and how many of them were struck, as I was, by the ironic juxtaposition of Howdy Doody's grinning mug with the dour, craggy face of Uncle Sam, who had been the embodiment of political evil in the mythologies of 1968. Everyone within the scope of television would know, in a general way, who Howdy Doody was. But there was an intraversable line between those who held this knowledge as an external truth, and those whose souls were internally shaped by Howdy Doody as the kind of friend the plush dinosaur Barney became for a later generation, or as the image of the Virgin must have been for the Crusaders: a glowing inner presence that united them in a network of meanings, and gave them a focus of feelings and of values. That line divided my generation from theirs, and for that matter divided Andy Warhol from them, since he and I were near in age. But Warhol had the tremendous gift of understanding which were the defining myths of a generation, whether or not he belonged to it, the gift of identifying the images which unite a group of disparate individuals in a common mind, and placing those images before them as the substance of their being. The images may be as intrinsically shallow or inane as Howdy Doody, which doubtless led Warhol's critics to think of him as shallow and inane. But such critics were blind to the power these images held for the vast populations whose lives they distilled and energized. Who would have known of it until he showed us the moral sublimity of canned soup? Who would have acknowledged the domestic power of Brillo, that emblem of cleanliness and

brightness, a metaphor for what one wants the world to be like, with shining kitchens and television sets in front of which the world's children, warm and safe, sing the songs of innocence?

Warhol seemed not to be part of the crowd that evening at the Feldman Gallery, loping the margins of the crowd whose common inner self he had made objective in the great suite of prints whose images were drawn entirely from popular culture: a movie star (perhaps Elizabeth Taylor as Cleopatra), Superman and Mickey Mouse and Santa Claus as forces of good, Dracula and the Wicked Witch of the West as forces of darkness, Uncle Sam as ambiguous, somewhere between good and darkness, Aunt Jemima as the emblem of our daily bread, and, of course, himself, whose image seemed so much more substantial than the lank figure with drawn features and fine, silvery hair. He was not a myth for himself. *He* was *The Shadow*, the absolute outsider, whom only the Shadow knew!

How much of this might have been clear to me in 1981 is hard for me to say, for my own interest in Warhol as an artist lay elsewhere at the time. That year I published *The Transfiguration of the Commonplace*, which elaborated ideas that had been inspired by Warhol's work when I first saw it at the Stable Gallery, on East 74th Street, in 1964. The Feldmans took over that space sometime in the 1970s, and Ron Feldman recently told me that Warhol used to drop by the site of his first triumphs as an artist, before he was taken up by Castelli, asking if Ron or Frayda had any ideas he could use for art. I do not know who had the idea for *Myths*, which was published by Ronald Feldman Fine Arts, or for that matter the suite they published the previous year, *Ten Portraits of Jews of the Twentieth Century*. It is a biographical fact that Warhol was always mooching ideas, and there are legendary stories of how he had been set on the right track by such figures as Henry Geldzahler, Emile di Antonio, or Ivan Karp. Still, it was *Warhol* who was soliciting ideas, and only someone who had internalized what one might think of as that which Jean-Paul Sartre would designate as his *original project*—the project which defined the entirety of his individual decisions as an artist and a man, and which gave his life its strange unity—would have had anything useful to tell him. Or better, it was Warhol who knew whom to ask when he was at some choice-point of his career. Whatever the case, *Myths* is a magnificent example of one aspect of his original project, and this came home to

me after his death, when I was asked to write the piece *ARTnews* published as "Who was Andy Warhol?" Just as that opening at Feldman's evoked the memory of the Columbia students in a moment of benign regression, the meaning of the opening rose to consciousness when I sought to see his art as a totality in the retrospective light which death makes available to us. I thought of his political genius.

I do not have in mind by this his explicitly political images, such as the celebrated poster which shows Nixon's face in menacing colors—could Nixon's face, however colored, *not* look menacing?—but rather his uncanny ability to find the images that defined the consciousness common to a populace. 1968 was a year of student uprisings in universities the world around, and the causes of unrest have to lie deeper than the Vietnam War or military research, which formed its occasions in America (at Columbia the occasion, but hardly the cause, of the student uprising was the university's planned construction of a gymnasium in Morningside Park, one of Olmstead's public parks which covers the east slope of Morningside Heights, with its lower edge forming a natural boundary for Harlem). The students of each nation involved had to find occasions for their uprisings, whatever the roots. The American students formed a unitary group through a common set of emblems which included the memory of the television figures of their childhood. French students would hardly have known who Howdy Doody was, nor German nor Yugoslavian nor Scandinavian students. Not to know who Howdy Doody was would automatically exclude someone from the culture his image defined. To have to ask who he was and what he meant was the cognitive mark of not being part of the community which was partially constituted through knowing who he was and what he meant. A community is defined by the images its members do not have to find out about, but which they know and understand immediately and intuitively. If twenty-year-olds in 1968 knew Howdy Doody in this immediate and intuitive way, irrespective of their class and their racial backgrounds, the central community to which they belonged transcended differences between class and race. Everyone in America knew Liz and Jackie, Elvis and Marilyn, Mickey Mouse and Superman, Campbell's Soup and Brillo. When this knowledge vanishes, the culture will have changed profoundly. Odysseus was once instructed to set off with an oar over his shoulder, and when people asked him what that was,

he would know he was among people deeply strange to his culture. When people know who Marilyn was only because they have made a special investigation, Marilyn will have stopped being part of who "we" are—or there will be a new "we." But when this knowledge is internalized by persons outside the political boundaries of America, they are in effect deeply American, whatever their nationality.

Warhol's political gift was his ability to make objective as art the defining images of the American consciousness—the images that expressed our desires, our fears, and what we as a commonality trusted and mistrusted. Very few politicians actually possess political genius in this sense, and perhaps it is a good thing that it is as rare as genius is supposed to be, for the symbols are not necessarily as benign as Howdy Doody. Joseph McCarthy possessed the gift, for example, and so did Hitler, who created an image of the Jews so virulent that it had to have captured something deep in German consciousness, and formed so basic a stratum of the German mind that it is not possible to claim that it was Hitler's fixation alone: he did not teach the Germans something about the Jews, he taught them something about themselves. If those images have lost their virulence among Germans today, theirs is a culture which has changed radically since World War II. It is clear that Patrick Buchanan has such a gift, and equally clear that Robert Dole does not. It is exceedingly difficult to believe that a balanced budget energizes the American soul at present writing. If it is energized by Howdy Doody, by Santa Claus and Mickey Mouse, by Superman and by Coca-Cola—or by Andy—then there is some grounds in the content of consciousness for what Eugene McCarthy once described as the myth of American innocence—if we could erase the electric chair, the race riots, and various other horrors we also recognize as us, and instead paper our souls with cows and flowers.

It would be interesting to connect the politics of Warhol's symbolic vocabulary with the print, which allows the identical image to pass into a larger number of hands by far than would be possible with paintings, democratizing the distribution of art. I remember the stack of offset prints of *Flower* at the receptionist's desk at Castelli in 1964, where they cost, in my recollection, five dollars each. I was surprised to learn from Frayda Feldman's catalogue that there were only three hundred of these, since everyone I knew bought one or two. That shows the narrow radius of the art world in that era. That

they were cheap and unnumbered, printed on ordinary paper by a vernacular shop not especially known for fine art prints, went, I think, with the idea that everyone who wanted one could have one, and that there were no relevant differences from print to print, so that connoisseurship could not intervene and make its arbitrary distinctions. Because they were so democratized, on the other hand, those prints were treated as virtually disposable—who thought of them as Art-capital-A? People wrapped packages with them, or tacked them up unframed until they became soiled and torn, so that by now they have a rarity and value altogether subversive of artistic intention. (I put mine in a good frame and hung it in my younger daughter's room, not because I was prescient in protecting an investment but because I thought it a bright and cheery touch for a space which was just being transformed from a nursery). I doubt I would have bought the Campbell's soup can printed on a shopping bag, even if autographed, just because I still would have carried in my mind a prototype which distinguished fine art prints, which could be matted and framed, from utilitarian objects with images printed *on* them. Greatly as I admired the philosophical energy Warhol released by over-throwing boundaries between art and life, I was unprepared for the boundary between prints and what the post office designates as "printed matter" to be overthrown—though this, too, was part of the tremendous philosophical in-tuition that first aroused my admiration of him as a thinker. My appreciation of his political gift only dawned on me after his death.

When I speak of philosophical intuition, I refer to the complex dialectic involved in philosophical analysis, where the aim is to nail down a definition of something—of knowledge, of justice, of goodness, of art—by finding the necessary and sufficient conditions for something to fall under such a con-cept. This enterprise is magnificently presented in the Socratic dialogues of Plato, where Socrates seeks to bring the definition of a concept to the sur-face of consciousness by taking the tentative definitions of his various con-versational partners, and probing to see if there are not some obvious counterexamples, and then how the definition can be modified to block the counterexamples. The Abstract Expressionists revolutionized the concept of abstraction, chiefly because the latter had been so closely identified with geo-metrical forms and clean planes of color, and in a way they revolutionized the concept of painting by making personal and subjective work on a scale

ordinarily reserved for public and monumental motifs. But they did not rev-
olutionize the philosophical understanding of art the way Duchamp did
when he bumped aesthetic consideration from works of art, when these had
been, since the eighteenth century at least, counted as part of the essence of
art. Warhol was marvelously intuitive in this kind of project by drawing his
images from the vernacular, by using ready-made images, by accepting au-
thorship of work made by the "Factory," and especially by making works of
art so like real counterparts that it became obvious that one could not differ-
entiate art from reality by perceptual means, or teach the meaning of "art"
ostensively—by pointing to examples. In case someone thought that one
could define moving pictures as pictures that moved, he made an epic film of
the Empire State Building which was a moving picture in which nothing rel-
evantly moved.

This philosophical impulse inevitably carried over into his prints. The
distinction between a print and something merely printed was overcome by
means of the shopping bags of 1964 and 1966, and the distinction between
art and mere utilitarian objects was overcome by signing the shopping bags
(no one today would think of carrying laundry in one of these, or using one
of the *Flower* prints to wrap packages, which would be like Duchamp's exam-
ple of employing a Rembrandt as an ironing board). The distinction between
a print and a reproduction was similarly erased when he used the most com-
monplace of contemporary reproductive methods, the xerox, to make prints,
incorporating into the identity of the print the internal mechanism of invol-
untary enlargement meant to thwart copying. His putting out editions of his
"trial prints" is a further subversion of certain considerations of connoisseur-
ship having been allowed to penetrate the philosophical essence of the print,
and his making an edition in which each of the impressions is different, not
merely *solo numero*, dissolves at once the idea that the impressions in an edi-
tion must be all the same, while making differences of an irrelevant sort
count for purposes of connoisseurship. Making prints consisting of only one
impression (but which are not monotypes), while putting out editions of
prints which in effect use the same technology and imagery as concurrently
executed paintings, are examples of further conceptual erasures. So what
then *is* the definition of "print"? Well, he might say, pointing to the array of

works, *these* are prints. If you want a definition, it cannot include among its conditions those which are exploded here!

The strategy of weakening and widening the concept of the print, and aiming through editions open in number and cheaply enough made that all who wished to own one could, was an effort to weaken or blur the social boundary between the rich and the poor, while the strategy of finding images that went to the heart of everyone in the culture democratized meaning. The egalitarian motive, though not the democratic one, inevitably came in conflict with the price structures of the print market in the 1980s, when newly issued prints by famous artists sold for prices far beyond the average reach. *Myths* is executed on 100 percent rag paper, acid free, of "museum quality." The print had gone from being something it made sense to think of as ephemeral—like the flyer for an exhibition which has merely archival value when the show comes down—to an investment to be protected. To be sure, Warhol made paintings of the same images and by means of the same processes as he used with the prints in the *Myths* portfolio, as if to guarantee those unable to afford paintings were getting in the prints they could still acquire nothing relevantly different. And they possibly got more, if they were to acquire the entire set of ten, since almost nobody could afford all ten of the corresponding paintings. And, beyond that, the portfolio of ten prints was like a time capsule, preserving the defining images of an aging population on paper and in ink chosen to withstand the tests of time. In its own way, the portfolio had a memorial function, looking backward. It answered to the same impulses as the technologies of mummification in ancient Egypt.

It would be instructive to map the prints of succeeding decades onto the transformations of consciousness the common mind underwent from the 1960s through the 1970s into the 1980s—from the decade of revolutionary political imagination, through the decade of sex, drugs, and rock and roll, to the decade of money, when those who sang along with Howdy Doody began to think seriously about dollars and of art as an investment. There is something moving in the fact that the 1970s, marked by images of transvestites, of Mick Jagger, of sexual parts and fellatio—and of the once inspiring and feared emblem of hammer and sickle played with as an ornamental motif—should climax with a sober black-and-white still life, "After the Party," and

end with the shadows Warhol was to associate his own image with in *Myths*. After the *Myths* come the *1$'s*, which is obviously for the Reagan years, but then, it seems to me, the subject matter becomes similar to what one finds in the prints that ornamented genteel parlors of bourgeois households in an earlier and less frantic moment: images of antiquities, of famous structures like the Brooklyn Bridge, Cologne Cathedral, and Neuschwanstein; of famous athletes and actors; of reigning queens; of wild animals; of famous products; and, above all, of works of art by famous masters—Botticelli, Raphael, Leonardo, Paolo Uccello, Piero della Francesca, Tischbein. Such images appeared in monochrome reproduction, framed on walls, or in heavy albums of rotogravure of the kind I used to pore over as a child in my grandfathers' dens. Explicit sex has undergone transformation into three stages of love which end in a tender embrace. One could deduce from these works that the nation, if not the world, had gotten older and more conservative. But the works remain political in the sense I have sought to specify: it is still the American soul, *mis à nu*. And one of Warhol's famous statements, with suitable changes in pronoun and medium, becomes crushingly true: "If you want to know all about yourself, just look at the surface of my prints . . . and there you are." That, of course, would be true for those who lived their lives through the same period that Warhol did. For future generations, the saying must be altered: "If you want to know who we were, just look at the surface of Andy's prints . . . for there we are." The measure of their distance from us is the degree of externality between those images and them.

My only actual memories of Warhol are from scenes like those at the Feldman gallery in Soho in 1981, where Andy roamed the margins. I congratulated him and we shook hands, and he signed one of the invitations for my then new wife. I never introduced myself, nor explained why I thought him a great artist. We lived in worlds which really only touched at the margins. As I read the memoirs and the biographies, I feel I knew the best of him. The rest belongs to gossip and to an as yet unformulated science of artistic genius.

—*Andy Warhol: Catalogue Raisonné, 1997*

THE BRIDE & THE
BOTTLE RACK

■ ■ ■

THE IDEA OF CRAFT IS AN UNANTICIPATED PRODUCT OF THE INDUS-
trial Revolution. Since everything humans made before that time was crafted
in one way or another, involving hand and eye, the concept had nothing to
contrast with. But the Industrial Revolution robbed the hand of its skills,
building them instead into machines, leaving the hand to perform basic
repetitive actions—turning a knob, tightening a nut, pressing a button.
Everything that distinguished handed beings was appropriated by the ma-
chinery that turned out uniform products in quantities limited only by the
capacity of society to consume bicycle wheels, grooming combs, snow shov-
els, bottle racks, and urinals, all in profitable numbers. Craft emerged as a
concept in the late nineteenth century as an anti-industrial ideology, which
advocated returning skills to the hand and aestheticizing the autographic
quality of nonuniform products—the handmade, the handwrought, the
handsewn, the handspun, the handwoven, the handpainted. To choose the
often rough and uneven craft-object over the smooth and uniform industrial
object was to declare one's preference for a society radically different from
the one industrialization generated. It was to will a more elemental and al-
legedly a more fulfilling form of life. "I still find it amazing," the artist Tim
Rollins wrote, "that the greatest indictment of capitalism can be found in but
a yard of [William] Morris's perfect, beautiful materials." Morris undertook
to re-enfranchise the hand in the age of mechanical production. The hand,
of course, had never disappeared from *art*. The Arts and Crafts movement,
with which Morris's name is associated, accordingly treated art as the para-

digm through which to understand what craft should be. The artist's touch became the basis of aesthetics and connoisseurship.

"My hand," Marcel Duchamp said in a late interview, "became my enemy in 1912. I wanted to get away from the palette. This chapter of my life was over and immediately I thought of inventing a new way to go about painting. That came with the *Large Glass*." The *Large Glass* is a paralyzingly complex work, on which Duchamp labored from 1915 until 1923, when he more or less abandoned it. But he had begun to compile ideas for the work as early as 1912, using whatever scrap of paper was at hand and throwing the notes together in a box. It is widely assumed among Duchampians that the notes, with their cryptic references, their calculations and diagrams, hold the key to the hermetic *Large Glass*, a work at once scientistic and erotic. Like Picasso's *Demoiselles d'Avignon*—the only twentieth-century work with which it can be compared—it is something of a comic masterpiece. The full title of the work is *The Bride Stripped Bare by Her Bachelors, Even* (*La Mariée mise à nu par ses célibataires, même*). The prurience aroused by the title is not readily gratified by looking at the work, least of all the Bride herself, who scarcely looks naked and hardly looks female. She is suspended in the upper left corner of the glass, like the Sibyl of Cumae, which Petronius's narrator claims to have seen, hanging in a bottle (*ampulla*), with his own eyes.

Fascinated as I have always been with Duchamp as an artist, I have been content to learn what I could from those who sought to glean meaning from the notes, as the art historian Linda Dalrymple Henderson has done in a remarkable new study, *Duchamp in Context: Science and Technology in the* Large Glass *and Related Works* (Princeton, 1999, 374 pp., $85). "The complex iconography of the *Large Glass*," Henderson writes, "can be fathomed only with reference to the multitude of notes Duchamp began to make in 1912, in preparation for the work." Duchamp himself characterized the notes as "somewhat like a Sears Roebuck catalogue," meant "to accompany the glass and be quite as important as the visual material." Henderson, however, has gone further: She has undertaken to set notes and *Glass* together, as her subtitle announces (*Science and Technology in the* Large Glass *and Related Works*), in the context of early-twentieth-century science and technology. It is not Henderson's claim that tracking down scientific references is "the whole

story," and of course it is not (there may not be a "whole story"). But she captures enough of the science to make clear that much of the inspiration for the *Glass* derives from what, to us, is a fairly remote period of scientific discovery. Consider the discovery of X rays. The X ray is so common a diagnostic instrument that it is difficult to imagine anyone today as thrilled by X rays as Flammarion, the French science writer, was: "To see through opaque substances! to look inside a closed box! to see the bones of an arm, a leg, a body, through flesh and clothing!" Fearing that they might be "stripped bare" by X rays, Henderson tells us, women could avail themselves of lead undergarments as modesty shields; and she quotes a scrap of contemporary doggerel: "I hear they'll gaze/thro' cloak and gown—and even stays/These naughty, naughty Roentgen Rays." It somewhat confirms the lubricity of the male gaze feminists have made so central to their reflections on gender, that one of the first applications to occur to anyone was a new way of peering up skirts. It also alerts us to an irresistible connection between erotic humor and scientific concepts, which played so large a role in Duchamp's sensibility. Alas, if the Bachelors should have used X rays to strip the Bride, they would have gone too far, for they would also have stripped her of her nakedness. I cannot imagine the prurient readers of men's magazines being aroused by X-ray photographs of famous models.

I greatly recommend Henderson's book as an exciting exploration of the borders between art and science, as they were traced at the dawn of Modernism by an elliptical genius. But my immediate interest in it lies in the connections she implies between the *Large Glass* and a body of work produced at around the same time, and perhaps more notorious than the *Glass* itself. These were the so-called readymades—the industrial products of which I gave a partial listing in my lead paragraph: bicycle wheels, grooming combs, snow shovels, bottle racks, and urinals. (Talk about the Sears Roebuck catalogue!) Both the readymades and the *Large Glass* were responses to Duchamp's disillusionment with painting in 1912, leading him to say, in a famous episode, that painting was "washed up." In part, one feels enough confidence in Henderson's account to suppose that Duchamp, like many other artists of the time, had learned enough about reality as understood by science to believe that painting as traditionally conceived was inadequate to represent it. Cubism, Futurism, and Surrealism were among the many avant-garde

programs dedicated to finding ways of representing reality not as we actually see it but as it is. Since the Renaissance, painting had been tethered to the way the world presents itself to the eye, so all at once the eye became—paradoxically, since we are talking about the visual arts—villainized. Duchamp was of his moment in history through his attitude toward the eye and, incidentally, the hand. "I was so conscious of the retinal aspect of painting," Duchamp later said, "that I personally wanted to find another vein of exploration." To the critic Walter Pach, Duchamp said, "I want something where the eye and the hand count for nothing."

The readymade is not a "found object," or not entirely. Found objects have been selected by artists and others because they have enough visual interest that they can be treated as if they were works of art. By contrast, the readymades were selected because of their complete absence of aesthetic interest. "A point which I want very much to establish," Duchamp said in 1961, "is that the choice of these readymades was never dictated by aesthetic delectation. This choice was based on a reaction of visual indifference, with at the same time a total absence of good or bad taste . . . in fact a complete anesthesia." No one can differentiate one metal grooming comb from another by aesthetic criteria—they are all alike. So no one can have good or bad taste in grooming combs. And this will be true of the readymades as a class. There can, one feels, have been no concept of readymades before the advent of mass production, so the readymade falls outside the scope of craft. Industrial production minimized difference and maximized efficiency. (Duchamp famously said that modern plumbing was America's greatest contribution to human happiness.) Much of what we are surrounded by is ready-made, like nails and screws, coat hangers and toothpicks, any one of which could have been a readymade, given the criterion of aesthetic indifference. Duchamp's brilliance lay in putting the question of why not ready-made art—art that could be picked up at the supermarket, costing no more than an accessory for dog owners or home brewers?

With this, Duchamp closed the gap between art and craft, for he demonstrated that painting and sculpture, through their handedness, were in the end examples of craft, exactly like pottery or basketwork. We respond to, among other things, the artist's touch. The real contrast puts handedness on

one side and intellect on the other. Duchamp spoke with contempt of "olfactory artists," in love with the smell of paint. Little matter if they were in love with the smell of sawdust or of wet clay. For him, the work of art was an embodied idea. He envisioned an art into the making of which neither eye nor hand played any role, but only the operation of principled choice.

There is some controversy as to the correct inventory of Duchamp's readymades, but the majority belong to the period 1913 through 1917, when he made his notorious effort to exhibit a urinal with the Society of Independent Artists in New York, using the assumed name of R. Mutt. Even though there was no jury, *Fountain*, as he titled it, was turned down by the hanging committee on the grounds that, while any work of art was welcome to be shown, this was not a work of art. Having provoked that distinction was in some ways Duchamp's greatest contribution to twentieth-century art and the ultimate vindication of the readymade. It made the problem of defining art a part of every piece of art made since then. "A ready-made is a work of art without an artist to make it," Duchamp said. At the very least, the philosophical definition of art can eliminate, along with aesthetics (what meets the eye), the necessity of being made by an artist (the presence of the hand).

How the nullification of the artist's hand and eye is to be reconciled with *La Mariée mise à nu par ses célibataires, même*, widely considered Duchamp's masterpiece, has never been entirely clear. The work seems labor-intensive in a way quite at odds with the no-eye/no-hand philosophy of the readymade. In 1915, the year he began the laborious execution of the *Large Glass*, Duchamp bought an ordinary snow shovel, which he titled *In Advance of the Broken Arm*. So the *Glass* and the readymades were pretty much contemporary with one another. But the *Glass* appears to contradict the spirit of the readymade. Its execution, for example, was painstaking: Like a tapestry-maker, Duchamp used a cartoon—a full-scale drawing—fixed to the face of a pane of glass, which he worked on from behind. Henderson suggests that Duchamp might have preferred to think of himself as an engineer, working from a blueprint, constructing some kind of scientific apparatus. Whatever the case, he "drew" the outlines with lead wire, attached to the glass by drops of varnish. And he filled them in with metal foil. It was, Calvin Tomkins writes, "a slow, tedious process, and after two hours of it he was usually ready to quit for the day." It

is recorded that Duchamp often stepped back to eyeball his handiwork. Questions of interpretation aside, the *Large Glass* seems all hand and eye. It is dense with the attributes of craft. It could hardly be an object of aesthetic indifference, though Duchamp claimed that "the glass in the end was not made to be looked at (with 'aesthetic eyes')." So what was Duchamp's overall philosophical view of art in the period that saw both the *Large Glass* and most of the readymades?

It might be a good idea at this point to describe the *Large Glass* a bit further. It consists of two panes of glass, about nine feet tall and five and a half feet wide, partitioned into two fairly equal spaces. The upper space is the chamber of the Bride, the lower space the domain of the Bride's Bachelors. This space is shared by nine "malic" figures, a large chocolate grinder, and what appear to be some pieces of optical apparatus. The notes provide an imperfect guide to the Bride's components. In Henderson's number diagram of the Bride, #10 identifies the "probable location of 'Reservoir of love gasoline'" and #8 the "General Area of 'Desire Magneto.'" These are Duchamp's terms—like "Sex cylinder" or "Desire gear"—and hardly exhibit gynecological exactitude. They are rather intended to get us to see the Bride as some kind of eroticized machine. Small wonder, then, that the *Glass* "must be accompanied by a text of literature, as amorphous as possible, which never takes form." And small wonder that the anatomy of the Bride, like that of the *Glass* itself, is likely to remain forever unachievable.

I am greatly interested in Henderson's observation that in connection with the *Glass*, Duchamp was "to find a model for a depersonalized expression, free of 'taste,' in the techniques of mechanical drawing or scientific illustration." But freedom from taste, hence freedom from hand and eye, was the basis for the readymades. "I wanted to be intelligent," Duchamp said. He wanted to discover how one can be intelligent and an artist at the same time. (The French have an expression, *bête comme un peintre*.) "I wanted to go back to a completely *dry* drawing, a *dry* conception of art. . . . And the mechanical drawing was for me the best form of that dry conception of art. . . . A mechanical drawing has no taste in it." That might explain his decision to draw with lead wire. There is nothing to appreciate, as there is in brush or pencil lines. *Large Glass*, in Duchamp's own words, is the "renunciation of all aesthetics." Since this is precisely the case with the readymades, both exemplify

a new kind of art, a new conception of the artist, and a new kind of responsibility on the part of the viewer.

The overall importance of seeing the *Glass* and the readymades as alternative ways of making the same general point in regard to the relationship between art and aesthetics is that we have to think of Duchamp systematically. Lately a considerable stir has been made about the ready-madeness of the (so-called) readymades. That is not a controversy I am eager to enter. But if the connection between the readymades and the *Large Glass* is as systematic as Henderson's exposition suggests, we have to think of his work as a unified whole, each part supporting the rest, so that we cannot finally think of the Bride and, say, the bottle rack as entirely separate conceptions.

There is an uncanny relationship between the handlessness Duchamp sought in his art and a very old conception of what makes images genuine. The art historian Hans Belting has written a great book, *Likeness and Presence*, on the images worshiped in the period between the end of the Roman Empire and the beginning of the Renaissance. It was important that the images not be the product of an artist's hand. Thus, Christ's face was miraculously imprinted on the veil of Saint Veronica. The Virgin and Child allegedly painted by Saint Luke in fact materialized magically on a panel because Luke was not that good a painter. If it were definitely discovered that the Shroud of Turin was in fact done by an artist, it would become a mere work of art and lose significance as a devotional image. When looking at and admiring images—aesthetics, in short—became the point of art in the Renaissance, the age of the devotional image was all but over. The artist became a more and more exalted being. In erasing the relevance of hand and eye, Duchamp was attempting to deconstruct the idea of the artist and replace it with something more technological and impersonal. But, as Jean-Jacques Lebel recently reminded me, "Marcel was after all a chess player. He set traps within traps within traps."

This essay has been stimulated by a book rather than an exhibition. But the *Large Glass* is on permanent view in the Arensberg Collection at the Philadelphia Museum of Art, where it is surrounded by the readymades. It is worth a pilgrimage. While you stand in front of the *Glass*, trying to remem-

ber which is the "Sex cylinder" and which the "Reservoir of love gasoline," you are certain to hear whoops and shrieks nearby. They come from visitors unable to resist looking through the peepholes at *Etant donnés*, a work Duchamp secretly devoted himself to for the last twenty-five years of his life, pretending that he had given up art in favor of chess. As an incentive to your visit, I won't disclose what meets the eye, but, as a hint, it will not be all that different from what those with lewd imaginations hoped that X rays would expose. For all the complexity of his philosophy, Duchamp also had a one-track mind.

—August 23, 1999

"SENSATION" IN BROOKLYN

• • •

THE BROOKLYN MUSEUM OF ART, AS IF PERSUADED BY ITS OWN ILL-advised publicity that the art in its "Sensation" show might endanger the welfare of its viewers, at first thought it prudent to turn away children under age seventeen unless accompanied by an adult. It ought instead to have turned away adult viewers unless accompanied by a child, preferably one well under seventeen. Children are not squeamish, nor capable of indignation. They giggle at things that make adults uneasy. They do not carry a burden of art history, so they will not dismiss things on the grounds that it has all been done before. They are not cynics, nor are they "taxpayers." And they exist on the same level of feeling as do many of the artists in this extraordinarily youthful show. So borrow a child if you don't have one—or better still, be your own child, and treat the exhibition initially as if you were making an expedition to FAO Schwarz. There is, surprisingly given the title of the show, no sex to speak of, though there are some oddly distributed penises that the child will find hilarious. Whatever may be said on the floor of the Senate, it really is art. Whatever has been said in City Hall, it is not sick. It is, on the contrary, healthy. The worst that can be said of it is that it is brash. It is the brashness of art students the world around. There is an exuberance, a confidence, a swagger unfortunately not to be found in the demoralized American art world of today (for explanation refer to the floor of the Senate and the offices of City Hall).

The first work you will encounter, dominating the first gallery of the show, is a real shark in an immense tank. The child will gasp at the majesty

and beauty of a work it would have been difficult to anticipate from pho-
tographs of it or from descriptions or representations on the Internet. The
artist is Damien Hirst, effectively the *chef d'école* of the post-Thatcher Lon-
don art world. Putting a huge fish in a large tank of formaldehyde sounds
easy enough for even a city official to do. But *imagining* doing it requires a
degree of artistic intuition of a very rare order, since one would have to an-
ticipate what it would look like and what effect it would have on the viewer.
The work in fact has the power, sobriety, and majesty of a cathedral, some of
which, of course, must be credited to the shark itself. It does not look pre-
served but as if it rests in its fluid medium ready to strike. Hirst is given to
florid titles (as well as to rude and silly ones): This work is called *The Physical
Impossibility of Death in the Mind of Someone Living*. It is a very philosophical
title, which goes perfectly with the work itself. Heidegger pins his entire phi-
losophy of authenticity on the difficulty of envisioning one's own death—a
difficulty Wittgenstein explained by saying that death is not an event in life,
not something we live through.

The child, having registered the shark and emitted its admiring
"Wow"s, will want to press on, pulling you away from the metaphysical
reveries in which Hirst's work has entangled you. There is, after all, more to
experiencing art than what the involuntary "Wow" implies. (Being your own
child simply helps keep you open to what you see—it will not enable you to
understand what anything means.) The show, like any, is almost always more
than mere sensation, and the works of art more than toys for the rich. You
have to function simultaneously as child and adult, and it is to the credit of
the art on view that "adult" does not mean "mature enough to deal with sex-
ual content" but "wise enough to respond to conceptual significance."

Let us at this point tour the first gallery, which serves as a prologue to the
show you are about to see. To your right as you enter the gallery is a large
painting (156 inches by 126 inches) of a woman's head. It is titled *Myra*. The
child will have but a modest interest in the work until it discovers that the
paint resolves itself before our eyes into a pattern of tiny handprints. Wow.
The child resolves to give this a try in her next art class. You, *hypocrite lecteur*,
will see it as a kind of knockoff of Chuck Close, especially a painting he once
did of his mother-in-law using fingerprints. Close's fingerprint painting is a

virtuoso performance, but the fingerprints play no role to speak of in relation to the content of the portrait. The subject of *Myra*, however, is Myra Hindley, a notorious and reviled child-killer. That makes it difficult not to see the tiny handprints as referring to her victims. (In Britain, the painting is seen as a greatly enlarged police photograph rather than a distant derivative of a format Close has made his own.) It was *Myra* that was detested most when "Sensation" was installed in the Royal Academy of Art two years ago—as if the wickedness of the subject were transferred to her effigy in paint. It was *Myra* for which a Plexiglas shield had to be made, *Myra* that was declared sick by right-thinking Londoners. Brooklynites, unfamiliar with British headlines, give the painting an aesthetic once-over and pass on to the next work.

That will be a frivolous doll called *Bunny*, by Sarah Lucas (who has made a comically sexy still life, called *Au Naturel*, where a cucumber sticks up between two oranges on one side of a mattress, and a pair of melons surmounts a water bucket on the other). *Bunny* has stockinged feminine legs, no head, and protuberances that could be read as bunny ears. It has the floppy look of one of William King's handsewn sculptures, and it will certainly appeal to the child, if only because of its name. You will have to invoke some concepts from feminist theory—the male gaze! the objectification of women!—in order to get the child to lose interest in what it thought was a plaything. It is *Bunny*'s misfortune to have to share space with a shark.

We now encounter a painting by Chris Ofili, a recent celebrity in consequence of Mayor Rudolph Giuliani's animadversions on another of his paintings, *The Holy Virgin Mary*, which had scarcely been noticed at the Royal Academy. The Mayor's lawyers brought up the fact that the auction house Christie's is a kind of cosponsor of the show as evidence that the whole exhibition is just a way of inflating the value of the work, all of which belongs to a single collector, British advertising mogul Charles Saatchi. Whatever the increase, it dwindles to nothing in proportion to the value conferred on Ofili's work by Giulianian invective: *The Holy Virgin Mary* must by now be the most widely reproduced painting since Millet's *The Angelus*. The painting we find in this gallery, called "Afrobluff," is of what appear to be white chains painted on a blackish ground, possibly—since Ofili is an Anglo-African—alluding to the practice of slavery. The child will know immedi-

ately that there are some lumps of shit attached to the surface and that the painting in fact rests on some other lumps of the identical substance. You will explain that it is elephant dung, adding a word to the child's vocabulary and powers of connoisseurship: It will always be able to recognize an Ofili by the presence of dung. Seeing how educationally successful the exhibit has been, you will explain further that Ofili is English-born but of African descent, and that Africa is a place where certain magical properties are ascribed to elephant dung. The child will find this comical, but you will reflect that since it is unlikely that as a black Anglo-African, Ofili would have used dung to besmirch the slaves implied by the picture, there is no reason to suppose he was bent on besmirching the Holy Virgin through its presence there either. Probably it is intended to transmit power to the art, irrespective of its content. In any case, it adheres to each of his four paintings in the show.

Adjacent to Ofili's picture is a bust in what looks like wax, a traditional enough material. It is called *Self*, and it is the artist's self in two senses: It is a self-portrait, and it is made of the artist's own frozen blood. ("Some of the exhibits," a CNN anchorperson gasped, "use *human blood*!") Blood did not recommend itself as sculptural material until the invention of refrigeration (there is a backup system in the event of an electrical outage), but it would have instantly recommended itself to the artists of the Counter-Reformation had they known how to turn it into art. The sculpting is competent enough—it looks like a death mask—but it is the knowledge that the substance is the artist's blood that gives the work its excitement and uncertainty.

Finally, there is another very large painting, titled *Trace*, by Jenny Saville. It shows a woman, seen from the back and cropped just under her buttocks and just above her shoulders. The woman's flesh and her undergarment are of the same opalescent pink tone, so the only clue we have that she is wearing a chemise and panties is some lines traced in the pigment. Hence—I surmise—the title. Saville is far and away the best painter in the show, which includes several of her monumental studies of amply fleshed naked women. In one, titled *Plan* (in another gallery), the woman is probably lying down, her body cropped just above the knees, and diagonally across her forehead. The title refers to several sets of concentric lines traced around her belly and on both thighs, which we see in topographical maps showing the heights and depressions of a certain terrain. This is almost certainly a femi-

nist emblem, and though an exceedingly ambiguous one, it probably refers to a tendency to see the female body as a landscape and hence an object of some kind. There is a very generous pubic thatch.

Body, blood, menace, death, shit, murder—these are pretty heavy subjects, and we are only in the first gallery. But already we are able to sense the agenda of the young British artists. They are probing certain boundaries it had never occurred to us to think about. We know when the boundaries are touched because we feel queasy in the presence of the work, though exactly why is probably too deeply buried in the thalamus for the higher cognitive centers to access. Though it is in another gallery, the same order of question is raised by Ron Mueck's *Dead Dad*—alleged to be an effigy of the artist's own dead father, naked on a slab, the penis curled against a thigh. We know from the Bible the dangers inherent in seeing one's father's nakedness. But does this apply to one's father's *corpse?* The work, exceedingly realistic, is only forty inches long—a gruesome kind of doll from which one supposes even the child will recoil. But why? We perhaps all respond in the same general way—but we have not transformed feeling into thought as yet. What does it matter that blood is used as a sculptural material? Does it make a difference if the blood is one's own? Male poets often refer to their beloved's bodies as landscapes—but do they really see the body they love as something to be mapped and perhaps exploited? Is anyone justified in immortalizing the face of a horrible criminal? Is it right to use a once-living animal in a work of art? In my view, the shark lucked out to have animated a powerful piece of art rather than being turned into fertilizer or cat food. Indeed, the vision of danger from which we know ourselves to be protected is precisely what Kant meant by sublimity: "One can regard an object as *fearful* without being afraid of it." How much of all this should be communicated to the child depends, of course, on the child and upon you. But having ascended to this level of speculation, you can appreciate the foolishness of the museum's publicity, in the form of a "Health Warning" that "the contents of this exhibition may cause shock, vomiting, confusion, panic, euphoria, and anxiety." And you will be less tempted to agree with the newspapers that all the artists were interested in was to shock. Indeed what you will have recognized is that virtually everything in this gallery is the kind of reflection on art in which so

much of modern and contemporary art consists. It always has a philosophical dimension. That is its post-Modernist birthright.

Hirst uses whole animals in a number of works. There is a lovely lamb (*Away From the Flock*) and a somewhat less successful pig, which has been split in two, from tail to snout, showing the animal's insides. I think this distracts from any meaning the pig may have, since it is now midway between animal and pork—and because the preservation process dulls the forms (they are not viscera-red but pickled brown). Animals have meaning for us primarily in their integral state. A shark split in two could not affect us the way the integral shark does. It is hard to generalize, however. Hirst has distributed cross sections of some cows among twelve tanks, set in a line at regular intervals, like a sculpture by Donald Judd. I could not suppress the memory of a French advertisement for bouillon cubes, some years back, that shows the front half of a cow, sniffing appreciatively at a cup of hot Maggi presumably made from its rear half. I would have thought a work made of bovine sections would be pretty hard to take, but alongside Hirst's *A Thousand Years*— in which a cow's head slowly putrefies in a large glass case, as generations of always new black flies deposit eggs that turn into maggots, which turn into flies in a cycle that never ends—it is fairly civilized. Even art critics have a threshold of squeamishness. But I cannot think of a *moral* reason *A Thousand Years* is any more objectionable than the beautiful *Away From the Flock*. The difference may have to do with all the marvelously poetic allusions lambs evoke, by contrast with maggoty animal heads, which evoke none and are, in the idiom of contemporary childhood, simply gross. (Kant thought the disgusting to be one kind of ugliness that could never be overridden by beautiful representation.)

The best artist in the show is the sculptor Rachel Whiteread. Her main work here is *Ghost*, which we initially perceive as a large white cubish structure. It replicates the interior of a child's room in an old house, however. The room serves as the matrix for plaster slabs, which register its architectural details— a door, a fireplace, etc. The slabs were reassembled in such a way that the interior of the room was reproduced as the exterior of the sculpture. The room

was in effect turned inside out. That and its funerary whiteness make it a monument to lost childhood. You cannot enter the room—the door does not open—and this surely is a metaphor for the fact that we cannot revisit childhood. All we can see are its ghosts.

In 1993 Whiteread extended this procedure to replicate the interior of a whole nineteenth-century house, scheduled to be torn down to make way for a housing development in East London. She made, in Norman Rosenthal's words, a "concrete cast of the interior of an old terraced house [which] seemed . . . almost an apparition in the pallid daylight . . . palpable but not quite believable, pale and forlorn against a backdrop of trees and grass." *House* was bulldozed away the following year, as Whiteread was told it would be. Perhaps its ephemerality is a dimension of its meaning, but I cannot help wishing some enterprising institution had found a way of preserving what I have no hesitation in describing as one of the supreme masterpieces of twentieth-century sculpture. Whiteread's work often consists in sculpting negative spaces, such as the space beneath chairs, bounded by legs, floor, and seat. One whole gallery is given over to ranks and files of these. Critics like to say that Bruce Nauman did the same thing years ago, but I cannot see in Nauman's work the humanity that belongs to *Ghost* or to *House*. So maybe something much deeper is being transacted in Whiteread's spaces, to which the similarities to Nauman blind us.

I have left untouched the large portion of what I think of as one-dimensional works, pieces that you and the child can negotiate easily enough and find more or less interesting but never deep or serious enough to clarify the topography of the soul. No harm in that. How many of the works in the concluding segment of the Whitney Museum's "American Century" rise to that level? As the Whitney show enters the present decade, it becomes more and more diffuse, lacking entirely the robust coherence of the British work here, which was all made in the 1990s. I have to say that, whatever we may feel about Charles Saatchi, he has, as an adventurous collector, helped create an art world that would not have existed without him. I think the role of the collector is badly underappreciated, probably because of the art world's lingering suspicion of commodification. Saatchi has no real counterpart on the American scene. And that, augmented by the government's craven reluc-

tance to support the arts, accounts in large part for the present demoralization of art in America. We have wonderful artists, but a vital art world requires a lot more than that.

I want to conclude with *The Holy Virgin Mary*, the occasion for political spite and spume, for the accusation of sickness and of what the mayor calls "Catholic bashing"—although like the mayor, the artist is himself a former altar boy. It is not a marvelous painting, questions of Ofili's signature elephant dung aside (a substance we now know comments on art itself rather than on what the art is about). On the other hand, the Holy Virgin has never been especially choosy as to how she is portrayed. The wonderworking Madonnas are usually badly painted, as if the Virgin were not entirely comfortable being shown as beautiful or even pretty. The *miraculous* paintings of the Virgin rarely have much by way of aesthetic charm, but they are not prayed to for the rewards of aesthetic gratification. They are prayed to, rather, for the things that matter in the dark moments of life. If I were a praying man, I would pray for a miracle in the Brooklyn Museum—the tiniest miracle, as long as it could be attributed to the Madonna. All at once, I imagine, someone looking through the Plexiglas protective screen might say, "My God! The Virgin is weeping!" People would come running, kneel, pray, marvel—or say "Wow." The gallery would soon be overrun by pilgrims. It is asking too much, perhaps, to expect that some would throw down their crutches, but still, it would be a miracle if even such a miracle helped. The mayor could always say the Virgin wept because of the elephant dung. It would be hard to know how to deal with that, but at least the discussion would have moved to a higher level.

—November 1, 1999

SHIRIN NESHAT'S *RAPTURE*
∎ ∎ ∎

IN THE 1970s, A CLUSTER OF CONCEPTS THAT HAD TOGETHER FORMED the received idea of art and artists came under intense criticism. It included the concepts of the Great Artist and of artistic genius generally, but also the concepts of quality—an "idea whose time has gone," according to an influential article by Michael Brenson in *The New York Times*—and of the artistic masterpiece. It was commonly supposed that various pathologies were the price of possessing artistic genius, and that the Great Artist, more frequently than not, was neglected and misunderstood until after his—let us emphasize the gender—death. These still form part of the heroic narrative of the Great Artist's life to which popular films are devoted—Michelangelo, van Gogh, Toulouse-Lautrec, and Jean-Michel Basquiat, with Jackson Pollock awaiting his formulaic portrayal. Since more or less all the Great Artists—more or less all the artists of Western art history—were males, critiques of the conceptual cluster came initially from feminist theorists, who wondered what these concepts had to do with women artists. Moreover, since the Great Artist was nearly always a painter, painting itself became suspect. The concept of sculpture, by contrast, was greatly enlarged so as to include a great deal of art made of nonstandard materials, while painting—sharply politicized—was pushed to the margins. Essays appeared on the death of painting and even the death of the museum, construed as an institution primarily dedicated to the display of paintings. Easel painting almost always comes under attack in revolutionary times. Soviet artists dismissed it as belonging to a his-

torically superseded society—not because painting was dead so much as because it was irrelevant to the aspirations of a Communist society.

The entire cluster was anchored to the concept of the Great Work—the kind of work that became an object of aesthetic pilgrimage, like *Mona Lisa* or the Sistine vault—and all Great Works were thought to form part of a canon. Since the advent of Modernism, it had been already recognized that the canon was elastic enough to accommodate Cézanne, Picasso, and Matisse, as well as Michelangelo, Leonardo, Titian, and the like. But the idea of the canon also was contested in the 1970s, either because of its exclusionary character or because it failed to include sufficient art from non-Western cultures. Artistic practice through the decade was not entirely consistent with the idea of a canon either, inasmuch as the cluster of essential concepts could not easily apply to it. In an important show of mainstream art by women—"Making Their Mark: Women Artists Move Into the Mainstream, 1970–1985"—there was, for example, a work that looked exactly like a rose-colored gown, titled *Inaugural Ball*, by the artist Judith Shea. Obviously, the criteria by which dresses are judged from the perspective of couture had no bearing on an artwork in the form of a dress. *Inaugural Ball* could have been a fairly casual piece of dressmaking and still be strong as a piece of art. It would have been commonplace for men to design women's dresses—but given the lingering machismo of the art world, it was highly unlikely that a male artist would have produced a dress. So, in addition to the complex of metaphoric associations the piece evoked, it also made important claims about art and gender. It was difficult, certainly on the basis of looking at it, to decide whether it was a great work, or even if a work consisting entirely of a woman's dress *could* be a great work. The problem was altogether general, since, under the pluralistic spirit of the art of the 1970s, art could be made out of anything. It was difficult to apply to such works the aesthetic rules, which had mainly to do with the appreciation of paintings. Almost by default, it was a time when it was enough to acknowledge the pieces as art and let it go at that.

There was a moment in the early 1980s when painting all at once was back, as if the history of art had jumped back on track and everyone—critics, collectors, curators, and dealers—rejoiced in the large Expressionist and even

figural canvases that began to appear in epidemic proportions. But by the mid-1980s, Neo-Expressionism had subsided. And, in practice if not in ideology, the 1970s have been with us ever since. We are still diffident about using the discredited concepts, though we have nothing to put in their place. So except for those critics who define artistic excellence through the aesthetics of painting and are in consequence intolerant of much of the art of the past quarter-century, most of us wander in the dark. "But is it art?" has, I think, been settled, at least as a philosophical question. And few are eager to return to the question the 1970s put on ice—"Is it any good?"

Every once in a while, I try to think about the concept of the masterpiece and whether anything can be salvaged from it for the purposes of contemporary art. In 1962 Roy Lichtenstein painted a wonderful piece called *Masterpiece*. It shows Brad (of course) studying a painting whose back alone we see. His girlfriend says, "Why, Brad darling, this painting is a *masterpiece*! My, soon you'll have all of New York clamoring for your work!" Brad has the face of a comic-strip pilot, with clean-cut regular features. His girlfriend has the face of a comic-strip movie star. It is, like much of Lichtenstein's work of the time and after, a highly ironic statement. In those years, Lichtenstein was ironizing many of the concepts that formed part of the cluster, in order to break down completely the divisions between high and popular art. So it is fair to imagine that he was ironizing the concept of the masterpiece. Is *Masterpiece* a masterpiece? I think that Lichtenstein would have said *obviously not*. This entails no deficit in his work but in the concept, which has no application to art in the comic-strip style. Something drawn and colored in that style is so distant from what we are accustomed to terming "masterpiece" that it is a joke to think of it in the terms that apply to, say, *Las Meninas* or *The Night Watch*.

Still, I feel as though the idea of the masterpiece is internally related to what we want art to do for us, and that it retains its legitimacy after all the other concepts have been abandoned or qualified. What makes it interesting is that even when the material possibilities of art have been radically and pluralistically expanded, there is still the possibility that contemporary art, however different from the traditional, retains some of the functions of art, and indeed of great art.

By "masterpiece" I mean something quite different from *chef d'oeuvre*.

Chef d'oeuvre refers to the best work of a good artist, and it belongs to the language of connoisseurship. It applies retroactively, when an artist's entire work can be surveyed and certain works singled out—like the *Perseus* by Cellini or Watteau's *Gersaint's Shopsign*—as an artist's finest work. I mean something that would qualify a work for inclusion in a canon of large visions of human life—visions it would be important for anyone to be acquainted with as part of the process of humanization. Canonical works project theological or philosophical ideas by sensuous means. Can there still be masterpieces in the contemporary art world, in which more or less anything goes? It seems to me that if that were not possible, the whole point of contemporary art would need to be called into question. I have been compiling my own canon of works that are contemporary, in that they could not have been made at any earlier period, but that qualify as masterpieces through the power of their vision. And I keep my eyes open for new candidates.

Recently James Rondeau—a curator of contemporary art at the Art Institute of Chicago—walked me through six newly installed galleries, and I felt that one of the works he showed me might very well be a masterpiece by my criteria. It was a video by Shirin Neshat, an exiled Iranian artist working in New York who is deeply concerned with the situation of women—and, by indirection, men—in Muslim societies. Neshat had been a codirector of the Storefront for Art and Architecture in New York, a space given over to advanced architectural exhibitions. A few years ago, she began to make what one might call political self-portraits. She showed herself in Muslim garments and head cloth, often holding a gun. On the soles of her feet and palms of her hands were poems by Iranian feminists, written in Farsi calligraphy. The images portray her as "martyr, warrior, wife and a mother," according to the catalogue for the Istanbul Biennial of 1995. I confess that I was not crazy about the work: Whatever her difficulties with Iranian politics and Muslim culture, it was hard to think of her as a martyr or a warrior, save in some metaphorical sense in which the gun might stand for the power of art. And since she said, "My art isn't about pointing fingers," it was never clear what she meant to achieve. I would not have gone out of my way to see more of her work, and so missed entirely an earlier video called *Turbulent*. I might very well have missed the new work as well, were it not for my high

regard for Rondeau's sensitivity to and understanding of contemporary art. I was deeply stirred by the new video, called *Rapture*, and sat through it three times (it lasts thirteen minutes). One of the attractive properties of video is that it can appear simultaneously in different venues; and a week after Chicago, I was able to see it twice again at the D'Amelio Terras Gallery in Manhattan's Chelsea neighborhood (at 525 West 22nd Street). It has been selected for the biennial exhibition at SITE Santa Fe. And I expect it will be shown frequently in a museum near you.

The situation of women under Islam is, one might say, the occasion of *Rapture*. But the work rises to a universal level of humanistic allegory, and becomes significant for us all. It is, moreover, a good example of what one would look for in identifying contemporary masterpieces. Its currency is assured by the technology of video projection, which did not exist when the canon of great art was formed. But there is something almost timeless in the action: The narrative itself could have been enacted in the remote past.

One enters through curtains into a darkened space. To the left and right are two facing screens. The left screen belongs to the Women, the right one to the Men. Women and Men enact different sequences, connected through the fact that most of the Women's actions are in response to the actions of the Men. The responses of the Men to the Women, on the other hand, are few and far between. The Men are mostly involved with one another, and by the time the story is over, the Women, too, seem mostly involved with one another. It is a narrative of an achieved separate identity for the Women. No individual stands out in either group: There are no heroes and there are no speeches. The only characters are the two groups, consisting of more than a hundred people each. It is as if there were a chorus that had divided itself in two, according to gender. It has been speculated that the earliest Greek tragedies were written for choruses only, the hero being a later invention. In Nietzsche's account of the birth of tragedy, the tragic chorus was an invocation to a god, and the hero was the god made manifest. There is no god in *Rapture*, however, and nothing to bring the two choruses into a unified whole. The Men are dressed alike in neat white shirts and black trousers. The Women are dressed alike as well, in the traditional black chador. The film is in black and white.

In the first pair of shots, a stony desert and a heavily fortified castle face

each other. (The building seems to date from the era of the Crusades.) The Desert is the site of the Women, the Castle that of the Men. Desert and Castle are connected somewhat in the way in which Troy was connected to the field outside its walls, where the great combat took place. In Homer, the women are protected by the walls of Troy, while in *Rapture*, the Castle belongs entirely to the men, and the actions of the women take place under its walls, in the stony desert outside them. There is a battery of fierce antique cannons around the Castle's battlements, but they have long been abandoned, like the Castle itself. It is now more a playground for the Men than a building with a military function.

In the next shots, we see the Women, their black garments fluttering, advancing toward the Castle. At the same time we hear—and then see—the Men parading through what we will infer is the Castle's gate. There is a moment when the Women and the Men stop and face one another across the gallery. There is no effort to get together, and the Men begin to take up various activities of no obvious consequence, mainly in the castle's courtyard and on the battlements above it. They carry ladders and lean them against the wall. They engage in shoving matches that have the potentiality of turning violent, but don't. Then there is a card game in the center of concentric circles of spectators. The Women, for the most part, appear merely to observe these activities in a distant and passive way. The activities evidently have nothing to do with them, and their faces show no obvious emotion. Then, abruptly, the Women ululate loudly and frighteningly. The piercing sound is a declaration of triumph in Muslim culture, or a battle cry and a taunt. The Women then turn their backs to the Men, perhaps as a gesture of contempt. When they next face the Men, they hold up their palms, overwritten in Farsi script, as in Neshat's self-portraits. I imagine the texts are much the same. The Women then kneel in prayer.

The Men exit the Castle, rhythmically clapping their hands. From the appearances, the men prepare to feast. A steaming caldron is passed from hand to hand, and Persian carpets are unrolled to form paths for the Men to walk on. The Women, however, begin to move away from the Castle, toward the horizon, in no particular formation. The Men watch from the battlements with a certain shallow interest, as if the exodus of the Women were only a matter of curiosity. On the Women's screen, we see a pair of feet

beating out a violent tattoo by dancing on a drum. To its accompaniment, the Women move across the sands a heavy boat, of a kind one might have seen on the Sea of Galilee in the time of Jesus. With great strain, the boat is launched, and six women seat themselves. The Women appear to have no oars and trust simply to currents to carry them away, as if surrendering to a higher will. The Men, perfunctorily, wave goodbye. And the film ends.

This bare description gives no sense of the extraordinary beauty of the black-and-white photography and the remarkable choreography with which the Men, and especially the Women, are deployed in their very different spaces. Nor does it give an idea of the powerful music by the Iranian composer and singer Sussan Deyhim. The music gives voice to the various actions. It expresses what the linked sequences show. It combines with the ululation, the clapping, and the drum tattoo—the only sounds the two groups make. The work was filmed in Essouria, Morocco, since Shirin Neshat is persona non grata in Iran today. The men and women of the village are the Men and Women of the work.

What is it all about? What has taken place, and what is its meaning? What occasions the Women's triumph? Is it that they have gone off on their own, or is it that they place themselves at Allah's mercy? The work seems to have something urgent to communicate, but it does so in the way a solemn ballet would do. Neshat is still not pointing fingers. "From the beginning," she says, "I made a decision that this work was not going to be about me or my opinions on the subject, and that my position was going to be no position. I then put myself in a place of only asking questions but never answering them." It is not a self-portrait. And the actions are too emblematic to furnish an agenda for social activism in the Middle East. Yet they seem to belong to some immemorial enactment, which has been ritualized and repeated. The work is mesmerizing, and if you are like me, you will want to see it again and again. It is an allegory of obscure but inescapable meaning.

—*June 28, 1999*

THE AMERICAN CENTURY: PART II

■ ■ ■

THE TRIUMPH OF THE NEW YORK SCHOOL, A DEEPLY IRONIC PAINTING BY the American artist Mark Tansey, looks at first sight like a rotogravure depiction of a military surrender that took place long ago. Representatives of two opposing forces are arrayed on either side of a field desk, on which the defeated commander signs the document in the presence of the victor. The losing army wears French military uniforms circa World War I, while the victors are dressed in the GI khakis of World War II. The picture is obviously not a historical possibility, as the United States and France were not at war on either occasion. But in a sense, there was a battle between the schools of Paris and New York in the late 1940s and early 1950s, and Tansey has painted an allegory of the latter's triumph. André Breton, *chef d'école* of the Surrealist movement, ceremonially acknowledges defeat at the hands of Clement Greenberg. Behind Greenberg, we can identify Jackson Pollock, Willem de Kooning, Robert Motherwell, and New York School stars of various magnitude. Behind Breton, we see Henri Matisse, dressed in a French officer's cape and kepi, and Picasso—Hector to Pollock's Achilles—wearing the fur duster of a World War I flying ace. Smoke rises in the distance, as in Velázquez's *Surrender at Breda*.

Tansey was being ironic about the triumphalist language used when New York indeed achieved pre-eminence in modern art—a tone that lingers on in "America Takes Command," as the Whitney Museum of American Art designates the first set of works that begin the second installment of "The American Century." Tansey's painting, though held by the Whitney, is not

included in the show, though it would have introduced a welcome note of self-satire if it had been. Whatever the case, *The Triumph of the New York School* belongs on neither side in an aesthetic conflict that was ancient history when Tansey painted it in 1984. Neither side would have considered his painting an allowable form of art. But from the 1970s on, American art became more and more deeply pluralistic, to the point that artists were no longer constrained to work in any given style—they could choose, indeed, whatever style served their larger purposes. Tansey used a dated style of illustration to achieve ironic ends—particularly appropriate since both schools used "illustrational" as a pejorative critical epithet.

In the light of Tansey's wry historicism, it is possible to ironize a logo selected for "The American Century"—Jasper Johns's nested trio of American flags, laid one upon the other in graduated size. The largest flag would be the state of American art in the 1950s and 1960s, when Abstract Expressionism, Pop Art, and Minimalism established New York as the capital of the art world. The middle-sized flag might then denote the 1970s and 1980s, when Conceptual Art and Neo-Expressionism became universal practices in art worlds the world around. David Salle, Julian Schnabel, and Eric Fischl were our best Neo-Expressionists, but not necessarily better than Gerhard Richter and Sigmar Polke in Germany or "the wretched Italians," as Donald Barthelme liked to speak of Enzo Cucchi, Francesco Clemente, and Sandro Chia. The art world of the 1980s acquired a complex geometry, with various art centers as foci, while New York shrank in status to the kind of art market Chelsea now makes vivid. The smallness of the smallest flag emblematizes the 1990s, when there is very little distinctive about the art produced in America in contrast to art produced anywhere and everywhere else.

Lisa Phillips, who curated this show, ends her catalogue essay by asking two old questions: "What is art? And what is American?" The answer to the first question is: anything. That answer must not be confused with: everything. The history of post-Modernism, which began early in America under the leadership of the Frenchman Marcel Duchamp, is the history of erasures, of overcoming boundaries to the point that little is left to distinguish works of art from the most ordinary of objects—snow shovels, to take a characteristic example, or urinals, to take a controversial one (both of these were shown in

the first part of "The American Century," in the gallery devoted to New York Dada). In order for there to be a distinction between Anything and Everything, the question becomes urgent of how one snow shovel can be a work of art and another, exactly like it, not be a work of art. That is part of the treachery of the concept of art: We cannot imagine two animals exactly alike, but one a giraffe and the other not. There was a time when art and nonart could be told apart as readily as giraffes and camels. But since anything can be a work of art, this is no longer true. Since there can be no perceptual difference between artworks and their counterparts that are not works of art, the philosophical question is wherein the difference lies. That is what makes the definition of art a thrilling and indispensable task. A good place to begin is to recognize that artworks necessarily have meanings that explain their structures. In any case, it is at the level of metaphysics, rather than connoisseurship and taste, that Phillips's first question must be pursued.

So far as the second question, "What is American?" is concerned, it seems to me decreasingly relevant as our century has evolved. Artists of every nationality live and work in the United States, and American artists work in various corners of the world—in Munich, Berlin, Milan, Florence, Paris, London, Tokyo, Tangier, and Stockholm. The art world has become an entirely polyglot entity, and the tiny size of Johns's flag conveys this to perfection. This point is perhaps general. There were so many foreigners in the School of Paris that xenophobic legislators suspected a plot to subvert the purity of French art. There were so many artistic refugees in New York during World War II that it is counterfactually true that Abstract Expressionism, however American, could never have arisen had they not been here. When the century was young, American artists painted American things in a kind of universal *beaux-arts* representational style. Between the two wars, artists in France painted within the traditional art-school genres—portrait, figure study, still life, landscape—in adventurously nontraditional ways. Among the Abstract Expressionists, Mark Rothko was born in Russia, de Kooning in the Netherlands. But New York painters vied to be the first to get their hands on the latest *Cahiers d'art*, much as artists in Nairobi and Oslo rush to read the newest *ARTFORUM* to see where to go next. The art world at century's end is analogous to the European community, where national differences mean

less and less, and borders are more and more like parallels on the globe—mere devices to tell us where we happen to be. Artworks look, with some qualification, as if they could be made by anyone anywhere. One of the last works in the show, *Lineup* (1993), by Gary Simmons, a New York artist, displays upscale (gilded) gym shoes on the floor beneath lines indicating graduated heights—allegedly a familiar New York sight to young black men. It would probably not have been painted anywhere but New York—but what especially American essence relates it to the other work of its time and place?

There are, of course, cultural differences between Americans and others. It is always easy to tell when a foreigner has spent some time among us. There is an American informality, for example, to which visitors easily adapt, even if in their own cultures they must continue to respect the formalities. In a way, Mondrian loosened up sufficiently when he moved to New York to use diagonals in his abstractions instead of the vertical and horizontal lines he had considered mandatory in Europe. But Agnes Martin, who lives in the Southwest, could scarcely be more American as a person or more formal as an artist. The Whitney has a vested interest in the concept of Americanism through the fact that it is the Whitney Museum of American Art. But the decision as to what counts as American art is pretty much a matter of casuistry. Must one have been born in America, as well as live and work here? These seem radically external determinants of a national style, when the latter, where it can be said to exist, is present among artists who were born here but work elsewhere (like Sam Francis) or born elsewhere and work here (like Lucio Pozzi and Alain Kirili). The informality of American social relationships—dress as you wish, live as you like, find love with whom you will—is taken at times as what freedom means. Someone might then argue that much American art of the second half of the century is a further exercise of freedom, since making what you like is licensed by the fact that art can look whatever way one wants. But the breaking down of barriers to the present state of art was the product of twentieth-century art in general. Picasso and Matisse broke down barriers at least as powerful as the ones Pollock and de Kooning overcame. So the freedom exists everywhere in the world today, except where political limits are imposed on making (as against showing) art. That is why artworks at century's end are all alike in their differences from one another.

There are, on the other hand, differences from decade to decade. Abstract Expressionism is the paradigmatic style of the 1950s as Pop is of the 1960s. Johns's nested flags (1958) belong between the two decades, as does the work of Robert Rauschenberg and Cy Twombly. With interpretive imagination, we can even see what the Whitney designates "The New American Cinema" as a melding of Abstract Expressionist aesthetics and Pop content, spiced with some surrealistic lingerings from the 1940s. Alfred Leslie, a second-generation Abstract Expressionist, collaborated with the photographer Robert Frank on the film *Pull My Daisy*, which has the raw, grainy quality that goes with the raw ropiness of the Abstract Expressionist brushstroke. Cindy Sherman and Nan Goldin exemplify the 1970s, especially as those years were lived in the East Village by young people whose preferred form of art was photography. The East Village produced exceedingly minor Neo-Expressionist paintings, the defining style of the early 1980s, when the hope was that the art stars of tomorrow would come from its mean streets and druggy air. But Neo-Expressionism was an entirely international style: When the Museum of Modern Art reopened in the early 1980s, artists from no matter where were working in that expansive, messy manner. But after the mid-1980s, when Neo-Expressionism turned out to have been a false start, there was no defined style whatsoever, in the United States or anywhere else, and this has remained true throughout the 1990s, outside the United States as well as here. The art world settled into its present pluralistic, globalistic structure, which I cannot believe will not be with us forever. The art world proclaims the same disregard for boundaries as our mighty corporations.

In a way, the nested American flags correspond with the order in which the show is installed—or it would if there were five flags or only three floors. The 1950s ("America Takes Command") is on the top floor, the 1990s in the lowest levels. It is impossible to resist the thought that art in America grows increasingly diluted as the decades succeed one another. There can be no denying the energy of Pollock and de Kooning on the fifth floor, though the small and undistinguished Pollocks on view give little sense of the majesty and power of his great work. De Kooning's *Woman and Bicycle* is the one

masterpiece on view in this section, with *Marilyn Monroe* not far behind. Rauschenberg's famous *Erased de Kooning Drawing*—which turned out to be predictive of what was to happen to Abstract Expressionism just a few years later—hangs in the same gallery with the art it symbolically erased. By contrast, the lowest levels, with the 1990s installed, are very thinly populated, not because there is not a lot of good art being made today but because it is not united by any recognizably common style—though it is probably unthinkable that Simmons's *Lineup* could have been made in an earlier decade. The artists on the fifth floor project a sense of being in on the beginning of something tremendous. The artists on the lowest levels feel very much as though they are in the end-state of whatever the 1950s began. What art won was the freedom to do anything. But in a certain sense that was the end of art as well. The young British artists we see in the "Sensation" show in Brooklyn derive a certain energy from penetrating moral limits, which accounts for the cheerful repulsiveness of much of their work; but there is a spirit in London that is no longer to be found in the American art world.

Critics have complained that the Whitney show provides far too much context for the art on view. But a lot of what might be considered context in fact exhibits the same aesthetic values as the art itself. One of the treats of the show (perfectly installed on the mezzanine of the fifth floor) is a set of clips from the great underground films of the 1960s: *Scorpio Rising*, *Flaming Creatures*, *Pull My Daisy*, and Stan Brakhage's films, edited at a breakneck speed the Futurists would have adored. The films anticipate Warhol's idea of a New York cinema as against a Hollywood cinema. They are unbuttoned and free, and go with the sense that anyone can be a filmmaker. But they are not "context" for the art: Rather, they carry the impulses of the art into another medium. Hollywood films perhaps belong to context, at best indicating what was happening while the art was happening, without helping explain why the art happened as it did. Some music was part of the art scene, some was not. Morton Feldman belonged with Abstract Expressionism, John Cage with Johns and Rauschenberg, Philip Glass with the phalanx of major artists who descended on New York from Yale in the early 1960s. Glass's work with Robert Wilson was not part of the context but part of the scene. And the music that was part of the context—the rock that went with drugs and sex—was ubiquitous among American youth, whether artists or not. The

New York poets—Ashbery, Koch, Schuyler, O'Hara—rubbed shoulders with artists, and a case can be made that they had more in common with the painters they were friends with than with poets from different milieus, whose writing again formed an inert context, accounting for nothing in the art. There are a great many books on display, some of which may have been read by this artist or that, but which penetrated artistic sensibility to no appreciable extent. But in the later 1960s American artists became interested in a number of books written by French and German thinkers: Derrida, Lacan, Baudrillard, Althusser, Barthes, and Habermas. Their obscure and often frivolous writings were debated as intensely as artists of the 1950s debated existentialism. Almost nothing written in the United States had that kind of impact on those who were making art.

Barbara Haskell and Lisa Phillips, mounting half a century of American art each, have discharged a necessary but thankless task. Their achievement, however, is considerable and in its own right somehow American—Americans being insatiably obsessed with questions of their own identity. By contrast, the curator responsible for MoMA's ModernStarts, the first installment ("People") of which is now on view, had an easy time. It is a display of the museum's treasures from 1880 to 1920, grouped and juxtaposed in different ways. It is an art lover's dream: Virtually every question worth raising can be answered from the works themselves, and the ingenious pairings made between them. Against that, "The American Century" belongs to the same struggle it puts on display, of artists for whom America itself was a certain burden. To be in moral struggle with America, while it may not show through all the art (and though the art it does show through is often not the best), is something one feels at every step. The question of what is American, rather than any answer, is what it means to be an American artist. The exhibition is perhaps its own best exhibit, since the questions it raises are of a kind the individual works cannot raise on their own.

Happily, the museum is thronged. Whatever the critical discontents, the Whitney audience is seeking to make sense of America through making sense of American art. They are finding out what they lived through and what they are. This could not have been true of a more cosmopolitan show, which, on the same model as "People," merely showed and juxtaposed treasures of twentieth-century American art, much of it by many marvelous

Americans, like Tansey, excluded for whatever reason. Such a format was not possible partly because of the deep pluralism of the art world today. A Modernist work is easily recognized as such, and which are the treasures is relatively easy to determine. This is not true of postmodern art—say, art since the mid-1970s. Heidegger defines a human being (his term is *Dasein*: "being-there") as the kind of being for whom its being is in question. American artists have something akin to this. They have had to grapple with the question of being American, and that, somehow, is part of what makes them American. There is something profoundly moving in the reflection that the art is ours, American in whatever way we are American, in perhaps the last time in our globalized world in which that will mean very much at all.

—November 29, 1999

The Work of Art and
The Historical Future

■ ■ ■

<center>I</center>

GIORGIO VASARI OPENS HIS LIFE OF MICHELANGELO WITH A
prophetic exordium, in which the Tuscans are pictured as a kind of chosen
people and Michelangelo himself as a redeemer, sent by God, yielding
though his example a knowledge to which the Tuscans aspire, but which
otherwise would lie beyond their powers to achieve. Here is the famous pas-
sage:

> While the best and most industrious artists were labouring, by the light
> of Giotto and his followers, to give the world examples of such power
> as the benignity of their stars and the varied character of their fantasies
> enabled them to command, and while desirous of imitating the
> perfection of Nature by the excellence of Art, they were struggling to
> attain that high comprehension which many call intelligence, and were
> universally toiling, but for the most part in vain, the Ruler of Heaven
> was pleased to turn the eyes of his clemency toward earth, and
> perceiving the fruitlessness of so many labours, the ardent studies
> pursued without any result, and the presumptuous self-sufficiency of
> men, which is farther from the truth than darkness is from light, he
> resolved, by way of delivering us from such great errors, to send to the
> world a spirit endowed with universality of power in earth art . . .
> capable of showing by himself alone, what is the perfection of art. . . .
> The Tuscan genius has ever been raised high above all others, the

men of that country displaying more zeal in study and more constancy in labour, than any other people of Italy, so did he resolve to confer the privilege of his birth on Florence . . . as justly meriting that the perfections of every art should be exhibited to the world by one who should be her citizen. (III, 228)

Clearly modelled on the Christian epic, Vasari's is a narrative of disclosure and revelation, stipulating the end of a history, defined by the cumulative effort to achieve a perfection artists are incapable of without the revelation through example of a divine intercessor, born, like a savior, in Florentine precincts: a Florentine among Florentines, as Christ was a human among humans. I employ the term "revelation" here as implying knowledge of the highest importance which we would be incapable of attaining through the common cognitive routines—induction, deduction, observation, testimony, experimentation, or, in the specific case of the visual arts, "making and matching," to use Gombrich's expression. Artists, in Vasari's account, now know what *perfection* is, and need no longer blindly seek it. Rather, they can, by emulating Michelangelo's example, achieve perfection in their own work. The history of art, conceived of as the seeking of representational perfection, has concluded through divine intercession. All that remains is the refinement of skills.

Imagine, on the model of revelation, a vision granted to Giotto of Michelangelo's *Last Judgment*. A voice calls out: "Is this what you are trying to do?" Vasari assumes that Giotto's answer would unequivocally be "Yes"— that he would instantly see not only that Michelangelo had achieved what Giotto himself aspired to, but that, in point of the art criticism that belonged to that project, Giotto's personages were revealed as wooden, disproportionate to their architectural settings, and visually unconvincing. Of course, Giotto might well have thought differently, and if we could then imagine on what grounds he might have rejected the model of Michelangelo, we would have a very different understanding of Giotto's art than the one we have now, which depends upon seeing him and Michelangelo as belonging to the same developmental history. Suppose, however, he were granted a vision of *Les demoiselles d'Avignon*, or Matisse's *Luxe, calme, et volupté*. My counterfactual opinion is that Giotto would not have viewed these as art, or, if as art,

then art as done by savages or madmen, or by individuals who had the ambition to paint well but unfortunately were at the wrong part of history to do much—like the Tuscans before the revelation of Michelangelo: captives of cognitive darkness. These were to become the fallback positions when Modernism challenged received views of art with precisely these works. Giotto would have had no impulse to emulate, to learn how to do what Matisse and Picasso were revealed to have done. Rather, he would see himself as having made immense progress beyond them, whoever they were and whenever they worked. It would be like Chinese art, had he had a vision of that. In his *The Philosophy of History*, Hegel writes that "The Chinese have not yet succeeded in representing the beautiful as beautiful; for in their painting shadow and perspective are wanting." With qualification, Giotto had both.

I think we might use this counterfactual story to make plain what *belonging to the same history* means, and at the same time what it would mean *not* to belong to the same history. So I would assume that while Giotto and Michelangelo belong to the same history, neither of them belongs with Matisse or Picasso, and that, if this assumption were true, then we would have an intuitive grasp of historical discontinuity. To belong to the same history would mean that earlier artists could achieve what later artists achieved, without the labor of searching for it, once they had the example. Vasari's image is that artists would have stumbled forever in the dark, without finding what they were looking for, and that Michelangelo showed them what it was. One might argue that Michelangelo appeared when the Tuscan art world was ready for him, and that he had in some measure internalized the history that intervened between Giotto and himself. Certainly we could not imagine him as a contemporary of Giotto, nor as coming immediately after Giotto in an historical sequence instead of the artists who did, like Masaccio. But we could imagine a counterfactual history in which artists were spared the search and could move directly and immediately to their goal as embodied in Michelangelo's towering work. Of course, a lot would have had to change for this to happen: Were there actually walls high enough to execute something like *The Last Judgment* in Giotto's time?

In any case, art after Michelangelo would be post-historical with respect to a history whose terminus is the Sistine Ceiling and *The Last Judgment*. There was a great deal of art made after that, so it was not as though the his-

tory of art had stopped, but rather had come to an internally defined end. It had moved from search to application, from looking for representational truth to working in the light of that truth. Beyond the figure of Jonah in the Sistine Ceiling, it was impossible to advance. Of course, artists were to become more adept than Michelangelo in certain ways: Tiepolo handled foreshortening with an ease and certitude Michelangelo would have envied, had he been granted a vision of Tiepolo's ceiling painting for *Der Rezidens* in Wurzberg. But he would in no further sense have seen it as diminishing his achievement—and in any case he always complained that he was, after all, not a painter. Tiepolo would be entirely a post-historical artist with regard to that history, though three centuries further along: Michelangelo died in 1564—the year of Shakespeare's birth—and Tiepolo in 1770—six years before the American Revolution.

In that long post-historical evening, there were a great many changes in what artists were asked to do, so that in a way the history of art was the history of patronage. Mannerist art was a response to one set of briefs, the Baroque to another, Rococo to yet a third, and Neo-Classicism to a fourth. It would be inconceivable that these varying briefs could have been imposed on art if it were as it had been at the time of Giotto. Rather, this variety was a possibility only because the use of perspective, chiaroscuro, foreshortening, and the like no longer had to be struggled with. They could be mastered and used by everyone, and they defined what the curriculum of the workshop as art school should be.

This merits a further observation. Multiculturalism in art is today very much a political ideal, but it is an artistic ideal just because there is no such curriculum—nothing which qualifies artists to enter the world of commissions. Today, a Chinese artist might respond to Hegel that he has exceedingly provincial ideas of beauty as beauty. In the seventeenth century, on the other hand, Mandarins could see, as immediately and intuitively as Giotto is imagined here seeing Michelangelo, that the way a western artist used perspective was correct, and that their own history would have been different had the ancients the luck to see such models. But in their case, art was too embedded in practices they could not change in order to assimilate the perspective they now knew. That knowledge represented what they freely admitted they should have done, but which (unlike the case of Giotto and

Michelangelo) it was too late to do. Art was differently implicated in their life and culture, and a deep transformation in the whole of their society would be required if it were to be accepted. They belonged to a different history entirely. But today the "should" would drop out of consideration. There is no art-educational curriculum. That is why multiculturalism is a valid ideal as it would or could not have been in 1770, or until the advent of Modernism, however we date that.

To the degree that anyone thought about the future of art, it would not have the form "Someday artists will . . ."—on the model of "Someday medicine will find a cure for cancer" or "Someday man will walk on the Moon"—but rather the form that the future would be in essential respects like the past, except perfect where it is now deficient. One could learn the meaning of the term "art" through induction over known instances, and could rank artworks in terms of their distance from Vasari's paradigms. In a way, the class of artworks had the structure of a species, with all con-specifics sharing the defining features, but with enough variation that connoisseurs could single the best out from the better, the way dog or pigeon breeders do in Darwin's best examples of artificial as against natural selection. These views loosely defined the visual arts through the long interval from Michelangelo and his peers—Raphael, Leonardo, and Titian—until the dawn of Modernism, at which time, for reasons it would be fascinating to discover, a discontinuity emerged in the class of artworks so sharp that even connoisseurs were uncertain whether it was art at all. The historically important painting of the mid-to-late nineteenth century did not seem to belong to the future of art as that would have been intelligible to someone at home in the Vasarian post-history. It was at times so discontinuous that one could not easily explain it with reference to the kind of grading which went with species-like variations. Modernist works seemed entirely off the scale. Nor could it be explained with respect to the principles of perfection it in fact counterexemplified. One would, as I have imaged on behalf of Giotto, rather have explanatory recourse to hoaxes or insanity, to mischief and mockery. This, as in science, was a way of saving the appearances, enabling the concept of art, together with the apparatus of connoisseurship, to remain intact. It was a way of "explaining away" whatever seemed to threaten the concept—an entirely creditable defensive measure, since the new work, if admitted under

the concept, would inevitably entail revisions in the tacit schedule of necessary and sufficient conditions for something being an artwork. This of course is not to explain the need to preserve appearances in the case of art, or why, nearly a century after Matisse and Picasso, Modernist art has still to be explained away. Perhaps it is because we are supposed to be made in God's image, and God could not look like one of the Demoiselles. Or, if he could, we were not his images at all.

2

In 1873, Henry James published "The Madonna of the Future," a story about an artist I—but hardly James—would describe as post-historical. This is Theobald, an American working in Florence, and consumed by the ambition to paint a Madonna that would equal Raphael's *Madonna della Seggiola*. He had found a model, a beautiful young mother who embodied the qualities of feminine grace Raphael shows, and which Theobald wishes his own Madonna to possess. But instead of painting this woman, he devotes himself to the prolonged study of the painting he hopes to rival, seeking to discover what he refers to as "the secrets of the masters." These secrets would at best have an historical interest today, and would have been of incidental use in the history which succeeded the Vasarian history. James sees Theobald as ridiculous and at the same time tragic. He nevertheless entirely accepts Theobald's project of painting what the Narrator refers to as *The Madonna of the Future*, giving James his title. That meant that James and Theobald belonged to the same moment of the same history: one could make valid art by re-creating valid art. So James could say that, if successful, Theobald's picture would embody the qualities that Raphaels's painting embodied and hence be as good a painter as Raphael was. (Precisely such an inference governed Hans van Meegeren's decision to paint what everyone would believe was done by Vermeer.) Theobald once drew a picture of a child which could have passed for a Correggio, and it is striking to speculate that he would not have made a drawing which could have passed for a Giotto—that would either have been a deliberate archaism or a mark of not having learned properly to draw. So Theobald and Raphael belong to the same prolonged historical moment. The story now takes a turn: James's Narrator is intro-

duced to the woman in whom Theobald saw his Madonna inscribed, and is shocked to discover she has grown coarse and stout and sexual, though what James calls *les beaux restes* can still be made out. Theobald has waited too long—waited twenty years too long in fact, during which his model went from youth to thickened middle age. He had studied painting too long to the detriment of depicting life. Stunned by this truth, he resolves to paint his masterpiece, which, he says, pointing to his head, is already created, needing only to be transcribed. In fact transcription is more of a problem than he envisioned, and when the Narrator seeks him out, Theobald is sitting before a blank canvas. Not long afterward he dies an operatic death, like Mimi in *La Bohème*—which is the only way to end a story like this.

Let us conduct the same kind of historical experiment with Theobald as we did with Giotto. We might imagine someone appointed in 1973 as chief curator of the Museum of Monochromy, in, let us say, Cincinnati. He enters Theobald's studio at the moment when, all passion spent, the artist sits listlessly before a canvas which James describes as "a mere dead blank, cracked and discolored by time"—an object which emblematizes as dramatic a failure as Fremincourt's painting in Balzac's *Le Chef d'oeuvre inconnu*. And indeed the canvas *is* to the curator's eyes a *chef d'oevre inconnu*. "It is," he tells Theobald, "a masterpiece." And he assures him that he is astonishingly ahead of his time. That the history of the all-white painting, which includes Rodchenko, Malevich, Rauschenberg, and Ryman, begins with him. "Has it a title?" he asks. Theobald replies: "It has been referred to as 'The Madonna of the Future.'" "Brilliant!" the Curator responds. "What a comment the dust and cracks make on the future of religion! It belongs in my monograph—it belongs in my museum! You will be celebrated!" This "Ghost of Art Worlds Future," as a curator, will have brought some slides—of Malevich, Rodchenko, Rauschenberg, Ryman. The slides are pretty much all alike, and each resembles Theobald's blank canvas about as much as they resemble one another. Theobald would have no choice but to regard the curator as mad. But if he has a philosophical imagination, he might say this: It does not follow from those blank canvases being artworks, together with the resemblance function between their work and my blank canvas, that *this* blank canvas is an artwork. And it will occur to him that it almost immediately must follow that one cannot tell artworks from other things on the ba-

sis of observation, induction, and like cognitive practices, which served in the art world he knew. At a more human level, he would continue to count himself a failure, even if the site of his failure would be regarded in the future as an artwork. That would not be a future he would wish to be part of: He wants to be the Raphael of the future, and achieve a work in every particular the peer of the *Madonna della Seggiola*. It is no consolation that there will be works which resemble something he has not relevantly touched. Still, the Ghost of Art Worlds Future will have planted a question. The question is: What is an artwork? That is not a question which could interestingly arise in the reign of Vasari.

"What is an artwork?" became part of every artwork belonging to the Modernist era, and each such artwork advanced itself as a kind of answer: *Anche io sono pittura*. It is because artworks could be enfranchised only through an analysis of art that it would be correct to say, as Clement Greenberg famously did, that the mark of Modernist painting was self-critique: "The essence of Modernism lies, as I see it, in the use of the characteristic methods of a discipline to criticize the discipline from itself." Greenberg saw this as a search for what was "unique and irreducible in each particular art," and hence for a perfection quite different from what Vasari imaged. Modernism, in virtue of this ascent to self-consciousness, marks a new kind of historical reality, and not just a new historical reality. Modernism contrasts, in virtue of this self-consciousness, with everything that went before, and does so, in virtue of self-consciousness, in ways in which the various stages and movements of the tradition did not differ one from another. In some way paintings themselves became objects rather than ways of showing objects. It is not surprising—it was to have been expected—that as Modernism advanced, more and more of the art that had not been considered part of the history of art was admitted as art—folk art, primitive art, oriental art, the art of "outsiders"—simply because it was no longer considered important that these arts look as if they fit into the Vasarian narrative. This induced an increasingly radical heterogeneity into the *extension* of the term "artwork." And it raised questions for each tentative definition of art, just because none of the ways in which these objects differed from one another could belong to the definition. If it belonged to the definition, one or the other of the differing works could not belong to the term's extension. So the answer had to be

universal and complete, which is by and large what Hegel meant by Absolute Knowledge. And, in a singularly important way, the answer had to lie outside history, as having to be compatible with whatever art there was or would be, in any possible world in which there was art at all. It would in particular have to explain why a blank canvas from 1873 and a blank canvas from 1973, otherwise entirely alike, differed in that one could not be an artwork, though the other is one. This I regard as the central question of the philosophy of art. It is scarcely a question that could have arisen for the doomed Neo-Raphaelian painter Theobald. It is after all the mark of history that the future is not disclosed in the present, barring visitors from the future. One might have been able to imagine, at some earlier moment in Vasarian history, that there would be a time in the future when artists could create works so like reality that no one can tell the difference. But they would not know how to generalize upon their own representational strategies to know how—which is why Vasari counted Michelangelo's coming as a revelation.

3

The first stirrings of Modernism, of course, could be seen by 1873. If we think of the consignment of Manet's *Déjeuner sur l'herbe* to the Salon des Refusés as the first event in Modernism's history, that history was but ten years old when James published his story. The First Impressionist Exhibition was held in (*nota bene*) the studio of the photographer Nadar in 1874. In 1876 there was a famous encounter between the critic Ruskin and the painter Whistler (which James reported on in *The Nation*). Whistler insisted that *Nocturne in Black and Gold: The Falling Rocket* was a painting, while Ruskin dismissed it as "flinging a pot of paint in the public's face." Compared to what Ruskin admired, it could hardly have been accepted as art. Compared to Pollock—or even to Bacon, who talked about throwing paint at the canvas—it is pretty tame. But the quarrel was over what everyone thought they knew. The history of Modernism was the history of scandals as one after the other, works of art bumped some cherished criterion out of the definition of art. The first two thirds of the twentieth century saw the end of this history, when works of art began to appear that resembled quite ordinary things—

like soup cans and Brillo boxes—far more than they resembled what would have been counted works of art in the age either of Giotto or of Theobald.

It is this moment of closure that I refer to as The End of Art. As with Michelangelo, beyond whom, on the Vasarian narrative, one could not advance, there would be no going beyond the Brillo box in the history of artistic self-consciousness, since the class of artworks includes *Brillo Box* but seemed to exclude Brillo boxes which look exactly like them. With the breakthrough it was plain that one cannot hope to base a definition of art on what meets the eye. Warhol's achievement would be reenacted in the history of Appropriation—Warhol himself was appropriated by Mike Bidlo and by others—but in no sense could any of this be regarded as an advance beyond Warhol. Since the motives for Appropriation are many, The End of Art does not mean that art will not be made. It means the closure of a history, not the termination of a practice.

I want to pause and reflect upon the kind of concept the concept of art is. Logicians distinguish between what they term the *intension* of a concept, and the concept's *extension*. The extension of a concept (or a term) will be all and only those things that fall under the concept—the robins and sparrows and ducks if the concept is "bird." The intension comprises all the conditions deemed necessary for something to be classed as a bird—wingedness, oviparousness, and the like. Everything in the extension must, through meeting these criteria, resemble the rest. Whatever the difference between ducks and sparrows, both of them are birds. The history of Modernism, by adding disjunctively to the extension of the concept "artwork," tended to bump from the intension one or another condition—and when that happened, things became candidates for art that would not have been before. The intension of "artwork" is transhistorical: it specifies the invariant condition for something being art in every world in which there is art at all. But the extension of the concept is entirely historical in the sense that Theobald's canvas could not have been an artwork in 1873 though something just like it could already have precedents a century later. Indeed, the possibility was realized in a few years after Theobald's death, albeit as a spoof by the artist Alphonse Allais, who, in 1879, printed a blank white rectangle with the joky title *Première communion de jeunes filles chlorotiques par un temps*

de neige. Chlorosis is a disease due to iron deficiency, leaving the skin green-ish (it is called "greensickness" in the vernacular), and "chlor" means "green"—think of chlorophyll. "Albino" would have served Allais's purpose better, since he clearly intended a picture of abnormally white-skinned girls in white communion frocks in white snow. He did an all-black picture as well: *Combat de nègres dans une cave pendant la nuit.* Both, however are *pictures,* and though the difference between one of them and Theobald's blank canvas could have been invisible, it is no less profound for that. It is a picture of an all-white world, whereas the blank canvas is not a picture at all (including not a picture of nothing), however great the resemblances (let them be arbitrar-ily close). The blank canvas can become an artwork only with the advent of abstraction, which bumped "is a picture" from the concept of the visual arts. And in that, startling as it may seem, the concept of visuality itself was bumped from the concept of the visual arts, even if the extension of the con-cept was filled with objects of visual beauty and interest. What delayed the advent of Absolute Knowledge in the case of art is that, for historical rea-sons, certain features of objects in the extension were believed to form part of the intension of the concept, when in fact they lay outside the essence of art entirely.* Even if there were no conceptual analogue, it is valuable to see in what ways the concept of art is different from such concepts as "bird," with which the old logic texts concerned themselves. This would explain why the history of Modernism differs from the Vasarian history as well. Giotto could have made great strides in approaching Michelangelo by studying the future great man's secrets, just as Theobald did in studying the secrets of Raphael. But Modernism is conceptual. Its history is the history of adding to the extension of art and at the same time modifying its intension until it be-comes plain with the fullness of self-consciousness that there is no way a

*It would be fascinating to find some other concept of which something like this is true. It has at times seemed to me that the concept of number, which has its own his-tory, beginning with the whole numbers, the integers with zero, the rationals, the re-als, and so on, has something like the structure of the concept of art, but I do not wish to develop that comparison here.

work of art cannot appear—that anything can be a work of art, the question now being what must be true of it for this to be true.

This way of seeing the problem did not disclose itself all at once. But there is a marked difference between Modernism's approach and that of the art which in a way put an end to Modernism. Modernism's was a pursuit of essence, of what art solely and truly is, hence of a kind of pure art, very much as if the art which resulted was like an alchemical precipitate, from which impurities had all been purged. This suggests a Grail-like narrative, in the framework of which the all-white painting might have been regarded as the climax—the work beyond which it was impossible to go. It was precisely in those terms that Aleksandr Rodchenko painted what he proclaimed as the last painting possible, using three monochrome panels of pure red, pure yellow, and pure blue. That done, painting was done, and artists were liberated to enter into life, as Rodchenko himself did in the 1920s and 1930s. I heard Robert Colescott explain his reasons for making comic paintings of blacks, namely that Ryman had gone as far as one could go with his all-white paintings, and that in consequence a history was over with. There is, I think, a logical flaw in this agenda, namely that though the all-white painting could be considered art and be considered pure—it would not follow that it was pure art—art in a pure state. That is because white is at best a metaphor for purity. The essence of art must be possessed by every work of art, even the least pure—like Colescott's cartoon masterpieces.

The other and succeeding strategy was to put pressure on the intension of the concept by advancing something as art which violated some accepted criterion, and to see what happens. Wittgenstein talks about a chess-player who puts a paper hat on a king, which of course, whatever meaning it has for him, means nothing under the rules of chess. So you can really take it off without anything happening. In the 1960s and beyond, it was discovered how many paper hats there were in art. They were thought to be part of the meaning of art when in fact they were subsidiary properties of certain works of art of surprisingly local interest. I think of Warhol as having followed this line of investigation with greater conceptual imagination than anyone else, erasing false criteria at every step, until it began to be appreciated that there was nothing that could not be art. But that was happening everywhere at that time in the arts—in dance, in theater, in music. Since anything could be art,

the question arose why everything wasn't art: What made the difference between what was and what was not? A number of fairly bad answers were given. One would be that whatever an artist says is a work of art is through that fact a work of art, period. Or—this is the Institutional Theory of Art—whatever an art world decrees is a work of art is one through that declaration. This makes the history of art a series of proclamations, which leaves the problem of why Theobald's blank canvas was not an artwork in 1873 a mere matter of his not declaring it to be one. And that seems to leave a great deal out of the picture. It seems simply unacceptable that the members of the class of artworks have only the fact that someone called them art to license their being in the class at all. But what then can they have in common if there are no limits on what can be an artwork . . . especially if two things can look entirely alike but only one of them be an artwork? That question is philosophical, and when I speak of the end of art I mean specifically that progress from this point on is philosophical progress, progress in the analysis of the concept. It is not that art has turned into philosophy as much as that the history of art has moved onto a philosophical plane. Art-making may go on and on. But so far as self-understanding is concerned, I do not believe it can take us further.

I might only add that the history could not have attained this point by philosophical reflection alone. It has been entirely internal to the history of art, and the progress to artistic self-consciousness has emerged through the kind of philosophy in action which the history of Modernism has been. Philosophers could not have imagined a situation like the present one in which, with qualification, anything goes.

4

So what does it take to be an artwork in what I term Post-History? I want to concentrate on an interesting example that should make the problem vivid, and that shows to what degree art-making has been penetrated by philosophy. This was an installation by an artist with the surprising name (in fact a pseudonym) L. A. Angelmaker, in the Momenta Art gallery in Brooklyn. The work has a title—"Bad Penny: For Museum Purchase Only." And it consists of articles of antique furniture which were either not considered

works of art, because they were works of craft instead—or were works of art only because they were made at a time when the line between art and craft was not considered firm. These articles in any case had once been in the decorative arts galleries of museums, and had subsequently been deaccessioned. But through Angelmaker's intervention they constitute works of contemporary art, or are in any case integral to a work of art which would not have been possible as art in an earlier moment, and certainly not under Modernism. Whatever else we can say about them, their being art now has nothing greatly to do with an artist or a group of artworlders transforming them into art by saying simply "Be thou art." One of Angelmaker's objects is a French Henry II–style walnut extension table, incorporating Renaissance elements. It was given to the Metropolitan Museum of Art by J. P. Morgan in 1916. The other object is described as "A French Provincial Late Renaissance Walnut Armoire, early 17th Century." Both are handsome pieces of furniture that anyone would love to live with, but I am interested in them through the fact that they are offered as art today in a different way from any perspective under which they might have been viewed as art before. The items of furniture were, as said, "deaccessioned" by museums, and offered at auction to a public which doubtless bid on them as luxurious articles of use. Angelmaker "is offering to resell the furniture to museums as contemporary works by dint of their participation in his project." So the seventeenth-century armoire is transformed into a late-twentieth-century piece of art, as part of a complex performance. The artist is attempting "to disrupt the flow of objects from public collections into private ownership." In any case, the art criticism of Angelmaker's project is obviously vastly different from the art criticism of the pieces of furniture as such, with reference to the patina of the wood, the design of doors, the cabinetry. In becoming art, the articles of furniture retain those now irrelevant properties, which form no part of their status as art in the late twentieth century.

I regard this work as a deeply post-historical object in that it could not, unlike Michelangelo's work—or a blank canvas—be imagined as of use in showing what earlier artists in their respective histories were trying to do, since they culminated those histories. Nor can we imagine some later work showing what Angelmaker really aspired to achieve. Angelmaker's work generates no subsequent history, at least not as art. This is the mark of contem-

porary art, in which each work has only its own history. But that is to say that contemporary art has no mark, which is the external side of the slogan that anything can be art. Beyond that it is clear that *Bad Penny*'s status as art has nothing to do with its maker merely declaring it to be art. Its being art instead is implicated in its conceptual complexity, its purpose, and its means. One might notice in passing that one would have to view antique furniture as part of the material of the artist, like paint and plaster. The materials of the artist are as diverse as the class of artworks themselves, since anything is subject to having its identity transformed by someone who sees how to use it in a work. The art supply store would then have to carry *everything*. Their inventory would have to be as rich as the inventory of life.

I want to conclude with one further example. The sculptor Tom MacAnulty recently completed a commission he had received from a monastic order in Indiana, to make an altar for their church. The brothers had been struck by the magnificent Ottonian altar in Aachen, from just after the time of Charlemagne, and wanted something exactly like that, though not an imitation of it. This left the artist a great deal of room when it came to the gilded bronze panels, which decorated the four sides of the altar (the frame would be built by a monk gifted in cabinetry). It was a wonderful commission, and involved a great deal of discussion as well as careful reading of the Bible, but at the same time it left MacAnulty uncomfortable. What business, he wanted to know, has a modern sculptor working on an Ottonian altar? I told him that a *modern* sculptor would have had no business producing such a work. But it was perfectly all right for a *contemporary* artist to do so. For an object not deeply different from an eighth-century altar can be a work of contemporary art. His work may enter into subsequent history in many ways: he may go on to execute other liturgical commission, he may start a trend in which non-liturgical artists find satisfaction in liturgical art. But this is not a master narrative. To say that the work is post-historical is merely to stress that. If we think of everything actual and possible as art laterally—that is, the art being made all across the art world at a given time—then it must be clear that the heterogeneity today is of so high a degree, the media so interpenetrate one another, and the purposes are so diffuse, that a next lateral cut will be strictly unpredictable. All that one can predict is that there will be no narrative direction. And that is what I mean by the end of art. It is per-

haps part of the cunning of reason that the end of art closely coincides with the end of the millennium!

When I first wrote about this concept, I was somewhat depressed. I concluded my text by saying that it had been an immense privilege to have lived in history. I wrote that as a New Yorker who had lived through so many changes, each surprising and yet each developing what went before. So one went to exhibitions to try to determine where art was heading. I felt about that history, in truth, as I did about analytical philosophy, which had also seemed to be moving inevitably toward certain ends. But now I have grown reconciled to the unlimited lateral diversity of art. I marvel at the imaginativeness of artists in finding ways to convey meanings by the most untraditional of means. The art world is a model of a pluralistic society, in which all disfiguring barriers and boundaries have been thrown down. (For what it is worth, I have no use for pluralism in philosophy.)

Hegel's final speech in the course of lectures he delivered at Jena in 1806 could be describing this moment in the history of art:

> We find ourselves in an important epoch, in a fermentation, in which
> Spirit has made a leap forward, has gone beyond its previous concrete
> form and acquired a new one. The whole mass of ideas and concepts
> that have been current until now, the very bonds of the world, are
> dissolved and collapsing into themselves like a vision in a dream. A new
> emergence of Spirit is at hand; philosophy must be the first to
> recognize it, while others, resisting impotently, adhere to the past . . .
> But philosophy, in recognizing it as what is eternal, must pay homage
> to it.

From that tremendous perspective, the liberation of a life beyond history might be experienced as exhilarating.

INDEX

. . .